Images at War

A John Hope Franklin Center Book

A book in the series

Latin America Otherwise

Languages, Empires, Nations

Series editors:

Walter D. Mignolo / Duke University

Irene Silverblatt / Duke University

Sonia Saldívar-Hull / University of

California at Los Angeles

Images at
WAR

Mexico

from Columbus

to *Blade Runner*

(1492–2019)

Serge Gruzinski

Translated by Heather MacLean

Duke University Press Durham & London

2001

© 2001 Duke University Press All rights reserved Printed in the United States
of America on acid-free paper ∞ Designed by C. H. Westmoreland Typeset by
Keystone Typesetting, Inc. Library of Congress Cataloging-in-Publication Data
appear on the last printed page of this book.

Originally published in 1990 as *La guerre des images de Christophe Colomb à "Blade
Runner" (1492–2019)* by Librairie Arthème Fayard

Contents

About the Series

Latin America Otherwise: Languages, Empires, Nations is a critical series. It aims to explore the emergence and consequences of concepts used to define "Latin America" while at the same time exploring the broad interplay of political, economic, and cultural practices that have shaped Latin American worlds. Latin America, at the crossroads of competing imperial designs and local responses, has been construed as a geocultural and geopolitical entity since the nineteenth century. This series provides a starting point to redefine Latin America as a configuration of political, linguistic, cultural, and economic intersections that demands a continuous reappraisal of the role of the Americas in history, and of the ongoing process of globalization and the relocation of people and cultures that have characterized Latin America's experience. *Latin America Otherwise: Languages, Empires, Nations* is a forum that confronts established geocultural constructions, that rethinks area studies and disciplinary boundaries, that assesses convictions of the academy and of public policy, and that, correspondingly, demands that the practices through which we produce knowledge and understanding about and from Latin America be subject to rigorous and critical scrutiny.

In *Images at War* Serge Gruzinski tells a story that begins with the emergence of the Atlantic circuit and the expansion of Western capitalism to the second decade of the twenty-first century. The past lies not only in the present from where the story is being told, but also in the future that the story of the past announces. By bringing together Columbus and *Blade Runner*, Gruzinski—perhaps the most imaginative French scholar of colonialism in the Americas—is indeed identifying one of the most powerful elements in the imaginary of the modern / colonial world, the image. This book is the companion of his early and classical one, *La colonization de l'imaginaire* (1988), in which he explored in detail literacy and the colonialization of language.

This book should also be read keeping in mind how one can study an "area" without falling into the ideology of "area studies." Gruzinski builds a theory inscribed in the very act of narration, and that theory is articulated in the concept of *ixiptla*. *Ixiptla,* neither signifier nor signified, was a keyword around which two epistemic paradigms or ideological cosmologies entered into tense relations of power, the coloniality of power that put together and kept together the modern, today global/colonial world.

List of Illustrations

Introduction

Los Angeles, 2019: plumes of fire and acid rain punctuate the orange skies hanging over the pyramids of the great "Corporations," buildings whose colossal bulk mirrors the image of Teotihuacán's pre-Columbian sanctuaries. Images are everywhere: on skyscrapers, in the skies, behind the rain-splattered shop windows. A noisy and hybrid crowd of Westerners, Hispanics, and Asians swarms through the dirty streets, surges into alleyways, zigzags through garbage, geysers of steam, and puddles reflecting the sparkle of multicolored images.

Ridley Scott brought his masterful work of contemporary science fiction, *Blade Runner*,[1] to the screen in 1982; the endpoint, or one of the conclusions of the history narrated in this book, is perhaps when the war of images becomes the hunt for "replicants." "Replicants" are androids created to accomplish perilous tasks on distant planets. They are such perfect copies that they are virtually indistinguishable from humans, and they are such dangerous images that it becomes imperative to "retire" or eliminate them. A few "replicants" have a grafted memory that clings to a handful of old photographs, false memories designed to invent and maintain a past that never happened. Before he dies, the last android reveals himself to the human tracking him; he hints at a limitless knowledge and shares a quasi-metaphysical experience acquired at the edge of the universe in the dazzle of the Tannhäuser Gate, as yet unseen by any human eye.

The false image, the too-perfect replica that is more real than the original, the demiurgic creation and the murderous violence of iconoclastic destruction, the image bearer of history and time entrusted with inaccessible knowledge, the image escaping its creator and turning against him, a man in love with the image he has created: *Blade Runner* gives us not a key to the future—science fiction only teaches us about our present—but indexes themes that have arisen during five centuries on

the Hispanic (formerly Mexican) part of the American continent. These abundant themes were the impetus for this book, though perhaps one cannot completely explore them here but only indicate tracks, or paths to follow.

The war of images is perhaps one of the major events of the end of the twentieth century. Difficult to define, entangled in journalistic common-places or the meanderings of a hermetic technological sophistication, this war covers—beyond the struggles for power—the social and cultural stakes whose present and future importance we are yet unable to measure. "Would it not be a great paradox for us to be living in a world of inflation of images, while still believing we are under the sway of text?"[2] From Orwell's omnipresent screens to the gigantic billboards piercing Ridley Scott's humid and illuminated night skies, the image has already invaded our future.

This is certainly not the first time that the image has troubled the minds of men, that it has nourished reflection and fueled conflicts in the Western and Mediterranean world. Iconic theology has played an impor-tant part in religious thought.[3] In the eighth century it unleashed a famous "quarrel" which shook the Byzantine Empire. Iconoclasts and iconodules fought bitterly over the cult of images.[4] In the sixteenth cen-tury the Protestant Reformation and the Catholic Counter-Reformation made opposite and decisive choices for modern times, one of them cul-minating in the baroque apotheosis of the Catholic image.[5]

For spiritual reasons (the imperatives of evangelization), linguistic rea-sons (the obstacles of the many indigenous languages), and technical reasons (the spread of the printing press and the rise of engraving), the image exerted a remarkable influence on the discovery, conquest, and colonization of the New World in the sixteenth century. Because the image—along with written language—constitutes one of the major tools of European culture, the gigantic enterprise of Westernization that swooped down upon the American continent became in part a war of images that perpetuated itself for centuries and—according to all indica-tions—may not even be over today.

Images became vital as soon as Christopher Columbus set foot on the beaches of the New World. The nature of the images the natives owned was quickly a matter of interest. Very early on, after the Church resolved to convert all Indians from Florida to the Tierra del Fuego, the image was used as a marker, then became a tool for acculturation and domination.

Colonization ensnared the continent in an ever-growing net of images that was cast out over and over again, and that shaped itself according to the rhythm of the styles, politics, reactions, and the oppositions it met. Though colonial America was the melting pot of modernity, it was also a fabulous research laboratory where images helped discover how the "West Indies" became a prey for the West, and how they then confronted these images, image systems, and *imaginaires* of the conquerors in successive and uninterrupted waves, from the medieval to the Renaissance image, from mannerism to the baroque, from the didactic to the miraculous image, from classicism to muralism and right up to today's electronic images which ensure for Mexico, by an astonishing reversal, an impressive rank in the planetary empires of television.

While *Blade Runner* marks the fictional endpoint of this history, the Mexican company Televisa is without contest its contemporary culmination. It has succeeded in a prodigious breakthrough, with close to thirty thousand hours of broadcasting exported annually to the United States, Latin America, and the rest of the world. In the United States alone, eighteen million spectators of Hispanic origins watch its programs. The near-forty years of supremacy acquired through its manipulation of information and culture, as well as the thousands of hours of soap operas broadcast each year, have gained Televisa a tentacular influence, often encouraged by the weakness or complicity of the Mexican state. Paradoxically, even as the country was in near crisis, having failed to boost its development through the exploitation of oil fields, it continued to show unbridled enthusiasm in the field of communications and the image industry (film, video, cable). But the control of images is worth as much as that of energy; and the war over images is as important as the ones over oil. Without reaching the fascinating heights of *Blade Runner*'s California "Corporations," Televisa still reveals a facet of Mexico that might be disconcerting to lovers of exoticism. Though it is impossible to explore fully—and even more so to explain—this giant of the Americas within the scope of this book, these realities can no longer be ignored when choosing to reread the colonial past in terms of the image.

Let us focus our approach. Just as speech and writing, the image can be a vehicle for all types of power and resistance. The train of thought it develops offers a specific matter, as dense as that of writing but often irreducible to it, and as such hardly facilitates the task of the historian who is constrained to superimpose words on the unutterable.[6] This

book, however, will not linger on the paths of figurative thought, nor, more classically, on art and stylistic history,[7] nor even on the content of images.[8] Instead, this study will focus more on examining the programs and politics of the image, the multiple forms of resistance that the image causes or anticipates, and the roles that it takes on in a multicultural society. A reading at this level not only unearths conflicting interests, confrontations, and oft-forgotten figures; it also sheds a different light on the religious phenomena that have weighed on Mexican society since the seventeenth century. The cult of the Virgin of Guadalupe—who appeared to an Indian in 1531—is the most astonishing example of this: as much as television, this miraculous effigy is still a magnet that draws multitudes, and her cult remains a phenomenon of the masses that no one would dare to question, upon pain of iconoclasm.

Let us add to these successive avenues, either explicitly or latently, a questioning of the unstable contours of the image, historical product and Western object par excellence, which in fact is neither immutable nor universal. It is therefore understandable that the image, here, cannot be defined abstractly.

But this process will lead us to open up the *imaginaires* that arise at the intersection of expectations and answers, the crossing of sensitivity and interpretation, the meeting of the fascination and the attachment the image can provoke. By favoring the *imaginaire* as a whole and in its fluidity (which is also the fluidity of real life), I have given up beginning an overly systematic description of the image and its context, for fear of losing sight of a reality that exists only through their interaction. And I have tried to resist, whenever possible, the usual avatars of a dualistic (signifier / signified, form / content) and compartmentalized (economic, social, religious, political, aesthetic) way of thinking whose overly utilitarian outlines manage to imprison more than they explain. Perhaps, in any case, it is one of the virtues of historical inquiry to be able to demonstrate how much the categories and classifications that we apply to the image long have been inherent to a scholarly understanding tinged by Aristotelian and Renaissance thought, but whose historical roots and pretended universality are not always perceptible.

There is another problem: where and how to interrupt the exploration of an *imaginaire* that continuously redisplays itself in spite of the usual period classifications, and the necessarily limited specialization of the researcher. The *terminus ad quem*—2019—is a sign of this impossibility as

much as the singular and nonarbitrary nature of the dates which mark the trajectory of the *imaginaires:* they have whatever "reality" and content that an age, a culture, a group consents to give to them. The reader will discover other "fictional" dates that overflow onto the past—as others overflow into the future—and that manage to influence *imaginaires* and societies even more than our "real" and historical timelines do.

A final word about the chosen field: as in other matters, Latin America and more particularly Mexico offer an unequaled observatory. "Chaos of Doubles,"[9] colonial America duplicates the West through the intermediary of its institutions, practices, and beliefs. From the sixteenth century on, the Church sent forth its evangelizing missionaries; they carved out parishes and dioceses everywhere. The Spanish Crown cut out vice-kingdoms, set up tribunals, installed a continentally scaled bureaucracy. It tried to impose a language—Castilian—and during three hundred years it tried to subject the South American immensities to the same rules, the *Laws of the Indies.* The Crown brought forth new cities; the Church built convents, churches, cathedrals, palaces; Europe sent over its architects, its painters, and its musicians: Manuel de Zumaya, the baroque composer from Mexico, was contemporary with Telemann, in Germany. But this also became the flourishing heart of an empire that took on the colossal task of integrating the indigenous societies and cultures it had partially dismantled. Some Indians resisted, others attempted trickery, or tried to find and make arrangements with the conquerors' reign. Very early on, ethnic groups became mixed; the people, their beliefs, their behaviors were mingled. Latin America thus became the land of all syncretisms, a continent of the hybrid and of improvisation. Indians and whites; black, mulatto, and mestizo slaves coexisted in a climate of confrontation and exchanges where we might easily recognize ourselves today. America, "Chaos of Doubles."

The unforeseen and brutal clash of societies and cultures exacerbated tensions, increased the challenges, imposed choices at every moment. Such a clash so closely evokes our contemporary world in its postmodern version that it forces us to reflect on the fate of conquered cultures, on cross-fertilizations of all kinds, on the colonization of the *imaginaire.* I have analyzed the reaction of indigenous groups to the Spanish domination, showing how, far from becoming dead or frozen worlds, such groups continually built and reconstructed their cultures. *Man-Gods in the Mexican Highlands* retraces the evolution of the conception of power in

the indigenous milieu, juxtaposing and dissecting a few individual life stories that drew a picture of failed but dazzling godlike leaders. *The Conquest of Mexico* examines, in a more global fashion, the fate of the peoples of Central Mexico during the colonial period. The Indian communities managed to live through the demographic apocalypse that decimated them; they forged new identities, invented memories, and set up a space for themselves in the midst of the surrounding colonial society— when the fascination of the mestizo city, alcohol, forced exploitation, or anonymity did not break or disperse them.

Between the lines of Mexican history one begins to sense that the process of Westernization reached its height in Latin America from the sixteenth to the eighteenth centuries. How is one to interpret this gigantic undertaking of standardization, whose planetary outcome can be seen at the end of the twentieth century, right down to the students in Tiananmen Square? With Carmen Bernand, in *Of Idolatry*, I examined one of its intellectual consequences. The West projected categories and grids onto Latin America in order to try to understand, dominate, and acculturate it. After that, in order to identify the adversary they wished to convert, missionaries adopted the Church leaders' terminology, tirelessly denouncing indigenous "idolatry" while chasing after the "idolaters." Theories and interpretations closely followed one another. The Christian West reduced its prey to fit its own schematics and made it the object of its debates—inventing "Amerindian religions" on the way—until, tired, it turned to other forms of exoticism and fresh polemics.[10]

During the analysis I realized that the question of idols was in fact only an accessory to that of idolatry. In order to restore its true import, it had to be compared with the question of images. Christian and European images had assaulted the indigenous idols. The subject required one to grasp simultaneously the acts of the colonizers and the response of the colonized, whether Indian, mestizo, black, or mulatto. But I also needed to return the strategic and cultural weight—that I had undervalued—to the image, and better capture that which the seductive, but too often imprecise, notion of the *imaginaire* covered.

This is the purpose of *Images at War,* fourth and last part of a historian's travels through Spanish Mexico.

1

Points of Reference

Placed from the outset in the realm of the gaze and the visual, the peaceable prologue to this war of images is as unexpected as it is disconcerting. It seems to have followed a different scenario, one that might not inevitably have led to the Islands and continental tragedy, to the massacres, the deportation of indigenous populations, or the destruction of idols.[1] Ethnography, centuries later, would reexamine these emerging intuitions, these nascent trails, these prospects that could be guessed at between the lines. The prologue was a brief respite before a more respectable process of referencing, with its ballast of categories and stereotypes about classical idolatry, could reclaim its rights and swoop down on America's novelties.[2] But at that time, observation and questioning were the order of the day.

The Admiral's Gaze

Monday 29 October 1492. Christopher Columbus had landed two weeks earlier. The Admiral of the Ocean Sea was exploring the Greater Antilles. He marveled at the beauty of the island of Cuba. His gaze lingered on its coasts, its rivers, its houses, its fields of pearls. The Admiral, fulfilled, believed the Continent—of Asia—to be close-by. "Beauty" (*hermosura*): the word crops up over and over, becoming the leitmotif of the Discovery. The Admiral's gaze stopped on Cuba long enough for this thought: "They found many statues of female figures and many head-shaped masks, very well-carved. I do not know if they keep these for their beauty, or if they worship them."[3]

First contact with the island peoples had put the explorers in the presence of beings and things they knew nothing about and which surprised them. Columbus had been searching for a path toward the Indies and their gold. He was readying to land in Cipango (Japan) or China, land of

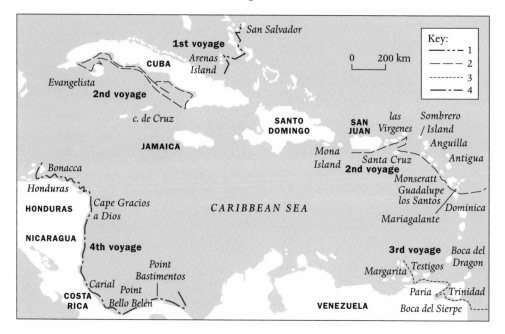

The Voyages of Christopher Columbus. From S. E. Morison, *Christopher Columbus* (London: Mariner, 1956).

the great khan, and had planned on converting people known to be civilized. But none of that happened. Instead of "urbane and worldly peoples," instead of the "great vessels and merchants" he had hoped to meet at any moment, the Admiral discovered men with painted naked bodies who believed the Spaniards to be creatures descended from the skies.[4] Having left behind the dreams and legends haunting their imagination, Columbus and his companions found themselves confronted by "destitute people." These people did, however, own a few objects that attracted the Admiral's gaze. This was enough to initiate yet another discovery marked by a fifteenth-century Genoese sensitivity, as if the Italian eye of the quattrocento were the first to settle upon the Americas.

Among the objects held by the natives—spears, balls of spun cotton, canoes, gold jewelry, hammocks—Columbus spotted what we would call today "representational objects." His curiosity was not aroused by the body stamps—even if they were pointed out and described as early as 12 October 1492—nor by the baskets hanging from the beams of the huts containing, according to him, the ancestral skulls of the family lines.[5] But

of other objects, the same question was asked during at least two years: were the statues of women and "the skillfully worked heads in the shape of masks [*caratona*]" objects of worship, or decorative pieces? "I do not know if they keep these for their beauty, or if they worship them."[6] What are they used for? he asked, and not, What do they represent? As if it were more urgent to identify the function rather than the nature of the representation. Similarly, a year later in the Lesser Antilles, he fretted: "After having seen two crude wooden statues each topped by a coiled serpent, [the Spanish] thought they were images worshipped by the natives; but afterwards they knew they were placed there as ornaments, since, as we indicated earlier, our men believe that they only worship the celestial *numen*."[7] The description is brief: it notes the composition of the statues, the crudeness of the shapes, no more. Puzzled observers, at first inclined to perceive objects of worship, the explorers were forced to accept the evidence of their own beliefs (*"creen los nuestros"*) or what they believed they understood from the natives' own explanations. The approach was the same as in December 1492 in Cuba, when Columbus inquired about what he thought might be an indigenous temple: "I thought that it was a temple and I called [the natives] and asked by signs if they said prayers in it. They said no."[8] He once again abandoned an initially religious interpretation in favor of what the natives said, without worrying in the least about the uncertainties of verbal and gestural communication, as if these natives navigated as easily as Columbus the registers of religion, the secular, and aesthetics.

Such behavior was, on the other hand, quite natural for a Genoese from Renaissance Italy, where for almost a century artists had multiplied figurative and profane "objects of civilization," all the while producing a considerable array of religious representations.[9] There is nothing surprising in that an Italian from the quattrocento should manipulate iconographic criteria and visual and functional indices that helped him classify such registers and distinguish the profane from the sacred. It was more difficult for him to establish reference points outside of his own cultural background, even if the latter did extend to the Eastern Mediterranean and was enriched by the experience of the Guinea blacks[10] and the Canary Islands natives. Columbus's perplexity and groping explanations can also be explained by the disappointments of the Discovery. Persuaded that he had reached the coast of Asia, convinced that Japan and China and its cities were close, the Genoese had been prepared to meet idolatrous

peoples or "sects," that is to say, Muslims and Jews. But reality was completely different. As early as 12 October 1492, he observed that the islanders had no "religion" (*secta*), and, shortly thereafter, that they were not idolatrous: they possessed no idols.[11] It would subsequently be necessary to reconsider such an assumption.

The Discovery of the "Cemíes"

With experience and time, the newcomers finally realized that the natives did indeed revere objects, figurative or not. Around 1496, Columbus and the Catalonian friar Ramón Pané (to whom the Admiral had entrusted an investigation on the Indians' "antiquities"[12]) had far more information about the Islands at their disposal. They had reformulated the initial question: instead of trying to establish whether certain figurative items were indeed worshipped, Columbus and Pané turned their examination to the set of objects the Indians revered as a whole.

These things had a generic designation in Taino, the Island language: *cemíes;* when considered individually, they each acquired the name of an ancestor. Endowed with political functions and therapeutic and climatic properties, the *cemíes* also had a gender, spoke, and moved about. Recipients of an undeniable, though uneven, veneration,[13] they were so precious that the natives stole them from one another, and after the Discovery hid them from the Spanish. Each *cemí* was given a unique origin: "Some contain the bones of their father, and of their mother, and relatives, and ancestors; these are made of stone and wood. And of both types . . . there are many which speak, and others that make grow the things which they eat, and others that bring rain, and others that make the winds blow."[14] The *cemíes* of the Islands thus took on an assortment of disparate guises: a receptacle containing the bones of the dead, a piece of wood, a tree trunk, a *cemí* "with four legs like a dog's," a root "like a radish," "the shape of a thick turnip with their leaves spread out on the ground and long like the caper bush."[15]

These "relief-sculpted stone images,"[16] these works (*hechuras*) of wood represented nothing, or rather, too many things. They were not only masks or statues: that trail of the first few months was erroneous, or more precisely, inaccurate. Everything diverts us, indeed, from the world of anthropomorphic figuration. The only human silhouettes Pané's description evokes are those of the dead, who manifested themselves to the

living "in the shape of father, mother, brother and sister, relative or under other forms."[17] Unlike idols representing the devil or false gods, the *cemíes* were essentially things, endowed or not with a life: "dead things shaped of stone or made of wood," "a piece of wood that appeared to be a living thing," objects that recalled memories of the ancestors.[18] They were stones to relieve birthing pains; or whose use brought rain, sun, or the harvests, like those Columbus sent to King Ferdinand of Aragón; or yet similar to those pebbles the islanders kept wrapped up in cotton inside little baskets and that "they feed what they eat."[19] Columbus knew it, and thus took care to avoid the word "idol," denying idolatry to instead denounce the fraud of the caciques handling the *cemíes*. The Catalonian Pané confirmed this: when he wrote of idols, it was clearly a laziness of the pen, or because the term was handy; he then corrected it to "demon"—"to speak more properly"—or to distinguish the *cemí* from the idol: a *cemí* that spoke "became" an idol.[20] Pané's text, however, dealt neither with idolatry nor idolaters.

At the same time the Portuguese, at their trading posts in Guinea, were just beginning to explore the notion of the fetish. In many aspects the fetish was equally a god-thing, unique in its origins, shape, gender, and composition. But the Portuguese limited themselves to the usage of a vernacular and medieval term (*feitiço*) applied to practices and beliefs that intrigued them, and, moreover, competed with the word "idolatry."[21] Columbus and Pané dealt with the matter differently, thus earning the right to be called "modern." Instead of following the Portuguese example, or simply tacking the idol category that the classical tradition from the Old Testament to St. Thomas Aquinas offered them onto the unknown, they drew on the autochthonous term *cemí* originating in the Island culture. It is true that the explorers' linguistic borrowings were numerous (cacique, maize, etc.) and that the Islands spoke "one language" whereas "in Guinea . . . there are a thousand kinds of language and one does not understand the other."[22] But the choice of the term *cemí* indicated more than just linguistic receptivity. It betrayed an ethnographic sensitivity that in fact showed on almost every page the Catalonian monk wrote. By exploring themes as crucial as the body, death, visions, states of possession, and myths of origins, without ever letting his observations warp under the weight of stereotype or prejudice, Ramón Pané was opening the path for a reading of Amerindian cultures that would remain attentive to their specificity.

What should we retain from this reconnoitering phase? That the explorers immediately questioned the images of the Other, their functions and characteristics, and that this question seemed to be drifting toward an original answer. But it was only a digression, quickly cut off. Neither Columbus, nor his companions, nor the powers financing the expedition dreamt of giving themselves up to the delights of ethnography, and the Island paradise rapidly became a hell of brutal exploitation, famine, and microbial shock.[23] No matter what the first observers' curiosity might have been, this was a one-way operation: it was out of the question that the natives practice a "backwards ethnography" and interpret the images of the whites themselves.

But irreparable damage occurred late in 1496. There is no doubt it was the first American conflict in this war of images. A few natives seized the Christian images the Spanish had entrusted to some neophyte guards: "Once they had left the oratory they threw the images to the ground and covered them with dirt and then they urinated on them, saying: 'Now your fruits will be nice and big.' And this, because they buried them in a cultivated field, declaring that the fruit that had been planted there would be good; and all this to revile us. When the young men guarding the oratory saw this, they followed the orders of the catechumens and ran to their elders, who were on their properties, and told them that the people of Guarionex had destroyed and mocked the images."[24]

Columbus's brother punished the sacrilege by burning the culprits alive. The brutality of the Spanish repression—carried out by laymen—expressed the inviolability of a domain that inextricably blended the political and the religious: respect for the white man's images was as intangible as the submission owed to the colonizers. The profanation, however, had been accompanied by a fertility ritual, manifestly assigning an effectiveness to the images similar to that of certain *cemíes*. From this perspective the "sacrilege" betrayed the rapprochement the natives felt between the Christians' images and the local *cemíes*, even up to the benefits they imagined would ensue. It inaugurates the long parade of destructions, appropriations, misappropriations, and misunderstandings weaving through the cultural history of Latin America.

Under these circumstances, what was to become of the *cemí*? Neither figurative representation nor idol, in fact hesitating between many states (object, thing, image, idol), was it not the remarkable result of an attempted translation, one that turned its back on preconceived models in

order to record—without trying to cover up—the unexpected and the disconcerting? A chaos of shapes of laughable worth and grotesque bearing that awakened greed, thing that moved, living object, instrument of domination in the hands of manipulative caciques, but also a constant challenge to reason: the *cemí* was all of this. Would the brutality of colonization sweep aside this attempt to account for that which had never been seen before? Or were other, further menaces threatening this unique manner of seeing things, so close to how we conceive of the fetish today, this "totalization that absorbs and intensifies entire segments of temporal as well as morphological discontinuities?"[25]

Peter Martyr's Ghosts

A Milanese undertook the unveiling of the mystery surrounding these strange objects: Peter Martyr—who never once set foot on the American continents. Renaissance man, disciple of Pomponius Leto,[26] tirelessly in search of information, journalist before the title was invented (and displaying both the qualities and the faults of present-day journalists), in some cases so hurried as to become superficial, a necessary link between the New World, Spain, and Europe, he is a fascinating character. Born in 1457 on the shores of Lake Maggiore, Pietro Martire d'Anghiera—traditionally known in English as Peter Martyr—entered the service of the Cardinal Ascanio Sforza, went to Rome, then in 1487 to Spain, where he became a follower in the court of the Catholic Kings. He received his priesthood in 1492, the same year Granada fell into the hands of the Christians and the reconquest of Muslim Spain ended. Queen Isabella made him her chaplain. From then on, privy to the discoveries—such as the occupation of the Granada kingdom—he questioned the travelers, met Columbus, Amerigo Vespucci, and Sebastian Cabot, collected their letters, and dissected their accounts. Until his death in Granada in 1526, it was through his letters—the famous *Decades*—that he broadcast news of the New World to the four corners of Europe, and built up its image. His duties within the Indies Junta (1518), then the Council of the Indies (1524), and his title as "Castilian Chronicler" all gave him access to the best sources. Finally, his ties with the Bolognese, the Venetians, and the Florentines residing in Spain, and his correspondence with the popes of Rome (Leo x, for example), placed him at the heart of an Italian network of lettered people curious about the Indies.[27]

The *cemies*—Peter Martyr's preferred spelling was *zemes* in Latin; English traditionally uses the term "zemi"—intrigued him. His curiosity was not merely bookish, as he had received a few samples from the Islands. He even made the effort of sending a few of them to his protector, the Cardinal Louis d'Aragon, nephew of the King of Naples, so that the Cardinal might judge for himself "better than based on a description" before showing them to his uncle. It is in Book IX of his *First Decade,*[28] written around 1500–1501, that Peter Martyr introduced the word "zemi." He apparently borrowed it from Ramón Pané's work. But from April 1494 onward, based on some information obtained after Christopher Columbus's second voyage, the Milanese wondered about the figurative objects. He noted that the natives made "masks of cotton, woven into an imitation of those painted ghosts that they insist they see at night."[29] By associating masks with nocturnal specters, Peter Martyr started down an increasingly tangled path. He ignored the masks' function, but emphasized their figurative characteristics and discovered an identity in them, if not a meaning. This was the opposite approach to that of Pané and Columbus, who had worried more about their use than what they represented. Peter Martyr came back to this rapprochement in 1501: "They make seated human images with woven and stuffed cotton, similar to the nocturnal specters our artists paint on the walls"[30] (illustration 1).

This time, the object was first catalogued as a *simulacrum,* a figurative representation.[31] Peter Martyr was obviously interested in the anthropomorphic image, but it was the figurative image that was debated. Peter Martyr's zemi was identified and visualized according to a Western iconographic model ("the nocturnal specters our artists paint on the walls"), even if in a very ambiguous manner. Did the rapprochement spring from Peter Martyr's mind, who had several of these zemis in front of him, or did it originally come from the natives? If the 1494 testimony—reworked twenty years later, in 1514[32]—let it be understood that the natives reproduced, "imitated" the specters they saw at night to make their cotton masks, the 1501 text is much less explicit. It leads us to attribute this association to speculations by the Milanese, or those of his informers. Another note points toward this: "It is well known that nocturnal spirits appear to the islanders so as to lure them into vain errors, and this is known from the idols they worship in public."[33]

1. Zemi, Haiti.
Museum of Anthropology and
Ethnography, Turin.

Such clues lead us to speculate that Peter Martyr and his informants were comparing zemis to images of phantoms, and deducing, without any further inquiries ("it is well known") the local apparition of nocturnal specters. Peter Martyr tamed the foreign object by making it the replica of a specter. He was successful in rendering it visually both for himself and his readers—an essential task for a writer whose goal was to show the unknown—and placed it within a framework. For the specter required a specific context, a pictorial framework or a nocturnal space. In this, Peter Martyr followed the medieval tradition in which "the image is always linked to its space,"[34] whereas the zemi of Columbus or Pané floated free of ties, and moved in the most diverse contexts.

The Cardinal Louis d'Aragon, Peter Martyr's correspondent, was also invited to verify the resemblance unifying the zemis and the painters' specters.[35] A comment developed much later (1520) confirmed this feeling: the zemis were "similar" to the image we had of nocturnal specters.[36] This does not really imply in any way that the Indians shared the interpretation of the Milanese. Throughout his work Peter Martyr clung to this vision of things; it found little basis in the writings of Pané or Columbus, and pushed to the background all zemis whose shape departed from that of the objects known to the chronicler. Twenty-three

years later, in the "Seventh Decade" dedicated to the Duke of Milan (1524), Peter Martyr was obstinate in defining the zemis as "simulacra they paint like the infernal Manes."[37]

The zemi was thus purported to be the image, or more exactly, the "simulacrum," of a specter. The only systematic attempt to inscribe or recuperate this object into the figurative field gave it the outlines of a ghost. In the mind of a quattrocento Italian, this meant evoking a creature of horror endowed with an appearance—and therefore representable—but perfectly lacking in physical existence. It did not matter which specter it was: Peter Martyr's world of the dead was riddled with ancient reminiscences. *Lemures* (specters), *larvae* (masks, sprites), *simulacra* (in its meaning of ghosts); all these allowed Pomponius Leto's student to place the objects of the Islands into a Latin framework. Such an exercise in stylistics took advantage of the paganizing humanism of the Roman years and prolonged the passionate quest for antiquity that had animated academic debates. It is also true that Pané's tale called attention to the dead since it described the nocturnal apparitions as the wandering of the defunct, and lingered over the interrogations the Haitians performed on their dead. The Catalonian never took the plunge, however, by making the zemis indistinct images of revenants. On the other hand, still in 1501, haunted by his own interpretations, Peter Martyr related that certain zemis were made by suggestion of "nocturnal shades."[38] And around 1515–16, along the same lines and as if to prove himself right, Peter Martyr noted with satisfaction that the suppression of the zemis on Haiti was accompanied by the interruption of the nocturnal apparitions.[39] He did not, however, even though Pané had pointed it out, explore the path that could lead from the zemis to ancestry. He confined himself exclusively to a formal approach that drew an interpretation from his own culture and was likely to satisfy him.

Peter Martyr's ghosts were not American in the slightest, or very little.[40] Beneath the antique varnish, of course, the ones scaring the popular and literary milieus of fifteenth-century Italy showed through. Many works touched upon this theme, whether they dealt with purgatory or grieving souls. Specters were not imaginary. It was commonly believed in those times that spirits could infest the home and that one could protect oneself according to the stipulations provided by Roman law; it was believed that the deceased, the "shadows," spread sickness and sowed death;[41] people collected horror-awakening tales of apparitions.[42]

The Church recognized that spirits appeared in "houses, cemeteries, churches, monasteries,"[43] while clerks such as Jacopo da Clusa deemed it licit to question the dead as long as it was for pious motives, *ad pias causas*. The border between what the Church tolerated and authorized, and beliefs shading into magic, was certainly quite thin. If revenants could be souls from purgatory in quest of prayers (*suffragi*), as the Church taught, if demonic apparitions were far from excluded, one must also take into account the troubled and shifting collectivity of popular beliefs and terrors, capable of sudden crystallization. The ghost battles taking place near Bergamo in December of 1517[44] fascinated all of Europe, and Peter Martyr did not fail to mention them in his correspondence. Finally, let us not forget medieval literature and the ambiguous status it reserved for the simulacrum: it was charged with a magical dimension and was the center of a seductive world of images, of mirrors and doubles, perhaps more perilous for the illusions it distilled and the enchanting power it harbored than for the diabolical heresy or idolatry it sheltered.[45]

Everything leads us to believe that in Peter Martyr's mind, what he understood of the insular beliefs, what he knew of purgatory and what he shared of Italian fears, were superimposed. The description of the return of the dead and of the malevolent apparitions[46] on faraway islands also betrays the influence of a humanistic culture that alternated between the shades of the ancients and the memory of the "dryads, satyrs, Pans, and Nereids" of antiquity. Peter Martyr was as much a reader of Lucian as of Columbus and Pané.[47]

By making reference to "the . . . specters our artists paint," Peter Martyr, who was basing himself on a system of diffuse beliefs, also openly evoked a form and type standardized by the art of his times. Here the reference originated less in a common and scientific experience than in a two-dimensional, pictorial model. Could this be interpreted as the quattrocento eye, the self-confidence of a gaze formed by the Italian painters and painting of the fifteenth century?[48] Or rather, should we recognize in the Milanese's models Grünwald's living corpses, the dead staged around the theme of *memento mori* and the dances of death occurring throughout the course of the century, except perhaps in Spain?[49] This perceptual style was probably more Gothic than Renaissance, familiar as it was with the Flemish collections of the Catholic Kings.

Nonetheless, Peter Martyr presented himself, and his reader, with a way to imagine and visualize this exotic object that came to him from the

Islands. He gave it a general shape, provided it with an identity, and extrapolated beliefs from it. But most of all he created an image: the ghost-zemi, open to a number of meanings that finally rendered the ethnographic facts opaque, and that substituted itself for them. No doubt this undertaking was customary for a conquering and reductive thought pattern, an obligatory reflex of any dominant ideology. But why did he associate the autochthonous image to the fugitive and disquieting shade, to the terrifying apparition, to the spectral? These representations, contemplated and not destroyed, these "sitting human images" almost recognizable as the Manes from Hades, awakened a mixture of attraction, curiosity, and repulsion; they blended together the fascination of exotism and the horrific mark of a disturbing presence.

Looking at it in this manner, it was reassuring to learn that the nocturnal apparitions had disappeared with the elimination of the zemis at a time when, on the Islands, the world of the dead was swollen with populations decimated by hunger, work, and sickness. "From 1494 . . . to 1508, over three million people [in Santo Domingo] had perished from war, slavery and the mines."[50] In 1508 there were still sixty thousand natives in Santo Domingo, and yet the era of massive deportations was only just beginning.[51] While the humanist Peter Martyr was dreaming about his ghosts in Granada, the Antilles were rushing, body and soul exhausted by sickness and overwork, into the realm of the living dead.

From the Specters to the Demon

The ghostly interpretation—already far from the one Columbus had proposed—would fade with time as Peter Martyr gave his zemis the appearance of demons. The metamorphosis took place around 1514, when he related the nightmarish aggression on the island of Cuba of a "long-tailed demon of a zemi, with enormous teeth, horned, similar to the one that is depicted by its hand-made effigy."[52] Ten years later, in 1524, he compared the specters he had already likened to infernal Manes and genies to the demon and devils that used to show themselves to the natives before their Christianization.[53] Peter Martyr then delivered a new pictorial reference: the zemis resembled "the monstrous creatures the painters draw on the walls to keep them away, in terror of their evil acts."[54]

The zemi sank into the demonic and the monstrous, dissolved into the

figure of the devil, as if the author had given in to the ease of the cliché and given up on extracting the specificity of the object. Demonization— here related to a sort of cultural neutralization—resulted in making the zemi an idol,[55] a wooden or stuffed cotton deity.[56] The slippage from zemi to idol was not accidental: it happened in Peter Martyr's works after the discovery of idolatrous Mexico and the description of the unknown Darién rites and its idols.[57] But was it a coincidence that Peter Martyr long delayed identifying zemi and idol? It can be assumed that better than anyone in Spain, Peter Martyr could distinguish the zemis of the Islands from the Pharaoh's idols: had he not gone to Egypt in 1501 as an ambassador, had he not left a description of the relics of this country in his *Legatio Babylonica*?[58]

Ghost-zemi, devil-zemi, idol-zemi: little by little the object sank beneath familiar labels, disappeared under conventional designations. Peter Martyr's progressive turnaround sounded the death knell for an epoch, a generation, a way of seeing, and curiosity. The time for attentive descriptions and original interpretations, corresponding to the quarter-century since Columbus's discovery, had come to an end. Not that those attempts had been devoid of distortion or prejudice, on the contrary. But they still deserved praise for trying to pierce the mystery of the unknown.

Paradoxically, the more information there was, the more the stereotyped label of idol and idolatry appeared satisfactory to the Spanish. One has only to read the Indies chronicler Fernández de Oviedo describing, in 1535, "the idolatries and abominable and demonic ceremonies" of the Islands. The procedure was automatic: for Oviedo, who had known America since 1514, the zemis were quite simply "images of the devil" that the natives considered to be their god, and this devil was "as ugly and as fearful as the Catholics usually depict him at the feet of St. Michael or the apostle St. Bartholomew."[59] The iconographic reference had thus become even more pointed in 1535, subsequent to Pané's firsthand descriptions and the specters of Peter Martyr's painters. Now Oviedo's biting pen accumulated an abundance of Spanish and Flemish deviltries reminiscent of the late Gothic period: "the abominable devil's figure, painted and sculpted in numerous and diverse fashions, with numerous heads and things, with terrifying and misshapen canines, and ferocious jaws with great fangs, and huge ears, and the burning eyes of a dragon and a ferocious serpent."[60]

Even if we were told once again that the *cemi* appeared at night in the

form of a ghost (*fantasma*), the demonic imagery painted over Pané's eyewitness account and Peter Martyr's first interpretations. Confirmed in its status as figurative representation, the *cemí* lost all its strangeness. It was reduced to the known and the familiar, to any diabolical imagery. One no longer looked at the object since one already possessed its key, its identity. It was the expected, inevitable sign of idolatry and the devil's presence. One could only summarily declare, of the Cubans, that "their religion consists in worshipping the devil."[61] But there was more in Oviedo. The native image was such an obsession for him that he called one of his chapters "The Images of the Devil That the Indians Had,"[62] the leitmotif of "infernal images" and "cursed images" serving as the basis for his tale. It was the proliferation of "infernal images" that unsettled him, and not what they represented: "On Terra Firma not only do they take pleasure in putting such diabolical and perverse images on their idols of gold, of stone, of wood and of earth," but they reproduced them as body stamps, on jewelry, on fly-swatters, on the furniture, in the houses, everywhere the natives could.[63]

This distortion of the gaze in a man with practical experience is no doubt partly explained by the disclosures of the spectacular "idolatries" of Mexico and the disappointments of the evangelization of the Islands: "These people are far removed from wanting to understand Catholic faith.[64] . . . None, or very few of them, are Christians."[65] Civil servant for the Crown, direct artisan of the colonization, Oviedo nourished a dark vision that broke with the optimism of earlier times. His "colonial" and anti-Indian commitment led him to apply stereotypes and clichés, while in other domains—his *Historia natural*—he showed himself to be an attentive observer.

But if these clichés legitimized colonialism at just the right time, this "blindness" was coupled with a pointed knowledge of the multiple recourses the image offered: transmission, permanence, visualization of knowledge. He expressed it marvelously when he worried about the proliferation of representations and their significance: was not the "cursed effigy"[66] "the [devil's] seal printed on the skin and in the hearts"[67] of the natives, whose resistance to Christianity Oviedo denounced in the same outburst? He knew otherwise how to distinguish the native image from the object and the idol. This sensitivity to the image was perhaps distantly related to adolescent years spent in Tuscany, Rome, Naples, and Sicily, where Oviedo discovered Mantegna and Leonardo da Vinci. A

culture of the image bursting with political and ideological calculations was substituted for the pre-ethnographic gaze of Columbus and Pané.[68]

From Columbus to Pané, from Peter Martyr to Oviedo, the Western gaze cast upon the Islands' objects had progressively become fixed in the double certainty of spotting an image and recognizing the devil in it. Once the shock of the unknown and the first flexible, groping Colombian interpretation had passed, Peter Martyr established the framework. Then the field narrowed, the vision became stylized and dramatized until an "American vision" emerged: it was in fact a pure and simple replica of a European déjà vu. The colonizer's gaze placed the reductive but ever so efficient and handy grid of the demonic onto the native. The code was given once and for all, the die was cast. The obliteration of strangeness, the leap from discovery to recognition, the refusal to see were not a flinching of the gaze, but an imperative, coupled with a denunciation of "cursed and perverse images."

Zemi: the category and term were successful only briefly, for the span of a generation. The term was vague enough to allow the description of most of the objects of worship and the "images" from "Terra Firma" (the continent), which was explored after the Islands. In 1520 Peter Martyr was still using the Taino terminology associated with his former "spectral" interpretation for the Mexican "images" that Cortés had observed two years earlier, on the island of Cozumel: "It was verified that they were idolaters, circumcised, and that they sacrificed little boys and girls to the zemis or images of the nocturnal specters they worship."[69]

Peter Martyr had read Cortés, however, and thus knew that these Indians owned idols, but the object he had held in his hands twenty years ago continued, seemingly, to haunt his imagination. Such was its weight that eventually it became a cliché, a linguistic convention. Our Milanese was also aware of the fact that the Mexican zemis belonged to a different world than those of the Islands. The former came from a land where there were real temples, sacrificial practices, and even "books" whose "letters are almost as those of Egyptian writing,"[70] a writing he had had ample time to observe in his capacity as ambassador to Egypt. Despite this, carried by the force of habit, he attributed the use of the word "zemi" to the Cempoala cacique who had offered his allegiance to Cortés: "Angered by the absence of sacrifices, our zemis will let the worms devour what we sow."[71]

Perhaps this was an effect of distance, or age; no doubt it was a laziness

of memory, an ease of writing, and a perceptual habit. Though it is more difficult to detect, let us attribute to Peter Martyr the vague realization that an American irreducibility expressed itself through the zemi. Even direct observation was not enough to make him change his mind. When he examined the Mexican objects sent to the Spanish Court, the Milanese still found a way to identify a zemi on one of the wheels: "An image one cubit long resembling a king sitting on his throne, dressed to the ankles, comparable to a zemi and with a face similar to what we use to portray nocturnal specters."[72] He made out, tied onto a shield of skin woven with feathers, a gold plaque sporting the "effigy of a zemi."[73] Peter Martyr would not shift his position, as if he could only see that which he believed he had identified and observed for a quarter of a century: the oft-repeated replica of the specters of the night. Another Italian, however, the nuncio Giovanni Ruffo, merely recognized in these objects a face analogous to the painters' devils, "with their mouth open and much puffed up cheeks."[74] This was still not an idol.

Peter Martyr was not alone in linking the figurative representations of the Mexican Indians to zemis. In 1518, a year before Cortés' arrival, the chaplain of the second expedition to explore the Mexican coasts observed zemis on top of a "tower," that is to say, a pyramid, on the island of Cozumel: "figures, bones, and cemíes of idols."[75] But then he added, right away: "If one is to judge by their manners, [these people] are presumably idolaters." The passing from zemis to idols was still performed with some caution ("presumably"), as if the Mexican Indians suddenly stopped being associated with the exotic, disconcerting, and strange universe of the zemis to be linked to a more familiar society, one that was more easily placed and named, with its laws, its temples, and its "police."[76] The term cemí (zemi) disappears from the remainder of this history, to be replaced by that of idol. From that moment on the gaze will slide over the object, fly over the idol to plunge into the policed world surrounding it, feeling just like déjà vu.

Cortés' Idols

The years 1517–1520 marked a change in direction in many ways. Even if Peter Martyr adopted the term "idol" in his telling of the discovery of Mexico in 1520, the word most likely had been floating in the air of the Islands since 1517. Upon the return of the first expedition from the coasts

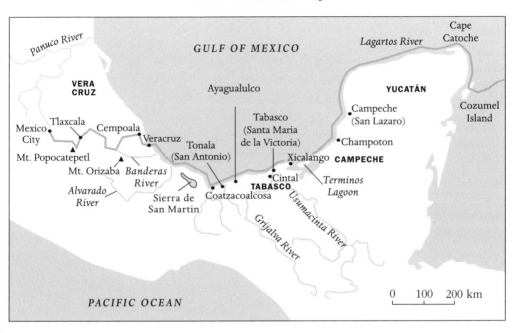

Hernán Cortés' Expedition

of Mexico, and from then on, the objects of worship, the "terra cotta idols" that were brought back, caused a great stir, even if the eye was still hesitant in recognizing them. These idols intrigued and fascinated the Spaniards of the Islands as they did later the Peninsular Spaniards: "Certain [idols were] like demon heads, others like heads of women, and yet others had such vicious faces that it seemed they were Indians practicing sodomy with each other."[77] If we are to believe the chronicler Bernal Díaz del Castillo, who told the episode nearly forty years later, these figurines were food for conjecture: "When they saw idols of terra cotta and so many kinds of figures, they said that they came from the pagans. Others said that they came from the Jews Titus and Vespasian had chased out of Jerusalem, and whom they threw into the sea on ships which had then landed here."[78] In 1518, during the second voyage, an additional step was taken: the Spaniards identified "idols of earth, wood, and stone," "figures of gods," and "what seemed to be their wives."[79]

It is thus the proliferation of "figures," as much as the visual analogies (women, demons) they inspired, which suggests the presence of idols even before the second expedition corroborated these speculations by

clearly showing traces of worship and the existence of oratories and priests. It would be only a few years before the vocabulary was adapted to the new elements revealed by the Mexican adventure, and before its usage reached the West. Far from corresponding to a refinement of perception, the adjustment provoked a darkening and paralysis of the gaze. The reactions of 1517 require us henceforth to measure the opacity of the idolatrous screen erected between the conquerors and the natives, a screen whose strength was both intellectual and passion-driven. Though the negative connotations—demonic and sodomite—betrayed the spectators' initial movement of repulsion stained with voyeurism, the multiplied presence of the idol constituted a powerful cultural and historical marker, a reference that immediately called up other distant but prestigious ones, both ancient and familiar. As the figurative native object lost its strangeness, abandoned its exotism to become the equivalent of the false image the pagans adored, the discovered lands entered straight away into a past and a universe that were apparently common to the conquerors and the Indians: that of the image worshippers.

Ever since the first expedition, the Mexican societies of the Gulf of Mexico had stood out from the historical and cultural anonymity that had belonged to the Islands. Thanks to the idols, they were tied to ancient history, which was also the history of civilization. For a few people they even became the welcoming lands of the Jews dispersed by Titus and Vespasian following the destruction of the Temple of Jerusalem. In 1518, less peremptory but still as preoccupied about rapprochements, the chaplain of the second expedition thought he could detect in the practice of circumcision—or what he believed to be circumcision—the trace, and therefore the relatedness, of Moors and Jews.[80] This takes us far away from the strange and fabulous paradise that fascinated and disappointed the discoverers in turn; far away as well from Japan or that China of the great khan Columbus was looking for.

The Mexicans' idolatry constituted a well-established fact even before Cortés' departure. The members of the second expedition choosing to leave again with him knew ahead of time that they would find idols everywhere. It was as if Columbus's initial question—Do they worship images?—had finally found a positive answer. Nonetheless, Cortés, and Cortés alone, exploited this "discovery" in depth by deciding to make the idol into something quite different from a label or a handy reference mark, so as to include it at the center of his personal strategy. This

strategy dictated an ambivalent attitude when confronted with the Mexican figurative objects, opening a transition phase between the era of zemis and that of the hunt for idols.

When Cortés conjured up the Mexican idols for the first time—describing the rites from the Island of Cozumel in his letter of 1519—the reader, visually, was left hanging. The accessories of the effigies were briefly recorded, the sacrifices and "ceremonies" meant for them were described, the affection ("devotion, faith, and hope"[81]) dedicated to them astonished the Spanish. But only its matter was recorded. As soon as it was thought of as an idol, the figurative object became mute, opaque. As it congealed, the gaze became veiled, blind. "Idol": the word was all that was necessary. One no longer needed to describe the thing, to capture its origins, to formulate its properties.[82] At the most Peter Martyr felt the need to indicate that these idols were the images of the natives' "Manes and terrible demons."[83] Which was tantamount to saying nothing, if not what the term "idol" presupposed. This is how an entire range of figurative objects, trapped by cliché, received once and for all its final destination, idolatry, and a pre-established identity, the idol.

Other pieces, however—manifestly figurative and ceremonial objects— aroused even more curiosity. Their descriptions lingered, the aesthetic and mercantile appreciation increasing their value. A mask of gilded wood, a gold mask the writer found "quite beautiful," "a little golden man" also wearing a gold mask captured the attention of the chaplain of the second expedition.[84] Cortés' first letter ended with an inventory of the precious objects sent to the King and Queen[85] with no mention of the word "idol," whereas it is clear that the "monster figures" on the "golden wheel" or on the "blue stone miter," and the "large gold caiman's head" could have easily fallen into this category. Such a silence is even more surprising since in 1520, according to the nuncio Giovanni Ruffo, the Indians accompanying the envoy admitted "praying in front of the figure" ornamenting the wheels of silver and gold. But the nuncio also avoided the word "idol."[86]

Idol, or precious curio? It is striking from the outset that in the two cases an exegesis of the object was abandoned. No one wondered what it represented anymore, nor to what it referred, since it was too obvious in the idol's case, and completely superfluous in that of the object of value. This indifference as to the specific identity and function, this surface relationship—encouraged by the ignorance of the Mexican cultures of

that time—was indeed the result of a choice and not of some inability to identify the object. It probably explains why a similar representational type could slide from one register to another according to its material (wood, terra cotta, stone or gold, silver, gems) and thus its market price and scarcity, changing from the cursed idol to the rare and prized curio, from a nonvalue to a monetary evaluation. It is not surprising that we are given the weight in gold of the great "golden wheel" decorated with monstrous figures, as well as that of all the pieces sent over to Spain.

The same reactions occurred in March of 1520 at Valladolid during the presenting of the objects to the diplomatic corps. Though he lingered more over the details of the representations and the ritual function of certain pieces, the nuncio Ruffo did not forget to account carefully for the value of the most notable pieces. Peter Martyr's gaze was not much different: the Milanese's account gives the impression of a bazaar of oddities unpacked under the dumbfounded eyes of the courtesans; his observations never go beyond superficial descriptions, cries of admiration, or the market value each time the object deserves it. Calendars of gold and silver (the "wheels") are jumbled together with objects of feathers, weapons, shields, animal heads and skins, nuggets of gold and jewel necklaces, tiaras and miters, "panther skins," parrot feathers and that "infinity of figures and faces" whose beauty and quality were stupefying and fascinated Peter Martyr: "I do not think I have ever seen anything so capable of attracting the looks of men with its beauty."[87] Columbus, in his own time, also went into raptures over the "beauty" of the Islands.

How can we not notice the double gaze of the Europeans? One takes place on the spot, in the midst of the perils of conquest, biased by the demonic prism, bestowing upon the figurative object a status as precise as it was artificial and devalued. The other occurred in Spain—or was destined for Spain: dilettante, curious, nonjudgmental, not worrying much about meaning, barely wondering about the function and confining itself to exterior, material, and "aesthetic" considerations. Quite obviously, this contradiction is only an appearance. It originates in the ambivalence of the notion itself of idolatry, that is all at once the incontestable sign of the presence of the devil, and the visible and palpable symptom, the obvious mark of highly civilized societies, like those of antiquity.[88] This explains why, depending on the context or the intrinsic worth, one approach was chosen over the other. In Mexico the image was an idol; but torn from its surroundings if shipping was worth it, the

same image became a harmless curiosity, beautiful and seductive, proof and reminder that the neutralization of the adversary's images must systematically go through decontextualization.

An analogous attitude prevailed with regard to the Mexicans' "books," the famous pictographic codices, some of which were also presented to the court. Cortés listed two books "of the kind the Indians have here,"[89] and added "six brush paintings"[90] without troubling himself to indicate what they represented. The drawings Peter Martyr observed suggested an audacious parallel to the printed and illustrated books of his time. Even though he knew perfectly well that certain of these works contained "the nature of their sacrifices and their ceremonies," the Milanese welcomed them with the interest and the curiosity he must have manifested in Egypt toward the hieroglyphics. As in the case of the idols, extracting it from its context spirited away the idolatrous and demonic nature of the object.

Nonetheless, a transitory stage seemed to be taking place around 1520. It moved from a renewed sensitivity—the astonished curiosity of the first years toward pieces without the slightest mercantile value—to the coming blindness, the destructive perseverance of idoloclasts. The oceanic distance introduced inevitable lags, and it is significant that from Europe, Peter Martyr still "saw" zemis[91] while Cortés was denouncing idols. But the process was well on its way. The "ethnographic" observation process and the acuity of the gaze were lost. The symptoms of this disinterest abounded. The Amerindian term *cemi*—or its Latin transcription, *zemis*—was already well on its way to being overthrown, even though Mexico's languages could furnish no words better adapted to the objects the conquistadors had discovered. The *cemi* could only slowly finish its literary career in Europe and America, with no hope of catching up, or of being promoted. In the *Mercurio* composed by Arias de Villalobos at the beginning of the seventeenth century, Quetzalcoatl appeared as a zemi, but Tlaloc was the "god" of the lake.[92] Initially, no inquiry would be made about the Mexican effigies anyway. There were no more references to painting and European painters either, to explain and describe the native idols: Cortés, in this respect, lacked the quattrocento eye, or even the Gothic eye. Finally, the first zemis sent to Europe had not provoked this obsession with worth that now prevailed, for they were only poor objects of wood and stone.

This change in appreciation and perspective was not simply the result

of chance. The first Renaissance in Europe was growing distant, the Italian participation in the discoveries was fading: Columbus, the Genoese, died at Valladolid in 1506; Amerigo Vespucci, the Florentine, disappeared in Seville in 1512; Peter Martyr, the Milanese, passed away in 1526. With the dawning of the Reform the question of idolatries—those of Catholic Rome—grew timely. In the Americas, as it gradually became exclusively the affair of the Castilians, Andalusians, and people of Extramadura, the business of colonization collided with complex, highly civilized, lawful societies with their own merchants, temples, and religions,[93] thus requiring more elaborate strategies of domination. The war of images was about to break out.

In other words, if Cortés did not see what was in front of his eyes, it was mostly because he knew ahead of time what he must find there in order to justify his conquest of Mexico: idols. From Columbus to Pané, from Pané to Peter Martyr, from Peter Martyr to Cortés, the Western gaze successively buffeted the American object, whether it was figurative or not. The image the Europeans hounded and that they were obsessed with appeared from then on as a notion they had imported with them, a category they plastered over things and whose contours emerged through their approach as observers and discoverers. The image was as much a landmark as a figurative representation (specter, man, woman); it was a cultural marker as well as an instrument—that of the devil, in Oviedo's writing. One could equally foresee that it was indissociable from a complex and mobile whole made of attitudes, feelings, and interpretations, from an *imaginaire* hinting at incessant modulations that were not well understood at that time. In any case, from 1492 to 1520, disparate stages and elements emerged and meshed one after the other: the recourse to an analogy that was both visual and—as unprepared perceptions can be—superficial; the speculation about function based on determinations from the field, or extrapolation; the tacked on and pitilessly reductive identification; the wonder attributed to an object of "beauty";[94] the explorer or the European collector's curiosity;[95] the attempt to seize what was strange and capture what was unique in a "pre-ethnographic" thrust. The degree of receptivity, the expectations, the perceptual and conceptual grids this *imaginaire* summoned changed according to the milieus, the times, and the lands they discovered. The obsession with idolatry, for example, never ceased dominating the vision of the idol.

Zemi, devil, idol, and image were not only names placed on new

objects. At the level of the *imaginaire,* these labels translated and synthesized the evolution of the relationships between the Europeans and the natives. They blazed a figurative way of thinking that was not expressed through plastic creations, but that entailed interpretations less and less sensitive to the specificity of the worlds they encountered. Finally, Columbus and Pané when they landed, the Spaniards living in the Islands, the well-read men of Granada, the Italians in Spain: all of them were watching the natives—even if they did not see the same things—for the presence of the worshipped image, for signs of a religious and a complex society, indicators of a coveted and easily taken wealth. The waiting had been constant since Columbus. Once this had been fulfilled by Mexico, the fate of the adversary's images remained to be determined. Cortés took care of it.

2

War

The adversary's images are unacceptable when they are meant to be worshipped. Mexico learned this the hard way by becoming the theater of an offensive that was completely disproportionate to the military interventions punctuating the occupation of the Islands. Neither Columbus nor Pané systematically devoted themselves to destroying the zemis, and if they did so it was without the passion, the dramatization, and the publicity that Cortés displayed. It is reported that a sailor advised a Cuban cacique to drive away (*desterrar*) his zemis, and to welcome in their place an image of the Virgin. But the natives adopted the image without the need for bloodshed, thanks to the miraculous help she brought them.[1] The persecutions came later.

During the first years of the sixteenth century, contacts with the natives of Terra Firma—from Orinoco to Darién—did not seem to end in conspicuous destruction. In all likelihood, the most brutal Spanish intervention was Vasco Nuñez de Balboa's massacre of the sodomites.[2] One must admit that the conversions were only hastily noted by Peter Martyr, who was more interested in marine pearls.[3] Would he not have recorded the destruction of idols and objects if he had heard of them, since he was writing to the Pope himself? Could the absence of "sects" and institutionalized religion, or the embryo of solar monotheism attributed to the natives, or even ancestor worship explain why there were few conflicts?[4] There was nothing for the discoverers' Christianity to snag on, and to the humanist Peter Martyr, the natives were merely "clean slates."[5] Moreover, Iberian Catholicism was better prepared to confront rivals of its own standing—Islam, Judaism—than what anthropology would call "primitive religions."

The first two "Mexican" expeditions did not lead to "idoloclasty" either, that is to say, to the systematic annihilation of the Indian idols. During the first expedition (1517), the priest Gonzalez restricted himself

to carrying off wooden chests, some gold, and a few idols stolen from the Indians.[6] During the entire second expedition (1518) the chaplain Juan Díaz prudently took refuge in his role as observer, while Grijalva—the leader of the expedition—and his companions only had eyes for precious metal.[7] Reconnaissance, inventory, and pillage: these different stages show that the Spanish still hesitated; they had not yet truly sized up their new adversary, nor had they exploited the gold mine of idolatry.

Love of Images and Hatred of Idols

The extirpation of the Mexican idols was long, progressive, and very often brutal. It goes back, in fact, to Cortés' expedition, and began in 1519 at the edge of the Yucatan peninsula on the island of Cozumel. According to the chronicles it was carried out by way of a simple and precise scenario that would often be replayed. A scenario in two acts, linking annihilation and substitution: the idols first were broken (by the Indians and / or by the Spanish), then the conquerors replaced them with Christian images.

In 1520 Peter Martyr, writing in Granada, circulated one of the first versions of these destructions, using the term "zemi" once again. The conquerors having disembarked upon the island of Cozumel, the Indians "consented to the destruction of their zemis and installed in their place, in the sanctuary of their temple, a painting of the blessed Virgin that our people gave them."[8] According to the chronicler-conquistador Bernal Díaz del Castillo, in a more detailed but much later telling, Cortés demanded that the idols be taken away before having them broken to pieces and thrown to the bottom of the steps of the "pyramid." He then had the natives' sanctuary whitewashed with lime, and had the island's carpenters erect a "quite proper" altar to the Virgin.[9] Finally, in a move as astonishing as it was paradoxical, he entrusted this cleaned and Christianized collection to the caciques and *papas* (priests), that is to say, to the idols' usual guardians.[10]

Hernán Cortés deployed an amazing energy toward destroying the "images" of the natives, whether or not he had first conquered them or had to imperil his life and the lives of his men.[11] It was he—and not the priests in his entourage—who plunged the conquistadors into adventure. In Mexico, in Montezuma's capital, without even waiting for the backup he had requested, he swept down on the temple's statues: "He seized a

kind of iron bar that was lying there and started to hit the stone idols with it. . . . it seems to me now that the Marquis [Cortés] was making supernatural leaps and that he hurled himself, with the bar gripped by the middle, up to the very top of the idol's eyes, whose mask of gold he pried off with the bar."[12]

The violence of the gesture was undeniable, despite the narrators' pleasure in amplifying and magnifying it. The act still needs to be explained. The goal and nature of the expedition, without a doubt, weighed upon this attitude. Though the balance of power was more favorable to the Spanish, who set up a veritable armada, and while it was no longer a question of trade but an attempt "to conquer and people,"[13] Cortés did have large-scale political intentions: forcing rich and powerful native states to submit to the Castilian Crown. Their idolatry furnished him with both a reason and an alibi: a reason because it implied that these peoples constituted complex societies with sophisticated institutions and abundant resources, and an alibi because the destruction of idols ideologically legitimized aggression and justified forcing these civilized peoples into submission. López de Gómara (1552), Cortés' designated chronicler, writes clearly enough in the first chapter of his military ordinances (December 1520):[14] "In truth, the goal of war and of armed men is to take the idols away from these Indians."[15]

Nonetheless, these political motives were perfectly indissociable from the religious project. Perhaps it might be exaggerated to lend Cortés the messianic dimension the Franciscan chronicler Mendieta later attributed to him, but it is apparent that the conquistador believed himself to be entrusted with a spiritual mission—his standard, following the Constantine model, was decorated with the inscription "Let us follow the sign of the cross. . . . With it, we shall conquer."[16] It was indeed he, and not the priests accompanying him, who took the initiative in preaching against the indigenous gods,[17] throwing down the idols and replacing them with Christian images. Let us not dig for theological subtleties. This is indeed what gave this intervention its strength and its genius. It can be summed up with a few repetitive, succinct, and effective slogans based on the confrontation of good and evil, truth and lies, divinity and the material realm: "Their idols are quite evil and induce them into error, they are not gods but evil things that carry their souls to Hell"; "they are evil, they do not tell the truth . . . they lie to them"; "their idols are evil and they are not good."[18] Can we say that Cortés explicitly thought—as

did the Anglican bishop Stephen Gardiner toward the middle of the sixteenth century—that the destruction of images would "subvert religion, and the state of the world"[19] in his adversary's eyes? The conquistador had at his disposal, it is true, more expeditious means to reach his goals and annihilate the native devices.[20]

The *Conquista* of Mexico is consistent also with the *Reconquista* of the Iberian peninsula. The secular battle against the Moor kingdoms had ended with the taking of Granada in 1492. The first observers hurried to compare the Mexican Indians with the Moors and the Jews: Peter Martyr and Juan Díaz insisted on the native "circumcision,"[21] and the Indians' "pyramids" were first mistaken for mosques, their servants for ulemas. The revival of *Reconquista* enthusiasms is easily explained in this context, although paradoxically the traditional enemies of the Spanish Christians, the Moors and the Jews, were people without images.

It does seem that the "Old Christian" attachment to images emerged strengthened by the *Reconquista,* and that it contributed to mold the identity of the Spanish Christians and their religious practices, at a time when the Church was encouraging the worship of images on the condition that it not become idolatry.[22] In any case, protected from the destructions of the Moors, many miraculous images were dug out from isolated areas as the *Reconquista* progressed. Among those we find—not the least of them—the Virgin of Guadalupe, venerated in the mountains of Extremadura and dearer than all others to the hearts of the conquistadors.[23] Besides, how could the idoloclastic scenario and the Cortesian project be separated from the expression of Iberian piety, constructed as it was around images and saints? It was said that while still a child, Cortés risked losing his life several times; his nurse saved him, all the while drawing lots to determine which of the twelve Apostles would bring him protection. St. Peter became his patron, and from then on Cortés celebrated his saint's day each year.[24] With good reason, as it turns out: the apostle was to lend him his miraculous assistance against the Indians during the battle of Cintla. Other saints, moreover, intervened during the conquest. St. Christopher made it rain over Mexico in 1520 at the conquistador's request.[25] St. James appeared to the Spaniards of the second expedition before helping Cortés' men several times.[26] The Virgin also demonstrated her support.[27]

This direct link, this familiarity with the saints was coupled with a fervent attachment to their images. The conquistadors seem to have

landed in Mexico with an entire cargo of graven, painted, and sculpted images, since they distributed them generously to the natives as they went. The Cozumel Indians, the Tabasco caciques, Montezuma's envoys, the pagan priests of Cempoala: each in turn received images of the Virgin as gifts.[28] They were probably statuettes and in two cases at least, a Virgin and Child. A few weeks later in Mexico-Tenochtitlán the conquerors obtained permission from Montezuma that a Virgin "on a little painted wooden retable"[29] and a St. Christopher be placed on the Templo Mayor "for want of other images at the time."[30] The faithful allies of Tlaxcala,[31] without whom the *Conquista* would have been doomed to fail, found themselves equally favored by a Virgin called *Conquistadora* who commanded a certain prestige in colonial Mexico. "Conquering" effigy, as its name proclaims, both a Virgin and an image, the *Conquistadora* supported, legitimatized, and completed the military and earthly enterprise of the conquistadors.[32]

One cannot help but be intrigued by the eminently secular tone of this enterprise. The clerks surrounding Cortés expressed little confidence in the virtues of idoloclasty, being more afraid of its tactical risks and superficiality. Indeed, it was at Tlaxcala, then at Cholula, following the lucid and measured intervention of the priest of the Order of Mercy accompanying the expedition, that idoloclasty was headed off: "Why bother taking away their idols from a temple or an oratory now, if they then transfer them elsewhere? . . . For the moment it is sufficient to admonish them as we have, and to give them the cross."[33] This pragmatism[34] contrasted with Cortés' activism; in this case it did not stop with images, but embraced the predication of Christianity, the setting up of altars, chapels, and crosses, and the organization of the service.[35] It was the conquistador himself who orchestrated this first evangelization and took major initiatives in a domain that the Church would jealously reserve for itself a few years later.

The Ambiguities of Destruction

The Spanish invasion—an invasion of "gods," for the Indians—thus unleashed a flood of Western images onto the American continents. Iconoclasty—or idoloclasty, if you prefer—carried Old Testament connotations with this invasion. The destructive act resurrected the often reckless aggressiveness of the prophets of Israel, who had been opposed

to idols. Perhaps it was also inspired by the spirit of chivalry romances (a type of literature that fascinated the conquistadors[36]), by the memory of epic and legendary fights that Amadis or Roland led against pagans and sorcerers. Mexican idols, though, were never perceived as sources of seductive and pleasant illusions: they had neither the devil's beauty, nor the perilous ambiguity of the simulacra in the romances. Nonetheless, Cortés and the chroniclers often sought to freeze the idoloclastic act in a theatricality that masked any existing diversity of situations, and the reality of the proposed or completed compromises.

Testimony surrounding the Indians' reactions was sometimes contradictory. In general it seems that the Indians first refused to do anything about their own idols. At Cozumel they announced to the Spanish that the latter would sink if they attempted to break their gods.[37] At Cempoala the Indians were terrified: they feared for their own lives, and those of the Spaniards;[38] they refused to take action against their statues, cried at the debris littering the ground, begged the pardon of their gods. Then, turnaround: local priests (*papas*) took it upon themselves to burn the remains. At Cozumel, also, the Indians were purported to have participated in the destruction, and finally to have clamored for images.[39] It is probable—or Díaz del Castillo's observations suggest this, at least: "They looked on carefully"—that the natives were first alarmed at the consequences of the profanation, then, upon seeing their fears unfounded, they admitted the superiority of the Spanish gods. Did the Spanish aggression not consecrate the powerlessness of the local divinities by shaking the ties uniting them to the natives, and tearing the idol from its original space, the "pyramid"?

But the operation was more a mutilation than an annihilation. It did not succeed in confirming the inexistence of the autochthonous divinity; instead, it allowed an ambiguity to persist, it allowed a margin of belief that would undeniably weigh upon the future. If the idols were not gods but "bad things" that "deceived" the Indians (Cortés), it was because they harbored, according to the foreigners themselves, an existence and power that were still appreciable, or at least sufficient to open a path to all kinds of confrontations, exchanges, substitutions, or associations between the divinities of the two worlds. Even in the nineteenth century, under other circumstances, the Polynesians reacted in a fairly comparable manner when confronted by missionaries and the profanation of a *tapu*.[40] There remain cases where there was no prior destruction. Cortés

showed up then as a petitioner; he requested that the Indians authorize the installation of his images, choosing as a church "the house of a major idol," but foregoing idoloclasty.[41]

In Mexico matters were infinitely more complicated. The soldier-chronicler Díaz del Castillo was probably the one to get closest to the facts. At the beginning of his stay in Veracruz, Cortés was said to have insistently asked Montezuma to have a cross and a Virgin and Child installed in the temples of Mexico-Tenochtitlán.[42] He ran into complete nonreceptivity: the "idols" of the distant capital "made known," through their priests, that they were opposed to this.[43] Having reached Mexico City, the conquistador expressed a desire to see the Mexica gods, and demanded that a space be reserved on top of the Templo Mayor, the most important sanctuary of the city, for the cross and an image of the Virgin. Their presence, if he is to be believed, would have been enough to terrorize the native effigies.[44] His project for installing images on the sanctuary and his words, considered "blasphemous," brought jeering from the native priests and Montezuma's scandalized refusal.[45] The sovereign then repented of having exposed his gods to the stranger's gaze and offered an expiatory sacrifice. Cortés presented his apologies, and was content with erecting a chapel in Montezuma's palace, with his blessing.[46] One might have noted, in passing, a profound divergence between the two worlds: Christianity exhibited its images everywhere, while the native divinities were usually concealed in the darkness of sanctuaries, far from the crowds, their visibility periodic and subject to rules whose infraction was the equivalent of a "sacrilege."

It was only later that Cortés obtained satisfaction. The Spanish placed the cross and the Virgin at the top of the Templo Mayor, on an altar apart from the "idols." The compromise had been the subject of bitter negotiations. Montezuma resigned himself to having to convince his priests and accepted what Cortés proposed with a heavy heart, "sighs, and a most contrite look."[47] It had taken the threat of a serious military intervention to weaken the sovereign, who above all feared the anger of his gods and his clergy. Nevertheless he had avoided the worst, the overthrowing (*derrocamiento*) of the "idols."

The "official version," that of Cortés, deviates from that of Díaz del Castillo on several points. Cortés, as usual, stole the show and placed himself in the spotlight. It was he who initiated destroying the "idols," erecting chapels and putting images in them without even consulting

Montezuma. Intrepid, he ignored the sovereign's fearful warnings that the profanation might unleash an uprising of the "communities."[48] He minimized the natives' reluctance considerably: convinced by the conquistador's speeches, Montezuma had supposedly left the decisions to the Spanish. He even was said to have personally participated, with the collaboration of his court, in the removal of the "idols" and the installation of the images, "and all this with a joyful countenance."[49]

Bernal Díaz del Castillo's account is less spectacular, less heroic than those of Cortés or Andrés de Tapia, who is also prone to exalting the idoloclastic frenzy of his captain. One notices that the conquistador and his followers, when necessary, knew how to moderate their destructive ardor without neglecting the version they wanted to offer the Crown and leave for posterity, a version where the loser willingly accepted the winner's law, or here, the winner's image. The divergences and the contradictions in the accounts betray deals, blackmail, and compromises that no doubt affected the way in which the Indians perceived the Christian images. They confirm, if need be, that the victory of images over the Mexican idols represented a crucial prize in the eyes of the conquerors.

The Ambiguities of Substitution

Under the right conditions the two acts were connected: destruction was followed by replacement, with other representations. Even here the conquerors' behavior was still ambiguous. At Cozumel, during the first stage of the operation, there was no, or little, question of baptism, catechism, or conversion. The main part of the Cortesian message seems to have centered upon the material advantages or the profit[50] (healing, good harvests) that the Indians would no doubt reap from the new representations. Christianization was thus laid down in terms of images, more easily so because Christian images and idols were perceived as competitive, and in a certain sense equivalent, entities, one dispensing—supposedly—the same advantages to the natives as the other. From the Christian image Cortés retained not so much its didactic, mnemonic, and emotional capacities[51]—and thus its qualities of representation—as its material efficacy and its operational and thaumaturgical properties. Just as he proposed a radically different god, Cortés communicated and reassured that other channels would satisfy secular expectations as well.

At Cozumel, and similarly at Cempoala in the Veracruz region a little

later, the pagan sanctuary was cleaned and whitewashed with lime, an altar was erected and covered with embroidered cloths, and the space was decorated with flowers and branches. The pagan priests of Cempoala, who from then on had to cut their hair and dress in white, received the guardianship of the image; Cortés assigned them precise tasks: bringing flowers, sweeping—an elementary and obligatory ritual of pre-Cortesian religions—and burning incense for the "holy image."[52] Within the "decontaminated" and "rededicated" space serving as reliquary, the Christian image could begin to function. It mattered little that the material and human environments were of pagan origin: they could be reorganized around the image without the conquistadors feeling disturbed in the slightest. This was why, at Mexico-Tenochtitlán, Cortés had no trouble having Mass celebrated on the two altars erected on top of the Templo Mayor.[53] For if the conquistadors exhibited as strong an allergy to the native representations as they did to human sacrifices, they did tolerate certain local customs, and since they could not count on having sufficient Catholic priests on hand, they temporarily turned to the technicians of the divine that the native priests appeared to be. And they were neither the only ones, nor the first, to do this. In Cuba, a sailor had already helped spread the worship of an image of the Virgin by accepting as a matter of course that the Indians were bestowing the effigy with the honors they gave to their zemis, and even consecrated their usual food offerings to it.[54] Thus, after the deliberately transgressive and sacrilegious act, an immediate restoration took place: the sanctuaries, the local clergy were imperturbably recycled around the new images. Should we see in this a plasticity of polymorphous medieval piety, still abounding with national and regional variations? But though the sacred space was capable of being transformed, and indeed reused, this was never the case for the idol.

It is remarkable that save for a few exceptions, the Spanish were convinced of the appropriateness of their approach; it is even more remarkable that the procedure was successful among the Indians, for whom the presentation and imposition of these new effigies constituted the major, if not the only, immediately perceptible and tangible manifestation of Christianity. Paradoxically, the natives' reactions were far from being unfavorable once they discovered that the profanation remained apparently without consequence on the order of things and the world. The Mayas of Cozumel followed Cortés' instructions and watched over the

upkeep of the statue and the cross; they sailed toward the Spanish ships with an image of the Virgin aboard their canoe;[55] the Tabasco caciques welcomed the Virgin favorably, and baptized her *Tececiguata*, the "Great Lady;" she was probably adopted as a new avatar of their mother-goddesses.[56] After the installation of the images on the Templo Mayor, the Indians of Mexico-Tenochtitlán asked Cortés to intercede with his god in order to make it rain.[57] "Some days" they brought offerings, "for you took away our gods."[58] The matter of images played such a role in the Spanish strategy that the Indians could not help closely associating, even identifying, the invaders with their practices, which were alternately idoloclastic and iconophilic. In the natives' eyes the Spanish were the ones who "overthrew the *teules* (divinities) in our temples and who put their own there."[59]

While certain elements facilitated the operation of substitution—the proposed equivalence between Christian images and native "idols," the undifferentiated properties Cortés and the Spanish had attributed to them, and the temporary retention of the former clergy—the misunderstandings and the compromises resulting from this were legion. The briefly peaceful coexistence practiced on the Templo Mayor brought about others. The cross and the images of the Virgin were commonly mixed with the "idols"—which greatly scandalized the missionaries when they noticed this a few years later, and had to take them back from the Indians. The natives would only regain their Christian images as they constructed hermitages and oratories.[60] Other misunderstandings arose from the association of images and half-understood sermons. The Indians saw so many Virgins and heard so much about *Dios*, that they began to see *Dioses* everywhere and called them all *Santa María*.[61]

An Unequal Exchange

This substitution of images is evocative of another form of exchange: barter, or *rescate*. A scene bathed in light comes to mind: on the beach of Veracruz, while Montezuma's envoys listened to an exposition of the Christian faith and received a Virgin and Child and a cross, in the background, in the moist heat, the other Indians and a few Spaniards were busy. A fierce barter was begun between the swarm of natives arriving with the Mexica ambassadors and Cortés' troupe. The soldiers obtained the objects of gold of little value that the Indians had brought; but, so as

not to die of hunger, in turn exchanged them for the fish the expedition's sailors were selling.[62] When it was learned that Montezuma had decided to refuse the "image of Our Lady" and the cross, all communication came to a halt. The barter was interrupted, the Indians disappeared, and the beach emptied.

After Columbus, barter, along with the giving of gifts, became the essential factor in the first encounters with the autochthonous populations: objects were exchanged, usually European trinkets, "little things" (*cosillas*[63]) for gold, objects of value, or food. This merchant relationship seemed at first eminently to favor the conquerors, who prided themselves in always coming out on top. Reality seems more complex if we admit that criteria of appreciation are relative, and that the natives were not children: what was ordinary and contemptible for one could, for the other, become rare or novel. Any transaction, in any case, presupposed the agreement and interest of the natives. They could refuse simply by not showing up. Barter could turn against the conquistadors when the gold they acquired suddenly proved to be too highly polished copper. And the Spanish did experience the downside of barter when, in the grips of hunger, they exchanged their gold for a loss against the fish of their own sailors. Nonetheless, the path of barter led European objects to penetrate into the native worlds much more rapidly than the conquistadors.

Idoloclasty woven with the distribution of Christian images added a distinctive relationship; they became a sort of imposed barter, different from the so-called free exchange of presents or the negotiated exchange of the *rescate*. It made the brutal, spectacular, and dominating intrusion into the very heart of the indigenous culture quite real: by bartering their "damned idols" against true images, the conquerors shook the symbiosis between the Indians, the world, and their gods. If this breach was felt on the spot by the natives, whose anger the Spanish feared, it was because— above and beyond the violence of the act itself—the Christian images were not objects like the others. They were corrosive, they carried the negation of their adversary and rendered it visually, whereas the other objects from Europe and America that circulated and were exchanged could more easily lead to misinterpretation, reinterpretation, or destruction. The treatment Montezuma gave the chair that had been offered to him, or even the manner in which Cortés appreciated the divine emblems of Quetzalcoatl, did not challenge the culture of the addressee.[64]

Indeed, the Indians were soon quickly able to conceive of taming the image and temporarily defusing its menace—which they did for centuries—but the idoloclastic attempts and the conquerors' "blasphemes," at that point, generally caused paralysis.

Barter for gold, and the imposition of images: the two sides of an enterprise of domination destined to extend to the entire planet—Westernization—were already linked.[65] The two registers were simultaneous, and even echoed each other. Barter constantly served as a background for the intrusion of images, as one could observe on the beach of Veracruz. The two registers were equally permeable: the exchange could eventually turn to native idols coveted for their beauty, or even more so, the materials that composed them; as long as the idol had some merchant value, it ceased to be a demonic presence and became an object of value. But there was more than parallelism or crossing: the barter of images was meant to compensate for the barter of objects. If, during the course of barter, the Spanish exchanged trinkets for native objects worth their weight in gold, the barter might thus be unequal (and the conquerors boasted of it), but in the area of representations the relationship was supposedly the inverse, and favored the Indians. According to the Spanish the natives gained from the exchange because it rid them of false, evil, and "damned" representations, and gave them efficacious and beneficial images. The Indians were clearly the winners in this.

Barter, haggling, compensation, substitution, exchange, reinterpretation: the circulation of objects played with their identity, value, and meaning. All were touched by this acceleration of history, hurried along by the conquest of the Americas; today, these acts are in practice worldwide. "Idols" and images were at the heart of an operation of negation and redistribution of the divine, the shadow of secularization slipping in already behind the Westernization. The Mexica "idols" were emptied of their power and then relegated to the nothingness of matter, except when the seduction of form, allied to the fascination of gold, spared them from destruction by condemning them to the aesthetization of collections, and thus to another form of neutralization. Demystification is a double-edged weapon, and can turn against its initiators: did the Reformation not hold the same discourse on the images of the Catholics as the conquistadors applied to the Mexica effigies? At that moment the demystification was partial and operated only one way; it merely con-

cerned the idols of the conquered, and was interrupted by the immediate substitution of Christianity. Nonetheless, while it is true that the divinity denied to the "idols" reappeared, reintroduced in large quantities by the Christian images, entire sections of native cultures fell into nonsense and the demonic, while only a few relics were displayed as curios before ending up, much later, in our museums.

The Idol: Devil or Matter

The substitution of images for idols might lead one to oppose two irreducible worlds, where one would present itself as that of the image, while the other would prefer that of the idol. This antithesis is artificial, however, for both the exchange, and its terms, were created by the Spanish. Idol and image belonged to the same mold, that of the West. Endowed from the very beginning with a demonic identity, function, and form, the "evil and lying," "dirty and abominable" idol[66] could only exist in the gaze of the one who discovered it, was scandalized by it, and destroyed it. It was a creation of the spirit touched by a Western vision of things, a little like those walls of silver the conquistadors had thought they discovered in the Mexican city of Cempoala, which were only walls of polished (bruñido) white plaster bathed by the unbearable glare of the tropical sun. "Imaginación," the chronicler López de Gómara commented years later, "assí fue imagen sin el cuerpo y el alma," an "image with neither body nor soul." The Spanish saw idols everywhere, just as they wanted (desseavan[67]) to see gold and silver everywhere. They saw none of the density and strangeness that radiated from the zemis springing up wherever this fresh gaze stumbled over a unique reality.

Preconceived notion, prefabricated figure cut out a priori, the idol was the declension of a pagan and Judeo-Christian heritage suddenly resurrected by the Mexican adventure. The astonishment of the Island Spaniards, who thought they had found traces of Gentiles, was proof of it. The idol proceeded intellectually from a theory of the religious, and of religion, that combined the Old Testament interdicts, Aristotelianism, the lessons of the Church Fathers, and Thomism.[68] But for the conquistadors it was more immediately and simply the reverse and the foil for the worship of saints and the devotion to images.

Perhaps, nonetheless, it had only been a figure of speech, a phantasm, a

delirium of the mind analogous to the silver mirage of Cempoala, pinned to walls too bright to be real. The idol also designated, as much as it condensed and interpreted, a selective perception of native cultures, an understanding centered on figurative and anthropomorphological representations (statues, paintings) that the Spanish used as one of their keys in their interpretation of the adversary. This obsession with the figurative among the conquistadors was secondarily a phenomenon of ideological nature, relating to a theory of religion and idolatry; mostly it flowed from an education of the visual that favored anthropomorphism and figuration,[69] identifying it with significance and feeding itself emotionally with a piety based on images.

But what did idols become in the eyes of the Spanish? Faked objects, illusion-machines designed to facilitate fraud;[70] but also devils, "evil things we call devils" (which explains why the idols were afraid of the Christian images), or even objects into which a demon had been inserted: "It is quite notable that these people saw the devil in the figures they made and that they hold as their idols, and that the demon placed itself inside these idols, speaking to them and ordering them to make sacrifices and to give it the hearts of men."[71] This demonic "possession" was not only how the conquistadors saw matters; even the most learned clerks confirmed that "the Spanish believed it, and that was as it must have been."[72]

It is thus useless to search for a specific meaning or a particular reference to the idol. Either it was pure materiality, or, as a demonic instrument, it was inevitably associated with a demon. Whether it presented itself as a sort of sign to be destroyed, or even as a rare object, the idol was not a representation worthy of being contemplated or deciphered.[73] It is probably for this reason that one sees the chroniclers place such an emphasis on the material and the fabrication of the idols, on their human origin; Las Casas added a touch of psychology as he evoked, at the source of idolatry, the attachment ("inclination and natural love") children have for the dolls they create.[74] It is also probably because of this that one finds an ordinary laconism or the "it-looks-like" of descriptions ("like women"[75]), unless they help corroborate the perversity of the representation (the allusions to sodomizing positions in Díaz del Castillo[76]), or if they wish to insist upon the exotism and the spectacular (the idols of the Templo Mayor). Such were the qualities likely to awaken astonishment,

to capture the Prince's admiration and to increase the prestige of the conquerors: "The idols they worshipped were statues of the size of a man and more, made from a dough of all the grains they have and they eat, and that they bound with the blood of human hearts, and in this manner were their gods."[77]

Subjected to the reductive game of signifier and signified—a distinction that continues, for the most part, to govern our approach to the figurative object—the idol was inevitably destined to lose its mystery, its aura, and to undergo annihilation. For did the idol not hide within itself its own potential negation? The idol interpreted native reality at the price of a frenzied reductionism: either the idol was the devil, a lie; or it was a reification: the idol was matter, an impure thing.[78] This double operation—reification or "demonization"—was merciless; the idol was sentenced to be destroyed unless it could escape opprobrium and become an objet d'art—or rather, a curio—to be exported to the faraway courts of Europe. One can observe a similar "flattening" regarding its function: the idol satisfied material needs, and it also distributed "temporal goods." Yet on this point these properties only replicated that of the Christian images in their role as "advocate" for humans.[79]

Designed as an instrument of battle corresponding to precise political and ideological aims, the notion of the idol was not based upon the field experience of the conquistadors, even if doing so might have established a differently complex link between representations and divinities. For example, when the conquistadors learned that the human sacrificial victim was given the task of carrying a message—"la principale ambasciata"—to the god, "for he must go where he can meet his god;"[80] or that warriors who died in battle rejoined the Sun or Huitzilopochtli in the sky,[81] they had plenty of opportunity to realize that the idol did not exhaust the ideas the natives held about divinity; nor did they ignore this. The Spaniards' blindness was deliberate, for they knew how to record and manipulate the natives' beliefs when they needed to for tactical purposes. Desirous of approaching Montezuma's gods, the conquistadors diplomatically expressed their wish to contemplate the *teules* and the *dioses,* and not the "idols;" in order to convince the Mexica of the validity of the decisions imposed on their sovereign they attributed utterly fabricated oracles to the idol without hesitation. The conquistadors acted then as if they shared the natives' beliefs. Such a maneuver only confirms the Spanish indifference toward information about idols that happened to

reveal dimensions about which they cared nothing. Despite all this, the ambiguity of an idol torn between its double essence as dead thing and menacing devil may still have remained.

The Idol: False Image

If the idol teaches us nothing, and can tell us nothing about what the natives revered, it can, on the other hand, enlighten us as to the other half of the couple, the image. The idol alone existed in relationship to the image, only through and for the Spanish gaze. Many times the idol was proposed as an equivalent to the Christian image—"to remove the idols and set up the images"[82]—inasmuch as they shared comparable functions, and one could be substituted for the other. The idols' environment was transcribed in a vocabulary (chapels, oratories, devotion)[83] that originally applied to the world of Christian images. But at the same time the idol was the opposite of the image because it lied, it misled. This explains how in the eyes of the conquistadors the confrontation between the cultures and societies could be understood, interpreted, and depicted in terms of representations: images against idols, true images against false idols. It was as much the visualization of a dualistic way of thinking that opposed truth to lies, good to evil, as the display of an *imaginaire* that favored figurative links.

The Spanish were convinced that the Indians lived in a universe filled with idolatrous representations. This was the scene they beheld. Oviedo had noted it in the Islands; the *Conquistador anonyme*[84] and the Franciscan Motolinía reinforced this impression for Mexico: "[They adored the demon] in almost all visible creatures and [they made] of them sculpted and painted idols."[85] There is no doubt either that these representations were images: "In other places they adored the sun, in others the moon and in others the stars, in others the serpents, and in yet others the lions and other ferocious animals of this kind whose images and statues they have in their mosques."[86] Nor did "the embossed images of all the kinds of pleasures there can be between a man and a woman, that they portray with legs in the air in different fashions,"[87] escape the conquistadors' voyeurism.

But what was an image, for these Spaniards? The term appears when designating figurative representations, whether painted, sculpted, or engraved. It was generally reserved for the Christian register: one spoke of

an "image" of the Virgin, or of a saint, while "figure" (*figura*) was more associated with idolatry, at least in Castilian.[88] The conquistadors remained discreet about what they meant by image, no doubt as much because it seemed matter of course as because the visual was difficult to capture in words. The image could be manipulated, venerated, or destroyed. The image could not be glossed. The Indians still needed a minimum of explanation, which was done by resorting to acting it out: the conquerors kneeling down, praying, masses celebrated on improvised and richly decorated altars. It was against this background of liturgical spectacle that the Virgin was presented to the caciques of the pueblo of Tabasco: "We explained to them that we express our devotion [*reverenciamos*] in this image because in this manner She is in the heavens, and she is the Mother of Our Lord God."[89] Under analogous circumstances, Cortés explained to the Tlaxcalan Indians that the image of the Virgin was "a figure of Our Lady who can be found in the high heavens."[90]

The Cortesian dichotomy of the celestial model and the terrestrial copy posited a relationship of similarity ("*así está*") between the archetype and the image. This was a given for Cortés and the conquistadors. In any case, the idol was subjected to the same grid. Nonetheless, the nature of the relationship about which the theologians had orated at length[91] remained blurred enough to give rise to invasive beliefs and practices. Images and idols were endowed with properties that went beyond the field of representation and allowed an understanding of what the notion of image (or idol) implied for the conquistadors: a triple nature of representation, object (the base, stone, or painting), and a power capable of action. An image had the ability to bring "health, good harvests, and goods," to move about or stay still, to speak, to menace; while as idols were supposed to tremble in fear: "You will see the fear they inspire to the idols that are misleading you" Cortés said to Montezuma when he proposed installing a cross and an image of the Virgin on the Templo Mayor.[92] This quality, or potential, of representation presumed an interference of the signifier and signified in the minds of the conquerors: if to see the image was to reach god, to destroy the native representation was to end the divine referents of the adversary and thus to abolish his idolatry. This was an assurance the Catholic clergy accompanying Cortés hardly shared.

In certain respects the dynamics of the image and the idol diverged.

One has the feeling that the Spanish judged that the signified and the signifier—the *represented thing* and *that which represents it,* to restate their meaning—had a tendency to be mistaken for each other, to be conflated with the idol more than with the (sainted) image, as if the idol were an image that worked badly. Native "idol" and "god" were even used as if they were interchangeable, but they could also appear as separate entities, or as distinct as material, inert, localized representations and the devil could be.[93] This uncertain and variable status contributed to turning the idol into a devalued equivalent of the image, trapping it in a false symmetry where it occupied the negative pole. It was as if this tension—which, incidentally, was also of consequence between matter and archetype at the heart of the Christian image—had become an amalgam, a contamination, a source of illusion, lies, and error in the native idol.[94]

Choosing the Image

Why, then, have chosen the field of representation, and have denounced the idol? Even beyond the material, religious, and political motives we have referred to, it is undeniable that the choice of the visual compensated for gaps in a rather unsatisfactory linguistic communication. In order to dialogue with the natives Cortés had to speak through two intermediaries: his companion Malinche, who translated from Nahuatl to Mayan, and the Spaniard Aguilar, who translated the Mayan into Castilian. The emphasis placed on the Western image, on nonverbal communication and ritual, and resorting to a liturgical staging in order to win over the Indians[95] are all in the same vein—and destroying the idol was an extension of this action. It was believed that this would break the material and visual link the Indians had with their gods in a spectacular fashion by marking it for opprobrium and annihilation: idols in pieces; frescos covered with a coat of lime;[96] areas whitened and cleaned; the air purified of the miasma of sacrifices, now invaded by the scent of flowers and freshly cut branches. Colonization, at the beginning, might seem like an impressive act of decontamination.

But the domain of the image offered not only a convenient means of communication and action, it also covered more fundamental stakes, most often implicit ones. By arrogating the monopoly on the representation of the divine, the Spanish displayed in one stroke the breadth of their superiority, their "imperialism," shall we say. From their god flowed not

only their strength and their interpretation of the visual and figurative orders, but also the division that appeared everywhere between the profane and idolatry, the border that tore beings and objects apart from each other, and that weighed so heavily on the fate of native cultures.

For not all native representation was banished. The fabrication of "painted canvases" containing information (they announced the arrival of Narvaez's fleet) or "realistic" portraits presented no problem.[97] On the contrary. Gold work or realistic copies of terrestrial and marine fauna aroused the admiration of Cortés and his circle: "[A]ll the things . . . both on land and in the sea, they have modeled, very realistically."[98] The Spanish marveled at the art of illusion attained by the conquered artisans.[99] This area of expression was distinguished and tolerated, for the Castilians were neither Moors nor Jews, and did not share their phobias. It was tolerated because it was judged to be profane, and not idolatrous. The fact is, nonetheless, that this split existed only in the Westerner's gaze, who thus forbid himself from seeing that the borders he assigned to idolatry were artificial and constantly ignored. This was a partial blindness that would lead to an infinite chain of syncretisms.[100]

One of the strengths of the Cortesian enterprise consisted in awakening the archetype of the negative image—the idol—in order to project it onto the adversary, getting him to interiorize it successfully enough to rid him of it at the same time, and finally, to impose the true image, the image of the saint. The development of this image strategy was based on detecting the enemy's weakness, destroying it rapidly, and replacing it efficiently. More implicitly, though this war of images might potentially impose a visual order that first went through a monopolistic representation of the sacred, in the long run it carried an *imaginaire* which we have yet to explore.

Under these conditions an ethnographic approach to the zemi was useless. The conquistadors chose to reapply an ancient grid specifically formulated against paganism, this time on a continental scale. It became a revival—again the return to antiquity—of notions based on ancient recollections. The idol was also the choice of a rising modernity that tolerated the primitive, and even explored it with curiosity, but that crushed anything that bore an obviously unfamiliar history. Exotic, primitive, without a past, the zemi could comfort a conquering humanism in its superiority and curiosity. The idol, by making other possible and long-visited avenues concrete, had to be erased from sight and from earth by

all means possible. For the first time perhaps, history, primitivism, and modernity focused a debate around the image that would continue under many different guises until our century.[101]

The Native Riposte

How did the native populations react when exposed to these attacks? They unfailingly established a link between the conquistadors and the images: "They have images."[102] They perceived—at least partially—the confrontation unleashed by the conquest in terms of a "war of images." The idols of the Templo Mayor had claimed, had they not, that they would abandon Mexico because they could not bear the presence of the Christian images?[103] It would be a stretch to further pursue such parallels, however. The approach taken by the Spaniards and Indians differed, or was even diametrically opposed, on many levels: the Indians first mistook Cortés for the god Quetzalcoatl, returning to Earth in human shape; and they ranked the strangers among the *teules*,[104] in a "divine" category, by calling them by a name they reserved for their "idols." From the very beginning, they tacked their own conceptions of representation and the divine onto the invader.

Other clues corroborate this attitude: Cortés and his men were housed in Mexico City amid Montezuma's idols, in the palace of his father Axayácatl;[105] Montezuma was so scared by the head of a captured conquistador that he made an offering of it to gods outside of Mexico-Tenochtitlán.[106] The Indians thus saw the conquerors as "living representations"[107] and in some sense divinized them, while the Spanish "demystified" the Mexican gods by reducing them to the demonic and to vile matter, and if need be, to a merchant value or to the status of a collectible. Enchantment against disenchantment, commercialization and aesthetization were played against each other, at least during the first months before the Indians were convinced they were indeed dealing with human beings.

But a quite different abyss separated the two worlds: the Indians did not share the Spanish conception of the image. The chroniclers and evangelizers were the last to perceive this. Slaves of their own gaze, and convinced that the Indians could see no differently, they were astonished that the natives had given the paintings or sculptures of their gods such a "fierce and horrible" appearance, instead of producing classically anthropomorphic figures. In their eyes, such monstrosity could only be the

result of a nightmare, or the tactics of a religious terrorism meant to impress the crowds.[108]

Inasmuch as we can reconstruct it, the aesthetic grid mixing the question of beauty with that of anthropomorphic realism arose from a different way of perceiving things than that of the Indians. Native painting—on skin and agave codices, on the walls of sanctuaries—did not constitute, strictly speaking, an image. On one hand it was a graphic mode of communication subjected to the logic of expression, and not to the criteria of a realistic imitation that would rely on reduplication, resemblance, and illusion. When the Indians painted they designed shapes that were both illustration and writing, graphism and iconicity. The parallel nature of "image" and "writing" that was emphasized in the West (or in China) was replaced here by a practice that melded the two.

In Europe, influenced by the phonetic model, writing is perceived as the tracing of speech; painting is seen as the tracing of visible reality, the faithful capture of appearances. In China, on the other hand, where writing is not reduced to the representation of speech, painting maintains a relation of knowing and analogy with the domain of visible reality, and not one of redundancy or reproduction. Mesoamerica would then constitute a third case: as in China, graphic expression escaped the paradigm of phonetic writing[109] but did not achieve an independent existence because it continued to be associated with painting; the Spanish, who indiscriminately designated the pictographic codices by the name *pintura* or *libro,* had sensed this.[110] The Mexican *pintura* also tried to capture the organizing principles of things, and attempted to express the structure of the universe[111] while developing a rigorously coded language that nonetheless was never frozen into a pure succession of abstract signs.

Native representation—inasmuch as we can speak of representation, in this case—did not try to trace the reality of the senses, even if it referred to it. A Nahua concept allows us to take the analysis further: *ixiptla.* The Franciscan evangelizers borrowed it to name the Christian icon, the image of the saint, whereas before the conquest it had referred to many manifestations of divinity. The *ixiptla* could be the statue of a god (we would say, with the conquistadors, an idol), a divinity that appeared in a vision, a priest "representing" a deity by covering himself in adornments, or even a victim who turns into a god destined to be sacrificed. The various "semblances"—this is how Spanish sometimes renders *ixiptla*—

could become juxtaposed during the rituals: the priest symbolizing the god placed himself next to the statue he "represented," and there was no need for their appearances to be identical.[112]

The Nahua notion did not take a similarity in shape for granted. It referred to the envelope that received, the skin enclosing a divine force that erupted from crossed influences emanating from the cycles of time. The *ixiptla* was the container for a power; the localizable, epiphanic presence; the actualization of the power infused into an object; a "being-here;" native thought did not take the time to distinguish between divine essence and material support. It was neither an appearance nor a visual illusion harkening back to an elsewhere, or a beyond. In this sense the *ixiptla* and the image were poles apart: the *ixiptla* emphasized the immanence of the forces surrounding us; whereas the Christian image, in a reverse, upward motion, is meant to raise us toward a personal god, the copy moving toward its prototype, guided by the resemblance uniting them.[113] It is understood that Christian anthropomorphism, based on the dogma of Incarnation, imposes a conception of man and divinity that is foreign to the *ixiptla;* it too is a presence, but not that of a god made human.

The *ixiptla* was reminiscent of the pictographs covering the codices. In certain respects the captive dying under an obsidian knife, and the priest who put on the clothes of the god or the skin of the sacrificial victim, both constituted perfect human glyphs. They were decorated with the attributes corresponding to each divinity; akin to the footprint left on the ground by the all-powerful god Tezcatlipoca—a concave witness, a palpable and visible trace of divine invisibility—that reproduced the glyph signifying passage, displacement. Here we find the parallel, and even the link that seems to associate graphic modes of expression and conceptions of representation within the most diverse cultures, for both *ixiptla* and "painting" were intended to manifest the divine presence.[114]

The chroniclers and native sources described at great length the rituals for the manufacture of the idols, the shaping (dressing the statues, skinning the victims, etc.), and the consuming of the *ixiptla,* since the paste images were just as likely to be eaten as the sacrifices.[115] These gestures all undeniably occupied a major place in establishing the presence marked by the *ixiptla.* In this it was different from the Christian image, whose conditions of production generally drew little attention. But it

comes closer in other aspects, if one considers the ritual of the Eucharist, and the incessant handling that medieval and baroque statues received. The chroniclers noted these similarities and tried to interpret them, perceiving in them some satanic duplication. Perhaps it is enough to keep in mind that the *ixiptla* was not the image, and that the two worlds were each perfectly capable of reproducing reality without having to share the same preoccupations, the same registers, or even the same goals. To ignore this difference is to be doomed to misunderstand the confusion unleashed by the conquest. Where the Christians were looking for *idols,* the Indians knew only the *ixiptla.*

The Hiding of the Gods

Faced with the Spanish idoloclasty, the natives organized their riposte. It was mainly a defensive one, where they tried to shield their gods from the invaders by all means possible. This was made easier by their familiarity with this kind of agression: during the fifteenth century, the Indians of Huejotzingo had broken Tlaloc's monolith—venerated in the Texcoco sierra—as a sign of hostility against the Mexica, their hereditary enemies. Montezuma's grandfather had the statue restored with a metallic wire made of gold and copper.[116] As a rule, the accepted custom was to ruin the sanctuaries of defeated peoples, and to "capture" their gods as hostages, piling them up in the winner's capital.

Nonetheless, whether allies or adversaries of the Spanish, the native leaders took precautions. In Tlaxcala the high priest had the temple of Camaxtli guarded to prevent the Spanish from taking it.[117] In Mexico City, the Mexica sovereign devoted himself to dispersing the principal idols of the capital by giving them to guardians chosen from within the sacerdotal ranks for safekeeping. Voluminous and heavy bundles, conveyed by small boat over the lagoon and carried by men through the mountains, the gods followed complicated and secret itineraries before disappearing into the depths of the ground or into the bowels of the mountains. In 1519, with the arrival of the Spanish, Montezuma charged his son Axayácatl with transporting Huitzilopochtli, Tezcatlipoca, and Topiltzin (Quetzalcoatl) to Tencuyoc's grotto in Culhuacan, while at the very same moment, but in a different place, they buried the goddess Xantico.[118] In 1522, or as soon as 1520, when Cortés left Mexico City under

Alvaredo's guard, a Huitzilopochtli and many other "idols" were moved to Culhuacan, then to Xaltocan and Xilotepec, and finally ended up in a Peñol grotto of Tepecingo.[119] Huitzilopochtli reached Culhuacan by boat as two "large and heavy packages," one black and the other blue, the colors of the god.[120]

Following Mexico City's fall, the idols of the Templo Mayor underwent the same fate. Other idols—Cihuacoatl, Telpochtli, Tlatlauhqui Tezca-tlipoca, Tepehua, and maybe Huitzilopochtli—left Mexico City for Azca-potzalco, a neighboring city under less stringent surveillance, where clan-destine sanctuaries received offerings from the local authorities.[121] Men then came to reclaim the idols, and carried them (*tamemes*) back to the capital by request of the lords of Tula and Mexico City.[122] Here we lose track of them. A certain number of gods are purported to have been gathered at Tula, ninety kilometers to the north of the capital, in the city of the ancient Toltecs whose prestigious culture still lingered in native memory. Tlaloc's great effigy, venerated by the Indians of the valleys of Mexico City and Puebla, was buried "among rocks in the midst of vegeta-tion" in the sierra of Tlalocatepetl where it remained until it was un-covered in 1539.[123] The sierras everywhere provided hiding places for the cumbersome statues and the "things of the devil": drums of gold, stone trumpets, divinatory mirrors, ceremonial masks, ritual objects of all kinds.[124] Trusted families also stored the divine packages, as well as their jewels and the mantles embroidered with green stones (*chalchuyes*) corre-sponding to them. Further from prying eyes, women's quarters some-times served as shelters for the statues.[125] In the palaces of the conquered nobility, oratories hid collections—sometimes quite impressive—of idols: almost forty of them were taken from the Tezcoco cacique, including two Quetzalcoatls, two Xipes, one Coatl, five Teocoatls, one Tecoacuilli, one Cuzcacoatl, one Tlaloc, three Chicomecoatls, and two miniature temples, one of which was consecrated to Quetzalcoatl.[126]

One could build a geography from these networks and sites, which were not as secret as they might have seemed. Rumors, more or less precise or verifiable, circulated among the aristocracy, and it was known that here and there the descendants of former dignitaries or their heirs had hidden or were guarding the effigies and the numerous, equally precious ceremonial objects. The priests who were in Montezuma's con-fidence at the time of the conquest; their sons, who twenty years later

surrounded the lord of Mexico City; don Diego Huanitzin; and even don Diego himself, were thought to know what had become of "all the idols on Earth."

Montezuma's brother, don Diego, belonged to the aristocracy that was collaborating by fair means or foul with the Spanish powers.[127] Before becoming the governor of Mexico City in the late 1530s, he was able to keep the Franciscans from obtaining a Huitzilopochtli they had discovered. The prince, whom the Spanish had restored to the remnants of the Mexica throne, was not beyond reproach. But despite being tortured, the principal suspects managed to keep their silence, and don Diego escaped prosecution.[128] On the other hand don Carlos, lord of Texcoco, was less fortunate: the Episcopal Inquisition sentenced him to be burnt at the stake in 1539. He was accused, among other things, of holding back idols.

We find the same scenario and politics of silence in the provinces.[129] As the Spanish approached, the lords and nobles made sure their gods, and in particular the deity watching over the fate of the community—the altepetliyollo, the "heart" of the pueblo[130]—were in a safe place. Caves situated near the temples often served as hiding spots. Guards were designated to preserve these precious deposits and charged with celebrating the god's feast each year.[131] It is true that secrets were often badly kept; the children the Franciscans had catechized soon discovered the idols and gave away their hiding places, just as they informed on their parents. Some domestic idols were given to slaves in extremis, in order to escape the searches, even though in general slaves were held apart from the rites that remained the privilege of the aristocracy.[132]

The Conquest did not interrupt the production of idols, even those of large dimensions. This is attested to at Azcapotzalco, where in 1535 or thereabouts, as in many towns of Mexico most likely, they made gods in honor of which periods of fasting were still observed.[133] Despite the destructions that were the trademark of evangelization, many Indians proved themselves capable of making idols without having to call in specialized artisans.[134] This ability encouraged the temporary continuation of cults, and one can imagine repeated scenes of mysterious bundles circulating from one pueblo to another, transported into the sanctuary long enough for a celebration,[135] discreetly buried, then unearthed before disappearing, lost and forgotten, at the bottom of a hole or a cave. Similarly, pictographic codices continued to be painted and

used, hidden from Spanish curiosity, in order to be able to follow the "count of the demon's feasts."[136]

The Conditions of Secrecy

Ancient beliefs and customs facilitated this withdrawal into secrecy, or rather, made it less unbearable: the native gods were traditionally hidden from the gaze of mere mortals, and contact with them was reserved for the nobility. The precautions and interdictions surrounding the clandestine effigies favored secrecy, and protected them from those who would be curious and risked death if they inopportunely attempted to lift the veil covering the gods, who were only "exhibited" in exceptional times.[137]

None but the high dignitaries might see the hidden gods "with their own eyes." The Texcoco cacique, don Carlos, and other nobles would gather for the sole purpose of contemplating the gods adorning one of his oratories. Their servants must have looked on in puzzlement at this silent adoration, and perhaps equally at the objects that had been embedded in the stonework for so long.[138] How can one imagine and describe the intensity of the gaze that clung to these inhabited shapes, that penetrated the thickness of walls, and physically touched the divine? It was a look that might be described somewhat between a hypnotic stare and an ecstatic hallucination—the nobles had the privilege of ingesting hallucinogens, thus they could attain an exceptionally intense vision that allowed them to cross the barriers between worlds and domains of knowledge. Words fail, here, to surmount that obstacle of overwhelming otherness, and to reconstruct a form of communication that could only be speechless. Perhaps the Indians reserved this same gaze for the Christian images.

An entire range of objects, paradoxically, was spared denunciation and annihilation because of this invisibility of the gods, as well as because of the Spanish fixation on the figurative and their confusion between idols and *figuras de hombres*.[139] The Indians had not only hidden their statues, they had also dissimulated their adornments (*atavíos*), the "insignias, ornaments, and clothes of the demons."[140] Native worship followed many paths besides that of anthropomorphic representation, and these were apparently more inconspicuous and more easily camouflaged. Certain completely unrelated objects "could" reveal the proximity of a god: a

colored tube in the shape of a sword and flowers [*suchiles*] were "objects of our lord Camaxtle," the god of Tlaxcala; stones "like hearts," "hearts meant to be eaten"; maguey thorns, mirrors that could speak; a mat, a seat covered with a mantle and a g-string, in front of which were left food (chicken, corn paste or *tamales*) and offerings of "colored canes," flowers, and cocoa revealed a divine presence (Yaotl, Ichpochtli, Tezcatlipoca). If it was a goddess, Chicomecoatl or Cihuacoatl, a box replaced the seat on the mat, and it was covered with a skirt and a blouse.[141] After the ceremony the master of the house offered the clothes that had been consecrated in this manner to whomever he liked.

Were these objects exclusively revered "in memory of" the idols to which they belonged? Or must one instead discover in the Christian (or Christianized) interpretation of the "memory-object,"[142] a belief in objects imbued with a divine force that could be favorably influenced? The fact remains that these practices indicated a nonfigurative mode of representation that must have been even more difficult for the Church to banish, once it became able to perceive the threat. Its importance had not escaped Torquemada's perceptiveness. In *Monarquía indiana* (1615), he wrote that the bundle (*tlaquimilolli*) "was the main idol they venerated, even more so than the monsters of stone and wood figurines they made."[143]

The obsessive interest the Church manifested toward the idols created impossible situations: the high priest of Izucar had a very difficult time trying to convince the Inquisition that the community's god (*calpulli*) was represented by "seven *chalchuyes* stones as little as pearls."[144] Ecclesiastical judges did not know whether the discovered objects—"headdresses, feather butterflies, shields, feather capes," and other drums—were used for forbidden sacrifices, or for the dances that were still tolerated.[145] Trapped in their ideas of the sacred and profane, the priests hesitated, as Columbus had done in the Islands: were these objects of worship, and therefore demonic, or profane adornments and instruments? For the Indians, such a distinction made no sense.

The Repercussions of Idoloclasty

Did this brutal and systematic offensive have repercussions on the natives' relationship to the divine, that is to say, with the forces surrounding them, and the notions they held of them? Forevermore separated from

their temples and the ceremonial cycles giving them life, as cumbersome as they were compromising, the gods became witnesses to a shattered, wandering heritage and were at the whim of sporadic worship. The conquistadors' idoloclasty, at times, brought the Indians onto the ground the invaders had chosen and imposed upon them. Having listened to so many sermons against idols, and having been so often reproached with idolatry, the Indians became familiar with the stereotypes the Spanish and the clergy had of them. Denounced and arrested, they admitted under fear of torture that they were "idolaters" and that they worshipped idols. In 1539 and 1540, ordered to deliver idols to Spaniards avid for gold and precious stones, the Indians began to make false ones, "so that they might cease aggrieving them."[146] The idolater became a type of deviant to be chased, and idolatry an accusation from which one could shrewdly gain benefit against a neighbor or rival. This became such a habit that in order to be rid of the cacique of his village, a certain priest concocted a complete idolatry, down to the (false) wooden idol purportedly requiring a sacrifice, to which the people all around were alerted by the sound of a conch shell. Obsidian knives—that once had served to tear human hearts from their chests—made excellent exhibits in court after they had been slipped to Indians, if one wished to be rid of them through the intermediary of the Inquisition.[147]

Under the effect of idoloclasty, Indians seem to have been led to separate beliefs and customs that had once been the same or interdependent, and made to emphasize certain rituals. Because of the lack of statues, bas-reliefs, temples, urban sanctuaries, clergy, and visually sumptuous public ceremonies, worshipping took on a less collective, and a more personal, more internalized and discreet aspect. The multiple spectacles of bloody human sacrifice receded from sight and thought. The teaching of the *calmecac,* those schools reserved for the nobility, was only a memory. Repression and prudence led the Indians to use objects of insignificant appearance, and helped maintain gestures that could most easily be disguised or justified. Only the well-informed observer knew that sweeping the paths leading to the mountain sanctuaries meant that forbidden practices were being carried out. The obsidian knives, copal, paper, feathers, *ollin* (a sort of gum) that were left at the foot of Christian crosses[148] were often the sole expressions of clandestine rites, as the great anthropomorphic effigies or the codex and fresco paintings faded from memory. Other avenues to access the divine, on the other hand, re-

mained passable. The ingestion of hallucinogens that opened up the world of the gods and knowledge long remained a deep-rooted habit, primarily because it was so uncontrollable.[149] The idoloclastic offensive was bound to produce a renewal of indigenous practices as well as, in all likelihood, a focus on anthropomorphic representation—a threat when it was pagan, but due all signs of respect if it was Christian.

For the natives, however, anthropomorphic representations were not restricted to painted or sculpted figuration. The gods could take on human form and life. The victims of sacrifices and the officiating priests used to be the *ixiptla* of the gods, and it is not by chance that the con-quistadors were first mistaken for divine beings. The menacing and dis-concerting impressions they produced could not be otherwise inter-preted, and the newcomers found themselves mistaken for the irresistible forces governing the lives of men. But the illusion vanished quickly. For their part, the *ixiptla*-victims disappeared little by little as the Spanish forbid human sacrifices and the god-priests appeared less frequently and more discreetly, with few exceptions.

During the first year of their presence in Tlaxcala, before the closing of the native sanctuaries, the Franciscans had to endure the hostility of the former clergy. One of the temple servants, clothed in the ornaments and emblems of Ometochtli, the "wine-god," and chewing on obsidian shards, left his sanctuary one day and crossed the market. The crowd escorting him was fascinated by this unusual sight, "the demon or his figure," a being of "fierce and terrible" appearance; it was in fact—as the priest himself proclaimed—the god's *ixiptla* come to remind everyone of the observance of ancestral beliefs.[150]

When reading the few sources remaining from this period, one senses that here and there a few living *ixiptla* took the place of the effigies that had disappeared, been destroyed, or hidden. During the 1530s several Indians claimed the power and identity that made man-gods of them, in the lineage of those unique beings who, like Quetzalcoatl centuries be-fore, had guided the steps of the communities.[151] Ten years after the Spaniards' arrival, crowds gathered to visit and venerate the Tlalocs, Uitzlis, and Tezcatlipocas dispersed throughout the Puebla sierra and the northeast of the valley of Mexico City.[152] These man-gods, whose names evoked the great divinities of the high plateaus, officiated, healed, acted on the elements, and received honors normally given to the stone gods: "[An Indian] did what they used to before to worship the idols: he

lowered his head and joined his hands as a sign of adoration and immense fear."[153] They were living memories who reproached the Indians for having abandoned the things of their past and forgotten their gods, those "gods they once adored and who helped them and gave them what they needed."[154] They were also producers of "miracles" and liturgical leaders; they became multiplying and reproducible *ixiptla:* one notable even wished to unite his daughter with such a man-god, "so that there might be many gods."[155]

The crowds avidly sought to contemplate them, and they themselves built their power through public presence and performances, which was not the case for the great statues who were to remain out of the people's sight. The man-gods were divine projections in the people's midst. They juggled with appearances and identities while the Spanish lost themselves in the maze of apparitions, names, and people. But the secrecy of the nobiliary cults and the double-dealing of the Indian aristocracy—split between collaboration and tradition—had little room for people who protested all monopolies loudly. Nonetheless, in this first half of the sixteenth century, at the height of evangelization, at least three indigenous "media"—man-gods, visions, and cult objects—lent their support, their physical or psychological substratum, to the communication between mankind and the forces of the world; they passed on means of representation as well as facets of the ancient *imaginaire,* whose expectations they satisfied as best they could.

One can already perceive a different path, a more or less conscious one, barely fleshed out: that of syncretisms and compromises. The ambiguities having accumulated from the destruction and replacements played a great role in this. From the very beginning of the Spanish conquest, Christian images coexisted with the idols of numerous "idolaters." The Indians installed the crosses and Virgins given to them by the Spanish in the midst of their idols, thus playing with accumulation and juxtaposition, not substitution: "But these people, if they had a hundred gods, wanted to have one hundred and one of them and beyond, if they were given more."[156] The mixing of representations was coupled, quite early on, with an interweaving of various beliefs. From 1537 on, some Indians offered the fire god papers that represented their dead brothers, "so they might find rest, wherever they are."[157] Was this already a hint of a Christian hereafter, against a background of ancestral offerings? These first wayward steps prefiguring many others were made easier by a progres-

sive erasure of the ancient knowledge. In 1539 in Texcoco, a native witness admitted not knowing what the stones decorating a prince's oratory represented. Another believed them to be reused material or "something thrown away";[158] these were the beginnings of a disenchanted vision of the state of things.

In truth, syncretism remained the only exit from a drawn-out situation. Following the fall of Mexico-Tenochtitlán (August 1521), the idolatrous Indians had believed that the Spanish occupation was temporary, and could not imagine that there would never be a return to the old order of things, or that improvised solutions would become unbearable with time. Death, forgetfulness, the reigning confusion, the rotting of effigies and adornments, persecution and denunciation undermined the networks of clandestine sanctuaries everywhere—in the center of the country, around the towns, in fertile valleys—as the Spanish presence progressed. "When we hid the idols we didn't know God and we thought that the Spanish would surely quickly go back to their lands, and now that we have been allowed to know God, we have left all that rot there because we were afraid and ashamed to pull it back out."[159]

3

The Walls of Images

The idoloclasty the conquistadors practiced was spectacular, but it was also limited and temporary. Focused on conquering, pillaging, and pacifying the land, they allowed ancient cults to survive everywhere, and restricted themselves to forbidding the public ceremony of human sacrifices. Material interests and strategic considerations motivated this indifference and prudence: the invaders feared the Indians would chase them out at any moment, taking advantage of the fact that the numbers were incontestably on their side. The Cortesian fury had thus only been a brief prelude, efficient enough, nonetheless, for the native leaders to consider measures of safeguarding and withdrawal when faced with this danger. In any case "idolatry was at peace,"[1] and the status quo reigned for a few years.

The War against the Demon

The country's first evangelization campaign began in 1525 with the arrival of the Franciscans. It opened with the systematic and irreversible destruction of sanctuaries and idols (illustration 2):[2] the war of images was intensifying. This time the aggression spared neither the buildings nor the priests that the "decontamination," theoretically, had respected. The offensive was initiated in the central region, at Tlaxcala and the valley of Mexico City. The Spanish launched brutal actions; they terrorized the pagan priests and threatened them with death. These raids gave the priests and their native disciples a chance to discover that the images of Christ and the Virgin had been mingled with the idols and irresistibly absorbed into the autochthonous paganism. The sacrilege forced the evangelizers to take the images the conquerors had given the Indians away from them. This was a return to the beginning, as if the Cortesian ardor had been a false start. For the most part, however, there

2. *The Franciscans Burning the Idols.* From Diego Muñoz Camargo, *Descripción de la ciudad y provincia de Tlaxcala* (1584), plate 13. Glasgow University.

was continuity from Cortés to the Franciscans. The conquistador had not stinted in his support of the priests, who were grateful to him for it and kept themselves from reproaching him for the rashness of his initiatives.

Why 1525? There were still only a handful of Franciscans, and the Spanish domination was hardly a certainty, nor in any case solid enough to bear the risk of a generalized idoloclasty. But should we not turn the picture around, and admit that idoloclasty would have been perceived as a means to overturn the pagan priests, and weaken all resistance? Could the war of images have been only a way to continue the war by other means and to win it? It seems that the trauma caused by the devastating

raids produced the expected results, and that the destruction of the idols contributed powerfully to the dismantling or the paralysis of the cultural defenses of the adversary. The war of images added its spectacular effects to the repercussions of the military defeat and the epidemic shock beginning to decimate the Indians. Even if one discounts the overconfidence of the chroniclers, and their sometimes naive self-congratulation, one must conclude that the priests' audacity hardly brought about any organized or open response from the center of the country. It gave rise, rather, to a concealed opposition that spread anti-Spanish visions and prophecies.

But how could one not note certain chronological coincidences? American idolatry was not unique during the sixteenth century. Indeed, the Mexican idoloclasty reigning from 1525 to about 1540 was contemporaneous with European iconoclasm, an iconoclasm of Reformation inspiration that condemned the worship of saints and banned their representation. Mexico preceded, by only a few months, the Jura. While the Franciscans were launching their first expeditions around the lagoon, Farel, the Reformer, was throwing St. Anthony's statue into the Aleine river in Montbéliard (March 1525), and fomenting raids against altars and images.[3] In the following years idolatry was solemnly "removed" in the Swiss towns that had been won over to the Reformation. In 1536 King Henry VIII had St. Edmund's two shrines in Suffolk destroyed "for avoiding the abomination of idolatry."[4] The same year, "following the example of the good and faithful kings of the Old Testament," the council of Bern gave the order "to suppress all idolatries . . . , all images and idols."[5] As if there were some transoceanic echo, the emperor Charles the Fifth enjoined his Mexican viceroy in 1538 to have "the *cues* [sanctuaries] and the idols' temples thrown over and suppressed," and to "seek out the idols and burn them."[6] While the Spanish were undertaking to purge the entire continent of its idols, Tudor England was progressively destroying its own images as the Reformation became more radical. Churches were even whitewashed, as the pyramids had been in Mexico.[7]

From the iconoclasm of the Münster Anabaptists (1534) to the wave that in 1566 was to wash over the Netherlands, the destruction of images was an act that either horrified or galvanized sixteenth-century Europe.[8] The scriptural foundations and the tone of the attacks strangely resembled one another, for good reasons; but so did the hatred being displayed, even if, from Europe to America, the roles were switched, papist idolatry transforming itself beyond the ocean into a sworn enemy of idols. The

distinction between secular, popular iconoclasm and theological icono-
clasm was not without its equivalent on American soil, where a more
thoughtful religious assault followed the hypersensitive idoloclasty of the
conquerors. One could push the similarities even further: in Henry VIII's
Reformation England, just as in Bishop Zumárraga's Mexico, the hunt
for treasure was often mixed up with the hunt for idols, and the destruc-
tions disguised acts of violence and abuses of all kinds everywhere.[9]

Thus, after 1525 when the Franciscans decided to destroy the temples
and idols, their attitude was based less on an irresistible repulsion than on
an argued denunciation of idolatry. The condemnations and Old Testa-
ment warnings, like the interpretation the Bible proposed for the origins
of idolatry, inspired most of the evangelizers. The Franciscan Motolinía
derived an exegesis of idol worship from the *Wisdom of Solomon*, sum-
marizing the image's multiple aptitudes: as an emotional substitute to
receive one's love for a dearly departed, as the basis for a memory (*"re-
memorar la memoria"*), as an instrument of political domination at the
service of a long-distance adoration, as a misleading lure when the vir-
tuosity of artists produced copies "more beautiful and elegant" than their
model.[10] To the warnings of the *Wisdom of Solomon,* the Mexican experi-
ence added the bewilderment provoked by the countless number of
Mexican idols: "all the things one sees on land and in the sky" possessed,
at the demon's instigation, their idolatrous replica.[11]

How can one reconcile such hostility toward idols with the eminent
role Roman Catholicism assigned to images? Unlike the Jews or Refor-
mation iconoclasts, the evangelizers of Mexico preached a religion of
images. It was, however, not the images, but the sacrament of Holy
Communion that they preferred to oppose to the idols and the devil
during their missions. As orthodox as it might have been, the counterat-
tack was not devoid of Old Testament resonances that the chroniclers
described at length: "Having been brought to their profane temple, the
Ark of the Covenant destroyed their idolatry; their idols fell before it, and
it cruelly inflicted mortal plagues on the Philistines."[12] It had been a long
time, however, since the Philistines and the biblical Egyptians had under-
gone the fate of the American idolaters. If the precedent of the Ark of the
Covenant—that distant foreshadowing of the real presence of the Eucha-
rist—had to be reawakened, it was because it was sometimes embarrass-
ing to have to propagate the destruction of idols in the name of a religion
of images. The evangelizers must have been aware of this when they

counted on a real, nonfigurative presence, the reliquary-god, to chase the demons away. Hence their discretion concerning the recourse to sainted images, and the precautions they ordinarily took in handling them.

The Franciscan Memory-Image

Certain quarrels opposed the Franciscans to the hierarchy and then to the Inquisition beginning in the middle of the century, when the mendicant orders—the Dominicans and the Augustines having joined the Franciscans—lost absolute control over the evangelization of the country. These confrontations shed light on the manner in which the first missionaries of Mexico conceived of the Christian image and the use they set aside for it. Pushed to explain their practice and their position, some Franciscans put forth arguments that let an unmistakable wariness show through. Their reasons were theological, tactical, and material. They revealed, toward images, a prudent—if not reticent—approach reminiscent of that of Erasmus, for the evangelizers of Mexico had not remained insensitive to pre-Reformation impulses and the work of the Rotterdam humanist. Their motivations expressed the desire to extirpate forever the idolatry "towards which, because of their paganism, the Indians have been strongly inclined"[13] and to forbid any backsliding by associating a politics of tabula rasa with the refusal of compromise; finally, and on a more banal level, they reflected a dearth of European images. It is revealing that the priests chose to banish the representation of Christ from the stone and wood crosses they were having erected everywhere. Instead of the human body, symbols of the Passion covered the arms of the cross so as to avoid any misunderstanding that could come from a comparison between the death of Christ and a sacrificial death that might carry pre-Hispanic tones.

The first evangelizers experienced difficulty trying to teach the Indians the difference between God, the Virgin Mary, and their images, "because up until then they only said the names 'Mary' and 'Blessed Virgin Mary,' and by saying this they thought they had named God, and they gave the name Blessed Virgin Mary to all the images they saw."[14] This interpretation came from neophyte audiences who still had little familiarity with the substance of the Franciscan sermons. The implicit equation established between God, the Virgin, and images probably stemmed from an overlap of the pre-Hispanic tradition—that of the *ixiptla*—and the mis-

sionaries' insistent monotheism. For the Indians, the Christian divine—
Dios—must have been prone to wearing multiple manifestations and
names, and any of his representatives could only be interpreted as being
him as well. In the eyes of the Franciscans, the Indians were making a
double mistake: one about the identity of the image, and another about
its nature.

It is understandable that the priests might have feared this confusion
would only turn the Indians' worship of images into neo-idolatrous prac-
tices more quickly. To exalt the worship of an image of the Virgin could
become a perilous exercise, "for they would believe that it was the Virgin
herself and with this idea they would worship her as they were used to
worshipping idols."[15] The criticism refers to Deuteronomy 13, which
condemns any latria not having God as its object and attacks the false
prophets when they preach of new gods and attribute pretended prod-
igies to them. The confusion thus sown within the native world might
even transform itself into disturbances, if the Christian images were
adored at the same sites as former pagan sanctuaries: the Indians would
then think that the Spanish were condoning former cults, and worship-
ping their gods; this might become an unexpected revival process fo-
mented by the conquerors. The worship of images was thus perceived
not only as a source for misunderstandings and scandals, but also, in
certain contexts, as an eventual fermentation that could perturb and
destabilize colonial order.[16]

Most of all the Franciscans feared the drift of idolatry. It was necessary
to avoid having the "naturals" believe in images of stone and wood.
These were only to serve as an impetus for devotion toward what they
represented and that which was found in the heavens, and to bring some-
thing to memory: "The image of the Blessed Virgin Mary is only painted
so one can recall that she is the one who deserved to be the Mother of
God and that she is the great mediator of the heavens." Or yet: "The
crucifix is represented, or painted, only to remember."[17] The dichotomy
of the signifier and the signified, the image and the "represented thing"[18]
could not be more clearly stated. An image of the Virgin was not God, no
more so than it could be confused with the Virgin herself. It was only an
instrument of remembrance and of memory.

The Christian West had long known of this pedagogical and mne-
monic function assigned to the image. The illiteracy of the European

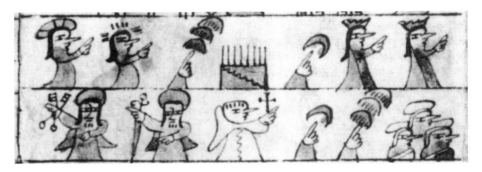

3. Catechism, *Libro de oraciones,* sixteenth century. Library of the National Museum of Anthropology and History, Mexico City.

masses, and of the Indians, amply justified it. For medieval tradition, images contributed to "the instruction of simple people because they are instructed by them as if by books. . . . What a book is to those who can read, a picture is to the ignorant people who look at it."[19] The Franciscans exploited this property of the image in their evangelizing campaigns. Names like those of Jacobo de Testera or Diego Valadés were associated with this "new method of teaching": "thanks to the image" the knowledge of the Scripture was to impress itself into the minds of these "unlettered [Indians] with no memory, eager for novelty and painting"[20] (illustration 3).

The Franciscans used painted canvases where the symbol of the apostles, the Decalogue, the seven deadly sins, and the seven acts of mercy appeared "in a fashion and order that are quite ingenious."[21] Systematically put into practice, the procedure proved to be fruitful and so efficient that it was submitted to the Council of the Indies and even taken up by other religious orders, who appropriated it to the great dismay of the Franciscans. When the Dominican Gonzalo Lucero evangelized Mixteco, a province in the south of central Mexico, he himself used paintings, and among them a canvas representing two brigantines: one filled with pious Indians, the other bearing drunkards and concubines. The allegory was only simple at first glance, for the natives of that mountainous country had rarely seen the sea and even less, ships.[22] But could these monks have guessed that by showing their painted canvases they repeated the gestures of ancient priests deploying the accordion-pleated

codices before the Indians' eyes, and that these same Indians were probably gazing at the Christian images with the heavy expectations and fears the old paintings had inspired?

Despite this sensitivity to the didactic effectiveness of the image, the obsession of idolatry and the haunting reminder of the condemnation of Deuteronomy inspired attitudes of a quickly suspect, "erroneous and scandalous" radicalism in the eyes of the Church.[23] For there was nothing better, in order to clear up all misunderstandings and keep the Indians from interpreting the veneration of images in pagan terms, than to refuse to allow them their cults.[24] Even more so since it was a delicate matter to translate all the subtleties of a theology of representation into native tongues that were not yet well mastered. Around 1558 the Frenchman Mathurin Gilbert—the apostle of the Michoacán Indians and the author of the first dictionary and grammar in the Tarasque language—suggested this in his *Diálogo de la doctrina cristiana:*

DISCIPLE: But lord, why are they once again painting the image of Our Lady and the saints that are now being worshipped, since God ordered us to worship no images?

MASTER: My son, we adore no images, whether it be the crucifix, the Blessed Virgin Mary, or the saints; it is only so that we can remember God's great mercy. . . . Even if we worship on our knees in front of the crucifix, it is still not the crucifix that we are worshipping, for it is only made of wood, but it is God himself Our Lord who is in the Heavens whom we worship.[25]

Semblance-Image

Even so, prudence and orthodoxy can be compatible. The Franciscan practice was based on a conventional definition of the image that a chronicler from the beginning of the seventeenth century, the Franciscan Juan de Torquemada, explained in his colossal monument, *Monarquía indiana* (1615), written to glorify the mendicant apostolate: "The image is the semblance of another thing, which is represented in its absence."[26] A relationship of similarity and resemblance (*semejanza*) associated the object with its representation. This was the image's vulgate, already brilliantly expressed in the fifteenth century by the Italian Alberti in his *Della pittura*,[27] based on the principle of *repetitio rerum* and undeniably linked to the specificity of an alphabetic writing where the image was the repro-

duction and the mirror of sensate reality, as writing could be for speech.[28] One can easily recognize "the strictly representative notion of the pictorial sign that phonetic writing impose[d]"[29] and that constituted one of the major foundations for representation in the Western literate world, so different in this aspect from the modalities that ancient Mexico had valued. Indeed, the same discourse ran from Alberti to Cortés, from Cortés to Juan de Torquemada, sanctioned by the Council of Trent and still held by the majority of our contemporaries, even if in practice, the work of art often strayed beyond the clearly defined limits of theoretical space.

As he tackled the crucial question of the representation of the invisible and of the divine, Juan de Torquemada considered that visualization represented an impossible, yet necessary operation; a last resort, as it were. Man, in his weakness, needed to materialize divinity and make it visible, "so that by seeing it with bodily eyes he might have faith in it during a [time of] conflict, when he feels all his anguish and his needs."[30] Representation and the visible sign, "as the artificial image is that represents it," were thus inevitable. But Torquemada was scandalized that man might be able to attribute even an iota of divinity to statues, and could not release his intrinsic mistrust: the image could only be "a malicious and misleading mask." Was it not likely to lend itself to all works of alienation and domination ("*dominio y señorío*")?[31]

On the other hand, the chronicler offered nothing consistent on the question of the Christian image. Reticence prevailed. It is true that the pages devoted to the image served first as an introduction to the refutation of native idolatries. By thus emphasizing the idol-image and remaining silent about the miraculous image—even though it was flourishing at the time he wrote—Torquemada merely illustrated the line of his predecessors with great scholarship. Even so, he was as fully conscious as they of the incomparable power of the image.

The Image from Flanders

What was the first visual imprinting the Indians received? The earliest images to land on Mexican soil were canvases and—more influential—sculptures; one can get an idea of them by looking at fifteenth-century Castilian, Aragonian, and Andalusian works and the few examples preserved in Mexico. For example, there was the Virgin of the Antigua,

deposited in the Cathedral of Mexico City.[32] It was the Flemish experience of the image as much as Iberian art—and very little that of the Italian quattrocento—that surfaced at the beginning of this adventure: Ghent as much as Seville, and much more so than Florence or Venice. Flemish influences crossed through the Spanish Gothic during the entire fifteenth century, and with them the idea that the figurative and empirical orders ran closely together and were governed by the same laws.[33] Most of the first printers established on the Iberian peninsula were of Germanic or Flemish origins, and many engravings spread throughout Spain were copied from Nordic originals.[34] Northern styles thus influenced sculpture,[35] painting, illustrated books, and engraving. The saturation was such that in order to magnify the talent of the Mexican Indians, the Dominican Bartolomé de Las Casas quite naturally invoked the example of the Northern painters: "They began to paint our images; they did it with as much perfection and grace as the very first masters of Flanders."[36] Elsewhere, it was Flemish tapestry that served him as a basis for his comparison.[37] To this artistic prestige one can add the special links that tied Castile to Aragon in the Netherlands and to Germanic Europe, since Charles the Fifth, heir to the Catholic Kings, was also heir to the Habsburgs and the Dukes of Burgundy. Let us not forget that it was in the name of a ruler born in Ghent and who was the Count of Flanders that Cortés conquered faraway Mexico, just as it was through the lessons of a Fleming, Peter Crockaert, that the theologian Francisco de Vitoria assimilated Thomistic thought, and gave the School of Salamanca an unequaled glamour.[38]

Flanders was present in Mexico in yet an even more immediate fashion. Thanks to the "favor of the Flanders greats [who] at this time led throughout the Spains"[39]—let us understand by this the Burgundy counselors of the young emperor—Franciscans from the Ghent convent went over to America and settled in Mexico after 1523.[40] One of them, a lay brother by the name of Peter of Ghent, was a pioneering figure of this history. He abandoned the Netherlands even as they continued to flourish. Painting prospered there under the influence of Memling, Gérard David, Hugo Van der Goes, and the epigones of the Van Eycks. The archaistic masters worked side by side with artists who were more sensitive to the Italian quattrocento experience. Bosch had been dead for seven years, and Brueghel was yet to be born when Peter left Flanders. Once arrived in Mexico, the Ghent painter opened a school in an annex of

the San José de los Indios chapel, to teach arts and Western techniques. In a town only just reborn from the cinders of the Conquest, he undertook to show the natives writing, drawing, painting, and sculpture based on European models, and therefore primarily Flemish ones. Tradition says that Peter of Ghent had enough talent himself to be the author of an image of the Virgin de los Remedios kept today in the Tepepan church, southwest of Mexico City.[41]

The missionary was accompanied by two other Flemish Franciscans: Johann Van den Auwera (Juan de Aora); and Johann Dekkers (Juan de Tecto), from Ghent himself as well, confessor of Charles the Fifth and theologian from the University of Paris.[42] Both had apparently packed books printed in the Netherlands and in the north of Europe. Without waiting for the arrival of the Twelve in 1524—the first Franciscan contingent sent to America—this little Flemish band laid the bases for the gigantic "spiritual conquest" that the evangelization of Mexico and Central America was to become.[43] Dekkers and Van den Auwera disappeared fairly early, but Peter of Ghent held an incomparable and magisterial sway until his death in 1572; in a half-century of uninterrupted activities his popularity and his prestige made him a rival of even the archbishop of Mexico.[44] Despite the distance, these Flemings kept ties with their native land, and not only through letters,[45] since it is possible that Peter the Ghent's Nahuatl Catechism may have been sent to the Netherlands to be printed in Antwerp around 1528.[46] Later, painters from the North settled in New Spain, and it is not surprising, in 1585, that the Third Mexican Provincial Council recommended to painters the use of the treatise on sacred images by Juan de Molano, a Fleming who was born in Lille and died in Louvain.[47]

The Bull and the Indian

For the Indians, the teaching of images immediately turned into an apprenticeship. The first native work inspired by the West is thought to have appeared in 1525: it was the copy of a vignette engraved on a papal bull representing the Virgin and Jesus. The work was so perfect that a Spaniard took it with him to Castile "in order to show it off and draw attention to it."[48] It is remarkable that this American "premiere" had the 1525 launching of idoloclastic campaigns as a background, and that the destruction of the idols of Texcoco was contemporaneous with the un-

folding, by a native hand, of the Christian image in Mexico. The simultaneity and the parallelism of these events might astonish us less if we remember the active part Peter of Ghent took in tearing down temples and idols while he was spreading the image and writing. The entire ambivalence of Westernization, its alibis, its lack of remorse, and its efficiency were incarnated through this character. The Christian image was thus literally born on the debris and ashes of the idol in Mexico.

It is equally revealing that the first image produced by a native immediately became an object of curiosity, exportation, and exposition (*"cosa notable y primera"*). What is more, it was followed by other works—feather mosaics, most notably—that went to richen European collections, as the zemis had thirty years earlier. From the beginning the role of the native artist was circumscribed: it consisted in reproducing a European original in the most faithful manner possible. From the outset confined to copying, Indian creativity was to restrict itself to displaying a technical ability or virtuosity that would be awarded only if it abstained from changing either form or content, that is to say, if it knew how to stay invisible: "It seemed there was no difference from the original to the copy he had made of it."[49] The ideal conditions for native copying were thus set in 1525: they stipulated a passive reproduction and reined in Indian intervention to the utmost. On the lookout for reproducers, and not conceptualists, the conquering West rarely ever abandoned that attitude thereafter.

The natives would from then on busy themselves with scrupulously reproducing "the materials given to them,"[50] *materias* that were primarily engravings, for they could reach Mexico more easily than canvases or sculptures and could circulate among the Indians. The late fifteenth century was not only the age of the diffusion of printing in all of Europe, but also the rise of engraving.[51] Mechanical reproduction opened horizons that constituted an unprecedented media revolution, comparable in scope to the spread of printed matter. It also corresponded to the discovery and colonization of the American continent, to which it offered quite opportunely the means for a conquest via the image. Even in Spain alone, almost one quarter of the incunabula Lyell counted contained wood engravings, and it was in 1480 in Seville—door to the Americas—that the first book to be illustrated in Spain was printed.[52] The image that the Western world could reproduce massively for the first time was thus reducible to a generally monochrome expression, within which the line

furnished a selective reading of reality, and space divided two principal planes with a quite rudimentary form of perspective. A Europe in black and white.

One can envision this by leafing through Peter of Ghent's catechism. The *Doctrina* was published in Mexico in 1553. Right from the beginning the eye is drawn to the astonishing diversity of quality and technique (illustrations 4–7). Very rudimentary, even crude drawings of local provenance alternate with extremely elaborate compositions of northern (Flemish and German) inspiration: Christ's entrance into Jerusalem on Palm Sunday or the Deposition are of an astonishingly more sophisticated rendering than the Ascension of Christ, or the Crucified Christ that looks like a hieratic icon.[53] A Northern influence, rather than Italian or Iberian, seems to predominate throughout the illustrations. The same tonality existed in the inventory of the library of Santa Cruz de Tlatelolco, where the Franciscans provided a superior education to the children of the native aristocracy. The printed books before 1530 originated primarily in Paris, Lyon, and Venice. But along with Basel, Strasbourg, Rouen, Nuremberg, and Cologne, the contingent that carried the day was that of the Northern lands, and with it, probably, the engraving from these countries. An examination of the library of the first bishop and archbishop of Mexico, the Franciscan Juan de Zumárraga, corroborates this tally: one finds books from Paris, Cologne, Basel, Antwerp, then a strong Venetian contingent and a handful of works printed in Lyon.[54] In any case Spain is in the minority, a Spain that was more often in the hands of German printers anyway, whose ranks featured the illustrious Crombergers of Seville.

The Northern image was thus particularly present in America, as it was in a great part of Europe. To measure its richness one has but to glance at a work belonging to the evangelizer Juan de Gaona: the second volume of the *Opera minora* by Denys the Carthusian. On the first page, printed in Cologne in 1532, a complex set of juxtaposed compositions are spread out in eight vignettes concerning the Church doctors; on the lower register one can see the ecclesiastical hierarchy and the kings present at the ecstasy of a saint contemplating, in his vision, God the father surrounded by the Virgin and Christ.[55] This may constitute a Northern predominance, but it is also an extraordinarily composite range of forms where the strokes vary from the most simple to the most complex, where the depth oscillates between perspective and a rudimen-

4. *The Entrance into Jerusalem*. From Fray Peter of Ghent, *Doctrina cristiana en lengua mexicana* (Mexico City, 1553), fol. 109.

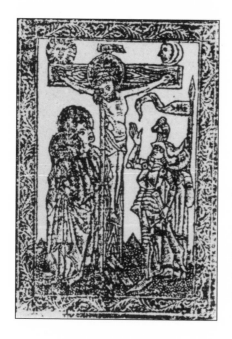

5. *The Crucifixion*. From Fray Peter of Ghent, *Doctrina cristiana en lengua mexicana* (Mexico City, 1553), fol. 139v.

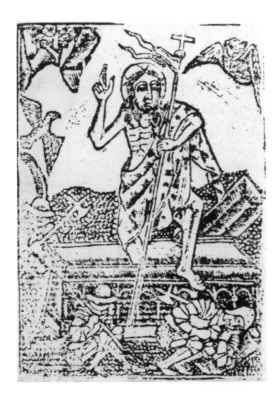

6. *The Resurrection.* From Fray Peter of Ghent, *Doctrina cristiana en lengua mexicana* (Mexico City, 1553), fol. 100.

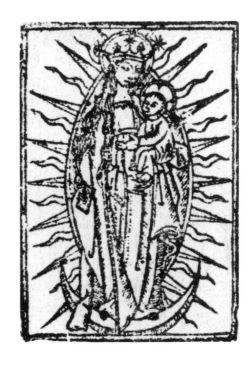

7. *The Virgin.* From Fray Peter of Ghent, *Doctrina cristiana en lengua mexicana* (Mexico City, 1553), fol. 128v.

tary juxtaposition of planes, where the legibility of the motifs and orna-
ments is far from being uniform: this is what the native eye discovered
and copied in the 1520s, 30s, and 40s. Europe's image was monochrome
and multiform, let us not forget, even if an analysis cannot always take
this into account.

No matter the style of the copied model, the link between books
and engraving and that between images and writing stood out from the
beginning, since Peter of Ghent's young native students learned how
to read, write, trace gothic letters, draw illuminations and engravings
(*imágenes de plancha*) all at the same time. By simultaneously discovering
the graphic reproduction of language and the engraved reproduction of
reality (the first image copied by an Indian accompanied the printed [?]
text of a bull), Peter of Ghent's Indians were, from the outset, able to
familiarize themselves with what the evangelizers meant by "image": the
tracing of a *molde,* a copy but never—such as the *ixiptla*—the irresistible
manifestation of a presence. Despite the hugeness of the project, Peter of
Ghent's undertaking was crowned with success: the native workshops of
the Fleming produced "the images and retables for all the country's
temples."[56]

The Walls of Images

The painted and sculpted image, in Mexico as elsewhere, was indissocia-
ble from the framework in which it was exposed to the gaze of the
faithful. One cannot, therefore, abstract it from the religious architecture
of the sixteenth century, that of the great Franciscan, Dominican, and
Augustine monasteries lining the roads of Mexico and filling one of the
most fascinating chapters of the history of Western art. It is an oft-
neglected chapter, for the interest focused on the pre-Hispanic remains
and the seduction created by the Mexican baroque contribute to leaving
in the shadows the hundreds of buildings that the Indians erected under
the direction of the mendicant monks.[57] Captivated by the spectacular
exotism of the pyramids, blinded by the retables' delirium of gold and
silver, our gaze balks at the familiar strangeness of these buildings . . .
and avoids it. We are confused to discover a medieval or Renaissance déjà
vu, an awkward, deforming, and shattered mirror devoid, in any case, of
the attraction of distance.

It was in the immense parvis in front of the cathedrals being built that

the open "chapels" rose up. In front of their altars, sheltered under stone archways, the neophytes followed the celebration of the mass under open skies. Then, after the late sixteenth century, the tall naves—seemingly defying the laws of gravity so much that they were said to have scared the natives, since the Indians did not know of the art of the archway—sprang up next to the cloisters. These were the places in the countryside and the native towns where the Christian image appeared. Mexico City and a few Spanish colonies scattered throughout the country gave the Indians, to begin with, their only opportunities to perceive other types of representation, this time of a profane, but equally disconcerting nature. This was notably the case of the playing cards the invaders always had with them. Images in general thus blended strongly with the Christian image in particular.

The Indians discovered the painted and sculpted image on the walls and the archways of churches, in the interior of open chapels, all along hallways and stairs, in the rooms and refectories of the convents, and more rarely, through an open door, on the cell walls of the monks. Frescos usually alternated with canvases and unfolded drapes—"*muy amplios tapices*"—along the walls of the churches.[58] Walls of images, at times gigantic screens displayed over tens of square meters, the Christian frescos were not plunged into the penumbra of sanctuaries as had been the pre-Cortesian panels only the priests could visit. These frescos were part of a new organization of space, shapes, and architectural volumes that the monks progressively introduced and transformed. How could one imagine the frescos of Actopan without the great stairway they decorate, and with which they form a whole built like the Benozzo Gozzoli chapel in the Ricardi palace in Florence?[59] The students of the Augustines, the servants, the sacristans, the cantors who took the stairs daily, all these Indians circulated amidst an overabundance of porticos, columns, and friezes. The great figures of the order were also represented there, enthroned on their sumptuously decorated cathedras, surrounded by a profusion of ornaments, fully comparable to the most exuberant pre-Hispanic works. The religious scenes of Epazoyucan, the paintings of Acolman, and even the pieces of frescos that remain in many places still reveal a recurrent trait of this decor: a saturation of images. The frescos followed each other seamlessly across the walls, as if the monks had wished to recreate surroundings that had been left back in Europe, and thus preserve at all moments a visual link with this distant heritage: were

they not the first consumers of these images? One must add, on a minor note but with a quite different impact, the illustrated books and engravings that the native nobility, instructed in the convents, were invited to leaf through and read.

Exposure to the image thus usually took place in a liturgical or catechistic framework. One followed the images the priest was interpreting, or one prayed in front of them. The image served as a base for oral teaching, or even stood in for it at times: since he did not speak Nahuatl, Jacobo de Testera used a painting featuring "all the mysteries of our Holy Catholic faith," and an Indian interpreted it into the language of the faithful.[60] The clandestine access provided by theft or a discreet intrusion into a library was less common, even if it was attested to.[61] This framework was indeed both that of an apprenticeship and of a conversion, a doubly personal investment centered on the founding of a process of communication with new forces, the Christian God and the supernatural associated with it. The education of the native eye—as the monks practiced it—went through instilling the rudiments of the catechism and stimulating an attitude of waiting and adhesion that the liturgical celebrations maintained. The explanation of forms and procedures was reserved for the artisans who collaborated with the monks, unless they were invited to copy what they saw mechanically. And even so, this explanation limited itself to what the monks deemed essential to transmit. The apprenticeship appears even more complex when one considers that the set of these artistic manifestations also put less explicit—and in a certain sense more fundamental—values and principles into play than those of the catechism, which were of a visual order and of an *imaginaire* whose internalization could only deeply upset the autochthonous *imaginaire*.

It is particularly delicate to recreate the neophyte gaze and the manner in which a native receptivity to the Christian image was developed. Let us offer a few hypotheses nonetheless. By discovering the painted or graven image the Indians were bound to stumble against an exotic and hermetic set of iconographic conventions. One would have trouble enumerating them in their entirety, but at the forefront one must incontestably place anthropomorphism, or the preponderance of the human figure, which since Giotto has become, in Western art, the instrument of figurative thought. Anthropomorphism postulated a representation invaded by the notions of incarnation and individuality.

One has only to glance over the engravings of Peter of Ghent's *Doctrina* again to immediately understand the emphasis invariably placed upon the human being, whether a saint, the Virgin, or Christ. All these beings were inscribed in history, or more exactly, in a particular relationship to the past that was maintained by faith and clarified by the ecclesiastical tradition. The frescos of the Actopan stairway displayed a gallery of portraits gathering the great figures of the order of Augustines; these "historical" figures were individualized by gestures, backgrounds, and attributes. These figures were neither abstract types, nor *ixiptla,* but beings of flesh that one could theoretically identify and distinguish from one another. One could say the same of the Christian "gods" displaying distinctly human traits, who were supposed to have lived a historic existence. Incarnation and historicity governed the Christian image and disallowed any confusion. But the two postulates were implicit: beyond conventions and attributes, nothing very essential distinguished an Augustine archbishop from a saint, from Christ or even God to the native eye, no more so than a woman saint or the Virgin was fundamentally different from a pagan sibyl. The Indians' response, at first mistaking the image of the Virgin for that of God and applying the name of *Santa María* to all Christian effigies alike, allows us to measure the magnitude of the obstacle. As much as it manifested a very natural ignorance of Christian figures, of connotations and contexts, their reaction supposed a polymorphous conceptualization of divinity that was very far from Christianity.

After the beings, the things. The Indians had to become familiar with a large quantity of figurative objects: with the cross, of course, but also with costumes, drapes and hangings, elements of architecture such as columns, chapiters, and arches. Under the iconographic convention was often lodged a European object completely devoid of concrete existence for the Indians. The representation of clouds, grottoes, trees, and rocks depended on a mode of stylization and an idea of nature that were not obvious to the natives either. The fantastic, decorative or demoniac bestiary that the monks liked to reproduce did not refer to any local or even Iberian reality, and only acquired meaning when referenced to the Western *imaginaire.* The allegorical groupings—Justice and her sword and scales,[62] the chariot of Time or of Death[63]—belonged to a figurative procedure meant to help visualize a category or an idea, as Torquemada reminds us in his *Monarquía indiana.*[64] On the other hand, this was not the case for St. Francis's chariot of fire,[65] an image drawn this time from a

supernatural whose "reality" was not even in question for an educated Catholic. Beyond the obstacle of recognition, the native spectators still had to get their bearings within this maze by assigning what they saw either to the reality of the senses, the supernatural, the fantastic, the category of ornament or stylized figure. This was to suppose that they implicitly possessed the "moral eye" the religious painting of the West privileged, an aptitude for identifying, under a concrete and trivial exterior, the spiritual meaning of the symbol.[66] One can see that traps accumulated around the Indian, whose *imaginaire* was suddenly confronted with the conquering grasp of the Western image.

On the walls of the Mexican convents, Western beings and things were ordered and took their meaning according to groupings and layouts that were not self-evident. The image of the frescos was, in many respects, a mise en scène close to that of the theater of evangelization the natives were discovering during these same years. The distribution of the characters in paintings of the Last Supper, the Crucifixion, or the Last Judgment expressed an economy, a traveling of scenic space and a theatricality that could only have disoriented the native spectator. The actions, the mimicry, the attitudes came from a repertoire unknown to the Americas; it needed to be explained, and it remains as hermetic to us sometimes as it was for the Indians. One cannot forget, after Baxandall's work, that the genuflections, St. John's open hand over Acolman's suffering of Jesus on the Cross, or Duns Scott's pointed index finger were in no way arbitrary, but were equivalent to precise contributions by the European designers and artists.[67] The sequences and the succession of situations unveiled a sense of causality and human liberty proper to Christianity that was clearly far from the complex mechanics that tended to make the native submit to games of divine forces and to the absolute control of the community.[68]

Visible and Invisible Spaces

These scenes unfolded within a space whose geometric construction is also worthy of study. The Italian image of the quattrocento was often symbolized by Alberti's Window, a cut-out portion of space analogous to that which one might see out of a window, and in principle following the same rules as the empirical universe.[69] It was this type of spatial perception that the openings of Actopan's stairway reflected back to the

onlooker seeing the trompe l'oeil walls through them. Truth be told, *perspectiva artificialis* and *perspectiva naturalis*—geometrically elaborate or not—were far from being present in all the images the Indians discovered. But when these techniques did appear, in very different forms indeed, they created new obstacles to the understanding of the image. The space of the native codices and frescos was bidimensional; the differences in scale did not translate an application of linear perspective, but very distinct modes of information hierarchization. It is true that perspective remained an empirical or poorly mastered practice long after the Conquest, and that at the beginning of the seventeenth century, in his musings on the image, the Franciscan Juan de Torquemada did not treat it as anything particularly special. On the pages of Peter of Ghent's *Doctrina* (1553), buildings were drawn from perspectives that defied the laws of the quattrocento; Christ's resurrection took place against a blank background, while as other engravings obeyed the principles of linear perspective.[70]

But realist illusion showed other aspects as well. Some frescos excelled at creating the impression of depth and relief: the cups, dishes, knife, and table top in the *Last Supper* of Epazoyucan were treated in a manner which, it seemed, hardly baffled the natives.[71] Trompe l'oeil was commonly used, and even deliberately promoted in Mexico, for it enabled one to obtain the equivalent of decorative sculpture at little cost. But ultimately its usefulness was restrained, or annulled: not only was the Indian not accustomed to "reading" these projections, but also, because he had no knowledge of Europe, he could hardly conceive of the shapes, motifs, architectonic effects—the caisson ceiling, for example—to which the procedure alluded and sought to suggest. Far from proposing substitutes to the eye, the trompe l'oeil risked being reduced, in the native gaze, to an additional decorative variation.

The European image was also a landscape. The rocky backgrounds or the forested heights onto which the false windows at Actopan opened illustrated the successful application of pictorial technique, as well as the rendition of a landscape captured by a recipe of Italo-Flemish heritage. The more or less finished sketch of a perspective, the art of the trompe l'oeil, the wall absorbed into the background all exposed the image's powers of illusion by distilling the magic of a "realism" in which the copy continuously competed with the model. Though the anachronistic term of "realism" might perhaps be doubly misleading: the West only cap-

tured the reality of the senses through codes and conventions as artificial as those of Mesoamerican painting, and for religious painting, this process remained constantly subordinated to the representation of the invisible and the divine, to the teaching of a superreality.

If an image devoted to reproducing the visible is to be capable of rendering the invisible, it must have recourse to conventions and markers that identify the nature of the painted space according to whether it is profane, terrestrial, celestial, or supernatural. This was quite enough to disconcert more than one native onlooker. And yet the Christian image constantly played within these registers, as the filmic and televised image today juxtaposes or mixes the live document with the reconstruction of events or fiction; even the modern spectator is sometimes incapable of identifying the origin of the visuals he receives. On one of the frescos of the stairs of Actopan, two kneeling Indians and an Augustine monk are worshipping a Crucifixion.[72] If the Christ represented on the cross was at first only a representation within a representation, an image within an image (the fresco), it was also an icon by its celestial referent, as opposed to the three characters venerating it.

Was it easier to make out the pure and simple figuration of the crucifixion, or the hierophany of Christ on a cross? Let us take the example of *St. Gregory's Mass:* the episode links the apparition of Christ with the stigmata, and instruments of the Passion with Pope Gregory the Great, who is portrayed leading the ceremony. On Dürer's engraving the position of the officiants, the presence of two angels surrounded by clouds, and the unusual posture of the Christ reveal that the participants are perceiving an apparition. One group of characters absorbed in their task marks a third space outside of the event and the miracle; it is out of the picture, as it were. On the native version at Cholula (illustration 8), it is very difficult to separate the world of men and that of the hierophany:[73] are we meant to see two levels, an inferior one for men, and a superior one for Christ? Or else must we contrast a first plane, that obeys natural laws, with a second supernatural one peopled with objects floating in the air, the instruments of the Passion? The Indians certainly had trouble distinguishing what was historical and event-related (the officiants) from what was epiphanic representation on this fresco; they had trouble differentiating the figuration of a materially present object (the chalice on the altar) from that of a "hierophanic" object (the nails of the Passion).

It was normal, however, for many levels of reality—one of which corre-

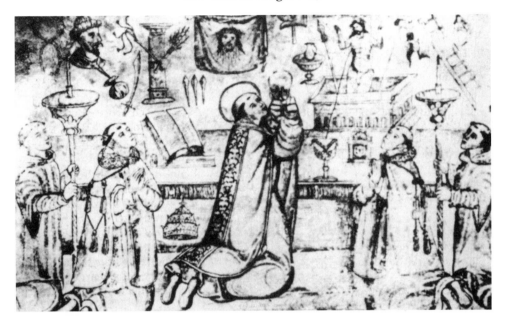

8. *St. Gregory's Mass,* sixteenth century. Cholula Convent, Mexico City.

sponded to the divine and to mystery—to coexist and interpenetrate within the same image. Of course there existed iconographic markers capable of separating hierophanic "reality" from the represented event: they were the same in sixteenth-century Flanders and Italy as in New Spain. The clouds surrounding the Virgin of Tlayacapan, in the middle of which God the Father appears on the engravings of the *Doctrina* in 1553;[74] the nimbus and crowns of stars; the thick clouds separating St. Cecilia's chambers from the celestial world of the musical angels; the angels defying gravity pirouetting above Simon Pereyns' Virgin of Forgiveness: these merely reworked constantly refined medieval recipes.[75] The irruption of the invaders' image thus challenged many things. By upsetting traditional space-time it foreshadowed other invasions that would perturb the visual habits of these peoples over and over again. From Cortés' and Peter of Ghent's image to today's, Western techniques would continue to influence the natives' *imaginaire.*

One might suppose that under these conditions the Indians' access to the image remained quite limited. No doubt the times and social milieu should be taken into account, since former generations had not reacted as did the adolescents who had been raised in the convents amidst Chris-

tian images. But it was the native artists working under the monks'
orders, and who were sometimes the overseers for the frescos, who first
had to conquer or overcome the obstacles that Western representation
put in their way. Certain factors played in their favor by easing the pas-
sage from one universe to another. The European chromatic palette—
and therefore Western color symbolism—was more often and easily
neglected since the models the monks and the Indians used were en-
graved monochrome works. The proliferation of decorative motifs fram-
ing the convent frescos lent itself to repetitive copying and to mechanical
tracing without much prior interpretation.

But it is mostly in the variety and extreme disparity of the European
models where one must look for the breaches enabling the native artists
to penetrate this new visual order. The absence of background in certain
engravings of European origin[76] might have built a bridge between the
two visual universes. The juxtaposition of elements, scenes, and charac-
ters in Acolman's *Thebaid* hardly takes the laws of perspective into ac-
count, even if they are spread over a mountainous landscape clearly
defined by a distinct crest line.[77] The plurality of representations of a
same space, and their synoptic accounts—so characteristic of the ancient
codices—are also present in the Huejotzingo frescos that depict St.
Francis receiving the stigmata, and further on, preaching to the ani-
mals.[78] The range of Christian symbols could thus easily be decrypted
and reused, since the principle did contain pre-Hispanic echoes: the Hue-
jotzingo Virgin appears surrounded by emblematic objects proclaiming
her virtues—the tower, the fountain, the town, the star (*Stella Maris*)[79]—
which act like ideograms; it is the same in the case of the symbols of the
Passion on the Cholula *St. Gregory's Mass*[80] or with animals representing
the three evangelists. Pre-Hispanic glyphs exploited a stereotyping remi-
niscent of decorative elements that, on Christian frescos, metonymically
designate landscape components: a tree trunk, a hill (the Sinai moun-
tain). The play of scale, measuring the height of figures by their hier-
archical importance and not their position in space, has native equiv-
alents: Joan Ortiz's Virgin, a giant at whose feet are gathered the praying
faithful, gives us a European example.[81] The bridges were thus diverse
enough to permit a partial reception of the image, even if it was riddled
with misunderstandings or did block out the essential.

If the image faced so many pitfalls, it was because it was the manifesta-
tion of a structure that was larger than it in every way: it was the expres-

sion of a visual order, and even more of an *imaginaire* whose conscious and unconscious assimilation was synonymous with Westernization. One can understand the importance of what was at stake, and constantly went further than the lessons of catachesis and the consciousness of the protagonists. This was not only about the discovery of a completely new iconographic repertoire but about the imposition of what the West meant by person, divine, nature, causality, space, and history.[82] In fact, other grids operate under stylistic and perceptual grids, thus composing a conceptual and emotional framework that unconsciously organizes all the categories of our relationship to the real. The monks' diffusion of the image fit perfectly into their project of making the Indian into a new man, even if the mendicant orders had not fully discovered every use of the instrument they wielded. It goes without saying under these conditions that the monks' commentary could not use up the substance of the image, and that the abundance of cultural and theological references, the depth of the memory the image brought into play and required made it into a fount of information, an instrument of apprenticeship and secondarily a source of illusion and fascination. The image of the frescos was an image under control, exacting and difficult. But it was not the only one that the monks placed before the eyes of their neophytes.

The Spectacle-Image

Very early on, the animated image extended and developed the potential of the fixed image, thus completing the implementation of the Western plan. After having participated in the first Christian processions organized on the continent, the Indians discovered the spectacle-image during the 1530s, and with it, what the evangelizers had judged important to keep (or were able to keep) from Iberian dramaturgy of the Middle Ages, whether texts, "scenarios," or theatrical techniques.[83]

It was probably toward 1533 that the *Last Judgment*[84] was played in Tlatelolco, at the gates of Mexico. After this "premiere" there was a rash of new plays presented in the capital and the center of the country, in Cuernavaca, Cholula, and mostly in Tlaxcala, before enthusiastic local crowds. With *The Conquest of Rhodes* performed in Mexico, with *The Drama of Adam and Eve, The Conquest of Jerusalem, The Temptation of the Lord, The Preaching of St. Francis,* and *Abraham's Sacrifice* played in Tlaxcala, the year 1539 seems to have marked the pinnacle of this astounding,

mostly Franciscan enterprise,[85] explicitly meant to put down Christian roots and to weed out local beliefs and practices. It is thus that while offering an extraordinary illustration of the itinerary of the sinner and of Christian eschatology, the Tlatelolco *Last Judgment* engaged in an official attack on native polygamy, which the Church was having great difficulties eradicating. In the same vein but on a more modest scale, far from the grand showy imagery of the country's cities, the Franciscan Juan de Ribas played on memory and the visual: "He made the Indians enact the mysteries of our holy faith and the lives of the saints on their own feast-days, so that they could better understand them and put them in memory, because they are people whose capacity and talents are so limited."[86]

These works exploited the Western image as did frescos, painting, and engraving. They developed a visual translation of the sermons, thus making them more accessible. The image and theatrical representation were nonetheless still temporary auxiliaries, tightly subordinated to the teaching of the catechism to the Indians. This was, certainly, what all those who were bent on ending this experiment and forbidding native theater in all its forms fought to point out at the end of the seventeenth century.

The Pre-Hispanic Tradition

Pre-Hispanic precedents have often been invoked to explain the success of the undertaking: the Indians had a "theatrical tradition" which, initially, might have resonated with the Franciscans' plays.[87] Matters are probably a bit less simple. It is known that the pre-Cortesian societies organized "spectacular" rituals and magnificent productions that took place at regular and close intervals. One almost gets the feeling that the pre-Hispanic cities spent much of their time preparing, then celebrating, ceremonies that followed each other at the rhythm of the calendar cycles. For the ecclesiastical chroniclers, carried away by their clerical culture and their Renaissance, then Baroque sensitivity, describing the native ceremonies as rites and spectacles using the categories and references they had, nothing was more natural—and of course more misleading. Can one, without any debate, compare sacrifices and dances to edifying spectacles? Or even make the platforms that abut archeological sites into "theaters," just because Cortés or the Dominican Diego Durán used this term in their descriptions?[88] But it is equally perilous to take as a given the words of the Dominican when he explains that some Indians "played"

gods or things,[89] nor can one file the makeup, masks, and ornaments that adorned the servants under the props category.[90] Moreover, nothing indicates that the evangelizers' idea of putting on a play was the same as our own. Is there not in this respect, once again, a laziness of our own gaze, a rigidity of our categories, and a distortion of the facts?

The prowess of the native "entertainers," who drew little figures from their bags, making them sing and dance and displaying them to the spectators, is more derivative of magic than of a theatrical production.[91] Without a doubt Diego Durán was describing some sort of farce that caused the public to laugh. But, he added with some insight, "this was not produced without mystery," since it was part of the worship of Quetzalcoatl in his role as "advocate against pustules, lazy eyes, head colds and coughs."[92] The dialogues were in effect interspersed with supplications for healing addressed to the god Quetzalcoatl, and the sufferers went to the temple with many offerings and prayers.[93] This was no doubt a therapeutic ritual, and not a simple comedic "entremets."[94] But the question is even more complex. It reopens the very notion of representation. Was there truly a performance with actors? Can one speak of roles and characters? Were there Indians who portrayed them, as we understand the process? These vanished societies have the immense merit of ceaselessly bringing into question the heritage of clichés that fills our world.

The dance of Xochiquetzal, goddess of flowers, with its artificial trees, its children disguised as birds and butterflies adorned with multicolor feathers, offered all the attractions of a sumptuous spectacle, but its status as performance was only an appearance. Through Xochiquetzal and the gods, the cosmos and its acting forces became manifest and were made present, immediate and palpable; they were presented, and not "represented," to the spectators and the celebrants. This was a ritual of appearance, a sort of hierophany, and not a trompe l'oeil spectacle given for the pleasure of the eye and the edification of the crowds.[95]

The existence of a Mayan theater raises fewer problems perhaps.[96] It would be difficult, this time, to make Mayan farces out of rituals that the evangelizers understood only poorly. One hypothesis therefore comes to mind: the Mayans had developed a glyphic writing with tendencies toward phoneticism—that is, the reproduction of speech—and they made it into a more autonomous mode of expression than the existing systems on the Central Mexican highlands, where grapheme and painting were

mixed on the pictographic codices. One may then ask oneself whether the Mayans—more sensitive to the dichotomy between the signifier and the signified?—had an understanding of plastic arts expression based on a register that was more illustrated than pictographic, and therefore less removed from that of the Spanish. If one admits that the relationships between image and writing, between writing and speech—indeed, the very notion of image and writing—weigh on the manner in which a society considers the question of representation, it cannot be discounted that the Mayans might have had a tendency to associate representation and reproduction, and that they might have cultivated a theatrical practice more open to the distinction between the referent and its image, between the model and its stage representation.[97] This would be in some manner a sort of "theatrical expression" nearing that of the medieval West and the evangelizers.

Celestial Worlds, Worlds of Elsewhere

Despite these gaps, evangelical theater, adapting religious dramaturgy for the Indian language at the end of the Middle Ages, was quite successful. The Dominican Las Casas estimated, with some exaggeration, that about eighty thousand people participated in the feast and attended the play of the Ascension in Tlaxcala.[98] It is not our goal here to write a study, as others have, on the history of this theater, but rather to encapsulate specifically what it brought to the domain of the image. The spectacle-image shared the characteristics of the fresco and of painting. It developed a new vocabulary and syntax for the natives. This vocabulary comprised not only characters never seen before, taken from sacred history and the hagiographic tradition, but also figurative elements that were bound to surprise them, such as the clouds of medieval scenography, so useful for indicating a celestial world and concretizing the ascension or the landing on earth of the saints. In *Las Animas y los albaceas,* the natives contemplated skies opening and closing under their eyes.[99] These had nothing in common with the skies of the Nahua. The latter were shaped in layers and peopled with divinities and forces spread over thirteen levels, under which piled up the nine strata of the infraworld; continuous exchanges kept this composite in touch with the earth.[100] If the exterior of the Franciscan sky was reminiscent of the Nahua heavens, it remained none-

theless exclusively the dwelling place of God and the chosen souls of the saints, and was radically opposed to earth and to Hell. This rigorous distribution was enough to disconcert native crowds used to a far more fluid circulation among the multiple levels composing their cosmos; the manner in which the Franciscans stuck their sky, by conventional representation, on the peak of a roof might also have intrigued them.

Furthermore, the Indians were encouraged to adopt the style in which the Spanish saw objects and protagonists that originated in faraway lands. They had to assimilate stereotypes and clichés referring to past and more or less mythical worlds. The *Conquests of Jerusalem* or *Rhodes* prompted true "superproductions" which left traces in the natives' imagination for a long time.[101]

For the production of *The Conquest of Jerusalem,* a citadel with five towers meant to represent the Blessed City had been built in the center of the city of Tlaxcala. The emperor Charles the Fifth had established himself facing Jerusalem, toward the East, while to the right of the city one could see the camp of the Spanish army. A procession led the Holy Communion onto the grounds of the show. It was composed of Indians disguised as the Pope, cardinals, and bishops. Among the squadrons making up the Spanish army one could recognize the men of Castile and León and the people of the Captain General Don Antonio Pimentel, count of Benavente; then came the troops from Toledo, from Aragon and Galicia, the contingents from Granada, the Basque Country, and Navarre. In the background, so that none might be forgotten, stood the Germans, the Italians, and the soldiers of Rome. Of course all were played by Tlaxcalan Indians. Inside Jerusalem, the Sultan and the Moors—again Tlaxcala natives—valiantly awaited the assault of the "Spanish" and Mexican troops. All of Europe, joined by the armies of Mexico, Tlaxcala, Huasteca, and Misteca, was ready to crush the eternal enemy in a profusion of speeches, ambassadors, and confrontations. And this, less than twenty years after the conquest of Mexico! This was exotism "squared"—the Orient according to the Spanish as revisited by the Indians—where the native *imaginaire* clung to the memory of the West and Iberian fantasies. This astonishing superimposition of gazes onto a past event is perhaps comparable to the idea we hold of faraway cinema, from India and Japan for example, when it refers to its own history and mythology. Each time, the mixing of temporal registers and the crushing

of cultural references produces an irradiated, composite, and fragmented memory that the spectator integrates with more or less success into his or her own life experience.

How these numerous medieval conventions were perceived raised other problems. For example, how was one to interpret those conventions organizing, distributing, and articulating scenic space, that displayed an unknown—and fantastic, in any case—geography, such as those inscriptions placed near the four springs representing the semi-mythical rivers flowing from Paradise?[102] Finally, the syntax of these spectacle-images was made up of scenic games and a theatrical progression designed to lead the native spectator to an understanding of the evangelical message. Here too its medieval heritage weighed heavily, with all that it left to the imagination of the Western spectator, and also with its understood game of criteria and rules governing the faithfulness and the verisimilitude of the production. But the success of the theater was not only dependent on how intelligible it was.

Informative Special Effects

The spectacle-image carried emotion; it was designed and produced to surprise, to make the spectator cry, and to scare, such as that Hell that caught on fire and carried away demons and the damned in its flames, or the savage beast that appeared to St. Francis.[103] Emotion was supposed to overcome even those who were aware of the special effects employed to create the illusion. For the strength of the impact and the success of the edification were derived from the quality of the spectacle and the means used: Adam and Eve's expulsion from Paradise "was so well played that nobody saw it without crying great amounts."[104]

The spectacle-image thus counted on appearance, illusion, and trompe l'oeil. The native spectator saw protagonists feign fear, horror, and flight.[105] The image "counterfeited" and imitated things from nature ("*contrahacer a todo lo natural*") with scrupulous care. In the city of Tlaxcala, during productions—and perhaps based on the model of the *Roques* of Valencia[106]—they enthusiastically represented mountains "*muy al natural*": "This was a marvelous thing to see because there were many fruit or wild trees; others were in flower, there were boletes and mushrooms as well as the lichen that grows on the trees of the mountains and on the rocks; and one could even see old broken trees."[107] Cloths perfectly mim-

icked the skins of wild beasts; pots of terra-cotta, skins filled with red ochre (*almagro*) burst or broke so that blood might flow during the staged fights; natives "counterfeited" the Pope, bishops, cardinals; "very well mimicked" witches intervened in and troubled St. Francis's speech.[108] In Mexico, in 1539, during the staging of *The Conquest of Rhodes,* scenic elements took on quasi-Hollywood proportions: "There were castles and a wooden city. . . . There were great ships with their sails sailing across the plaza as if they were on the sea, though they were on land."[109] False ships on a false sea to simulate the fleet of crusaders making for the Greek island—in the same spot where twenty years earlier the Mexica had made the *altiplano* peoples tremble.

But if the artifice served to allow a faithful echo of reality, it fooled nobody. The clear-cut distinction between what was natural and what was artificial seems to have been one of the keys of the visual culture of the monks, and one of the fundamental drives behind their notion of the image. It is true that certain pre-Cortesian rituals also sometimes took place among "decors" that meticulously recreated the fauna and flora of the country at the price of a "realism" that later made the chroniclers marvel.[110] Which does not mean that the technical perfection of the native stage productions was meant to dissimulate their artificiality, nor that it purposefully fed deceitful illusions. It seems rather that, far from playing on these registers, indifferent to the split between the authentic and the artificial, to the dialogue between being and seeming, native "realism" was trying—for the length of a ritual and the space of a feast— to reach, release, and express the cosmic essence of things.

When it represented the world of the heavens and of Hell—even more so than a fixed image, because it was endowed with movement—the spectacle-image became special effects and machinery: in the tradition of medieval falconry, angels "seemed" to come down from the sky in *The Annunciation of Our Lady* or *The Temptation of the Lord;* saints (St. John, St. Hippolytus, St. Michael) appeared next to Christians fighting against the infidels.[111] Fiction was staged in order to suggest "the real," in order visually to translate the supreme "reality" of the divine. Ascensional machines led Our Lady to the sky on a cloud, others were charged with making the Holy Spirit descend, and the sky opened and closed. Hell spewed flames, swallowed the damned amongst noises that announced the bursting through of demons, or the arrival of the Antichrist.[112]

Nonetheless, the special effects did not lead, could not lead, to trickery.

This would have been as vain as it was contrary to the rules of a healthy orthodoxy. The Franciscan image obtained its strength and specificity because it could act even on the soul of a spectator who already knew of its unnatural nature, its artificial mechanism. It was this ambivalence of the medium, held at the same time to be artificial yet scrupulously faithful to reality, that paradoxically could ensure its effectiveness and appropriateness.

To confuse, or to make one confuse, the presented image with the reality it invoked would amount to imitating the idolaters, and falling into the trap of idolatry. An anecdote recounted by Andrés de Tapia explains the reason for this. When the conquistadors accompanying Cortés became interested in the idols on the island of Cozumel, they discovered that one of them was hollow, and was secretly linked with a room where a priest held himself ready to climb into the statue "to make it speak."[113] This was a deceitful staging, and the conquerors had no trouble denouncing the fraud their cleverness had immediately discovered. A similar episode had accompanied the discovery of the zemis on the island of Santo Domingo. For Columbus and the Church, the natives who were misled by these speaking statues were committing the crime of idolatry, while as the local priests and caciques were despicable scoundrels and unscrupulous manipulators. This Voltairian-sounding criticism neglected the essential, to wit, that in both cases this was an autochthonous method for manifesting the presence of the "divine," and not a shameless manipulation of its representation. This attitude allows us to understand why the Franciscans refused to let Christianity have recourse to trickery, and why they practiced a deontology of edifying special effects. The baroque Church would display fewer scruples.

The Native Actor and Public

There remains the actor, this living image moving across the stage, and who was an Indian. Whether the image of a saint, a Virgin, or a demon, what did the actor of these dramas represent to the eyes of the native crowds, and to his own eyes? It is obvious, at least to us, that a theatrical representation supposes a distance, implies a radical difference in nature between the character and its interpreter. A double distance even: in *The Conquest of Jerusalem* played in Tlaxcala in 1539, the role of the sultan was held by an Indian appearing under the guise of Hernán Cortés, while the

chief of troops of New Spain represented the viceroy of the times, Antonio de Mendoza.[114] It is not easy to understand the reason behind this doubling of representation which superimposed, over the tale of the Crusade, the reality of a few of the great names of the Conquest (Pedro de Alvarado), of Spain (Charles the Fifth, Antonio Pimentel, count of Benavente), and of New Spain.[115] It should be noted that the Tlaxcala Franciscans tried in this manner to imitate the European fashion of allowing important figures to play the main characters of these plays. How much of this did the native actors understand? The young Indians the Franciscans had educated in their monasteries could memorize their speeches, and recite them quite well. Nothing about these first actors, who became familiar with theater as quickly as they did with reading, writing, and drawing, and even sometimes Latin, can astonish us. Later, it was usually the native cantors who played the dramas produced by the monks; the latter had educated them in their monasteries by giving them quite honorable spiritual and musical instruction. Filling the religious functions in the parishes not requiring the presence of a priest, often taken from the former nobility, they were thus in principle in a better position than anyone else to understand what the Franciscans required: to transmit a message faithfully, to incarnate a character in such a way as to move and impress the public, without, in so doing, mixing their personality with the character to be played.

The reaction of the native masses and spectators raises other questions, since it was not always possible to distinguish the actor from the public. Native participation sometimes acquired multiple dimensions. Let us consider the eight hundred natives playing, in 1539 in Mexico City, the gigantic *Last Judgment* by the Franciscan Olmos: "Each had his function and played and said the words that he needed to, and nobody bothered anybody else."[116] It is likely that these Indians each had to play their own roles, and that by consequence they barely felt the distance we referred to. To which one can add that, always concerned with effectiveness, the Franciscan productions could mix real elements with their drama. During the course of the show the monks baptized Indians, and their parents used the occasion to feast joyously. This was the case during the drama of the sacramental *auto* dedicated to the nativity of St. John the Baptist.[117]

A few of these initiatives could nonetheless have confused neophyte minds. The production of the baptism of St. John the Baptist was represented by the real baptism of an Indian; the celebrated ritual lending its

image to the production of this long-ago event. Spectacle, rite, and myth were here superimposed to such a degree that one might have thought oneself close to the pre-Hispanic celebrations. But as real as his baptism was, not once was the child to be considered some kind of *ixiptla* for St. John the Baptist. The Indians were meant to discover, through theater, the image of a past event, irrevocably accomplished, representable but not repeatable. Everything was acted; there was nothing but image, even if, should this happen, authentic elements were used to conjure up a reality that was just as authentic. As the priest proclaimed at the conclusion of *The Last Judgment:* "Here, you have seen this terrible, horrible thing. Well, everything is true as you see it, for thus is it written in the sacred books. Look at yourself in your own mirror!"[118]

The spectacle-image was thus meant to be a mirror-image, a true mirror, not by any presence it would instill, but by the sacred writing of the Scriptures which it reflected. The spectacle-image was an example (*neixcuitilli* in Nahuatl[119]), an illustration "offered by God" from which all must profit as they might. And yet the monks' linguistic choices created a most unexpected trap, for they contradicted the meaning of their approach: by translating "to produce" and "actor" in their sermons and in their explanations by Nahuatl terms constructed on the root *ixiptla,* the Franciscans sent the Indians back through a pre-Hispanic universe and opened the field to any and all rapprochements and confusions. In a field as subtle as that of representation, this was more than a faux pas.[120]

It remains—and no doubt because of this very reason—that the undertaking met the favor of the native public. Almost a century after the first production of *The Last Judgment* in Tlatelolco in 1533, the Indian chronicler Chimalpahin Cuauhtlehuanitzin could not help but note "the great astonishment and stupefaction" the Mexicans had experienced from it. The native informants collaborating with the chronicler Sahagún had only one word to qualify this show: *tlamauizolli* ("miraculous, marvelous," in Nahuatl[121]). The surprise of educated natives undeniably reflected the fresh strength of the message, the visual newness of the staging, and its truly exceptional proportions. This came perhaps also from its very qualities as a show, as a "mise en image" of the Christian myth. Christian "representation" was from then on substituted for "presentation" and the ritual actualization of pre-Cortesian times. The nobility discovered and experienced plays as they had discovered Western Christianity, writing, painting, and music.

Is this to say that the whole of the public was united with their Christianized elite, that it had fully understood the Franciscan message, and that it was conscious of watching decors, machines, and most of all, actors, and not *ixiptla* of pre-Hispanic lineage? What we know of the heritage of native theater,[122] transformed and "enriched" by the Indian cantors and their successors, reminds us to maintain explicit reservations about this notion.

Memory-image, mirror-image, and spectacle-image: the monks revealed the essence of the Western image to the Mexican Indians. They also taught them how to reproduce, paint, and sculpt it. Idoloclasty had only been a prelude. The war of images had definitely entered its conquering and annexionist stages. The monks subordinated it to their ambitious plan to create a new man, in principle irrevocably torn from his pagan past and given a Christian body whose use was as carefully regulated as that of his *imaginaire*. The Christian images drawn from paintings, frescos, and theater were to stand in for the destroyed idols and the banished visions of dreams and worlds still open to the natives through the use of mushrooms and drugs.

The image unveiled its new body, whose visible flesh covered its invisible soul, to the Indian. Through the use of perspective, the image gave the Indian a spectator's external point of view, but a privileged one; his gaze and body fully participated in the contemplation the image had established.[123] He became a spectator ideally endowed with a "moral eye"; free will and faith would enable him to gain mastery over the true image in order to escape the trickery of the demon and the traps of idolatry. Turn about was fair play: while one half of Europe sank into Protestant heresy, Mexico offered the promise of a new Christendom from which many missionaries might have wanted to exclude the colonizers.

4

The Admirable Effects of the Baroque Image

During the sixteenth century, in a Mexico that was no longer that of the Conquest, the Church modified its politics toward images. At that time about ten thousand Spanish and perhaps as many mestizos and mulattos lived in Mexico City.[1] Both multicultural and European, a new urban society emerged that contrasted with an indigenous countryside controlled by the religious orders and decimated by epidemics; as in Western Europe today, this new society daily experienced an unprecedented *métissage*. Neither the Crown nor the Church was unaware of this. Thirty years after Peter of Ghent's arrival, the Church's change in policy followed political ends: the Crown's desire to tighten its grip over the Mexican clergy and to force the priests to submit to hierarchy, bishops, and tradition. It was toward these ends that in 1551 Charles the Fifth appointed a traditionalist theologian, the Dominican Alonso de Montufar, as the head of the Mexican Church. Thus was the break with the "radical, utopian" evangelism of the first missionaries consummated.[2]

Montufar of Granada

Montufar was an enemy of the Erasmian penchants that his predecessor, Juan de Zumárraga, and other Franciscans with him, might have cultivated. Having arrived in New Spain in 1554, the second bishop of Mexico was resolved to end any reformist impulses by applying Catholic law to the letter. But he was also inclined to preserve traditional ritual and to respect certain forms of popular Iberian worship. It was in this spirit that the Council of the Indies had ordered the prelate's immediate departure for America: the evangelization of the Indians and the organization of the parishes required the presence of an undisputed authority figure, which could only be that of the archbishop of Mexico. In a revealing gesture, the King had given him the mission of overseeing the con-

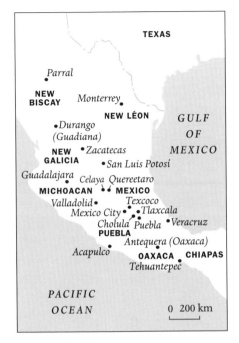

TEXAS

•Parral

NEW
BISCAY Monterrey•

NEW LÉON GULF

•Durango OF
(Guadiana)
 MEXICO
NEW •Zacatecas
GALICIA •San Luis Potosí

Guadalajara Celaya Quereetaro
MICHOACAN •• MEXICO
Valladolid• Texcoco
 Mexico City• •Tlaxcala
 Cholula Puebla •Veracruz
 PUEBLA
 Antequera (Oaxaca)
Acapulco•
 OAXACA CHIAPAS
 Tehuantepec

PACIFIC

OCEAN 0 200 km

Colonial Mexico, or New Spain
in the Seventeenth Century

struction of the new cathedral.[3] The baroque age in America was to become the era of cathedrals.

Confrontation between the archbishop and the regulars became a titanic task, since the latter's positions had seemed so secure. For the next few decades they would still have major trump cards at their disposal: a remarkable knowledge of the terrain and its cultures, exceptional ties with the native population, the obvious lack of secular priests ready to take over, and also—something even the Crown had to heed as well—the ability to handle their cumbersome yet indispensable allies with care. The confrontations occurring within the Catholic clergy amounted to more than questions of power and personality. They also included cultural and religious choices of crucial import. Montufar's interventions began the era of the Tridentine Church and Creole Mexico. In order to rip the Indians from the hands of the priests and to win them over to the secular clergy, the archbishop would step away from the tabula rasa politics practiced by the missionaries, who had counted on a perfectly clean break with the past.

Originally from Loja in the province of Granada, the son of conquerors inhabiting a Moorish kingdom that had fallen in 1492, Montufar was

raised close to the Moorish world in a context that could be considered colonial.[4] Along the way from Loja to Granada—where he became a qualificator for the Holy Office, and where he taught—he was in a position to experience cultural differences, the establishing of Christianity on Muslim territory, and the integration of the conquered.[5] In this respect one will remember that the kingdom of Granada existed until 1566 in a state of cultural remission, having essentially kept its "customs" and benefiting from the laxity of the Tribunal of the Inquisition.[6] Montufar of Granada thus did have reason to temper the intransigence of the monks, who strove to banish any form of reconciliation between ancient paganism and the neophytes' Christianity. A more tortuous policy developed, repudiated by the Franciscans, a policy that threw itself into a high risk area since it counted on taking over an idolatrous sensitivity and exploiting a cult that had flourished during the 1550s, that of the image: "Nowadays they make images of Our Lady and saints that are worshipped everywhere."[7]

This was of course a strictly limited tactic by orthodoxy guardians, but it was sufficient, in the Indians' eyes, to cushion their accession to Christianity. The word "transition" would in any case be preferable to "opening," or "compromise"; a transition that not only would ease the passage from the past to the present, but that would also favor exchanges between the diverse populations of the colony: Spanish, blacks, mestizos, Indians, all of whom were encouraged to embrace the same beliefs and practices. Montufar displayed a social vision, a political goal, and a religious ambition that explain fairly well what role he seems to have played in the dissemination of the worship of Our Lady of Guadalupe.

The Case of the Guadalupe Virgin

The beginnings of the cult are not well known. The Mexican historian E. O'Gorman has recreated, in a fairly convincing manner, the meanders of a story said to have delighted Leonardo Sciascia.[8] In the beginning there was a hermitage built in the early 1550s by the first evangelizers on Tepeyac Hill, on the site of a pre-Hispanic sanctuary about ten kilometers north of Mexico City. This was a chapel that the Indians visited, continuing an ancestral tradition; in the 1550s it became a place for Spanish devotion to a very recent image. The Creole society that was just then beginning to grow went to the sanctuary on pilgrimage (romería) to

worship a painted Virgin, Our Lady of Guadalupe. A Franciscan announced the new cult from the pulpit on 8 September 1556. His sermon caused a scandal.

The Tepeyac Hill, to tell the truth, had long been attracting the natives: a sanctuary devoted to the Mother of Gods, Toci ("Our Mother"), had stood there before the Conquest, and the chthonic divinity was given offerings and sacrifices. Relentlessly substituting Christianity for paganism everywhere, Franciscans had founded a chapel devoted to the Lady in the spot without paying this modest sanctuary much attention as they administered it from afar. It is clear that this superposition of worship spaces, which was often the case in Mexico as in old Europe when paganism shifted to Christianity, was thus an opening for all sorts of more or less fortuitous rapprochements.

Everything seems to indicate that the primitive image the natives worshipped—if indeed it ever existed—was not the image we know today. The current representation replaced an effigy of secondary importance, obscure enough not to catch anybody's attention, too mediocre to resist the vagaries of time. Though it is not simple to recreate the circumstances behind the apparition of the image of the Guadalupe Virgin, it is probable that the intervention of the archbishop Montufar was decisive. The archbishop was said to have ordered a work inspired by a European model from a native painter, Marcos; it was painted on a native-made backing that Montufar then discreetly had put in the place of (or next to) the primitive image. The substitution took place in 1555[9] and was apparently harmless, but it had significant consequences. Its surreptitious installation gave it an aura of mystery, and why not, of the miraculous, since the prelate accredited the associated prodigies to the image, and attributed the origins of the cult to Christ himself.[10] And there was some success: many Spanish came on *romería* to Tepeyac Hill. At the same time (in 1559), under different skies, in order to fight against Anglican iconoclasm and allow the worship of images to regain a bit of its luster, a Dublin monk tried to exploit the miracle of a bleeding Christ. The prodigy caused quite a disturbance, but the authorities then discovered the subterfuge and the event was attributed to superstition.[11] In Mexico, Montufar was in quite a different position, one of strength.

Even better: the natives, who seemed not to share the Spaniards' enthusiasm quite yet ("they were not staunch believers of Our Lady"[12]), were able to interpret the image's introduction in hierophanic terms.

The writings of educated Indians of the second half of the sixteenth and the beginning of the seventeenth centuries reflect this in their dating, which hesitates between 1555 and 1556. Juan Bautista's *Journal* gives the year as 1555: "St. Mary of Guadalupe appeared on the Tepeyac." *The Annals of Mexico* record that in the "Year 1556, the Lady descended on the Tepeyac; at the same time, the star smoked." Chimalpahin confirms: "1556: Our beloved Mother St. Mary of Guadalupe appeared on the Tepeyac."[13] If we look closely, in fact, do we not find that the 1555 apparition was equivalent to the production of an *ixiptla,* in the ancient sense, in the sense that the manifestation of a divine presence devolved from the manufacture and presentation of the religious object? Chimalpahin recorded, in the same terms, the "apparition" of the crucifix of Totolapan, although this was obviously an object, a representation, and not Christ in the flesh.[14] It is equally revealing that the chronicles noted the event of 1555 as a single apparition of the Virgin, mistaking model and copy, while the official legend as it was spread during the seventeenth century—the *Nican Mopohua*—associated two kinds of successive "apparitions": those of the Virgin on the Tepeyac Hill, then that of the miraculous image.

This ancestral place of worship was coupled from then on with a miraculous image and the presence of a divine *ixiptla* that the chroniclers hurriedly recorded. The prelate could thus boast of a double success: the Counter-Reformation diffusion of the Marian cult, and its territorialization, by linking it securely to the former sanctuary of Toci-Tonantzin. Montufar was both playing on the "exemplar"[15] value of Spanish reverence, on its merit as a training device among the natives, and on its autochthonous antecedents as represented by the Tepeyac cult: "One can discern, underlying Montufar's perseverance . . . , the goal of using this new image to refresh the goddess Tonantzin's ancient cult of substitution."[16] The name of the divinity, "Our Mother," was perfectly suited to the Christian Virgin. The Indians kept up their practice of going to the Tepeyac. The Spanish were attracted by the new image Montufar had placed there, and by the miracles it performed; in order better to appropriate this devotion, they designated her as Our Lady of Guadalupe. In turn, the Indian masses followed the European example and adopted the Spanish name without, however, giving up the name Tonantzin. Each group, either simultaneously or by turns, would appropriate the devotion for themselves, so great was the fascination of the image and of the prodigies attributed to it.

What had the prelate intended? Satisfying political aims by short-circuiting the Franciscan influence, and by intervening in the new Christianity among the natives? This is quite plausible. Indeed, he attempted to seduce the Indians by proposing a form of Christianity that was more or less compatible with the autochthonous traditions, or at least capable of inscribing itself less brutally into the wake of ancient practices. And he wanted to attract them in order to remove them from the grip of their Franciscan pastors: the prelate exhorted his entire flock—including Indians—to worship the Guadalupe Virgin, whose miraculous virtues he exalted without trying to attribute supernatural origins to the image.[17] That task would become the masterpiece and the triumph of the Mexican seventeenth century.

The Satanic Invention

The initiative largely appears to have succeeded, but it did not go unnoticed. It unleashed the opposition of the Franciscan dignitaries in New Spain, who seized this opportunity to display, publicly and visibly, their own conception of images, and what use they thought should be made of them. All this took place as if the war of images were shifting partly to reach even the interior of the catholic Church. In 1556, during that sermon that caused such a sensation, the order's provincial, Francisco de Bustamante, tackled the worshipping of images and attacked the archbishop's procedures: "And to come now and tell the naturals that an image, painted yesterday by an Indian called Marcos, is making miracles, is to sow a great confusion."[18] Twenty years later the chronicler Sahagún, who knew the native world quite well, also acidly denounced the possibility for confusion with the Nahua name for the Virgin (*Tonantzin,* "Our Lady," the same name as the one given to the ancient goddess), and wondered what meaning should be given to the crowds of Indians on pilgrimage: "It seems it is a Satanic invention designed to hide idolatry." One will notice that Sahagún's imprecations relate here to the link maintaining a pagan relationship to a place of worship—"They come from faraway [to visit] this Tonantzin, as they used to"[19]—and to the preservation of an ancient word. The image itself was not perceived as the instrument of "dissimulation" or syncretism. In order to shore up his criticism, the Franciscan chronicler spoke of the suspect cults of St. Anne (in Tlaxcala) and St. John (in Tianquizmanalco), where the same phenomenon

seemed to have happened: such cults appeared to conceal ancestral practices of pilgrimage and prayers centered around divinities that had been given a Christian-sounding name. Montufar's approach in these matters was poles apart from Sahagún's. It played with the superposition of places and the likening of names, sought roots in the land and in memories, and counted on a progressive confusion and substitution in people's minds without worrying about such possible slippage as Sahagún was to describe and condemn twenty years later.

Toward a New Politics of the Image

Montufar's Marian strategy took its place within the slow unfolding of a new politics of the image; the 1556 case of the Guadalupe Virgin was only one of its forerunners. This approach attempted to extract maximum benefit from the use of the image while still trying to maintain control over it. At least three institutions were involved with images from the 1550s onward: the viceroy, the painters, and the Church; more in fact if one distinguishes within the Church itself the archbishop, the Franciscans, and the council.

In 1552 the viceroy don Luis de Velasco ordered that from then on the native painters be tested by examination. In 1555 the first Mexican council, led by Montufar, spoke openly of its worries. It decided to regulate the manufacture of images to cut off what it called the "painters' abuse, and the indecency of images": "In this area more than in others one must take measures, for without knowing how to paint well, nor understanding what they do, any Indian who wants to, without distinction, can paint images, which results in insults to our Holy faith."[20] One glimpses therein the barely contained accusations leveled at the work of the missionaries, who for thirty years had undertaken to evangelize the Indians and teach them painting. It is rather revealing that Montufar of Granada saw in Peter of Ghent, the man from the North, his immediate rival for power.[21] At that time, the Flemish Franciscan exerted a considerable influence over the Indians from the capital and remained one of the foremost instigators of the introduction of the European image into New Spain. The council denounced, in no particular order, the "ruling anarchy," the bad quality of the paintings, the "indecency" of their content, and the superstitions (*abusiones*) derived from them. Judging this situation alarming, they proposed draconian measures to correct it. Some

pertained to the control of creation and distribution. Others aimed systematically at expurgating existing works. The Church intended to supervise the manufacture and commerce of images and their merchant value. All frescoes, retables, and paintings in the sanctuaries of New Spain were to be "visited" in order to confer upon them an appearance that conformed more closely with orthodoxy, or to eliminate downright "apocryphal or indecent"[22] works. Along the same lines, "superfluous" sanctuaries were fated to disappear under the demolishers' pickax.

This ambitious policy reveals, once again, the position Mexico occupied in the evolution of the Catholic world. The decrees of the first Mexican council of 1555 prefigured the worries of the Council of Trent, since the Tridentine decree on the legitimate use of images was published in 1563.[23] The Mexican council, however, stressed form, content, and production of the image more so than the conditions surrounding its use. Under those circumstances the initiatives of the archbishop Montufar served as an example: by encouraging the cult of Our Lady of Tepeyac, the Church sponsored, imposed, and distributed an image capable of capturing the devotion of the composite peoples of the colony.

It is true that the council's decisions raised protests. Two years after the 1555 council, European painters submitted the ordinances meant to govern the bulk of their occupation to the Crown.[24] From the viceroy they obtained the right to examine the paintings that "were made and that would be made." By 1585 they had again asked that the sale of images take place only inside churches, and that one avoid painting angels on beds or crosses, and St. Anthony figures in stairways or corners; and that neither satyrs nor animals be represented on retables. The painters proposed that they regulate the sale and resale of images not produced by them, so as to banish mistakes and defects in representation. The corporation was thus trying to exercise a right of "extended gaze" encompassing commercial, technical, and ideological concerns.[25]

As early as the mid-sixteenth century, the competencies of the Church and artists in the matters of production, marketing, or expertise overlapped each other and even clashed. Should the painter first refer to the Church before performing the touch-ups and corrections that the ecclesiastic authorities were trying to impose, or could he intervene himself? Were his ambitions merely restricted to the profane, or did he have at his disposal some authority over sacred figuration?

The setting up of the Inquisitorial Tribunal in 1571 was meant to clarify

matters and furnish the Church and the Crown with institutional means of overseeing, controlling, and punishing.[26] For two centuries, and until the end of colonial domination, the Holy Office took over the supervision of images and designated ecclesiastic members—the *calificadores* (qualificators)—whose task was to examine whatever representations passed through their hands, whether they be sacred or profane. These specialists were surrounded by experts who were variously titled "imagery overseer," "imagery examiner," or even "image expurgator." These men were recruited from the art world, such as Pedro López Florín, who was *maestro mayor*—that is to say, architect—of the cathedral in Puebla around 1629.[27] Very tight links, in fact, tied painters to the Inquisition: in 1643 the painter Sebastian López de Arteaga, one of the most brilliant artists of seventeenth-century Mexico, requested and obtained the title of Notary of the Holy Office.[28] Within the microcosm of the viceregal elite, circles were so tightly interlinked that everything led to making the baroque image the object of a consensus and a fairly coherent politics. But let us return to its origins.

The much-discussed flourishing of the Guadalupe Virgin's cult unfolded simultaneously within a divided Church and a society just beginning to care about the images it was producing. In the longer run, it also reflected the discreet beginnings of a different use of the image made possible by the success of ecclesiastical strategy, the growth of a circle of artists, and the rise of a Creole and mestizo population. The colonial baroque image spread by successive steps between 1550 and 1650. This was not the pure and simple application of some theoretical plan, but rather a manifold development that the sources only reveal in a partial and sporadic manner. The information in 1556 that Bustamante's "scandalous" sermon had triggered, the sparse allusions by the native chroniclers, and much later, Miguel Sánchez's book on the Virgin of Guadalupe (1648), to cite only the most striking sources, give us a few precious but incomplete markers. These indications, nonetheless, are enough to reveal the extreme complexity of a continuous creation that was never reduced to a simple, concrete translation of an aesthetic, political, and religious discourse, and that requires the ceaseless interweaving of the threads of art history and institutional history, of social history and cultural history. This explains the inevitable pointillism of our approach as it attempts to seize an object which by its very nature goes beyond the boundaries of discursive analysis and leaves few traces in the archives.

The Worship of Saints

Several of Alonso de Montufar's initiatives prepared the conditions for the emergence of the baroque image in Mexico. In this respect, the rivalry opposing him to the Franciscans reminds us of the battle "program designers" might wage. For both parties, everything hinges on the question of the representation of the invisible. Even so, it was not only a simple debate over form or style, but indeed about the definition, the functioning, and the proper use of the image: memory-image versus miracle-image, didactic image versus thaumaturgic image. Montufar and his successors would be the winners.

On the archbishopric's side, the undertaking was at first a prudent one. It would even seem that Montufar's partisans—that is to say, the defenders of the worship of the Guadalupe Virgin—had the same reasoning as their Franciscan adversaries: "It is neither the panel nor the painting, but the image of Our Lady that we revere and . . . the veneration [*reverencia*] addressed to the image does not stop there, but goes to what it represents and it is thus that [the Indians] are supposed to understand it."[29] Nobody was meant to confuse the copy and the "divinity" it represented.

The witnesses to the 1556 canonical inquiry displayed the same prudence, reducing the "miracles" attributed to the image to quite human signs of the spectacular favor incurred by Marian devotion. There was nothing surprising in this, since the 1556 inquiry was meant to clear the archbishop Montufar of suspicions that he had covered up or fomented an idolatrous devotion. The archbishop's intervention was also surrounded by verbal precautions aimed as much at appeasing Franciscan criticism as at stamping out the questionable and rash aspects of the undertaking. At that time one still had to measure one's words, and know how to minimize initiatives that might spark detrimental confrontations. This did not, however, keep the prelate from supporting beliefs and practices whose diffusion could only bolster his plans.

The more-than-complicit interest surrounding the worship of the Guadalupe Virgin and its image harkened back to the spirit of the first Mexican council's decisions. The assembly had encouraged the worship of saints, "patrons of the churches, cathedrals, and *pueblos*."[30] It was also the council which had designated St. Joseph as the patron saint of the

Mexican Church for his qualities as the traditional intercessor against "the storms, thunder, lightning and hail that torment this country."[31] The council, in the same fashion, had upheld the various dedications to the worship of the Virgin. Without turning these measures into the expression of an invasive and indiscriminate tendency toward veneration, let us assume that they were meant to facilitate the spread of a traditional Iberian piety, and, unnoticed, close the gap between Christianity and the native universe: the idol-saturated space made way for a new space peopled with saints and their images. Especially since Montufar's Church knew how to exploit the role of the image in popular devotions and secular piety. This was demonstrated by the spreading of the cult at Tepeyac, elevated to the rank of an "example" that was meant to garner the Indians' adherence: it was hoped they would invoke the Virgin's intercession following the model of the Spanish, "the people of the town," and "ladies and young women of quality."[32] This turned the Franciscan arguments inside out: they considered the image to be an object of "scandal" and civilian unrest. Having become a ferment of devotion and appeasement, the cult at Tepeyac became associated by its thurifers with a cleansing of mores, with the cessation of games and "illicit pleasures."[33]

Montufar's Tridentine Church had an aptitude for compromise that contrasted with the more radical attitude of the first missionaries. It is even possible that Montufar remembered the Grenadine experience and the attempts at integrating the Morisco populations, and that he retained from this a sensitivity to traditional popular forms, a familiarity with the hybrid; whereas his predecessor Zumárraga was highly distrustful of the "abuses" by the masses, as he was of all the profane and licentious festivities.[34] It makes no sense to attribute to Montufar the more or less deliberate, or even systematic, idea of diverting certain manifestations of native paganism. The prelate's goal was not to transform one culture into another, but to make the colony's populations more homogenous, to bring them together around Church-designated intercessors. He thus opened up to the natives the great European liturgies being performed in the cathedrals and diocese churches.

This pragmatism, breaking with Franciscan behavior and apparently fated to undermine their work, took place amidst strange silences. If the Indians were going to the Tepeyac to worship Tonantzin, how could the ecclesiastical authorities not have sought to know if this name referred to

the ancient goddess-mother, or the Christian Guadalupe Virgin? For the Franciscan Bernadino de Sahagún, or, much later, the Dominican Martín de León (1611), there was no doubt that "many among them [gave] her its former meaning."[35] Other cults prospering at that time were built on similar ambiguities, and were denounced by some but apparently tolerated by the hierarchy, who no doubt expected the natives finally to forget Toci, Tonan, or Tezcatlipoca and only worship St. Anne, the Virgin, and St. John. They based such calculations on a Tridentine religiosity that peaked during the baroque era, and on its powers of absorption.

Exploiting Miracles

The first evangelizers mistrusted the miraculous. They refused to take advantage of heavenly prodigies in order to establish the Christian faith: "The Redeemer no longer wants miracles to be made, because they are no longer necessary."[36] These positions betrayed the Erasmian influence that had undoubtedly marked the first Mexican Church and its leader, Juan de Zumárraga. Montufar, a bit hastily, had counted on a rancher's miraculous recovery to ensure the prestige of the Guadalupe Virgin's image; Franciscan voices were immediately raised against him for this, deploring the lack of serious examination of miracles: "They should have been verified and corroborated by numerous witnesses."[37] The Franciscans demanded without hesitation that those who broadcast the so-called miracles of the Virgin be punished. And they also denounced to the Inquisition, in 1583, the errors that the translation of the miraculous crucifix of Tololapan had sown among the Indians; but in this case perhaps it was more out of jealousy—since the cross belonged to the Augustines—than out of reticence to the miraculous.[38]

In the Guadalupe Virgin's case, a miracle was not the only show of the image's effectiveness. The miracle also stemmed from the image's aura of Christian *ixiptla;* it was born of the mystery that shrouded its origin, its manufacture, and its terrestrial appearance; it became more substantial as the native author of the image sank into forgetfulness. The times, however, still needed to lend themselves to making the miracle of the image a plausible one. The Tridentine Church contributed powerfully to this. It supported, by means of miracles, apparitions, dreams, and visions, an array of supernatural beliefs with which it wanted all of New Spain's faithful to interact and commune. Breaking with the hesitancies of the

first Franciscans, but efficiently aided by the Jesuits—come to its rescue in 1571—the Church fully and simultaneously exploited the resources of the image, the miracle, and the dream.[39]

Dozens of visionary experiences, framed, indexed, and disseminated by the Society of Jesus, familiarized the Indian and mestizo people with the Christian thereafter. Edifying visions were commented on and echoed in sermons that willingly made use of dramatization and collective role-plays. The relationship of vision and image was a close one. It rested on competing uses and dramatic affinities, but it also stemmed from the fact that the formal content of dreams and delirium referred in a striking measure to the pictorial and aesthetic canons of the second half of the sixteenth century. The dream spaces through which the native and mestizo visionaries traveled had their counterpart in mannerist painting of the times, and it was that same visual order, nourished by the same shapes and the same fantasies, that governed painting and subjective experience. Pictorial logic and fantasy logic followed parallel tracks for at least a century: the invisible became visible, and pictorial convention informed subjectivity. During the first half of the seventeenth century the painter Luis Juárez peopled his works with visionary blanks encircled by luminous clouds and angels lost in the brightness of divinity.[40] Saints in ecstasy witnessed the irruption of the supernatural into human space; they even modeled the manner in which to receive the image by their posture, in its fixity and tension.[41] Neither contemplation nor the visionary scene were able to escape from convention.

Even more intriguing, other rapprochements come to mind within the domain of image synthesis. The orthodox experience of visions and dreams, whether lived from the inside or reported by witnesses, was close to a process of "simulation" in the sense that the images personally encountered in this manner recreated themselves and reproduced, animated, and combined autonomously according to rules fixed by the Church. In this fashion, for the visionary, the symbolic and iconographic arrangements conceived and disseminated by the ecclesiastic institution acquired an independent existence, even if the Church jealously supervised putting the image into words or *relato,* giving them a quasi-stereotypical quality.[42]

But visionary production, or the subjective ability to evoke the surreal, was only one of the signs that the baroque image had been put into circulation; without a doubt the most striking one, if not the most spec-

tacular. It failed to describe fully either the multitudinous dimension of the phenomenon, or the means the Church had at its disposal to channel these states. The collective sharing of this experience constitutes a complex and decisive phenomenon for the historian. The direct entrance into the closed yet permeable world of the Christian supernatural of course presumed the instilling of Christian conceptions of space, time, and the person, as well as the assimilation of a series of properties potentially contained within these categories. The Indians were able to apprentice to all of this under the rule of the Franciscans and the religious orders. But during the second half of the sixteenth century they were also able to attend the implementation—and no longer merely its painted or theatrical representation—of the miracle through the thaumaturgical monks whose kind was then multiplying throughout New Spain and the baroque Mediterranean.[43] Were visionary experience and thaumaturgical prowess—another "visual event"—not two complementary forms of "simulation"? They lent inner life to symbolic configurations; they allowed the supernatural visual space that preaching, frescoes, paintings, or theater had marked out, opened up, and established to become a dynamic entity.

It was up to the peoples of Mexico, individually or by proxy, to go in turn through the mirror, to touch this Christian miraculous by recreating it, and to participate in a collective "simulation." This orchestrated production was a well-ordered handling of images, a programmed improvisation with Christian materials, and the display of an entirely invented model:[44] that of a formal and existential reality blending with the Christian thereafter. At this point a convenient instrument was offered to them: the miraculous image, an immediate, "snapshot" presence that synthesized and stabilized visionary memories, thaumaturgical capacities, and liturgical functions and that polarized the "special effects"—as long as the parameters and subtle laws of creation and reproduction the Church set forth were observed, which was far from always being the case.

Setting Aside Writing

If the image was essential to the success of this strategy, the same could not be said of books. In any case, they only affected a minority of the population, even if the native nobility had rapidly become familiar with the Latin alphabet. A technically dissatisfying and continuously suspi-

cious vector, the written word worried Montufar, while the Franciscans had insisted on spreading it. The 1555 council had already ordered that the sermons and catechisms the natives handled[45] were to be closely watched, and to limit their circulation. A strict control of books was established from then on. As in other lands of the Counter-Reformation, the image had to take precedence over text. In the name of the Episcopal Inquisition, Montufar undertook to deliver the first blow to the written word.

When the archbishop left office, the Tribunal of the Holy Office installed itself in its definitive form in Mexico City, and took over. This was the ideal instrument for eliminating dissidence. It is significant that the installation of a new politics of the image was accompanied by an inquisitorial campaign that obstinately set itself against pious literature in the native tongue. During the 1570s all written literature was to be confiscated from the Indians. The printed versions and the Nahuatl translations of Ecclesiastes, Proverbs, the *Hours of the Virgin,* or the Scriptures underwent the same fate.[46] How ironic that it is in Ecclesiastes that the strongest condemnation of the worship of images occurs! It is as if books and translations, which the first Franciscans had favored for Christianization, had been displaced by the image. The authors were harassed, the works were blacklisted or expurgated.

The proceedings Montufar instituted against the French Franciscan Mathurin Gilbert—the evangelizer of the Michoacán—were in every respect exemplary of this new orientation. The trial, which dragged on from 1559 to 1588, centered on the *Diálogo de la doctrina cristiana* that the monk had published in the Tarascan Indians' language. Gilbert was reproached with his reservations concerning the worship of images and his ideas were termed "erroneous and scandalous,"[47] when all they did was imprudently develop the opinions of the first Franciscans. The work had, however, been approved by the theologians in 1559, as well as the printing permits by the viceroy and the archbishop of Mexico. But it was once again the opposition between the Episcopal authority and the monks that set matters off. The bishop of Michoacán's determination started the Inquisitorial machine, and Mathurin Gilbert was constrained to explain his thoughts on images: "It is not that this declarant understands that the cross and images must not be worshipped, on the contrary, he believes and understands (and practices in this manner) that Christ is worshipped on the cross, and that the cross is worshipped as an object that represents

Christ, and it is in this sense that he wrote it and meant it."[48] It is nonetheless revealing that in one of his counterattacks the Franciscan reproached the bishop of Michoacán for multiplying "the hermitages and the paltry devotions for which they hold feasts every year; the poor are taxed for these and thus are quite victimized."[49] This was more or less what the Franciscan Bustamante in Mexico City was reproaching the archbishop Montufar for in his sermon of 1556, when he accused him of encouraging a piety as dubious as it was harmful.

The Arrival of the European Painters

The retreat of the monks—which was also, let us not forget, marked by the retreat of didactic images whose reproduction was primarily incumbent upon the Indians—cannot be explained solely by the rise of Episcopal authority, the diffusion of Tridentine Catholicism, and the precipitous decline of a native population decimated by epidemics. The closed world of the new Christianity, where the Franciscans had dreamed of shutting themselves in with their Indians, staggered under the rise of an urban and mestizo society directly connected to the metropolis. Following the viceroys, artists had landed here in search of an easy fortune. Here, more and more works of art—paintings, sculptures, trinkets, and furniture sent from the West—flowed in, and among them that famous portrait of Charles the Fifth on horseback, assumed to be by Titian.[50]

The gestation conditions for the baroque image were as material as they were technical. European painters were numerous enough in 1557 to organize and submit ordinances to the viceroy regulating their jobs and defining the "Imagery Office": drawing, the faithfulness of pictorial narration ("drawing and ordering any story without a single error"), the use of colors, nudes, draping, rendering the face and hair, and finally, landscapes ("pictures of distance and greenery") constituted the requisite qualities of a painter examined by the trade corps within a still narrow and provincial circle.[51] They remained, no doubt, far beneath what was expected of a Quattrocento painter. Nonetheless, painters and sculptors were more and more numerous in Mexico during the second half of the sixteenth century; their increased presence resulted in a stronger receptivity to Old World artistic trends, in this case, mannerism. This permeability instituted an aesthetic dependency that broke definitively with the originality of the monastic creations, and the monks' Mexico. The

cenotaph erected in 1559 to honor Charles the Fifth by the architect Claudio de Arciniega probably constituted the first expression of mannerism in Mexico, and the 1570s are commonly held to have been the period in which a new art form began.[52] These were years of transition for the colonial image. They marked the disappearance of Peter of Ghent and the slowing of the monastic construction sites, while two major supporters of baroque Catholicism took hold in Mexico: the Society of Jesus, and the Tribunal of the Inquisition's Holy Office.

Along with the architects Claudio de Arciniega, Francisco Becerra, and Juan de Alcántara, Flemish artists—the painter Simon Pereyns, arrived in 1566; the sculptor Adrian Suster; and the engraver Samuel Stradanus—and Andrés de Concha of Seville (who moved to New Spain in 1568) became the center of a social group whose talent was put to use for the Church and the new colonial society.[53]

Simon Pereyns was held, in his time, to be the best artist of the viceroyalty. His path illustrates the development of the plastic influences then converging on Mexico. Having left Antwerp, where it seems he had studied painting, he reached Toledo after a nine-month stay in Lisbon (1558) and followed the court to Madrid. There he met the marquis of Falcés, who, nominated viceroy of New Spain, brough him there among his retinue in 1566. The Antwerp painter therefore had only a few years in which to meet Peter of Ghent. Creator of war scenes decorating the viceregal palace, Pereyns painted mannerist retables for the capital's churches and the convents of the provinces, leaving behind "many images of saints and Our Lady."[54]

The presence of the Netherlands was also confirmed by means of the importation of tapestries, engravings, and canvases from Flanders. In 1586 the *encomendero* (the beneficiary of an endowment of contributing Indians, the *encomienda*) Pedro de Irala introduced "canvasses from Flanders with religious subjects (*a lo divino*), Apostles and others from the Passion of Christ, and a few with profane themes (*a lo humano*)."[55] The influence of Gérard David, that of the Geertgen School, and notably of Martin de Vos were exerted through the works reaching America. It even seems that Martin de Vos's *St. Michael* (that the church of Cuautitlán still owns) furnished the figurative archetype for the colony's angels, a major subject of the painting of New Spain.[56] Until the middle of the seventeenth century, dozens or even hundreds of imports of "stories and landscapes of Flanders,"[57] continuous arrivals of illustrated works printed in

the Netherlands conveyed the themes of northern mannerism, which weighed in a unique fashion on the destiny of Mexican architecture and baroque.[58]

A second wave of painters dominated by the personalities of Alonso Vásquez and Baltasar de Echave Orio landed between 1580 and 1603.[59] Vásquez worked for the palace, the University, and the Hospital of Jesus; Echave Orio displayed a prolific talent that led him to be considered the founder of the Mexican School of painting. These two first generations of mannerist painters were formed in Europe, and more and more frequently, in Spain, carrying with them their style and experience. They spread the Italian and Seville heritage of mannerism, whereas the missionaries' Mexico had had to rely on its own strengths. The change of direction was decisive. The monastic period's improvisation and stylistic loss of contact with reality would from then on make way for an industrious adoption of European trends.

Hidden behind the great names one must imagine a crowd of Spanish, Italian, and mestizo students and artisans busying themselves in the workshops, the stores, and the corporations. At the same time the clientele of the artists was growing and diversifying. The court, the Church, municipal authorities, the university, the Inquisition, brotherhoods and rich individuals increasingly competed for orders that publicly confirmed, in Mexico as elsewhere, their power, prestige, and social influence.

All the elements for a great predilection of the image and a large-scale means of production consonant with European tastes, initiated by the Church, placed under the watchful eyes of the Inquisition and sometimes inopportunely zealous prelates, were thus gathered in one place. Docility and conformity remained the rule everywhere: the Mexican painters' production largely favored religious themes, and besides a few rare portraits and the short-lived paintings of triumphant arches used only during festivals, it was for some "the asphyxiating world of religious representations"[60] that ruled over New Spain from the end of the sixteenth until the seventeenth century. This was a universe that, contrary to Murillo's and Zurbarán's Spain, rejected the trivial, the popular, and ignored "the reality of the countryside and the suburbs."[61] The Mexican baroque image was thus essentially religious and conventional, distinguishing it from baroque Spain and Italy, and probably from Peru, where the colored world of the caciques was frequently featured on canvas.

The third generation of mannerist artists was much more anchored in

the Mexican milieu, more subject to its tastes and wishes as contacts with Europe declined but did not disappear: fewer painters crossed the Atlantic, fewer works followed them. This generation ensured the transition toward the baroque in the early seventeenth century. It gathered artists of talent such as Luis Juárez († 1639), Alonso López de Herrera, and Baltasar de Echave Ibía.[62] With Sebastían López de Arteaga of Seville († circa 1655) and his disciple José Juarez, the shadow of Zurbarán and Tenebrism hovered a moment over Mexican painting.[63] But it was truly with José Juárez († circa 1660) that the baroque replaced the Italian atmosphere. It was at that point that Mexican painting began its great rise, corresponding, let us point out, to the spread of the worship of images. The increased number of paintings—and therefore the growing demand—was such that their quality suffered. This at least was what the painters bemoaned in 1681 when they called for the drawing up of new ordinances to stem "the great irreverence toward sacred images because their authors are Indians and other people who have not learned these offices and are ignorant of them."[64]

Words on Images

These painters all produced religious imagery in which one can trace the successive influences passing through Spanish Golden Age painting.[65] Beyond the stylistic variants, one can perceive in the artists and educated class of New Spain a new, more rhetorical and intellectualized relationship to the image. The mannerist and then baroque image played with decorative loading, allegorical flowering, the pursuit of wisdom, sophistication, and a multiplicity of meaning. The painters shared the Italian Cesare Ripa's concerns when he wondered in 1593 in his *Iconologia* about "images made to signify a thing that is different than what one can see with one's eye."[66] For Ripa, for example, "beauty must be painted with its head lost in clouds, for there is nothing that is more difficult to speak of in a mortal language and that can less easily be known by human intelligence."[67] The pursuit of allegory and denotation appeared even in works devoted to Mexican idols. The chronicler Torquemada involuntarily echoed Ripa's commentary in his description of the Mexica god Huitzilopochtli: "He had a mask of gold to denote (*para denotar*) that the god is covered and that he can only show himself with a mask . . . , for the divine is hidden from the eyes of men who are forbidden to see it."[68] A

same exegesis of the image, then, was operating in Europe as it was in Mexico. There clouds, here a mask, to signify that which escapes the sight and the art of the painter. Under Torquemada's pen the image of the Mexica god became a collage of attributes, symbols, and definitions: birds, butterflies indicated his rule over creation; the little shiny mirrors that were his eyes marked omniscience; the necklace of human hearts made manifest the idea that the life of men devolved from God. Mexican or European, representation was conceived of as a text, as a collection of signs to be decrypted. Mannerist vision allowed Torquemada not only to denounce the monstrous form of the Mexican idols, but it also incited him to go beyond the sphere of analogy and resemblance to examine the domain of meanings, emblems, and colors more closely. Or perhaps it was the study of idols itself, the Franciscan chronicler's own "ethnographic" curiosity, that suggested paths of interpretation rejoining the experience of a century of allegorical painting.[69]

The mannerist image emerged as a product of intellectual construction, a refined avatar of graphical reasoning and sign theory, as though conceptual order had completely directed perceptual order. This applied equally to the project and to the completed work, to the canvas yet to be painted and to the representation that was described and deciphered[70] within a world that had become hieroglyphic.[71]

Understandably, under these conditions, the mannerist image remained inconceivable and at times incomprehensible without the text that was invariably associated with it. Preachers, commentators, and pamphlet authors all evoked and described with the same enthusiasm the *pinturas y letras* that corresponded to the prodigy, the miracle, or the saint they were lauding. The praise and hieroglyphics[72] contained within the borders and the *tarjas,* the verses nestled there, constituted the indispensable complements and the awaited prolongations of the images. At the very beginning of the seventeenth century, just as Torquemada was writing his *Monarquía indiana,* it was possible to contemplate the *Apparition of the Lady of los Remedios to the Conquistadors During the Conquest* in a famous sanctuary on the outskirts of Mexico City. The painting is surrounded by Latin and Castilian inscriptions commenting on the miracle. There is a column on either side; Hope, with the word *Spes,* is represented at the top of one of them, then one discovers the drawing of a ladder accompanied by the inscription *Scala Coeli,* and "next to this an angel with a sign in its hand; on the inside is written '*Spes omnium Terrae*'."[73] The explora-

tion of this forest dense with images, interlaced with symbols (the "hiero-glyphs") and inscriptions, seems today to be an endless and repetitive exercise. Nonetheless, for the monks and the artists the verb and the image formed an indissoluble couple, deliberately redundant to the point of making any methodical description of the iconographic representations superfluous. The joint use of the "hieroglyphs" and the insignia accompanied by their respective captions eloquently illustrated this desire for redundancy: "The *Divine Mercy* was painted with its known insignia and the name *Misericordia;* above are painted flowers and inscriptions that read: *Flos campi.* . . . There is another hieroglyph, a tree painted with its fruit, and the caption reads: *Fructum dabit in tempore suo.*"[74]

The parallelism between the image and the text can be pushed even further. For example, it can apply to the reproduction of the image and that of the text with respect to the miracles attributed to it. In 1630, the invoking of an image of St. Dominic—now preserved in the Calabrese convent of Soriano—saved the city of Mexico from another catastrophical flood. That image, however, had not yet been seen in New Spain at that time; all that was available was the Italian tale of the miracles at Soriano. It was because a Dominican had made a point of preparing a Spanish version of the Italian original, and distributed six hundred copies of it, that this new devotion spread throughout the capital. It was only later that a reproduction of the image of Soriano reached Mexico and was copied by the painter Alonso López de Herrera, with a talent his contemporaries held to be miraculous.[75]

We still need to question the actual impact of the text accompanying the image. Dim light and distance normally rendered it difficult to make out, and in any case, it proved itself thoroughly inaccessible to the man in the street who, even if he knew how to read, was ignorant of Latin, or became lost in the biblical and mythological erudition the designers of these aggregates had assaulted him with. If they satisfied the scholarly, *eruditio* and *artificio* tired even the best readers, as those who left us these lengthy descriptions admitted themselves.[76] The mannerist image thus did pertain to a visual program breaking, in many respects, with the great didactic frescoes of monastic art. It lost the teaching power of the Franciscan image but became an extremely intellectualized product, as difficult to decrypt as a Peter Greenaway image in British film of the 1980s. Nonetheless, the lack of immediate readability showed itself to be entirely compatible with the thaumaturgical role assigned, from then on,

to the image. The baroque image, surrounded by texts too hermetic to maintain the distance from prototype to copy, was even born from the association of a representation overloaded with meaning and an object saturated with miraculous virtue. Crammed with hieroglyphics, the sphere of the baroque crossed that of the pre-Hispanic *ixiptla*.

The "News of Its Miraculous Origins"

Let us return to Our Lady of Guadalupe's trail. It is mysterious largely because the thought and creativity expressed through this image borrowed figurative paths that were not easily captured by words. The conceptual reclaiming that Miguel Sánchez tried in the middle of the seventeenth century, far from exhausting the specificity of the phenomenon, only added an extra dimension to it, even if in the long run that dimension became a crucial one.

One may remember that the painting Montufar had left (or more likely, had had installed around 1555 in the sanctuary on Tepeyac Hill), was "completely unfounded" in the exasperated eyes of the Franciscans. It is probable that officials within the archbishop's palace, without openly accrediting a miraculous basis for it,[77] tried to make people forget that a native painter, Marcos, was its author. The fact remains that this first epiphany, as mysterious as it was clumsy, as debatable as debated, hardly went unnoticed within native society since it was recorded by Indian chroniclers: Juan Bautista, *alguacil* (a minor agent of Crown justice) of Tlatelolco—a small town between Mexico and the Tepeyac—wrote in his diary for the year 1555, "Blessed Mary of Guadalupe appeared at Tepeyacac."[78]

Then followed a relative silence on the part of the Church and other official sources. It lasted almost a century. During this time the worship of the Guadalupe Virgin prospered among the native milieu—the Indians hurried to the Tepeyac in September 1566[79]—while also attracting the Spanish: in the 1560s the conquistador and writer Bernal Díaz del Castillo celebrated the miracle of the Lady, while Alonso de Villaseca, a wealthy man, offered a silver image to be placed on the primary altar in 1568;[80] during the 1570s a church replaced the hermitage of Tepeyac, and the archbishop of Mexico thought of erecting a parish or monastery on that spot; the viceroys went there for their devotions. But all this took place without any mention of an apparition of the Lady or of a miraculous

image. In 1601 there was a small scandal, but also some rare information recorded in the sources: Juan Pabón, the Indian (?) sexton of the hermitage, was taken to justice for cohabiting with a mestiza woman.[81] In 1622 the archbishop of Mexico, Pérez de la Serna (1613–1624), also upheld the cult and had the image placed in a silver tabernacle.[82] One year earlier, Luis de Cisneros, chronicler for the Lady de los Remedios—the neighboring rival of the Tepeyac Virgin—had indeed mentioned the numerous miracles of the Guadalupe and the popularity of her cult, but did not say word one about apparitions.[83] After the catastrophic inundation of 1629 the image was transported to the capital to stop the deluging rains. In vain. It was for this reason, perhaps, disappointment and forgetfulness helping, that the Guadalupe Virgin lost the favor of the people during the 1640s. According to Robles's *Diary*,[84] only the convent of Santo Domingo still had a copy when, in 1648, a priest, the bachelor Miguel Sánchez, published his *Imagen de la Virgen, Madre de Dios de Guadalupe* and gave the dormant worship a push that was as masterful as it was definitive.

According to that version, which was the one to be canonized, the Virgin had appeared three times in 1531 to an Indian named Juan Diego. Having come to tell the bishop Juan de Zumárraga of this, Juan Diego opened his cape and instead of the roses it had been wrapping, the Indian discovered an image of Our Lady, miraculously imprinted, "which is today preserved, guarded, and venerated in its Guadalupe sanctuary."[85]

But what happened from 1556 to 1648, from Montufar's inquiry to the publication of Sánchez's book? Officially, nothing. In actuality, a fair amount. One runs up against the enigma of this long latency period—almost a century—that might have ended in erasure and forgetfulness if the *Imagen de la Virgen* had not been published at the right moment. It is with difficulty that one can pinpoint, or more precisely, reconstitute the development of the devotion: native tales about the appearance are said to have circulated against a persistent background of creole and mestizo piety, interwoven with almost endless miracles. It is possible that they featured Indians and archetypal figures such as the bishop of Mexico, Juan de Zumárraga; it is also possible that they were mixed with Western chronology, such as the *Primordial Titles*—those indigenously forged property titles telling the origin of Indian communities in a cyclical form[86]—were later on. It is also probable that the information was oral, painted, and written all at the same time: oral in the form of songs

celebrating the miracle—or the miracles—of the image, painted in the form of pictographic codices in the hands of local caciques,[87] and perhaps written, since a Jesuit historian vaguely refers to annals of some sort.[88]

Nonetheless, this information and these tales—at one point gathered, unified, and transcribed—resulted in a manuscript known as the *Nican Mopohua,* whose compiler, or even the author, was perhaps the mestizo chronicler Fernando de Alva Ixtilxóchitl. This historian, lover of codices and manuscripts, often socialized with the intelligentsia of the capital, and it was easy for him to transmit the document to the clerks who lacked sources.[89] Finally, the native *imaginaire* and collective memory, just as the circulating texts, were indisputably fed by visual accounts, ex votos and frescos, such as the one in 1666 still decorating the dormitory of the Cuautitlán convent: it featured Sánchez's hero, Juan Diego, and his uncle, Juan Bernardino, at the sides of a "brother So-and-so of Ghent": this was of course our Peter of Ghent, who most likely would have been quite surprised to find himself among such company.[90]

Ever since the beginning of the seventeenth century, several clues—among which are the accounts of a vicar from the Guadalupe hermitage—have suggested that traditions relative to a miraculous origin for the image were common among the Spanish.[91] But these traditions only fully came to light and attained renown with the appearance of Sánchez's book, whose story was taken from tales and rumors. The author was forty-six years old. Eight years earlier, he had become famous by delivering a sermon to the glory of St. Philip of Jesus, the first Mexican saint to be martyred in Japan, as if he had already felt the need to exalt a Christianity rooted in New Spain. For that matter, it was then that he decided to devote himself to the writing of a work dedicated to the "Second Eve," Our Lady of the Tepeyac. Thanks to him, "the devotion of Mexicans for the sacred image was fired with enthusiasm and thereafter, as the news of its miraculous origins spread, the devotion for his venerable sanctuary only increased."[92]

The Launching of the Image

Miguel Sánchez's work was immediately followed by another publication, written by Luis Lasso de la Vega (1649), a friend of Sánchez's and chaplain of the sanctuary since 1647. The story of the apparitions and the prodigies was given in Nahuatl this time. Lasso de la Vega spoke to an

indigenous public in order to refresh "what ha[d] been much dimmed by the passage of time."[93] Not unsuccessfully, since after 1653 the fate of the abundant alms flowing into the sanctuary began to preoccupy the bishop.[94] Luis Becerra Tanco joined them by publishing his *Origen mila-groso* in 1666 to combat the "shroud of forgetfulness."[95] For their part, the Jesuits Mateo de la Cruz (in 1660), Balthazar Gonzalez (before 1678), Francisco de Florencia (in 1688), and many others then took over and tirelessly pursued the work of diffusion.[96]

It does matter that, far from having been the crowning and ideological sanction of a well-entrenched religious practice, the hagiographic enter-prise by Sánchez, Lasso, and Becerra Tanco was built on a diminishing devotion and a swiftly vanishing oral history. Conditions came together so that an irrefutable construction, clearly delineated and for the most part centered around a miraculous image, rose up to cover the uncertain-ties and gaps of tradition. The erasure and denial of the human origins of the image propagated by Sánchez's chosen version were the foundation for the Marian belief, the utter good faith of the three "evangelizers" lending even more force to their enterprise. It became a "definitive" work, ultimately hanging a "memory-screen" over the uncertain recol-lections that were themselves burying the all-too-human initiative of 1556.[97] The procedure prevented any hint of a reality that—at the price of an unthinkable and unbearable scandal—would put the divine and mirac-ulous origins of the Virgin in doubt. In this sense, the fiction of 1648 took on aspects of fetishization according to which, in this case as in others, "the fetishized object seems to reinforce itself, harden into certain defini-tive details."[98] It is thus that a new *imaginaire* crystallized, one that was yet to take root in the minds and institutions of the people of New Spain.

The three "evangelizers" of the Guadalupe Virgin were far from being the only ones. The writing of these priests, who had been born at the turn of the century, was not the only element necessary to revive and restart a dormant, almost extinct, worship. It was also essential that there exist an ecclesiastical milieu—in this case, consisting of theologians, Jesuits, inquisitors, and high officials of the Church—ready to uphold the enterprise. This became a prefiguration of a "Guadalupan lobby" sensi-tive to the prestige that would invariably reflect upon the land of Mexico: "for the honor of the country whose glories we, its children, need to uphold."[99] The whole business was not born suddenly from Miguel Sánchez's enlightenment. The way had already been paved a few years

earlier; how else could we explain that his miraculous tale so easily obtained the Church's blessing and its imprimatur? The ecclesiastical authorities must have gotten wind of the legend and of Sánchez's project to be so quick to validate several apparitions of the Blessed Virgin, plus that of an image *manu divinu depicta*. In fact, the author of the *Imagen* had been thinking about his project since 1640, and he may even have told Lasso de la Vega of it in 1646. For his part, Francisco de Siles—who, in 1648, was to heap praise over the *Imagen de la Virgen,* and who until his death played the role of propagator of the cult—was said to have published, around 1644, some of the letters addressed to Sánchez and devoted to the "Guadalupan story."[100] Behind this series of complicities, these writings, and this supporting documentation can be perceived one of the more prominent milieus of midcentury colonial society: a nucleus of Creoles and academics. Lasso de la Vega and Sánchez sat on the benches of Mexico University, where the latter applied for a chair;[101] Becerra Tanco was said to teach mathematics there; among the ranks of the academics bringing their approval and support to the undertaking were Juan de Poblete, dean of theology; Pedro de Rozas, lecturer in the same discipline; and Francisco de Siles, holder of the chair in theology. Most were friends, and did not hide it.[102]

Let us not forget, either, in the background, the shadow of Juan de Mañosca, archbishop of Mexico since 1645, whom Miguel Sánchez and Luis Lasso de la Vega (the author of the native version) thanked effusively.[103] The archbishop had taken sides against Juan de Palafox during the heated discord that shook up the viceroyalty and brought the bishop of Puebla in conflict with the Jesuits. Allied with the inquisitor Mañosca, his relative, the archbishop was all the better able to underwrite Sánchez and Lasso's enterprise in that he had spent his childhood and adolescence in Mexico City, where he had had the chance to become familiar with the traditions popular at the Guadalupe sanctuary. In any case, was it not another archbishop, Montufar, who had given almost a century earlier the first impetus for the Guadalupan devotion? Everything indicates, moreover, that the cathedral's chapter found the Lady of Tepeyac to be a patron figure they could oppose to the Lady de los Remedios, whom the municipality worshipped. In Mexico as in the rest of the Catholic world, the patronage of saints and images was both the expression of, and the basis for, rivalries that divided the ruling groups in baroque society.[104]

One must nonetheless await the 1600s for the ecclesiastical authorities

to intervene directly, and for an official initiative to be substituted for individual attempts. At the instigation of Francisco de Siles and Juan de Poblete, who had publicly supported Sánchez in 1648, the archbishopric and viceroy-archbishop's chapter asked Rome that the twelfth of December, date held as that of the apparition, be declared a holiday. To strengthen the petition, an inquiry was begun in Mexico City about the circumstances surrounding the miracle.[105] The Church followed the beginnings of the cult kindly; it authorized Lasso's publication of the tale in Nahuatl through its *provisor* and welcomed Siles's undertakings; the Inquisition allowed the diffusion of the Mariophony of the Tepeyac—no fewer than four Marian apparitions—without ordering an inquiry. Despite all of this, the operation organized around the image was above all the work of Creole priests and canons driven by an extraordinary perseverance. The 1666 inquiry verified that the local tradition among the descendants of those who had known or approached Juan Diego corresponded in great part to the information spread by Sánchez and Lasso. But, to the extent that the questions asked of the witnesses contained the elements of their answers, one gets the feeling that the procedure was more concerned with providing a native backing for the official version of 1648–1649, and molding local memories and accounts to Sánchez's vulgate. This was also the time to win the support of all religious orders, whether Franciscan, Augustine or Dominican, Mercedarian or Jesuit. A consensus had been achieved, the Franciscan dissidence had long been forgotten, and the image was triumphant.

Other factors benefited the launching of this enterprise. The first flames of an embryonic patriotism, that "Guadalupan national consciousness" that has been the focus of much scholarship was beginning to stir in 1648. For its promoters the miracle of the Tepeyac was exceptional, and its prestige was bound to spill over onto Mexico City and America. The cathedral's cantor, Juan de Poblete, had an unsparing pen when it came to the approval he felt for Sánchez's work: "the appearance of an image, which obviously is one of the most miraculous in all of history." The chancellor Francisco de Barcenas went further: "You have written the glories of Mexico, our homeland." This tone was maintained subsequently, carried by the emphasis and momentum of a baroque exaltation that Sigüenza y Góngora brought to its paroxysm.[106]

If the diffusion of the Guadalupan cult was indeed the beginning of a "proto-nationalistic" affirmation, it also coincided with the culmination

of the persecutions against the Marranos. Seemingly Christians but in fact Jews, the members of this small community had managed to integrate themselves into colonial society when, for political reasons—the revolt of Portugal in 1640—the authorities came to view them as potential traitors and resolved to eliminate them. The great auto-da-fé of 1649 sounded the death knell for this Jewish community in Mexico; they disappeared on pyres or the paths of exile. The simultaneity of the two projects—the annihilation of Mexican Judaism and the deliberate launching of the Guadalupan cult—was perhaps more than a chronological coincidence. Persecution fit in beautifully with a prenationalistic maneuver intended to bring colonial society together around an event that was profoundly Catholic and unbearable to the Jews, since it blended Marian worship and the worship of images.[107] The auto-da-fé of 11 April 1649, "the apotheosis of Inquisitorial presence in New Spain"[108] organized by the Inquisition, with thirty thousand enthusiastic spectators if one counts all ethnic groups, the viceroy and the court, the archbishop, the regular and secular clergy, turned into a great baroque feast prefiguring the ever-more numerous crowds that would, even today, hurry to the Tepeyac sanctuary. That same month of April 1649, a week after the Mexico City auto-da-fé, in another great moment of Mexican fervor, the *visitador* Juan de Palafox—important personage, as he was the bishop of Puebla, archbishop of Mexico, and viceroy—presided over the consecration ceremonies of the cathedral of Puebla, second city of the viceroyalty.[109] These spectacular signs also marked the end of a period of turbulence and conflicts (1642–1649) between the clans fighting over power in New Spain. Given this context, the Guadalupan operation perhaps was as much an initiative by the capital's secular clergy—to which Sánchez, Lasso de la Vega, and Becerra Tanco belonged—as it was a desire for reconciliation and unanimity brought together by an exceptional devotion. But to reduce the matter of the Guadalupe Virgin to strictly ideological and political dimensions would be to neglect the essential, the image at its base, and the unique and multiple influence that it exerted.

The Most Miraculous of Images

The operation led by Sánchez, and its imitations, was first a "book production," with all that that might entail concerning the appropriation, stabilization and authentication of the "event" within a viceroyalty

where printing was tightly controlled, essentially religious, and where publication was only used for consecration. For the first time the Guadalupan tradition was normalized, registered, and diffused through a book. It thus slid into the tradition of the Mexican Church with the hopes of being received throughout all Catholicity.[110]

By conjugating miraculous writing and painting, or the intellect and sight, Sánchez's initiative also satisfied one of the baroque requirements: "If the painting is accompanied by words that explain it, it receives much esteem from this beyond the admiring praise that the gaze has bestowed upon it, for the words encouraged their reading, and they were tongues preaching hidden excellence."[111] But the authors were also conscious of producing a "public story" "brought to public light,"[112] of creating a work of "divulgence," of developing a project that was to "arouse the devotion of those who were only lukewarm, and create it anew in those who live in ignorance of the mysterious origins of this celestial portrait."[113]

While offering an interpretation or an "advertising" medium, Sánchez's text killed two birds with one stone. On the one hand it replaced the silence of the written sources by publishing the "ancient, uniform and general" tradition to which, later, Becerra Tanco proposed to add "historical" bases.[114] On the other hand, it laid the groundwork for a long-term image within the perspective of the Tradition of the Universal Church. Sánchez's exegesis was based on the apocalyptic text by St. John, which he used as the theological foundation and the source of the image left by the Blessed Virgin: the Woman appearing to the apostle—"image painted in the sky"—and who overcame the Beast, was purportedly none other than the "prophetic original for Our Lady of Guadalupe," the prototype for the Mexican copy miraculously deposited onto Juan Diego's cape.[115] This astonishing rapprochement was popular at the time. It might have been suggested by the reading of a sermon which a few years earlier had compared the woman of Apocalypse to the Immaculate Conception.[116] The Mexican representation (illustration 9)—a Blessed Virgin without Child, in contrast to the statue of the same name adored in Spain—might have undergone sufficient touch-ups and restorations to suit the current fashion and to take its place in the wake of the cult of the Immaculate, and of the growing number of images representing it. In 1620 and 1622 one of the best artists of New Spain, Baltasar de Echave Ibía, painted an Immaculate and a Virgin of the Apocalypse surrounded by a

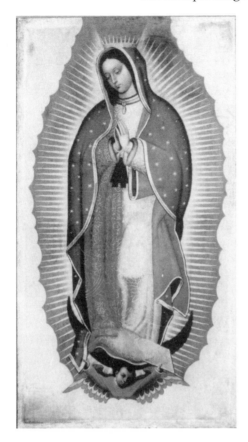

9. *Our Lady of Guadalupe,*
sixteenth century.
Basilica, Mexico City.

nimbus of blue standing on the crescent and the Serpent (illustration 10);
such paintings show how much interest this theme and invocation gave
rise to at the beginning of the seventeenth century.[117]

But Sánchez got even more out of the miracle of the image, extracting
from it a deeper meaning for the conquest of Mexico: the land was "won
so that an image of God of such worth might appear."[118] Mexico became
the providential receptacle, the stage "won" high-handedly in order for
the vision to be shown. This was enough to build a past fated to become
authority, a plausible, receivable, and irrefutable past for, and grafted
onto, the image.

Let us stop at this unique temporality the image carried and produced,
a temporality that the image prefigured, inaugurated, and accompanied
by its miraculous presence. By dating the epiphany to 1531, Sánchez inaug-
urated a fantastic prehistory that hid the Montufarian episode, and since it

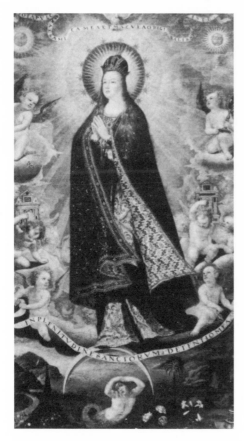

10. Baltasar de Echave Ibía, *The Virgin of the Apocalypse* (1622). Viceregal Library, Mexico City.

was from then on barren of any raison d'être, threw it into the pit of forgetfulness. The episode of 1555–1556, a tortuous and fabricated epiphany of the painted object, was erased by the blameless Mariophanies of 1531, the visions of the Blessed Virgin and of the image. Is this to say that myth replaced history? On the one hand we have authentic history—a progressive sedimentation of devotions and images, but also a gray period of time when nothing stood out in popular memory—and on the other, the late exaltation of the 1531 epiphany. Was this a knowingly orchestrated mythification, suddenly thrown into the seventeenth century? It might be more pertinent to seek out distinct time frames where the one that was the most charged with impact, meaning, and emotion, far from being the "authentic one"—in the sense that we mean it—would be the *noticia*, the designed and thought-out fiction that Sánchez, Lasso, and Becerra Tanco refined and successfully diffused. A fake temporality

then would appear, arched over the void, that all the "apparitionists"— those who maintained the miraculous version—would diligently attempt to explore, furnish with texts, surround with witness accounts, clues, and objects. Temporality became anchored by the appearance of the image, integrally built on an image and oriented by it. The Guadalupan image that had been projected onto the year 1531 suddenly illuminated the entire era, which it covered in such bright light that the initiative taken by the archbishop Montufar—in its day such a timely one—was lost from sight. It sank in turn into the shadow carried by the tale of the Apocalypse and emerged solidly tied to the Church tradition. Thus the temporality of the *imaginaire* diffused by Sánchez was crystallized, as the narration of the supernatural origins of the image had been. The image of the Tepeyac allowed America to be anchored to the time of Christianity. It was a magnificent registry instrument that allowed chronological perspective; even more, it was an assuredly eternal memory graft.[119]

A Perfect Image

Before this, the image was a miraculous object seized in a reflection, forever running from the text to the image and back. By defining the characteristics of the Guadalupan image, Sánchez scouted and confirmed the frontiers of the phenomenon. "Normalization," which for us paradoxically appears as a fantastic exaggeration of the miracle, played over three registers: the perfect *copy*, the miracle of *reproduction*, and its *presence* on Mexican soil. The earthly image constituted the miraculous copy, the *trasunto por milagro* of the celestial original.[120] Miguel Sánchez recaptured a theology of the image which made God the primary creator of images, since he was the creator of man. The Virgin was the most perfect image since she was "copied from God's original,"[121] "a privilege that was always hers in all of her images." Taken from an original that was itself an image—"the original image of Heaven"—and the image itself of the beauty (*hermosura*) of God, the Blessed Virgin was an image of exception.[122]

The Tepeyac copy, moreover, was the effect of a miraculous reproduction (*trasunto por milagro*) since the flowers gathered in the Indian Juan Diego's cape, as they fell out, "leave painted on it the image of the most Blessed Virgin Mary,"[123] pigment and developer blended together in a

few petals. Copy, but also sign. In contrast to other miraculous images that produced miracles and signs, for they preexisted those prodigious manifestations, the image of the Guadalupe was already in and of itself a *signum,* a "miraculous sign"[124] in the sense that she was a "legitimate daughter born of a sign," an "image" begotten by "a sign." This was the forever unique essence of the Guadalupan Virgin, conceived of as the manifestation of the divine universe and of the invisible. Spread by sermons, that theme was also fashionable: one might recall that a copy of an image of St. Dominic had reached Mexico in the 1630s, and traditionally it was said that the original had been painted "not on earth, but in Heaven,"[125] before being handed over in 1531 to the Dominican provincial of the town of Soriano. But had not rumors given the Tepeyac Guadalupe a divine origin from the very beginning of the seventeenth century? Sánchez had only to elaborate an orthodox formulation so that the preachers might indefinitely embroider upon the theme, even making the image into the "portrait of the idea of God."[126]

Formed without any human or physical mediation, the Guadalupe Virgin was thus not a handmade image, but was instead the unexpected—nothing had announced it in Mexico City—and renewed product of a symbolic and dreamlike organization: the Patmos vision that inspired St. John's Apocalypse. For Sánchez identified the Woman who confronted the Beast as the "prophetic original" for the Lady of Guadalupe;[127] but this was an original production, and not a reproduction. The uniqueness of the Guadalupe Virgin stemmed from its "uprooting" in relation to the immediate past. Wiping out its human origins gave it an unequaled aura. It was only with subsequent apparitions that the Blessed Virgin conformed to the features of painting and that, more conventionally, the vision's immateriality "re-produced" the miraculous sign.[128]

In contrast to an image of human origins, the Guadalupe Virgin displayed a surprising technical mastery, as proven by the episode of the roses. Before meeting the bishop of Mexico, the prelate's servants attempted to dissuade Juan Diego. They tried to see the contents of the Indian's cape, which held the flowers he had picked. Astonished by the beauty of the roses, they attempted to seize them unsuccessfully, "judging [then] that they were painted, engraved, or woven into the white mantle, . . . that they were only seeming, either sculpted or drawn onto the cloth."[129] This perfect three-dimensional illusion provoked the same kind of fascination our holograms do: "they were only seeming . . . ,

they were not real."[130] Other formulations lent a quasi-photographic origin to the effigy: "her Blessed image had remained imprinted on the cloth;" "the portrait of the Blessed Virgin was stamped onto the mantle."[131] The phenomenon might resemble engraving and the signs of the cross that leave a mark on the body of those who receive it: impression, *sigillum*, commented the Jesuit Florencia, conceived "to seal and signal others with the sign of the cross."[132] Becerra Tanco was even said to have argued that the sun had projected the Blessed Virgin's shadow onto Juan Diego's cape, and that the flowers he gathered had been responsible for the chromaticism.[133] Constantly trying to outdo each other over the prodigy of the Marian reproduction, the thurifers vaguely foresaw the technical and more prosaic magic of contemporary reproductions.

The Guadalupe Virgin, produced by a sign and a sign herself, was the "portrait of an idea," a mental, then figurative representation; the Christian supernatural in the sense of a collection of signs endowed with their own life, capable of regulation and autoregulation. If we are to believe that the Woman of the Apocalypse foreshadowed the miraculous image of Mexico, the latter in its turn prefigured, and just as "prophetically" and metaphorically, that which today is computer-based simulation or even better, the organized proliferation of the signs and images of synthesis. Indeed, the "continual appearance" of the image was evoked during the eighteenth century: "The Blessed Virgin appears within her in a continual fashion, as she appeared in order to shape her so as always to have appeared, and so that one would ignore the way in which she operated."[134] This continued presence of the Virgin was associated with her immateriality: "There can one see, and there appears that which is not, or at least should not be, naturally, and if it were, it should then disappear since it is an excessively carefully unified composition, without overlaps, a painting without colors, . . . an image that seems printed without colors . . . , a wash without a brush, painted without a brush, painted without a canvas, the canvas having no threads."[135] Immaterial image that existed in space and time without apparent intervention, the representation of the Tepeyac Virgin was enough to stupefy and fascinate the baroque gaze.

These analogies—photography, holography, simulation—might seem anachronistic. But perhaps they could allow us to define the extreme uniqueness of the Guadalupan effigy by pointing out, from under the baroque digressions, the acuity of the theological reflections that still

attempted to explain the miracle and the mystery; we might, also, better understand one of the ties linking the baroque world to our world of images. These characteristics strongly influenced the favor that the cult found with all levels of the colonial population. The image was not European, despite a name taken from a particularly renowned Iberian devotion; it was neither the work of a Spaniard, nor of a native. A sign produced by a sign, it thus benefited from the assets of a "cultural transparency" that allowed it to be solidly tied to the Christian supernatural, the Church Tradition, and its native Mexican soil. Mystery and transparency were coupled with incredible prestige, since the Mexican apparition was supposed to overshadow all those that had preceded and merely prefigured it: "All the miracles were prepared and arranged for the miracle of the appearance of our blessed image."[136]

The Presence within the Image

Other elements besides this divine programming, however, fostered fascination. Image and relic, "sovereign relic of the miraculous image,"[137] mixing representation and the divine mark onto a native mantle, the Blessed Virgin was as much a sacred object as it was an effigy. Fragments of the cloth's edges were cut out to create relics.[138] But the relic-image was still only an attenuated form of the presence. The Tepeyac image was strangely close, in the piety of the people and the fancy penwork of the exegetes, to the native sphere of the *ixiptla*. It was the locus of a presence, "the presence of the Blessed Virgin within the blessed image."[139] Miguel Sánchez was categorical: "I do not doubt that the Blessed Virgin is here, with her image, on this canvas."[140] She was a presence that unleashed all human enthusiasms, even amorous passions. The vicar of the hermitage, Luis Lasso de la Vega, wanted to be the Adam to this new Eve: "All my predecessors and I have been sleeping Adams who possessed this second Eve in the paradise of her Guadalupan Mexico. . . . Even though she was already mine because of my title as vicar [of the sanctuary], today, glorious owner, I announce my good fortune and I recognize that I am obligated to greater ties, cares, and veneration in her worship and her love."[141] Here the return to consciousness, the awakening to woman and mother, happiness, worship, and "possessive" love all opened up and became inextricably melted together. But how should we

interpret this impulse that draws one to the image, and whose secu-
larized avatars still exist today?

There is no doubt that the maternal imago the Guadalupe Virgin
concealed also fed the fascination she exerted over all. She offered the
seduction of a brown-skinned mother, just like those mestiza, Indian, and
mulatto nannies who watched over the young Spaniards throughout the
colony. The fetishization the Mexican evangelists induced was then or-
ganized around the production of a unique, feminine, and protective
imago; it was a production founded on the crazed and unconscious
obliteration of everything that made it possible: the painting of the work
by a human hand. One should not neglect the psychoanalytical track,
even if it is frequently content with codifying what is already known. One
might be tempted to follow it by rereading chroniclers rich in insights
about the origin of idolatry and the love of images, about the disquieting
interest that little girls display for their dolls, about the appeasing power
of the image when confronted with anguishing and stressful situations,
about its role as a substitute during the process of grieving and absence.
One might discover that these Spanish authors often had astonishingly
modern intuitions, but one might also notice that sources are scarce that
would allow us, without crashing into a wall of archetypes, to capture
what linked the "miraculous image" to the maternal imago, and the
imago to fantasy. The reader will be able to measure the limits of this
undertaking by skimming through the analysis of an exceptionally well-
documented but particularly strange case.[142]

We are far from having exhausted the richness of the Guadalupan
phenomenon. For the perfect image, or Lasso's "second Eve," expressed
the literary reactions of an educated milieu. They left those of the rest of
the population, who did not write, in the shadows, and they may cause us
to forget that for the most part an image does not follow the path of
words. Sánchez's work came to light almost a century after the events of
1556, when the image had already given rise to currents of devotion that
had nourished written and oral traditions. It seems as if, ever since the be-
ginning, the cultural process of mobilization and syncretism flowed di-
rectly through the image and its manipulations and not through speeches
and politics. The Montufarian undertaking was in this respect remark-
ably silent: as far as we can tell, it counted mainly on the image. It was
also the image that followed the trail Sánchez and many others tried to

blaze, explain, and legitimize a posteriori. The *imaginaire* grafted onto the Guadalupe Virgin constantly preceded conceptual formulation, all the while escaping its rigidity and constraints. It displayed possibilities that, in the beginning, orthodox discourse would never have had the nerve to imagine: the image's syncretic virtualities became apparent during the sixteenth century, before Cabrera y Quintero publicly linked the cult, in 1746, to the beliefs of the Indians of North America.[143] Similarly, the miraculous nature of the image gave absolute credibility to the stories of Marian apparitions, while the oral or written accounts might have, if alone, less easily overcome the barriers of inquisitorial censure. The Guadalupan image, like all images, triggered effects that constantly escaped its initial designers (Montufar, the painter Marcos, etc.) and that went beyond the intervention of the mediators taking turns around it.

Baroque Images

The sanctuary of the Guadalupe Virgin was the shiniest link within a mesh of images, feasts, devotions, and miracles that progressively saturated New Spain. Faced with idolatries deemed to have no future and that only worried a handful of overzealous priests,[144] the Church, one senses, was busy crystallizing all manifestations of transcendence into images and epiphanies in order to best capture the attention and the fervor of the faithful. A reading of the chronicles and diaries of the seventeenth century suggests that colonial times seem to have been ordered by a web of events at whose heart lay the religious image. In other terms, the event in New Spain was, more than usual, the image. The tear-off calendar of dates that follows might be annoying with its repetitions and retellings: the same rituals, the same feasts, and so on. But how else can one describe the constant surge of the divine and the miracle into a colonial life that knew no wars and civil unrests, though it suffered the devastation of epidemics and natural catastrophes, themselves owed to providence? Year after year, the image produced miracles, and miracles consecrated the image.

The history of the Blessed Virgin of los Remedios parallels that of the Guadalupe Virgin. In the beginning it was simply a little wooden statue brought over by a conquistador and hidden during one of the battles of the Conquest, only to be discovered in 1535 by a native cacique. In 1550 a

hermitage was built for it, then a more decent sanctuary was erected for it in 1574–1576, under the auspices of the viceroy and the archbishop.[145]

The 1580s were rich in Marian events that prepared the era of the baroque image: it was probably in Mexico City, around 1582, that a pious Indian woman received the head and hands of a Virgin from a Franciscan monk. She then had artisans—who mysteriously disappeared once the masterpiece had been accomplished—assemble a statue.[146] That same year an inquiry consecrated the renown of Our Lady the Conquistadora, a statuette similar to that of los Remedios, brought over like her by the conquistadors and venerated in Puebla, the second town of the vice-royalty.[147] The theme of the "conquering image"—that is also valid for Our Lady of los Remedios—became apparent by the end of the century, as the version of an evangelization strongly backed by miraculous effigies imposed itself.

This hagiographic interpretation reveals the major importance the Church and its faithful attached from then on to the image and its effi-cacy. It was around 1580 that, urged on by a cacique, the cult of Our Lady of los Angeles began in a suburb of Mexico City. In 1583 the translation of the miraculous crucifix of Totolapan unleashed the enthusiasm of the crowds: "On the Holy Thursday, the crucifix appeared larger than it is; it gave off a very strong light and was so white that it seemed of flesh."[148] The same year, during the month of June, at the foot of the Popocatepetl, the Christ of Sacramonte multiplied the miracles.[149] This high point of the miracle and the image corresponds to the gathering, in 1585, of the third Mexican council, which adopted the decrees of the Council of Trent. Perhaps now it is easier to imagine how and in what context during these years apparitionist traditions might have developed around the worship of the Guadalupe Virgin, notably among the valley natives. Mexico was not the only one to receive divine favors. Peru was said to have followed the same paths between 1570 and 1600: the miracle of the Copacabana Virgin—one of the most celebrated Andes Virgins—dates back to 1583. As the Augustine chronicler recounted in the seventeenth century: "One must absolutely note—and this is not a small mystery— that during those same times when that cursed Elizabeth Queen of England was destroying images, great miracles of images were happen-ing in Europe and in Peru."[150]

In Mexico after the 1580s the worship of images gained its "cruising

speed," so to speak. From dedications to translations, the country was covered in images. Around 1595 Alonso de Villasana painted the frescoes decorating the hermitage of the Blessed Virgin of los Remedios and telling her story, while the venerable Bartolomé de Jesús María, around the same time, withdrew into the Chalma ravine near the miraculous image of the Crucified One—said to have appeared in 1539—to build a shelter open to pilgrims.[151] In 1577 "against the plague," in 1597 and 1616 against drought, the image of the Blessed Virgin of los Remedios was carried through Mexico City, which implored its help. This devotion was, however, far from monopolizing the fervor of the faithful.

1611: the Inquisition assigned the painter Juan de Arrué to copy the silhouette of a Virgin, said to have appeared miraculously, onto a tree trunk in Oaxaca. *1618:* during the festivals devoted to it, the goldsmiths' corporation offered the cathedral a silver effigy of the Immaculate Conception.[152] The image was placed under a triumphal arch thirty cubits tall, covered in emblems that "signified the pure conception of the Virgin," while the principal arteries of the capital sheltered "innumerable" altars decorated with paintings devoted to the Blessed Virgin's Conception, and a particularly realistic reconstitution of the Island of Patmos that was quite striking to many—and perhaps to the young Sánchez who, twenty years later, would identify the Guadalupe Virgin's origins as the woman who appeared to the apostle St. John at Patmos. Bringing up the parade was a triumphal chariot—gold, silk, and silver—carrying a figure of the faith and a statue of St. Elias kneeling in front of an image of the Blessed Virgin. Multicolor feathers, plaques, and "diamond-decorated" mirrors, quantities of birds in gilded cages, braids of gold, precious velvet, drapes, adornments of silver hanging from the windows and on the roofs created decorations of sumptuous exuberance forevermore associated with baroque Mexico: "Everything was equally remarkable, superb, serious, peaceful, and wonderful."[153]

1620: despite the opposition of two thousand Indians, the archbishop of Mexico had a miraculous crucifix—that sweated blood and water among a great crowd—come from Ixmiquilpan to the capital.[154] The image was made of *zumpantle* (a native wood) and of "gray paper." *1621:* Luis de Cisneros published his history of the miracles of the Virgin of los Remedios, but without the success that Sánchez would experience in 1648. This same year an extraordinary masquerade took place, offered in honor of the beatification of St. Isidore the Farmer.[155] It was probably

during the 1620s that Urban VIII consecrated the cult of the miraculous Tepepan Virgin in the valley of Mexico.[156] *1629:* the church of the Virgin of los Remedios was built on the same site as the sixteenth-century chapel.[157] *1630:* the capital escaped flooding thanks to the popularity of a miraculous image of St. Dominic. A copy of the painting reached Mexico, and the replicas immediately began multiplying to meet the demand of the faithful.[158]

The same scenarios took place in the countryside. In April of 1631, St. Michael the Archangel appeared to an Indian, Diego Lázaro, in the bishopric of Puebla, the richest diocese in the country. Under the pressing entreaties of the archangel, the Indian finally went to the bishop to tell him of the miracle. One can recognize the model that Sánchez used for his Guadalupe Virgin, with a few variations. Events happened quickly. A first inquiry was held in 1633; already the faithful were rushing to San Miguel del Milagro to enjoy the benefits of the salutary waters, and to adore an image of St. Michael deposited in a neighboring grotto "in memory of his miraculous apparition." The miracle was authenticated, the image installed on an altar, and a solemn mass sung in honor of the archangel. In 1643 the new bishop of Puebla, Juan de Palafox, decided to open a second inquiry. Additional consecration: two years later Pedro Salmerón published the account of the miracle.[159] But the Indian Diego Lázaro, the blessed witness of the appearance, had already had a codex in the ancient style painted with the episodes of his adventure "to [mark] the memory of all of history,"[160] while local pictographic and alphabetical annals—preserved along with the song notebooks—recorded 1631 as the year when "St. Michael's water" was discovered.[161] As in the case of the Guadalupan tradition, a purely native means of transmission preceded the book's intervention. The Puebla bishop, Juan de Palafox, "always extremely zealous about sacred images," encouraged the devotion by having a church built on the spot of the poorer chapel. The inside of the sanctuary of San Miguel del Milagro was soon made richer by statues of the archangel and paintings telling of the apparitions and the history of the manifestations of St. Michael, while the cult reached the region of Puebla and the churches of Mexico. By the end of the century "the entire diocese of Puebla was overflowing with images and statues painted and sculpted of that supreme archangel"; practically every Indian household had one as well as all the Spanish, who kept "his painting carrying the emblem with which he appeared to Diego Lázaro, the golden rod topped

by a cross" in their oratories.[162] But one could write the same about images of the Blessed Virgin.

The 1640s seem to have been particularly good for the Marian cult, and not only because it was in 1648 that the Guadalupe Virgin came to know the honors of printing and books. Twice during this decade the image of los Remedios was carried through the capital to fight against plague and drought,[163] while the untiring bishop of Puebla, in his diocese, encouraged the rise of the Marian cult and in particular that of the Ocotlán Virgin, who appeared during the sixteenth century somewhere near Tlaxcala.[164] Still in 1648, the Tepeapulco cross was solemnly installed in the cemetery of the cathedral of Mexico City.[165] The following year, the face of a Blessed Virgin, kept in a sugar mill run by Jesuits, was miraculously covered in sweat. In 1652, an image of Our Lady of la Antigua, copied from a Seville model, was placed in the cathedral. In 1653, 1656, 1661, 1663, 1668, 1678, 1685, and in 1692 for the fourteenth time, the Virgin of los Remedios made the round trip between Mexico City and her sanctuary.[166] As monotonous and tiring as this litany may seem—and it is still quite incomplete—it alone can suggest the invasive role of the religious image and the miracle during the seventeenth century in Mexico.

In 1665 a miraculous image of Jesús Nazareno was created for the new church of the hospital of la Limpia Concepción: an Indian woman had seen Jesus on the Calvary in a dream, and had vowed to get this vision reproduced; only a few mysterious Indians succeeded in providing her with a satisfactory replica that she willed to one of the city's sanctuaries.[167] In 1670 the intercession of Our Lady of la Redonda—whose origins were comparable—caused a torrential rain on which the people had given up. In 1676 she extinguished the fire destroying the church of St. Augustine. The same year a Spaniard had a church built for the miraculous picture of Our Lady of Tolantonco, who had restored a blind Indian's sight.[168] It was in 1679 that a chapel sheltering Our Lady of la Redonda was dedicated, and that the construction of a replica of the house of the Virgin of Loreto began. The work ended with a "miracle" the following year, and the dedication happened amidst "fireworks, remarkable altars, and dances by the natives." A distinguished crowd attended: "Those who could enter considered themselves fortunate, for it seemed to them that they were entering the very house it represented."[169] In 1683, at Chalma, the dedication of the first church built for the worship of the miraculous Christ who had appeared in 1539 took

place.[170] Five years later, in 1688, the Ixmiquilpan Christ regained his original beauty; the *renovación* was said to be a miracle and the chaplains of the convent of the Discalced Carmelites of St. Joseph claimed official acknowledgment for it. During this time, miracles and prodigies, healings, saving rains, and spectacular conversions all took place one right after the other. There was always an effective image to avoid disaster just in time.

Churches and convents overflowed with images, but individuals were not to be outdone: at the very end of the century don Alonso Gómez, the generous host for the endless curiosity of the Neapolitan traveler, Gemelli Carreri, prided himself on owning the effigies of all the year's saints, or more exactly, "their costumes and their heads," and took it upon himself to accompany the image of the day's saint to the cathedral. Moreover, every morning he put "five statues and two engravings of saints in his oratory with many devotions and at much cost." It was enough to surprise even a Neapolitan during the height of the baroque era.[171]

Florencia, the Great Orchestrator

During the second half of the century, a swarm of priests—the Society of Jesus at their head—and other individuals contributed to the growth and success of these devotions. It was the Jesuits who built welcoming structures—a hospice—for the sanctuary of San Miguel del Milagro[172] or who spread the worship of the Virgin of Loreto. One episode sheds light, in passing, on the manner in which the statues were replicated. The father Juan Baptista Zappa had brought a head of the Italian Virgin and another of the Infant Jesus to Mexico, "copied perfectly in all aspects from the excellent images that St. Luke sculpted, carved, and colored in flesh tones at Nazareth;"[173] as was customary, images were created from these fragments, and came to enrich the capital's heritage.

The Jesuit Francisco de Florencia then became one of the ardent propagators and orchestrators of the baroque image in New Spain. A Creole born in Florida around 1620, he entered the Society of Jesus when he was twenty-three, at the same time Sánchez was planning the writing of his *Imagen de la Virgen*. A major interpreter of this watershed period, Florencia imperturbably collected and recorded the customs, became involved in trying to organize and structure them into coherent wholes, and also spent his time trying to find precedents, symmetries, and parallelisms on

either side of the ocean. He magnified the miraculous triad that the sanctuaries of Guadalupe, los Remedios, and San Miguel del Milagro formed—"the three are heavens on earth"[174]—just as he glorified the bulwark created by the four Marian images around Mexico City: Our Lady of Bala to the east, Our Lady of los Remedios to the west, Our Lady of la Piedad to the south, finally the Guadalupe Virgin, the "North Star of Mexico," to repeat the title of the Floridian Jesuit's work she inspired. "Is [the] correspondence of these four images of prodigy with the four poles of the city—if one can put it this way—purely a coincidence? Is it a coincidence if those of the East and the West are both identical in shape and size? . . . The four corners of this land are due to the Lord and Our Lady."[175] This was enough to seduce not only our Jesuit, but also the future practitioners of structuralist dissections.

From Florencia's mystical ramparts to the walls of Franciscan images, there is quite a gap separating baroque enthusiasm from humanist didacticism. The Jesuit used his flowery prose and his touch with formulas for numerous images. In 1685 he dedicated an essay to the Virgin of los Remedios, endlessly titled *The Miraculous Invention of a Hidden Treasure Found in a Field by a Fortunate Cacique.*[176] Brought over from Europe, perhaps installed on the Templo Mayor in place of the overthrown idols, before being lost then miraculously found again ("the hidden treasure") by a native cacique, this image became as important as the "North Star," the Guadalupe Virgin. Forever victorious over the idols, she offered herself up to the adoration of the faithful among the gold and crystal shimmering in the light of countless candles: "The miraculous image is in the center of the tabernacle, behind a crystal screen; the inside of the alcove is decorated with so many precious objects and priceless gems that when one discovers the image, it appears to be a sky of magnificent glittering stars in the shine of the lighting and the lamps that constantly burn in her chapel and on her altar. . . . Our Lady's throne is entirely surrounded by balls of amber decorated with gold, that make it a paradise of smells."[177] This is the magic of "special effects," without which the baroque image would not exist. Chronicler and tireless propagandist for the sanctuaries of the Blessed Virgin and their miracles, Florencia spares us neither the introduction to the worship of Our Lady of Loreto—*La Casa peregrina* dates back to 1689—nor the Ixmiquilpan crucifix—"before and after its miraculous renovation"—nor the Chalma Christ (1690) or the devotions of northwestern Mexico, in what was then called New Galicia (1694).[178]

As for the Franciscan cartography of the miraculous image, it was created by the chronicler Augustine de Vetancurt, who did not suffer the scruples of his distant predecessors and counted in his census—with the same passion as the Jesuit—more than thirty miraculous images, as he says in his *Teatro mexicano* published at the end of the century: "There are in the [Franciscan] province many other images and if one were to write of them, numerous treatises would still not be enough to finish this history."[179] Virgins lifting their eyes, shifting their head, stretching out an arm, moving around; St. Veronica sweating great drops of liquid, the Infant Jesus with tears of blood; Christs bleeding or whose body would swell up and be covered with reddish blisters; images looking at other images: the systematic anthropomorphization of representation was the rule. For Vetancurt the Franciscan, the Marian image was at the same time a presence of the divine, and the perfect replica of this divinity; whence these words said to come from the Blessed Virgin: "I am within the painted or sculpted images so therefore, assuredly, I am present through them when I work miracles."[180]

It was no coincidence either that the last decades of the seventeenth century, so rife with hagiography, saw an explosion of baroque painting, splendidly illustrated by the works of Cristobal de Villalpando and Juan Correa. From 1684 to 1686 the sacristy of the cathedral of Mexico City welcomed a fresco grandiose with lights and colors, the *Apotheosis of St. Michael,* as it was commonly painted during those times. The Virgins of the Apocalypse, the militant and triumphant Churches, the Triumphs of the Eucharist followed one another and set the tone. Baroque triumphalism threw its sumptuous battalions of muscled yet delicate archangels everywhere, while clouds of melodious angels restated the place music occupied in this exaltation of the image. The artistic program repeated itself from cathedral to cathedral: Puebla and Guadalajara both wanted, and obtained, their triumphs and apotheoses of the Eucharist, while the replicas of the Guadalupe Virgin swarmed under Correa's paintbrush and invaded the sanctuaries of New Spain and Spain, as Miguel Cabrera's copies would during the eighteenth century.[181]

Mises en scène and "Special Effects"

Frequent travel through the jungle of baroque images increases the risk of becoming lost, of being stunned by the proliferation of representa-

tions, the prodigies of colonial rhetoric, the endless relay of thurifers, the suave ambiguity of its angelic cohorts. And yet this image's multiplication and ubiquity did not exhaust its specificity. It existed only by means of a place, a scenography, and certain sensory devices. The scenography of the miracle and that of the sanctuary echoed one another's answers. The Jesuit Florencia mustered all his talent to depict the scene of St. Michael the Archangel's apparition at San Miguel del Milagro, to suggest "the beauty of the glorious archangel; the surroundings where, portrayed as two very beautiful boys, two other angels approached the Indian; the manner in which the shrubs of the ravine bowed down, and how the rocks parted at his sight; the light emanating from everything and that illuminated him as if it were daylight."[182] What was emphasized here was the illumination, the bright light, the miraculous water that shone; the Virgin of Ocotlán also chose to appear in an orgy of light: "everything burned as if it were the Etna."[183] Nor was the acoustic environment neglected either: in order to describe the framework of the Guadalupe Virgin's first apparition, Sánchez lingered over "the well-ordered chorus or the heavenly chapel": "Here one Saturday . . . an Indian was passing by, and though he had been converted not long ago was fortunately advised, for he stopped, very surprised to hear soft music, harmonious consonances, attacks in unison, accomplished counterpoints and resounding strains."[184]

The retables, paintings, and frescoes narrating the apparitions, the edifying theater recreating them, the liturgies brilliantly orchestrated by local compositors of the talent of Antonio de Salazar or Manuel de Sumaya (a contemporary of Bach and Vivaldi) all relayed these baroque scenarios to the illiterate crowds.[185] In 1656, for the dedication of the cathedral of Mexico, no fewer than four High Masses were celebrated simultaneously, a tour de force that brought together all of the capital's notables and ecclesiastic dignitaries. The framework offered by the sanctuary itself carried just as much effect, if one considers that the architecture of the seventeenth and eighteenth centuries made the inside of the church, or sometimes its facade, into gigantic image shows. The retable displayed a program defined by the painter and his patron along the entire height of the nave: an iconographic program whose balance had been well thought-out, loaded with symbolic elements (the vine, the Solomon's or twisted columns), and placed under the sign of gold, whose unchanging luster evoked both purity and terrestrial riches. The effect of

the relief-work and the play of lighting on the gold leaf encouraged the gaze to alight on the precious metal everywhere.[186] Would the baroque image have been as radiant without Mexico's gold? Constant improvements were made to the image's container (cabin, grotto, hermitage, chapel, church, then basilica) as the devotion grew and the offerings accumulated.

The manner in which the image was produced undoubtedly fed the fascination it occasioned. The festive scenarios offered endless examples of this, as did the dedications of altars and chapels, the great rituals of the Church, the processions and masquerades punctuating the life of the capital and the populous cities of New Spain. Religious holidays invaded the visual field, dotted urban space, opened avenues and transformed them into gigantic decors by the careful placement of stages, platforms, catafalques, silver sepulchers with crystal walls, and triumphal arches under which processions, parades, horses and carriages wound along. Let us add the shimmer of lighting on churches and palaces at night, as well as the surprise of fireworks, and the help of musicians and choruses.

On the occasion of the beatification of St. Rose of Lima in 1671, the procession left the cathedral to reach the convent of St. Catherine of Sienna carrying the gem-covered statues of St. Ignatius of Loyola, St. Peter Nolasco, St. Teresa, St. Augustine, St. Philip of Jesus, and St. Francis. When the procession reached the convent, the Blessed Virgin came out "to receive her dear Rose and her father St. Dominic."[187] This was the height of anthropomorphization and the animation of images amidst festive exaltation. We are now at the furthest point from the Protestant world that decried the accumulation of festivals as superstition and idolatry.[188] But this is exactly what allowed the baroque model to penetrate the native and mestizo worlds, and to maintain a consensus of beliefs and practices over time.

Territorialization and Sacralization

The insertion of the image into a physical environment is never an indifferent matter. The image of the Guadalupe Virgin was linked to the Tepeyac Hill, "a crude hill, rocky and barren,"[189] where she had demanded that a sanctuary be built; that of los Remedios was linked to the hill of the same name with such strong ties that the statue obstinately returned to the place where she was discovered, where once a year a

mysterious light was said to shine;[190] even St. Michael the Archangel appeared on a mountain. The Jesuit Florencia seized the occasion to hold forth on the Saint's predilection for "high places," and concluded, after having referred to the Guadalupe Virgin and that of los Remedios: "All three [sanctuaries] are heavens on earth."[191]

The apparition, then the image, allowed Christian divinity to establish and make concrete the absorption of a pagan space that was devoted, or supposedly devoted, to idolatrous cults, such as the goddess Tonantzin on the Tepeyac. The appropriation happened through intermediary images, since the Blessed Virgin was the "form of God" and the archangel was the "seal of the semblance of God," their images harking back to originals which themselves were meant to be images of divinity.[192] The removal of the demon—a desacralization of the pagan space along the same lines as the Cortesian decontamination—was the preamble for an immediate Christian "resacralization" that the image performed. The expulsion was always spectacular: "All of a sudden there arose a great whirl of contrary winds with great howls, groans and voices coming from it, and an awful din as if troops of people were fleeing from there."[193] The Christianized place then became inviolate, "taboo," in a certain way. The miraculous spring of San Miguel del Milagro dried up when a family washed their child's diapers in it; the expulsion of the guilty party (*violadores*)[194] from the sanctuary immediately brought the miraculous water's return. In Mexico City, a man who had secretly sneaked into the house of Our Lady of Loreto and had mortally wounded its sacristan was punished by death on the spot by the Blessed Virgin.[195]

Territorialization could take on unsuspected dimensions. Throughout the sermons dedicated to her, the Guadalupe Virgin was the object of boundless harnessing. The Tepeyac Virgin, María de Guadalupe, was the Blessed Virgin par excellence; the Virgin was Mexican before being celestial, and Mexico, thus magnified, became the chosen land, the Blessed Virgin's "cradle": "Mary was born in Mexico City, and that is where she lives."[196] The preachers took the bit between their teeth; for them, as well, it was not a matter of giving American roots to replicas of European cults, but of establishing the superiority of the New World over the Old, and even—why not—of Mexico over the Heaven that the Virgin abandoned in favor of the Tepeyac Hill: "She took all of Heaven away with her, to be born with it in Mexico City,"[197] as if any sacralization contained within itself a desacralization, even if it were to come from Heaven.

Because they formed sacralized anchoring points, one could imagine that images created a silent compromise between Christian monotheism ("divinity is indivisible, and cannot be split") and native "idolatries," that is to say, a paganism saturated with idols and cult objects: "Their gods were so numerous that one loses track when trying to count them."[198] This compromise would be complex if one were restricted to the use the baroque Church made of the image. It is true that through their power to multiply, images spread the divine everywhere; but images also established, in the name of some intangible orthodoxy, a uniform and standardized framework. Images rose up everywhere, imposed their anthropomorphic canons, and manifested an order of representation theoretically based upon the interplay of copy and original. Despite their "polytheistic" proliferation, and no doubt because of that very proliferation in the hands of the Church, baroque images in fact undertook a vast process of circumscription and confinement of the sacred. Inasmuch as yesterday's adversary—the Conquest's great demonic idol—existed no longer, from then on images would perform a systematic delineation and classification of the objective world. The poor, dreary, aberrant, and desacralized horizons of the profane and of superstition were meant to reemerge from the reality defined by the Church when confronted with the divine that was concentrated within the relic-image, the apparition or the edifying vision. For these ubiquitously located war machines, the target to be shot down was no longer the idolatry of statues and temples, but indeed that of the shapeless world of insignificant, perishable objects, things lost and found over and over again, where the shreds of the ancient world still clung: "the vial, the packet, the dried jumble, the decorated scrap, the string tying together seemingly useless leftovers; in short, anything."[199] The image intended to focus back onto itself an anticipation and a belief, an *imaginaire* that the Indians, throughout the seventeenth century, continued to divide among signs of Christianity, rivers and hills, the small idols they sold, the sacred bundles they hid in their hearths, an amalgam of plants, statuettes, often shapeless debris that no one, however, dared to touch or destroy yet.[200]

The Federating Power

It is obvious that each religious order exploited the prestige of the images associated with it. Symbolic capital perhaps, but also at times hard cur-

11. *Spaniard Giving a
Virgin to an Indian,*
eighteenth century.
Actopan Convent,
Mexico City.

rency. As the Franciscan Vetancurt had done for his order, Calancha in
seventeenth-century Peru and the Mexican Sardo at the end of the colo-
nial era proudly enumerated the images that had contributed to the glory
of the Augustines in America and Spain.[201] But the great miraculous
image played a role that went beyond purely local or class patriotism; it
extended a common denominator to the groups and milieus composing
colonial society; it attenuated the profound heterogeneity of a world
that ethnic, linguistic, cultural, and social disparities made more frag-
ile and separated to extremes. The image, deliberately, was called *vinculo*
(bond, tie, or link): an inalienable and perpetual bond, the ties of an entire
diocese (illustration 11).[202]

No matter that the prodigy happened within the Indian community:
rumor spread quickly in the mestizo and Spanish world.[203] Laymen or
priests, men or women; the witnesses to the miracles, the faithful and the
pilgrims came from all layers of colonial society. Unanimity governed the
destiny of these cults; the highest authorities, viceroys in the lead, vis-
ited the sanctuaries, worshipped the images, tried to rival each other in
generosity. Religious festivals, dedications and consecrations, beatifica-

tions and canonizations, crownings and translations of images, or even autos-da-fé provided repeated occasions for immense gatherings around the saints, each time renewing spectacular acts of allegiance that fed the colonial society, a society, let us remember, where power had few outlets for mobilization and intervention because it lacked an army and an adversary at the borders for whom to drum up troops. The movement of the faithful throughout the viceroyalty asking passers-by for contributions for their Virgin and selling engravings of her tightened the links of collective piety. The copy accompanying them in their peregrinations caused miracles just as did the original; villages welcomed it "with pealing bells, trumpets, arches, incense, kettledrums and other shows of rejoicing . . . ; notably the Indians . . . who never tire of seeing and saluting her. . . . A few hours after the arrival of the image, they obtain engravings of it for themselves."[204] The circulation of images irrigated the farthest reaches of the country, retransmitting everywhere that which the urban festival exalted only periodically.[205] The baroque image took on a unifying function in the midst of an increasingly hybrid world that mixed processions and official mises en scène with an endless range of entertainment, from indigenous dances to "dances of monsters and masks with various costumes as is the tradition in Spain."[206]

The Treasures of the Image

St. Philip of Neri covered in a chasuble flooded with precious stones, St. Francis-Xavier weighed down by two hundred thousand pesos worth of jewels, canvases trickling with painted topazes and diamonds: the baroque image was one of opulence. Loaisaga wrote: "I don't know where my Mistress and Lady got the nearly one hundred thousand pesos they have already spent for the jewels and decoration of the sanctuary. I do not know where so many diamonds and such precious stones have come from." For the priest of the Ocotlán sanctuary, the prosperity of the place only brought the poverty and decadence of the Tlaxcala region during the eighteenth century more into contrast.[207] The image of Ocotlán, just as those of the great sanctuaries, was the center of an incessant, "exorbitant" consumption: wax to be burnt, pearls, precious stones and metals, but also masses that were bought, song and music that depleted the alms and the gifts. Everywhere was the image of treasure: "Ah! if the world knew what God hoards in this simulacrum!"[208]

One might recall that the idol had already been associated with gold, the object of all covetousness and the pretext for any destruction. The Christian image, in its own way, hypostatized wealth, since a spiritual treasure was erected upon the temporal treasure that it magnified. One could admire its gleam and beauty, just as one lingered over its cost. This time the fetishizing worked in two ways: the occlusion of the production generating the wealth was superimposed onto the occlusion of the human origins of the image, quite excessively in this case. The colonial world was reputed to be a place of rapid, heady fortunes, one of ostentation and expense whose wealth was bestowed on the sanctuaries and images in massive quantities. The "unproductive" hoard seemed to many to be one of the drives—or one of the flaws, rather—of baroque culture and New Spain. There could be much to say about this "unproductivity" and this "irrationality." Mass consumption, in fact, ensured that the image worked properly, was inherent to it, and indispensable. The image irrigated infinite networks of sociability and exchange that united the colonial society; it recuperated and annexed autochthonous practices. The profligacy of material and human offerings once destined for the gods might seem to foreshadow colonial behavior. Such acts, moreover, had delighted the monks, who went into raptures over the innate religiosity of the inhabitants of the New World.[209] During colonial times the ceremonial banquet—agapes and drinking binges—remained a major component of native Christianity and the worship of saints.[210]

In the grip of these processes of fetishization, the *imaginaire* of the image was thus equally tributary to a dynamics of consumption that followed quite diverse paths: the modest circulation of offerings, shared food and drink, incense, altar candles and copal, or lavish donations. A consumption that allowed, drew out, and multiplied the intervention of the group and of the spectator onto the image, by breaking that which could otherwise only be an ecstatic passivity.

Public Images, Social and Political Images

The baroque image was not only a miraculous effigy or an object to be worshipped. It also designated a quite other range of minor representations that mixed together the political, the allegorical, and the mythological. The plan was analogous. Once again, as always, the point was to make the crowds and heterogeneous cultures share a single *imaginaire*.

But this time the religious ends were replaced by political intentions. The image glorified power at the same time as it informed people of the prince's accession or death, the viceroy's arrival or the bishop's entrance, the celebration of European victories and peace treaties.

The cenotaph erected in memory of the emperor Charles the Fifth in 1559 became the first grandiose occurrence of this type of imagery, while it also marked the introduction of mannerism into New Spain. Mythological scenes were mixed with historical reconstructions: among those tableaux we find *The Labyrinth of Daedalus,* where we see a goddess removing Ulysses' crown and placing it on the brow of Charles the Fifth; Apollo, "symbolizing the University"; but also Cortés before the Emperor; the city of Mexico City the day after its defeat, "with numerous burnt and broken idols"; Cortés yet again, "throwing down Huitzilopochtli from the Templo Mayor." The interest this iconographic program took in the events of the Conquest is remarkable. The sinking of Cortés's fleet, the destruction of the idols of Mexico City, Cuauhtémoc's irons, Montezuma's and the Inca Atahualpa's submission: the portrayal of these scenes all set in place the clichés spreading the official version of history and proposing a political *imaginaire* that glorified the conquerors and their distant and defunct leader. But if the cenotaph was the first of its kind, it was also in a certain way the last, since other achievements that followed in the seventeenth century rarely tried to inscribe Mexico's history into the celebrated event anymore. One must ask oneself if the iconographic program of Charles the Fifth's cenotaph was not the profane counterpart for the Franciscan image, itself carrying a didactic memory that was strongly anchored to a local reality, or to that of the Indies, and also futureless.[211]

Long bogged down in abstruse and aestheticizing rhetoric, prey to flashy but empty techniques, the political image underwent a clear weakening that corresponded to the retreat of the Franciscan image and the rise of the miraculous image. The triumphal arches and allegorical spectacles that periodically took place until the Enlightenment diffused a range of representations whose symbolism and hermeticism attained unequaled heights. Built of wood made to imitate marble and jasper, the triumphal arches were covered in painted canvases and "decorated with many stories of ingenious erudition."[212] "Stories, enigmas, most ingenious Latin and Spanish sayings, quite elegant and sententious": here we find the entire apparatus of a refined culture that seems more intent on

maintaining its ties to the metropolis than espousing a particular political stance. Hence the debauchery and the piling on of mythological allusions. The arch erected in honor of the viceroy Luis Enriquez de Guzman in 1650 took poetic license with the Perseus legend and staged myriads of pagan gods: Venus, Ceres, Amphitrite, Themis, Jupiter;[213] three years later the new archbishop was compared to Apollo and offered an arch that related the god's "fable"; the same year, the viceroy was acclaimed under the name of the "Catholic Mars." On this monument Philip IV was represented as a sun, and presented Mars—the viceroy—with a solar wheel.[214] As with other arches, and for a good reason, this one was also "explicated." In 1660 the viceroy Count de Baños was represented as Jupiter; in 1664 his successor as Aeneus; while as the funerary monument erected in 1666 in memory of Philip IV made the ruler into the king-priest Numa Pompilius.[215] The tradition of arches and funerary monuments continued into the eighteenth century with ancient and mythological themes—Bellerophon in 1716, Ulysses and the Emperor Maximin in 1743, Apollo, Atlas in 1746, Aeneas in 1756—and more exceptionally, biblical themes, such as the Maccabees in 1732.[216]

A close relationship linked the triumphal arches to the altars erected in the churches. The preachers strove to tie them together even more closely: "To dedicate an altar is the same thing as erecting and dedicating a triumphal arch."[217] It was the same undertaking, the same concept that was intended to consecrate the triumph of the divinity or the prince. But in contrast to the religious image, the political image was ephemeral, and the arches and decors disappeared as quickly as they were built without enjoying the lasting quality of the saint's representation. The political image was apparently contradictory, since it aimed at celebrating the grandeur of the prince in a public fashion, yet did so at the price of a proliferation of scholarly erudition whose hermeticism escaped the Indian, mestizo, black, and mulatto crowds, as well as the *petits Blancs* invited to come admire these constructions that only lasted a day. Political images were systematically encoded: allegory and emblems were a must, as an opuscule (the *"Imagen emblemática"*) for the arch erected in honor of the viceroy Duke of Veragua expressed. A painting codified, and commentaries deciphered.[218] It is true that the religious domain did not escape from the passion for allegory and symbol: St. Isabel, for example, became a mystical Cybele of the Church for at least one dedication.[219]

But if the image of worship had a presence and an immediacy that

were missing in the political image, the latter, on the other hand, was saturated with meaning, since its mission was to illustrate plastically the poet's chosen program and images. Very naturally, then, it became an image to be read and to be decoded, a seductive game for the cultivated mind and lover of enigmas:

You who guess and
Know everything about emblems,
But who relish the best:
What and which is that thing so clear?[220]

That the arch was always commentated and "explained"[221] resolves nothing, for this "deciphering" expressed itself in a language whose sophistication and complexity, ultimately, equaled those of the image.

One might be inclined to conclude that the "political" image failed when confronted with the deep and lasting success of the "religious" image. The attachment the Mexican people feel to our day for the Blessed Virgin of Guadalupe might then become the best example of a successful graft, while the colony's revolt at the beginning of the nineteenth century would illustrate the weakness of the political system and its means of propaganda. This might establish a misleading parallel, however, between the two kinds of images, and would become an improper reading of the boundaries of the political and the religious. In fact they constantly overlapped, as much as those of the profane and the sacred:[222] during a celebration of Corpus Christi, the most magnificent religious solemnity of the year, had they not decorated the *calle de Plateros* with a battle scene representing the conquest of Mexico, and notably "the way things were then in the city"?[223] The scope of the Guadalupe Virgin's worship apparently went beyond the domain of pure devotion to encompass eminently political and sociocultural strategies as well. Similarly, the images of power seemed to serve social and intellectual ends in addition to political ones: one had to show the newly arrived authority figure, viceroy or archbishop, the brilliant qualities of the colonial intelligentsia; confirm, through these practices, New Spain's ability to equal the metropolis and to follow its fashions; and affirm to the rest of the population a superiority that was beyond their reach. There was a certain "class complicity" between the courtiers and the people of Mexico City, as well as a local display of a body of knowledge that was more than honorable.

It is obvious that beyond the usual clichés such as a call for clemency or best wishes for prosperity, these cryptic messages also allowed the sponsor (the city, the ecclesiastical authorities) to express complaints or desires while surrounding itself with elaborate precautions and diplomacy. What was it, on the arch erected in 1660 in honor of the count de Baños, that Jupiter, taking the cup of nectar from the nymph Hebe's hands to give it to Ganymede, was meant to represent? If the new viceroy was being portrayed here as Jupiter, which group was hiding behind Hebe or Ganymede?[224] The Creoles used the political image in passing as a pretext for affirming an identity, for claiming a glory that the metropolis often denied them, and even as an excuse for drawing new inspiration from Mexico's past. This was what Carlos de Sigüenza y Góngora did. This mathematics professor at the University of Mexico, formerly expelled from the Society of Jesus, had been entrusted with the design for a triumphal arch that was to celebrate the arrival, in 1680, of the viceroy, the Count of Paredes and Marquis of Laguna. For the first time, ghosts of a past that had seemed drowned, pre-Hispanic figures, appeared on the "device": the kings of Mexico, from Huitzilopochtli to Montezuma. But the Gongoran innovation restricted itself to enriching the symbolic repertory: Acamapichtli represented hope, Huitzilíhuitl clemency and indulgence, Itzcóatl prudence; all were accompanied by Latin inscriptions. It was thus a game of scholars for an intellectual public, those *erúditos* whose approval Sigüenza y Góngora was seeking.[225]

The political image was thus public yet confidential; it became bogged down at the end of the seventeenth century as the artists produced images that were more and more gratuitous and without any apparent connections, in an empty display of technique.[226] In fact, the *imaginaire* of the image of power was not that of the image of worship: it responded to expectations, to intellectual reflexes and reading frameworks that stopped at the boundaries separating the colonial elite from the urban and peasant masses. Its games and its stakes obeyed the changing states of the local power map.

An immense majority of the population remained excluded, more receptive to the parades whose baroque pomp adorned all manner of festivities by producing a spectacle that globally encompassed, after the viceroy and his "family," the court; the archbishop; the judiciary, ecclesiastic and municipal authorities; the indigenous nobility; the university; the Inquisition; the corporations; the brotherhoods and the black, mu-

latto, Indian, and mestizo crowds. But this image of the social arena was better accomplished through the Church liturgies and sanctuaries than at the foot of triumphal devices about which the established poets wrote endlessly.

The allegorical, symbolic, and mythological "devices" were far from being a Mexican, or even a Hispanic, oddity. Their equivalents could be found thousands of miles away in the fog of English lands. But what was called *civic pageantry* in the realm of the Tudors and the Stuarts fulfilled an entirely different role; it had a clearly and "heavily didactic" function;[227] and its visual impact was made even stronger by the fact that the Reformation had banished Catholic liturgies and images of worship, and that the image of the sovereign, Elizabeth the First—the Virgin Queen, "as God-ordained ruler"—had a tendency to be ubiquitous. English political power thus enjoyed a sacralization that was partly drawn from the worship of images.[228] "Civic pageants" followed the lineage of medieval dramaturgy, and addressed crowds long since familiar with the language of allegory and morality plays through tradition, theater, and books. There was nothing similar in Mexico, where the profane theater and books had only a restricted influence, and especially where the potential spectators often had indigenous or African ties, or were completely rootless and devoid of ancestral memory. The religious image ruled— whether dependent on, or in competition with, that of the King.

If one were to establish any connection between the political image of baroque Mexico and an English image, it would probably happen in Peter Greenaway's films. Bursting with meaning, heavy with emblems and allegories, replete with art and literary references, the Greenaway- image can distill a refined and secret pleasure from the colony's poly- chrome arches. Perhaps it is no coincidence that the demented counting of the stars that opens *Drowning by Numbers*—imaginary stars with pseudomythological names—is given to a little girl straight out of a Velázquez painting, or that the fantastical astrology this child declines is the unexpected echo of the mystical zodiac of the New Spain poets. For Greenaway's image, just as that of the baroque devices, marks one of the poles that the image can reach in our cultures: both indicate, three cen- turies distant from the other, a construction by a tightly controlled mind, the height of artifice, the obsessive will to compose an image that will better escape the seduction of illusion: ". . . this is not a window on the world or a slice of reality."[229] It is an image that excludes a passive and

ephemeral adhesion as well as an active or hallucinatory abandonment of belief, an image to be deciphered, secreted by an *imaginaire* that is always scrupulously waymarked: "The boundaries are invariably marked."[230] In short it becomes the antipode—and perhaps the antidote—of the image of worship in its paroxysmal version, Lasso de la Vega's "Second Eve," the miraculous Guadalupe Virgin.

The Shadow of the Holy Office

The triumph of the baroque image, let us emphasize, was based on minimal coercion and repression. The ecclesiastical authorities devoted themselves more to exploiting the popularity of the worship of images by any means possible than pursuing lapses and excesses. They did, after all, welcome the miraculous traditions quite warmly. They also accepted the tales of prodigies and the Mariophanies consecrated by Sánchez's Guadalupanist work without the slightest examination. It would be easy to multiply the examples of this "openness" to the miraculous, to local traditions and collective rumors during the seventeenth century.

It was not that the Church kept from interfering in this domain. But it did so without fuss or muss, other than when the Protestant peril seemed to hover an instant above New Spain. Very early on, under the archbishop Montúfar, measures were taken to regulate the production of images and to watch over those that were in circulation. The mechanism that was put in place by the Mexican council of 1555 was reworked and completed by the Inquisition (1571), establishing serious fines that punished offenses to the image (*ofensa de imagen*); as for the other crimes it pursued, the punishment could include torture, reconciliation, and the release to the secular arm.

In reality the tribunal had little chance to act rigorously against the creators of such images or their owners. As for the incriminating images, it had them destroyed. However, if one detail were found to be shocking but the rest of the work seemed to be acceptable, the intervention of the inquisitors often limited itself to imposing a few touch-ups.[231] Since, in any case, the Indians were outside the Inquisition's jurisdiction, the repression of idols and idolaters fell exclusively to the ecclesiastical province judges and to the ordinary diocesan courts, in this case the *provisoratos*, the equivalent of the officials of the Ancien Régime. If it happened that the Holy Office needed to deal with this type of affair, it was because

a Spaniard, a mestizo, a black, or a mulatto, seduced by native practices, had been convicted of having owned or worshipped idols.

During the sixteenth century the Inquisition devoted most of its attention to watching over the foreign printing groups likely to produce or introduce wicked books and images. The Lutheran menace haunted the last few decades of the century. One of the first edicts of the Inquisition (1571) was concerned with heretic images featuring "improprieties, titles and inscriptions of a base nature or that could denature it . . . , often mixing sacred items with profane and ridiculous ones."[232] It incriminated an image—printed in Paris or Mexico City—of Our Lady of the Rosary in particular, whose author was thought to be a Frenchman from Agen who had emigrated to Spain, then to America, as it was said to show reprehensible inscriptions.

Juan Ortiz was an "engraver of images on wood." Witnesses accused him of having denied the miracles of the Virgin of Montserrat whose image had been shown to him, and of working on holidays without observing the saints' days and the day of the Virgin Mary.[233] Inspired by a book on the rosary printed by his patron—a Frenchman from Rouen who had moved to Mexico City—and a bull he was said to have seen in St. Dominic's convent, Ortiz was said to have "carved the shape" of an image of the Virgin of the Rosary. Most of all, he had composed and added a caption that led one to understand that the recitation of the rosary would be enough to guarantee God's grace to the person making the devotion. Hundreds of such images were purported to have circulated through Mexico City.[234] In the eyes of the inquisitors the caption "had a heretical twist" and the denial of the Virgin's miracles was not welcome: "It might be true, but it rings falsely, displays little devotion and attachment for Our Lady and her miracles, and [shows] the temerity of the one pronouncing it."[235] To tell the truth, the Inquisition appears to have mistrusted a group of Frenchmen—Pierre Ocharte, Juan Ortiz, and a certain Antonio—who seem to have picked up some Lutheran ideas.[236] These Frenchmen were even more dangerous for their prominence in the little world of Mexican printing.

The Inquisition also watched fairly closely over the circle of painters and the importing of paintings. The commissioner of the Holy Office on duty in Veracruz examined the imported works, noted the religious and profane styles (*a lo divino, a lo humano*) "in the manner and fashion of the Flemish," was astonished or even scandalized at certain audacities that

seemed to go "beyond the norms": "It looks like the Temptation when Christ found himself in the desert and they paint the demon as a very disreputable young lady, with bare arms." One wonders if it was not a question of taste ("because it is a new thing") more than the theme that shocked the expert in that year of 1586.[237] In 1573 already, mannerism had troubled the dean of the Guadalajara church, who worried at the sight of a "quite curious [Virgin] with unbound hair, whose chest was covered only by a slight veil, and whose throat was bare; She had Her Child in Her arms; the [Infant's] chest was entirely bare, and He had sleeves of gold cloth under curious curtains, and on a brocade cushion, His ear was completely uncovered." Puzzled, the dean limited himself to asking the tribunal of Mexico City for instructions.[238]

Painters, just as printers and engravers, were also frequently foreigners—Dutch, German, or Flemish—and for the most part very close-knit. The Flemish painter Simon Pereyns, who had landed in 1566 with a viceroy's retinue, was at odds with the Inquisition over a matter of bigamy and certain misplaced comments about the images of saints to which he preferred profane portraits, so that the Holy Office made him paint, at his own cost, a retable for the Blessed Virgin.[239] Cornelius the printer, a Harlem native, was accused in 1598 of not revering images "spontaneously, but [doing it] only by obligation."[240] He had worked with the widow of the printer from Rouen, Pierre Ocharte, and with painters (Adrián Suster, Juan de Rua, Balthasar de Chávez), retable assemblers (ensambladores) such as Juan Rolón, as well as with clock-makers. This was a disquieting milieu: it was deemed suspicious, like the beautiful painting of the city of Nimègue seized at Cornelius's house—"quite a good city, for it was decorated with many temple capitals." Nimègue had been taken by the heretics, and it was postulated that the printer Cornelius might be one of them. The image revealed too much.[241]

After the seventeenth century it seems that the production of images no longer created many problems. The policies for this area were well set up, the traces of Lutheranism had faded—if indeed they had ever posed a serious threat to the Mexican Church. The painters were faithfully fulfilling their assigned mission. During the colonial era the Inquisition preserved its mission to eradicate or correct defective images and to protect the worship of the proper images, but it never made that a priority. It was much more concerned with the heretics, libertine priests, or books put on the Index, not to mention a predilection during the first half of the

seventeenth century for the *conversos* or crypto-Jews whom, among other things, the Church blamed for despising or defacing Christian images.[242]

Indeed, the Inquisition was aiming for the inculcation of the *reverencia* owed the images[243] and the consensual condemnation of irreverence (*desacato*). There was no politics of great scope on the matter, nor even an intermittent campaign, but rather a fairly feeble piecemeal response to denunciations by zealous priests or "well-intentioned" neighbors. For example, a priest noted an image with an altered inscription; a neighbor gave testimony about the blasphemy he heard from one of his own relatives; a mulatto woman discovered the burnt remains of a painting and hurried to tell her confessor; a Spaniard maintained that the image of a saint was only a piece of wood, a *tetzquautl,* and provoked the disapproval of another European who answered, with the unanimous approval of the local Indians, that "it was true but it was his image and his semblance, and that as such, it should be respected;"[244] natives denounced sermons questioning the worship of images.[245]

Still, this "blow by blow" was generally reduced to an exchange of letters, or to the opening of an inquest that rarely commuted into a trial. This minimal interest was explained by the slightness of the denounced crimes themselves. One heard few scandalous sermons against the worship of images. The breaking of images was more the act of an exasperated individual, or a passing fit of madness, than one committed by true iconoclasts. The verbal attacks against the images called bits of wood (*unos palos*) had the same source, which is why the Inquisition always took care to establish the "emotional and affective" circumstances surrounding the crime to bring it back to proper and trifling proportions. Profane misappropriation, or more simply, the reuse of certain images, did not always go unnoticed: plates featuring St. John were used to retin a cauldron; engravings were put to intimate and hygienic use always found out and denounced by some good soul; images were thrown in the trash. More serious perhaps were those representations of the devil that it was not uncommon to find painted or tattooed on black and mulatto men.

It was less the Inquisition's zeal that prevailed—here more than in other domains, it primarily counted on the regulating impact its very presence would create[246]—than everybody's hurry to watch over the proper use of images and to demand the tribunal's intervention each time they thought it necessary. The crime committed against the image was felt as a blow to the *imaginaire* of all. This reaction reveals that the

imaginaire was threaded through with expectations and confirmations, but also concealed its own means of defense and censure. The faithful were their own police. The triumph in New Spain of the worship of saints could not be better shown than with the interiorization of the baroque image—which did not exclude, however, either controlled skids or more troubling flare-ups of passion.

Defending images was not the Inquisition's only mission. It also had to ensure that hierarchies were preserved, and delays: the image of some-one being beatified or canonized might not have the same right to be worshipped as that of saints, even if the impatience of the faithful jumped the gun of overly slow decisions, or if the crowds became fired up over illustrious figures. The Holy See was the only body that could decide in that case. The memory of Juan de Palafox, the Puebla bishop, preserved by countless engravings, uplifted the masses during the eighteenth century;[247] but already in 1637 the memory of a nun from Carrión had stoked excessive devotions that the tribunal had had to temper by forbidding "crosses, Christs, Baby Jesuses, plates, illuminations, flourishes, por-traits, images, rosary beads, and the relics of Sister Luis de la Ascención, whether they were originals or copies." In 1634 an edict forbade placing "portraits of people that had died in the odor of virtue, with aureoles and signs of glory, without the apostolic Holy See's decision"[248] on private altars and in oratories.

The tribunal also knew how to track iconographic inaccuracies in order to have traditions scrupulously observed: in 1665 all painted, sculpted, drawn, or printed representations on paper or taffetas of a Jesús Nazareno de Mexico were seized, for the Christ was unclothed above the waist, whereas according to the Gospels he was dressed while carrying his cross.[249] On the other hand, it was permissible to surround Our Lady of Seven Dolors with seven or eight swords, unless the number eight were employed "for some superstitious motive, or because of the false revela-tions of a visionary, a crook, or some 'delirious' person."[250]

The Holy Office also happened to remove from circulation those or-thodox images that might lead to discord within the Church: this was the case in 1635 for an engraving of St. Basil the Great that was distasteful to certain regular orders.[251] In 1706 a painting representing the great Italian saint of the Counter-Reformation, Maria Magdalena de Pazzi, caused feelings to run high for a while throughout the colony. The Decalced Carmelites defended their saint, "onto whom Christ, in the guise of a

seraph, imprinted His very holy wounds, bleeding, visible and palpable," with enthusiasm. The image, however, unleashed the opposition of the Franciscans, who considered, according to a bull by Sixtus IV, that the stigmata were the exclusive privilege of St. Francis. They quibbled about the shape of the stigmata, the Carmelites explaining that from the Christ's wounds "five rays of reddening fire come out, ending up on the hands, feet, and side of the saint, who was in position to receive them."[252] This became the claim for a symbolic and iconographic monopoly for the Franciscans, and the desire, for the Carmelites, to break it in order to spread the worship of their saint and to increase their order's prestige.

The image's quality was also a matter requiring the vigilance of the tribunal, one of the worries that the clumsy and debatable copies from indigenous workshops caused. But sometimes the image sinned by its outrageous and guilty sophistication: a Dominican denounced the existence, in the hands of the *alcade mayor*—the judge and local representative for the Spanish Crown—of Cuernavaca, of "images that, when looked at from different angles, show different, undignified and improper appearances than those that are represented on the holy images." These were probably anamorphoses. The case reminds us that the tribunal also watched over the respect of aesthetic canons.[253]

During the seventeenth century, and even more so during the eighteenth, the tribunal seemed less preoccupied with strict orthodoxy than it was with decency. It tirelessly proclaimed that the pious image was to excite piety and devotion, that it must be put in appropriate places, surrounded by "religious decency" and destined for "sacred ends that our Holy Mother intended." Any profane usage, any production or importation that might have a scandalous motive or one of "derision and mockery," was to be banished, particularly the figurations said to decorate dishes, snuffboxes, fans, shirt buttons, watch winders, seals, and charms.[254] Nor was it permitted to paint crosses or to put images in unclean places, or to have the orphan girls of the brotherhoods wear capes decorated with images of the Virgin: "The Indians, who perceive faith through their eyes, would be shocked."[255] The argument reveals much about the dominion that the image held over the whole of the colonial peoples. The Holy Office also supervised commercial practices that mixed the sacred and the profane: "The sellers called *trapaleros* [dishonest] have a growing stock of paintings of saints done quite crudely and shapelessly on little panels; they sell them at very low prices and

most of the time they give them away, as they say, *de pilón* [as a lagniappe]
to the Indians and ordinary people buying other items."[256]

The baroque image found itself paradoxically at the heart of a move-
ment of secularization of matters in which the Church also participated,
trying to exclude from the daily practices, to banish from habits and ports
of call objects and gestures for which it intended to keep an exclusively
religious orientation. The principle of separation of the profane and the
religious was reaffirmed in every possible way, constantly and stub-
bornly. The *mezcla,* the mixing of images, generated so much suspicion
that in 1692 a Spaniard from Guadalajara had to provide the tribunal with
an explanation for hanging portraits of Christ, the Virgin, and Roman
emperors all together.[257] There was nothing astonishing in that, toward
the end of the eighteenth century, a notary of the Holy Office, infuriated
by the dances and feasts taking place in front of the paintings and statues
in the tropical dampness of Tehuantepec, went off to propose a modifica-
tion of the decrees of the Council of Trent: images would only be shown
in the sanctuaries.[258] But everywhere the ambition of clearly delineating a
secular space in order to better mark out and preserve the holy image's
territory ran into the omnipresence, the hold, even, of baroque imagery.

Finally, the erotic image. It too proliferated at the end of the seven-
teenth century. It was seen everywhere, especially in high society. The
Inquisition pursued it, waving about the rule XI of the *Index Expurgatorio*
that governed the censure of books and forbade "lascivious and scanda-
lous paintings," and particularly their importation into the Spanish do-
mains. This did not keep amateurs from enjoying these visual pleasures.
Around 1691 four painters, two mestizos, one Indian and a Spaniard—
Miguel de la Cruz, Antonio Pardo, Bartolomé de Aguilar, Francisco de
Saldivar—had been hired by the Marquis of Zelada, knight of Calatrava,
to produce a dozen paintings pleasantly illustrating Ovid's works. A few
engravings had served as the artists' models. The nudes gracing the
canvases immediately attracted the attention of the inquisitors. More
seriously, perhaps, in the eyes of the *calificadores* of the Holy Office were
the nude nymphs shocking visitors in the very palace of bishop Juan de
Ortega at the beginning of the eighteenth century.[259] Clandestine im-
ports were in full swing all during the eighteenth century and preoc-
cupied censors searching for those European snuffboxes decorated with
"entirely naked women whose volumes and movements are extremely
dishonest, and with paintings of men contemplating the beauty of inde-

cency; the more exquisite the work, the more pernicious it is."[260] A number of these images were hidden within mirrors, fans, or boxes. Be that as it may, the new images appearing during the eighteenth century endangered neither orthodoxy, nor the supremacy of the miraculous image, no more so than the excesses or the swindles of the iconodules. During the entire colonial era the profane image remained a poor relative: even if one accounts for loss and destruction, there were only a few mythological scenes and a few portraits in comparison with the religious imagery that shone unrivaled over baroque Mexico. The scarcity of the Inquisition's interventions reveals the magnitude of the consensus that the worship of images and miraculous images elicited. Paradoxically, one might be led to believe that the true danger came from the Church itself, if one admits that enclosing its images in such a religious and sacred sphere, cut off from the daily world and its routines, involuntarily worked to slowly reduce its rule and its presence. By forbidding ever more obstinately this splitting of the *imaginaire,* the Church and the Inquisition evolved against the grain of a colonial society living immersed in images, in the proliferation of the hybrid and the syncretic, in the intermarrying of bodies, thoughts, and cultures. The mestizo population went from tens of thousands in the middle of the sixteenth century to four hundred thousand two centuries later.[261] An eloquent number, but one that cannot tell all about the astonishing intermixing that carried the Indians, blacks, mulattos, Spanish, and a few Asians into a world—notably that of the cities—that at times strangely resembled our own.

The Baroque Image and the Baroque Imaginaire

The baroque machinery, with its armies of painters, sculptors, theologians, and inquisitors, was not trying to impose an exotic visual order as the Franciscan image had meant to do. It assumed that that stage had been reached, and focused on exploiting other potentials. The emphasis was placed on the elements of the prototype, the divine presence—or, which in this case is almost the same thing, the Marian presence—the replica harbored: "I find myself in the images, present." The goal had also changed. The baroque image was meant for all. The war of images that the priests had led against the Indians had shifted, and now took place within the colonial society itself by espousing the splits opposing the peninsular leaders—the Creoles or the natives—to the majority of the

population, which was of mixed origins. The image had gone from being evangelizing to being integrative.

One might be surprised that an image that operated on the basis of fictitious prototypes, within frameworks that were just as fictitious, could have had such an impact on beings and societies. But is it not when the image strays toward fiction that it becomes the most efficient, if only by the diversion it creates? The chroniclers knew this, but only admitted it when the image was demonic, "a misleading and malicious mask" that then became merely falsehood, swindle, and alienation. This diverting of the reality of daily life toward another reality took place outside the image. It eluded the discourse of the baroque exegetes as much as it did an exclusively image-based analysis, and referred back to an *imaginaire* whose importance we have pointed out frequently. That this *imaginaire* maintained "a chronic hallucinatory state" or displayed "marvelous effects and mutations" was made even more true by the fact that the baroque Church was masterfully able to exploit visionary and dream experiences—such as special effects—to inculcate the worship of images. It also inventoried miracles to such a degree that all chronicles contained a chapter dedicated to the prodigies that had taken place, to the "exceptional favors and special apparitions," to the "notable cases," the "extraordinary visions," and the "admirable effects."[262] The baroque *imaginaire*, however, cannot be reduced to such an extent without taking baroque culture with it and diminishing it to the dimensions of a waking dream. And this, not only because the *imaginaire* put individuals, groups, societies, and institutions at stake through the expectations and the points of reference that framed it, but also because it transcended and blurred the boundaries that we habitually assign to reality and hallucination.

This *imaginaire* unfolded autonomously; it appeared to be punctuated by a specific temporality and endowed with its own regulatory mechanisms; fetishization, censure, and, as we will see later, autocensure, and the marking out of the profane and the religious. It was born, finally, from an expectation that was fed and accompanied by miracles, since the image was the ultimate recourse—and the only one, most of the time—against the sickness and natural disasters that befell the colony's populations. A study of the baroque machinery thus only delivers a partial and fixed approach to the *imaginaire* if it neglects the intervention of the image's spectator.

5

Image Consumers

Beyond Montufar of Granada's wildest hopes, colonial Mexico became a society pervaded and stuffed with images, and overwhelmingly so with religious images, as if the baroque Church, "making the deity visible and distributing it among various gods,"[1] had thrust the country into the very idolatry against which it had been fighting. Countless sanctuaries and chapels, houses and streets, crossroads and paths, jewels and clothes formed relays saturated with images (illustrations 12 and 13). According to the inquisitors, from the seventeenth century on it seemed that those who might have been the most resistant to the Christian image, the Indians, in fact owned a "multitude of effigies of Our Lord Christ, of the Holy Mother of God, and of the saints." Every feast took place in the presence of the images adorning chapels, private oratories, or even mangers. In 1585 Mexico City's two hundred indigenous confraternities each worshipped an image or a retable of their patron saint. Indians, mestizos, blacks, mulattos, rich or poor Spanish, regardless of ethnicity or class, all owned one or more images, no matter how modest or how crude. Who could forget the fabulous collection of saints gathered by Alonso Gómez, the friend of the Calabrian Gemelli Careri?

The Colonization of Daily Life

Images and objects for everyday use became superimposed and indistinguishable: a Spanish soldier from New Mexico sported a painting of the Virgin on his horse's saddle blanket (1602).[2] Snuffboxes, fans, watches decorated with scenes of the Passion of Christ; stockings, slips with St. Anthony's effigy; buttons featuring Christ on the Crucifix, the Virgin, and St. John; embroidery with the image of the Virgin; all these objects proliferated throughout colonial society. Bread, cookies, and countless sweets were decorated with the sign of the cross or a saint's face. The

12. *Our Lady of the Dolors de la Portería*

13. *Christ,* eighteenth century. Confraternity of St. Omobono, Mexico City.

fashion became so popular that the Church tried to curb it. Ordinary uses of the image mixed commercial and religious registers, just as they already blended decoration, elegance, greed, and piety. We have seen how merchants used to offer their clients a little pious image, something to attract or keep the more modest buyers, "the Indians and ordinary people."[3] In order to temper this omnipresence of the image, the baroque Church began to oppose both licit uses and profane misappropriations with increasing firmness, without yet, however, giving in to a rigorous push for purification and selection.

The Church had to mark off its borders and defend the monopoly it claimed against occasionally disquieting forms of appropriation. Writing, apparently indissociable from the baroque image as the Church conceived of and manipulated it, could constitute misuse. In a society where those able to write and read remained a minuscule minority, writing raised a rampart of interpretation around the image. But this link became twisted as unorthodox captions began to be substituted for the official commentary: a few heretical lines at the bottom of an engraving, or the brief transcription of a nonauthenticated miraculous rumor were enough to "contaminate" an image. Reception was a complex phenomenon that included multiple stages and such minute gradations that the user did not always recognize the "abuse" he was committing. It was sometimes difficult to distinguish a crude or clumsy copy from a manipulation that might turn into a swindle, or from an uncontrolled manifestation of spontaneous piety. A Crown functionary, in 1775, had a Virgin removed that seemed particularly ugly to him: "She was surrounded by various signs, and between her legs she had a naked monkey bending towards her lower belly; she was crowned, and above her was God the Father."[4] Was this heretical provocation, witchery, or merely a depiction that was unbearable to the spirit and tastes of an enlightened administration's representative? One might ask the same questions about a strange St. Michael, ordered in about 1643 from an indigenous painter, Alonso Martín: the wings on the saint's horse might have allowed him to take flight when in danger, but the Indian maintained that he did not know why his client wanted the dragon—actually a sort of winged tiger—to have a serpent's tail and immense claws. Ignorance, or prudent silence? The image—and therein lay its strength—allowed the crystallization of beliefs that were difficult or dangerous to verbalize.

Some images received worship that was not sanctioned by the Church.

Mystics or crooks ran about with statues and paintings, boasting of their miracles. The book is judged by its cover: during the 1720s, Diego Rodríguez (also known as *de la Resurección*), clothed as a hermit, and his wife María de Valdivia, dressed up as a mystic (*beata*), roamed throughout New Spain living off the donations offered to an image of Our Lady of Carmel. Their Virgin was said to have sweated seven times, and there were miracles attributed to her.[5] Around the same time a mulatto from Querétaro had a vision: the Christ of Chalma—the renowned sanctuary administered by the Augustines—at the last minute kept him from making a pact with the devil; he had this miracle painted and exhibited the work—a small painting—and gathered alms.[6]

Hybrid, heterodox, and clandestine images flowered equally here and there. From the seventeenth century on, carried by the continual waves of epidemics, the cult of the Holy Death, whose effigies filled private oratories, had an astonishing success. One can easily give it pre-Hispanic, medieval, and Renaissance antecedents. Around 1730 a few Jesuits described the Holy Death as having a skull of green stone with enormous teeth, and wearing golden earrings. The image received incense and offerings from the incurably ill, no matter what their ethnic origin. The cult of the Just, or Faithful, Judge (*Justo Juez*) was a variation on that: it focused on a red (*colorado*) skeleton with a crown on its skull, holding a bow and arrow in its hand.[7] At the end of the eighteenth century, pressured by the Indians of his parish, a Franciscan even agreed to say a mass to the *Justo Juez*.[8] About the same time, the inhabitants of Querétaro revered engravings and portraits of a man sentenced to death "as if he were a canonized saint."[9] It would take too long to explore the cult of the Holy Death up through the present, even if its longevity attests to the roots of a peripheral devotion that the Church never managed to eradicate.[10]

But inventions can only be a mistaken interpretation of a divine mystery or the attempt to make visible that which escapes understanding. At the end of the eighteenth century, an image discovered in a hacienda of the Querétaro region "monstrously" portrayed the Holy Trinity as a head with three faces, "with four eyes, three noses, three mouths and three beards, the body that of the Father while the head was that of the Son." Let us note the rationalism of the indignant clergyman describing this image: "If nature were to produce such a monstrous man, let the painter explain how one should baptize it!"[11] Yet even today one can find,

among the poor-quality color prints sold at the province markets, Trinities that are inspired by that invention. Hybrids and monstrosities expressed the popular *imaginaire*'s influence on the baroque image. At times, all it needed was to seize the representations that Christian iconography held out to it, to scribble devils on sheets of paper, or to paint them on a cell door.[12]

These demonic images were as efficient as the others, but they reacted noisily to sprinkles of holy water. They circulated from the seventeenth century on among mulattos and blacks, in the world of the haciendas and that of the herd guardians. The devil was shown in his stereotypical form: "A standing man, horrible and terrifying, with great horns and a big tail like a snake's, great claws on his feet and rooster's combs on his hands."[13] It is not easy to identify the authors of these drawings. At times they were native painters, who usually performed more orthodox tasks in the neighboring convents. Sometimes—but rarely—the demon-worship was accompanied by an explicit rejection of Christian images: "Our Lady is just . . . a figure of carved varnished wood, made by a carpenter."[14]

It was not enough to saturate the environment: the image also besieged bodies, and lent itself to that other appropriation: tattooing, or body painting. Any distance between being and image was abolished on the white, copper, or black skins of New Spain. The body served as a medium for these figurations; the difference between a tattoo or a painting was impossible to distinguish. Virgins or crucifixes often appeared on legs.[15] An Indian's chest turned into a true retable of flesh, showing the Christ of Chalma surrounded on his right by St. Michael, and on his left by Our Lady of Seven Dolors; the left biceps of a Frenchman from Albi, a deserter who had ended up in Mexico, featured, colored with crimson and touches of blue, a Virgin of Guadalupe with its four apparitions and the usual caption.[16] Could we then say that there existed a "baroque body," a physical, "terminal" human outcome to the images of the great sanctuaries? Similarly, an "electronic body" exists today, produced by new technologies of the image and of communication.[17]

These marks could be disquieting. Sometimes they were only cited as particular signs, as if the practice were perfectly normal. The mulattos and blacks, for their part, seemed to be fond of demonic paintings on the back, thighs, or arms:[18] clawed silhouettes, the "night owl," the devil Mantelillos, Lucifer's page, hearts pierced by arrows—the arrow expressing here a love for the demon, and the hearts signifying the submission

14. *Pact with the Devil*. From *Indiferente General* (1774).
Archivo General de la Nación, Mexico City.

owed him. Yet at other times they were only ephemeral creations: figures
were painted onto the body, then wiped off to gather the image's sub-
stance onto a piece of cotton before imploring the devil's help.[19] Their
models were drawn from old books of magic spells circulating amongst
the native *curanderos,* the mulatto *vaqueros* (cowboys), or in the almost
closed spaces of those prisonlike workshops called *obrajes.*[20] The pre-
dominant illiteracy of New Spain did not preclude the diffusion of these
collections of images, whose importance, as well as their impact, has
been underestimated, and who were clearly the objects of countless
replications (illustration 14).

Sadism and Release

At the peak of its presence, no matter what form it took, the image
became an interlocutor; if it was not quite a person, it was at least a
power to be negotiated or haggled with, a power to be coerced by any

means, whether physical or emotional. The awaiting, the expectations that set off the flow of the *imaginaire* addressed themselves to this presence more than to the material intermediary. Physical coercion: candles were lit at the wrong end to punish a saint's ineffectiveness. Emotional coercion: the Marquesado *alcalde mayor*'s wife, one of the most important people of Oaxaca, secretly ran her stockings along the Virgin's face (1704).[21] This was not an isolated "fetishistic" gesture. Yet more physical coercion: in the Pachuca mines, in 1720, somebody who was either a mestizo or an Indian buried a crucifix and swore he would not touch it until he had earned enough to have masses said for the owners of the image. The man was persuaded that a torchlight procession, observed each year on the mountain the night of *Jueves Santo,* would this time appear on the side where he had buried the crucifix. It would set off at the precise instant the usual Penitence procession would leave the mining town.[22]

Blackmail and threats of physical cruelty were directed right at the image, as if it were capable of satisfying the demands of its owner. In 1690 in Cocula, New Galicia, a Spanish woman, furious at having lost a china porcelain teacup, threw a statuette of Our Lady of the Conception onto the ground, promising to leave it there until her servant, "that Tarasca whore," gave the cup back to her.[23] By the aggressiveness it betrayed this gesture smacked of racism—the term "Tarasco" was used for the Indians of the area—and bordered on iconoclasm. An Indian woman denounced her to the region's ecclesiastical judge, who notified the Holy Office.

It is natural that the breaking of images should be a distinctive feature of a society that attributes such importance to them. It is an act punishing the ineffectiveness that becomes apparent after a supplication is followed by a period of waiting for results, and nothing happens. Anger ("He was so blind and drunk with anger that he had lost his judgment"[24]), temporary insanity, drunkenness, marital or lovers' disputes all inspired actions—nonetheless inexcusable—that always went against public opinion: "Christians do not do that to each other."[25] The image was insulted, whipped, scratched, burned with candles, broken, torn, trampled, stabbed, pierced, and shredded with scissors, tied to a horse's tail, covered in red paint or human excrements, and used to wipe oneself.[26] These became signs of an elementary sadism, and one that was apparently without risk since the victim was only an object. Except that it was not really just an object, and that it was more dangerous in colonial Mexico

to insult an image than a human being. The daily surroundings were therefore peopled with untouchable "presences," those pious and innocent images that were nonetheless favorite objects for aggression, depending on the flow of crises that shook each person's life.

Sexual frustration could also find an outlet in images, as was the experience of one of the victims of the 1658 repression that severely hit the sodomizing circles of the Mexican capital. Furious at having to be content with only his wife as sexual partner, the man burned an image of Christ, vowing to make it undergo the normal fate of his peers.[27] Elsewhere it was a frustrated lover who threw a statue of St. Joseph "publicly into the gutter," before stabbing a Virgin of the Seven Dolors—who is of course represented as pierced by swords that represent her afflictions.[28] Traditional iconography and symbolism suggested and modeled forms of aggression, as if to better uncover what the iconoclastic gesture implied in terms of interiorization and familiarity with the universe of images.

Iconoclasm frequently sprang up from the path of drunkenness in a society where alcoholism had endlessly ravaged the population since the Conquest.[29] Under the stunned eyes of his faithful natives, in a little lost village in the hot lands of the Michoacán, the priest Diego de Castejón y Medrano threw a painting representing St. Jerome onto the ground and kicked it over and over again. Instead of listening to the native governor, who pleaded with him to "not act in such a manner with the saint," the priest continued to hit the image. The governor managed to tear it from his hands, but the priest did not calm down. Abandoning St. Jerome, the priest then began attacking a Christ hung on the wall nearby. For naught: his fury only increased. The priest's actions had precedents: he had already broken an ivory Christ in another village. In 1723, two hundred years after the Conquest, by an astonishing reversal of events, the Indians were now defending the Christian images against their own priest. Had these images not become an integral part of the Indians' universe and their culture?[30] Rage at having lost a bet or a mere fit of pique at not being allowed to leave the convent to go into town could lead to such outbursts.[31] Despite their repetitious nature, at least the accusations of iconoclasm reveal the tensions, frustrations, and other kinds of conflict an individual might have to struggle with in colonial society. An anthropology of the feelings and passions displayed therein would have ample subject matter for exploring forms of anger, rage, delirium, or insanity,

and might also detect the slow workings of individualism. In any case, aware that most often it was dealing with emotions and not ideology, the Inquisition quickly ended its inquests in order to focus on larger prey: depraved or Judaizing priests.

Iconoclasm was felt by the group as a collective aggression because it expressed more than a temporary or definite rejection of a representation. Iconoclasm was an "unhinging," a short circuit, a brutal requestioning of an *imaginaire* that occurred when a dissatisfied expectation was abandoned, and the image's impotence revealed. This did not imply, far from it, the negation of divinity: at worst, the iconoclast attacked the worship of images, but he or she usually blamed a lack of reciprocity, the breaking of a more or less implicit pact that had clinched between him- or herself and the saint. No matter its real import, aggression against a divine figure was coupled with an equally sudden erasure of all the social and institutional links of the image: Church, local traditions, family, or community. This was why iconoclasm took on a subversive aspect, and how it so easily lent itself to all kinds of manipulations. A clever slave could concoct an accusation of iconoclasm or irreverence in order to take revenge on his masters by passing them off, for example, as Judaizers.[32]

Far beyond accusations against one's unwanted neighbor or obnoxious relative, iconoclasm could be useful for framing someone; it could become a political instrument. This tactic was probably at the origins of the desecration of the chapel of St. John the Baptist in Puebla in 1645. An investigation of the crime scene revealed the havoc wreaked by an iconoclast. But was this simply a poorly concealed setup, or a deliberate sacrilege? The saint's legs were broken, as were the arms of the Virgin, and religious engravings, torn and partly burned, littered the ground. One of them represented Christ on the Cross, surrounded by St. John the Evangelist and Mary Magdalene. A statue of Christ was found lying on its stomach.

The scandal caused much agitation. On the orders of the bishop Juan de Palafox,[33] an expiatory procession assembled the city's religious orders and went to the chapel where a sermon was delivered on the "reverence and respect" due sacred images. Very quickly a rumor spread that the heretics, or rather, the Portuguese, were the authors of the profanation. Portugal had revolted against Spain in December of 1640, and since then the Portuguese had come under suspicion everywhere. Even better, they were often mistaken for the Judaizers in whom the Inquisition was so

closely interested. A few months earlier the Marrano Sebastián Váez de Azevedo—one of the most prominent men in colonial society, and a personal friend of the marquis of Villena, former viceroy—had even been imprisoned, as the Inquisition arrested more and more people and was preparing for the great autos-da-fé of the late 1640s.[34] The Inquest did not identify the author of the sacrilege, but the iconoclastic scandal came at just the right time for stirring the populace against heretics and Judaizers. Lastly, the affair broke out as Sánchez was writing his *Imagen de la Virgen,* when sensitivity to images and the cult of the Virgin was reaching one of its highest points.

The respect for images was so strong that even gestures devoid of sacrilegious intent were spied upon, brought to the Inquisition's attention, and then examined. A poor Spanish painter tried his best to restore an old canvas representing the Virgin. The money he would have obtained from this was meant to feed his mother. Not finding any buyers, he destroyed his work in order to remove any of its merchant value. This was an imprudent move, and he was immediately denounced by the poor families sharing the house where he was struggling to survive with his mother.[35] Furthermore, it was not unusual for the guilty party, gripped by remorse, to turn himself in to the tribunal,[36] or, having repented, to gather up the pieces of the broken statue, kiss and worship them, imploring mercy for the disgraceful act he had committed.[37] One realizes that under these conditions profanation was ambiguous: because it was isolated and a minority within colonial society, the iconoclastic act contributed more to confirming the sacred value of the image than to reducing it to an inert and obsolete shape. It negatively defined the ideal relationship to the image. As such, it marked out the *imaginaire* surrounding the image in a spectacular fashion. It is understandable that the iconoclastic act was frequently followed by a personal or collective restoration of the sacred value, as it was the case in Puebla.

Images and Visions

During the 1680s in Tarímbaro, a village in the temperate Michoacán halfway between the province capital of Valladolid and the sleeping waters of Cuitzeo Lake, the images came alive, and saints came down off the retables and began to address humans. A Spanish woman, Petrona Rangel, was living with her sisters in a native neighborhood mixed with

whites, mestizos, and mulattos. She had her clients ingest some of "St. Rose's rose"—probably *peyotl*[38]—and told them they would see "how St. Rose would come out of the little painting she had on her altar and would speak to them, and heal them."[39] The saint revealed where misplaced or stolen objects could be found, and taught Petrona how to heal the ill. The Most Holy Virgin had also contacted the "witch." The case was banal in baroque Mexico, and was barely worthy of the Inquisition's interest.

The ingestion of hallucinogens, moreover, had been a common practice in colonial society ever since the late sixteenth century, a habit picked up from the native population who had continuously kept the custom since before pre-Hispanic times. The taking of herbs occurred at the foot of domestic altars, under the gaze of the Virgin, Christ, and those saints receiving the homage of the participants, whether they be mestizo, Indian, or mulatto.[40] But this time the images were more than benevolent and effectual presences: they became the direct protagonists of the consumer's dream experience. By appearing to the *curandero* or the questioner, by becoming animate, by intervening clothed in the attributes they wore on the statues or in the paintings, the Virgin and the saints were apparently only repeating the prodigies that baroque images manifested everywhere. The abolition at will of the borders between everyday events and the supernatural, the telescoping effects between hallucination and the lived experience, however, increased the representations' credibility and power over the senses tenfold.

This new conquest of the baroque image became exceedingly ambiguous. In part it permeated the dream experience of the white, mestizo, and even Indian populations by Christianizing the traditional visions caused by the eating of mushrooms and cactuses.[41] But the process unfolded beyond even the margins of orthodoxy; it escaped the Church—which condemned it—and the consumer himself, if one considers that it was a biochemical trigger—the alkaloid—that unfolded this new visionary space. It is clear, once again, that one cannot broach the phenomenon exclusively in terms of formal influences or images. The individual and collective *imaginaire* that the latter perpetuated had a historical consistency, and one of the Mexican motivations for that *imaginaire* was undeniably hallucination.

In this aspect Mexican society was a more deeply hallucinated society than that of baroque Italy, whose history was given back to us by Piero Camporesi.[42] But it was wrought by a hallucination that was less, as in

Italy, the product of poor and spoiled nourishment than the sum of a myriad of experiences reiterated daily under the direction of healers and "sorcerers." Parallel to the irresistible empire of the miraculous image, here then was the barely clandestine universe of thousands of visionaries that the hallucinogen gathered in a consensus no doubt just as strong as that secreted by baroque religiosity.

In turn, visionary Mexico wove close ties that associated the image, the body, and consumption. The consumption of plants was in part connected to the alcohol soaked up during the saints' festivals. It was made sacred and ritualized: one could not eat just anything, in just any manner, in front of just anybody (the saint's image).[43] The colonial experience of hallucination thus referred as much to pre-Hispanic practices as it did to the Eucharistic communion of which it was an extension, and the *imaginaire* that ran through it was deployed around a body that consumed odors (burning copal), light (the candles), music, and drugs. This was the same baroque body that carried tattoos of the Virgin, lived the ecstasy of orthodox visions or, bent in prayer, that stared at the miraculous image of the sanctuaries.

Delirium and Fantasies

Nonetheless, the hallucinatory experience was neither the extreme form of the "popular" *imaginaire,* nor even a mistakenly visited outskirts. It remained solidly framed by therapeutic gestures and anchored to the weight of a concrete necessity. It was almost an ordinary, routine experience. The "ultimate stage" of the baroque *imaginaire* perhaps was illustrated by a Oaxacan woman during the eighteenth century. Her example shows how difficult it often was to distinguish an iconoclastic and sacrilegious act from a fantasy. Unlike former cases, the outbursts of the witch María Felipa de Alcaraz were truly delirious and invented. But all the while expressing their own intense and passionate relationship to the image, they shed a harsh light on the obsessions and the phantasms that were harbored by the mestizo and Spanish populations of the colony around the 1730s.

María Felipa, if she is to be believed, had carnal relations with an image of Christ, "as if she were having them with a man, and for that reason she laid out the sexual parts of dead people, provided by unnatural means, onto that image; the accused did the same with the image of Our Lady as

if she were having relations with a woman."[44] María Felipa was said to have participated in the burial of an image of the Nazarene Christ at the entrance of a house, so that all the passers-by could trample on it; she added the blasphemy and insulting of images to her practices. These accusations appear among a jumble of most abominable crimes and a string of perversions, child sacrifices, induced abortions and the immolation of fetuses, bestiality (with all kinds of animals) and sodomy, the debauchery of young girls, the worship of male and female genitals, cannibalism and coprophagy. The image had its haunting place within this hallucination born in the heart of the Mexican province, a premonition of the experiences of de Sade's heroes that María Felipa's testimony preceded by half a century.

When, in a stream of accusations, María Felipa repeatedly indicated the existence of synagogues in Mexico City and Oaxaca, she was resurrecting old obsessions of colonial anti-Judaism though the Marrano community had already been annihilated several generations earlier. The collective profanation of Christian images was situated, in the popular imagination of this Mexican province, at the intersection of the Sabbath of witches, Judaic practices, and native idolatry. At this point her ravings, working the conspiracy theme, reached an astonishing level: "The Jews and the Spanish heretics teach the Indians they raise within their sects and their heresies—one of which is trampling the most Holy sacrament of the altar—how to be Jews. These Spaniards and Jews commit heretical acts such as flying through the air, and they reach Amsterdam and Bayonne in France, so that the Indians also go to European synagogues to learn Judaism and heresies that they later teach their children themselves."[45] The evocative description of these first transatlantic flights might make one smile.

During these ravings María Felipa told of an idolatrous cult in which some natives participated at a Spaniard's house. The Indians wore the garb of Catholic priests, and swore at an *Ecce homo,* a crucifix, and a Virgin while they sacrificed very young children and Indian women whose blood they splashed over the tortillas that the native pontiff passed around as a communion.[46] The assistants desecrated the hosts by "urinating and dropping human excrements, or even their seed on them, or else men and women put them on their sexual parts; on other occasions men and women copulated amongst themselves, and then with the demons."[47] In the midst of the worst abominations these "inverted faithful"

hung from their necks "various demon figures" as relics; María Felipa added that they "painted the demon under various horrible guises."[48] In other episodes it was the Christ's Passion that was "imitated," each station being represented by an Indian while the holy images were soiled in every possible manner. Three "Masters of idolatry" took on the roles of Father, Son, and Holy Ghost[49] while wearing either sacerdotal ornaments borrowed from the neighboring sacristies, or imitations made of skin. A parodic and blasphemous representation was involved in all these scenarios, as well as the body, through its excretions and its genitals in contact with the image. The suppression of the distance between reality and fiction that the baroque image had performed was translated in Felipa's case by a carnal copulation that completed, on a phantasmatic level, the fusion with the image.

Image, Madness, and Individuality

Whether objective or fantastical iconoclasm, María Felipa's confessions pushed the consequences of a complete appropriation and personification of these Church-proscribed beliefs to an extreme. By unveiling the individualization of behaviors, this iconoclasm betrayed the slippage—that can be traced historically—of the great collective rituals into those private rituals that foreshadowed the ordinary decor of modern perversions.[50] Once more, real-life experiences, the evolution of the relationship to the image, the personal and social uses of representation—and thus the multiple expressions of the *imaginaire*—revealed the often tortuous development of a society in the grip of a slow process of individualization and secularization.[51] One could already perceive hints of nineteenth-century fetishism and its Freudian consequences as if, beyond the baroque exaltation of the image, its place were being progressively carved out through private states of delirium, before it was to know other metamorphoses whose shapes we can already begin to guess at. Iconoclasm in New Spain established a passionate and paroxystic rapport with the image that shaped the ego. The baroque image, by these means and other less extreme and spectacular ones, participated in the elaboration of the modern body and person.

This is how individuals attempted to separate themselves from the Church and institutional religion in order to construct personal and physical ties to the image, ties over which each person was master, or

rather, thought he or she mastered. At the price of a violent reversal, they dissociated the image from its ecclesiastic context and mediations. But they never fully managed to "disenchant" it. This was undeniably the case with the *conculcadores* (the image-tramplers) and the iconoclasts, who, like María Felipa, did not touch the basic principles of the worship of images. Not only did the target of their aggressions continue to be an object endowed with a supernatural character, but often their desecrating gesture accentuated its supernaturalism. An act of exaggeration and limitless demands, a desire for fusion with the object—sexual desecrations were also hierogamies—sacrilege was the contrary of a reduction to the material. This was perhaps why the Inquisition did not persecute these guilty parties, who all in all were reaffirming, in their own language, the sacredness of the image, unlike the Jews and the heretics who denied it.

But how is one to analyze the meaning behind this diversion of the image? It is difficult to perceive it as the triumph of individuality in the face of ecclesiastic imagery, a perverse revenge, an unexpected and secret inveiglement the Inquisition would have struggled to contain. It could be seen as a dead-end trap; an interiorization helpless before the Church's attempted impositions; a game where the powerless victim was entangled, fascinated yet doomed to reproduce the sacrilegious gestures that one expected from a madman—or a witch, in María Felipa's case. In the long run, however, the image, and more precisely, the *imaginaire,* eluded the Church as much as it did the iconoclast or sacrilege.

Thwarting official scenarios as well as subjective and hallucinated strategies, the *imaginaire* blossomed forth like a specific piece of data that the Church and the individual tried, unsuccessfully, to dominate. Following its course, the *imaginaire* finally went beyond its designers and the faithful, upset their expectations and interpretations, and foreshadowed other avenues by dragging them toward worlds where impulses leeched away from the rituals of the faith, and detracted from the fixed path of conversion. The chaplain Vespoli of *Vice Amply Rewarded,* who sodomized God and the Virgin while torturing madmen who thought they were these divine figures, was also the heir—the literary heir—of María Felipa.[52] With them, the image—whether incarnation or representation—went from a system based on the visual or on desire to a system based on carnal consumption, where it disappeared, annihilated, far from the sublimated love that Lasso de la Vega addressed to the image

of the Guadalupe Virgin, crowing his "desire to be all hers, and the glory of having her for my own."[53] Desacralization was to claim all such images, all such states. At times it would leave an object in their place: the fetish. Once it had been integrated into the area the nineteenth century would call perversion and sexuality, the fetish would become a substitute for an unbearable reality in a world without God and, so it seemed, without sorcerers.

The Gaze of the Vanquished

The way in which colonial Mexico received Christian images could rarely be mistaken for apathetic adherence or passive subjection, despite the efficiency and the supremacy of the baroque machine, despite the institutional, material, and sociocultural supports that overwhelmingly ensured its perennialism and its ubiquity. The populace reacted to the images by continual measures of appropriation, a few individual translations of which we have already pointed out. Other responses belonged more to the collective arena. The consistent interventions of the native world reveal this the most perhaps, for they plot a course that covers many different methods of relating to the image, ranging from brutal imposition to experimentation, from deviant interpretation to autonomous production, and even going so far as iconoclastic dissidence.

Truth be told, when reading certain "idolatry eradicators" of the seventeenth century or the tenets of a nativism pushed to absurd extremes, it would seem that the Indians remained resolutely impervious to the Christian image.[54] At the most it might have served them as a decoy to mislead the priest's vigilance, some depositing pagan offerings on his altar and "outwardly" celebrating the feast of the saint it supposedly represented, while others hurried to hide "indecent things" inside hollow statues.[55]

Around 1730 a Jesuit told of a similar episode. An Indian from the Pachuca region was living tucked away in a pleasant little valley with his family, and intended to build a chapel. But his piety was only a façade covering his pagan practices. One day, a stroke of lightning almost hit his son and left a strange stone animal on the ground which the Indian added to the idols he owned. He then placed the object, covered in "flowers and ribbons," at the foot of a copy of the Cuzamaloapan Virgin circulating through the area at that time. He explained to the Spanish that it was an

ex voto while he was teaching the Indians that this same object "was the god helping them and that they were to invoke."[56] The Spanish were unwittingly trapped into worshipping an idol, and the trick was played. But the natives' surprising zeal toward the image made the Jesuits suspicious and finally dispelled this "pack of lies." The double game the Indian had played coupled two registers and two supernaturals by lending the stone an ex voto nature that celebrated the miracle that had happened to his son—while in the meantime perceiving in it the trace and the presence of a pagan force.

But not all Indians cynically manipulated Christian images so that in their hands they qualified merely as appearance, screen, or pretense. This would imply that the natives looked at the image in the same way the evangelizers had considered the idols, reducing them to the insignificance of wood and stone. In fact, if there was a war of images, it appeared less often with this kind of confrontation than through unending operations of recovery and capture, led equally by the native populace and the Church representatives.

One might be familiar with the idolatrous pattern that prepared the Europeans for the discovery of idols,[57] but for the most part the attitude in pre-Hispanic societies, when confronted with the object of an exotic cult, escapes us. We do know that the Nahua used to bring back the effigies of the conquered gods from their military campaigns, and that they "collected" the semiprecious stones of the conquered peoples for ritual purposes. Digs at the Templo Mayor in Mexico have revealed that the Mexica owned cult objects that originated in the great cultures that had preceded them, those of Teotihuacan (*circa* 300) and of Tula (*circa* 1000), and that they made copies of them marked with their own imprints, or interpreted in their own fashion by modifying the identity of the prototype.[58] This receptivity, whether one interprets it as an art of reuse or a strategy of appropriation, shaped how they looked at the conquistadors' images, even if the latter were devoid of the prestige linked with the ancient cultures of Mesoamerica. These practices did not exclude a native "iconoclasm" of which we know several examples: the destruction of the Tlaloc of Texcoco, or the breaking of the statue of Coyolxauhqui, the evil sister of the god Huitzilopochtli.[59] One can see that the Indians approached the European representations with a practical experience that must be taken into account, even if it is difficult to pin down the meaning of these archaistic revivals.

This experience had come into play ever since the Conquest. Along their path, the conquistadors gave images into the care of the Indians who newly supported them, and even to the native priests. The impact of this initial tête-à-tête, unmediated by Catholic priests or even the presence of a European, seems as crucial as it is difficult to measure. In order to better understand that "experimental" phase, let us imagine these images installed in the caciques' palaces on tables covered with flowers and multicolored cloths; they were revered there before being led into the arms of their owners for the "dances or *mitotes*" that punctuated the pagan celebrations.[60] This state of affairs lasted at least three or four years, until the missionaries were set up and the churches opened. This was what happened to the Virgin image Cortés had offered to the Tlaxcalteca captains to thank them for their military collaboration. Very early on, the Indians convinced themselves that the Christian images were hiding an effectiveness capable of fulfilling their expectations. An expectation, moreover, that was dramatically heightened by the idoloclasm of the conquerors. The Indians of Mexico City had asked Cortés for gods and images, and then venerated the Virgin and the St. Christopher placed on the Templo Mayor in order to reestablish communication with the forces of the cosmos ("For you took away our gods from whom we begged water."[61]) The Tlaxcalteca followed the same procedure when they approached the Franciscans: "When water was lacking, as it is now, we used to make sacrifices to the gods we had. . . . And now that we are Christians, to whom must we pray to give us water?"[62] The favorable response of the elements—a most opportune miracle—persuaded the Indians that the Christian image was also the manifestation of a divine presence: "After that, the naturals had great faith in this image."

Following this, a double misunderstanding was powerful in easing the acceptance of Christian simulacra. One may remember that the evangelizers used the term *ixiptla* to name the images of the saints in Nahuatl, while among the Indians the Spanish images were likened indiscriminately to the divine or the Christian god, and called St. Mary. The confusion—or rather the indigenous interpretation—can be cleared up if one remembers that the Nahua could assign distinct forms to the same divinity, or venerate several deities under one same form. It is even more understandable considering that the monks' terminological choice comforted them in their traditions. And in 1582, when questioned about the

origins of Our Lady la Conquistadora, a noble Indian from Tlaxcala chose to answer that "Cortés had given them a god whose name was St. Mary."[63]

During the sixteenth and part of the seventeenth century the Christian image may have taken on a tactical role for the Indians and been used to mask the recourse to ancient divinities, but it also fulfilled a function that was analogous to that of the traditional *ixiptla*. It was considered a living thing, to which one offered food and drink.[64] From the very moment of contact the Western image thus received a native interpretation. Its reception was accompanied by an immediate shift in meaning, to the point that the initial task of the evangelizers was less to impose Christian images than brutally to take back those the conquistadors had distributed, and to fight the misinterpretations they believed the Indians were making. This time, by a reverse effect that was much more common than one might think, it was native reductionism that was "perverting" the Western concept.

The "misunderstandings" were not easily cleared up. Just as in 1555, in 1585 the Church was worried at seeing the natives, who were not sensitive to the subtleties of "denotation," venturing onto heterodoxical paths: the Church was forced to forbid—though apparently without results—"that on retables or sculpted images, one paint or carve demons, horses, serpents, vipers, the sun or the moon as it is done on the images of St. Bartholomew, St. Martha, St. Jack, and St. Margaret. For even if these animals denote the prowess of those saints and the marvels and prodigies they create through supernatural powers, these newly converted peoples do not see it thus; on the contrary, they revert to the good old times because, since their ancestors worshipped these creatures and they see us worship the holy images, they seem to be understanding that we also address our worship to these animals, to the sun and the moon, and in reality they cannot be made to understand."[65] Let us note in passing that when medieval Europe had adored the zoomorphic symbols of the evangelists—the eagle, the bull, the lion—it had sometimes become lost in similar ways. It was thus better to try to forbid, than to enlighten.

But in vain. Almost half a century later the English Dominican Thomas Gage prepared an analogous report that he explained in these terms: " . . . Because they see some of [the saints] painted with beasts, as Hierome with a lion, Anthony with an ass, and other wild beasts,

Dominic with a dog, Blas with a hog, Mark with a bull, and John with an eagle, they . . . think verily those saints were of their opinion, and that those beasts were their familiar spirits, in whose shape they also were transformed when they lived, and with whom they died."[66]

It is true that a widespread, deep-rooted native belief—Nahualism—established a special link between animals and man in the form of a metamorphosis or a transfiguration: one of the forces that animated any human being could leave him under certain circumstances and take on an animal's appearance.[67] Nahualism, to a more or less corrupted degree, continued to haunt the colonial world; it is most likely what prompted the Indians' interest in the animals accompanying the saints' representations.[68] Contrary to what the Church proclaimed, the indigenous interpretations were rarely the result of chance or error, but of habits, practices, and notions—of which Nahualism is one—that could more or less easily accommodate colonial domination.

Contamination and Interference

Can we analyze the welcome that the natives had in store for images only in terms of interpretation or reinterpretation? In doing so, we would neglect the oscillation effect that constantly ran through their gestures, beliefs, and cultures. In the beginning was that well-known misunderstanding: at first the Indians, the Spanish, and the Church shared a conviction that *idolos* and *santos* belonged to the same register, never imagining that each side attributed to them a very different content, connotations, and linkage. Analogy, parallel, and symmetry more than opposition directed the relationships the Indians established between their own deities and the conquerors' images. There is nothing more revealing than this succinct phrase of the Peruvian Indians, who maintained, at the end of the sixteenth century, that "images are the Christians' idols."[69] The images of the Virgin and saints, the crosses arranged everywhere that were reminiscent of other pre-Hispanic crosses, and later the worship of relics were all substitutes for pagan statues; these symbols enabled rapprochements that set off, in the native *imaginaires*, unending states of contamination and interference.

Time and the deleterious effects of colonization took care of erasing the material markers onto which the Indians had hung their understanding of the world, of beings and of things. The destruction of the temples,

bas-reliefs, frescoes, and great idols nonetheless left behind a series of objects throughout the countryside; their modest size, their formal insignificance, and their lack of merchant value protected them from destruction. Minuscule idols, ritual containers, hallucinogenic herbs and plants: these objects had been chosen by some ancestor, the "head of the lineage." They were to remain in the household, and by their very presence, release the gifts of power they contained. Reminder of the domestic group, in direct competition with Christian images, these sacred bundles lost, little by little through wars, dispersal of the family, forgetfulness, and secrecy, the function that had once been theirs. But in the seventeenth century nobody had yet tried to displace or mock them. By maintaining a presence both concrete and invisible, palpable but intangible, they contributed to positioning a native *imaginaire* that the figurative and the anthropomorphic influenced far less than the expectations and fears created by the immanence of a familiar power, even if to us that remains obscure.[70]

That invisibility was shared by idols buried close to crossroads and springs, privileged places of passage in the ancient geographies and cosmogonies, situated between the world of humans and that of cosmic forces. If dug out and moved, these idols exerted a malevolent influence that was only stopped once the object was put back in its place. The Jesuit Juan Martínez found this out the hard way in 1730 among the Otomis of Tizayuca: he had unearthed the figure of a monkey crowned by a serpent and had entrusted it to some Indian women who, as a joke, had wrapped it up like a doll. One of the women immediately fell dangerously ill, and it was only once the idol had been restored that she was cured. The Jesuit then asked some children to smash the idol with stones, in order to make them lose the "reverential fear" they held for the object, and to break the diabolical pact. In vain. The children came back bloody, wounded by rock shards from their blows. In the eighteenth century it was still more common for the Indians to fear the anger (*enojo*) of the bundle, or the idol, than the threats of the priest. This is even more understandable since our Jesuit was far from putting the effectiveness of the idol into question. His tale even ends in failure, rather curiously, since the episode with the children was what came last.[71] One will have of course noticed that the reverential fear occasioned by these presences, and the privileged ties associating the object of worship with its physical space, had their parallels in the world of Christian images: recall, for example, the punish-

ments and sicknesses that befell those who violated the baroque sanctuaries. In a similar fashion, the comical swaddling of the idol reminds us of the dressing of Christian images that some Indian women, as devout as those of Tizayuca, frequently enjoyed.

The use of sacred bundles was continued through sorcerous practices. In order to purify (*limpiar*) their patients, the *curanderos*—and this continues today—used "bundles" jumbling together grains of copal, strands of multicolor wool, and "forest" paper. The *limpia* took place with the help of the "bundle" and under the protection of the Virgin and the Holy Trinity.[72] Other objects, "little men . . . nailed together with thorns," made out of "corn paste," bitumen, or peppers (*chile*), hidden in gourds and placed at the corners of the house, were used to focus the evil eye on a hated relative or neighbor.[73] One might suppose that the force, the effectiveness, and the presence that these objects contained contaminated the Indians' gaze on their saints.

Their coexistence with the saints on household altars maintained these interference patterns so well that it seems that only the exterior appearance, or the shape, continued to differentiate the colonial idol from the Christian image. Representations linked to Christian iconography—the works of a local artisan, modest engravings or copies that approximated the Spanish original—could be found side by side with strange heaps of disparate objects—whether inherited, bought, or found—occasionally disfigured by time: statues, a "foot-long figurine of a man hung by his neck in the nook of the altar," "a monkey crowned by a serpent," statuettes, little green stones inherited from one's ancestors, human-sized rocks in the secret of a grotto, miniature toys of terra-cotta representing musicians and animals, a little bell, a grinding-stone (*metate*), "shapeless bouquets of cotton," palm leaf crosses, "bundles with a cigar in each of them tied by colored woolen strands," "paper banners . . . painted with little men. . . ."[74] Let us add to this sampling the reptile that the Indians of Coatepec fed in a sort of temple erected across from the church, right up until the middle of the eighteenth century, under the pretext that this serpent was the "mascot" of their *pueblo;* it was not a mascot at all since they fed it newborns and offered it wine and liquors just as they did to their guardian deity.[75] In the arid countryside of Mezquital, around 1739, some of the Otomis worshipped a rose of "curiously-made ribbon serving as an ornament on the veil of the very holy image of Christ."[76] The cult prospered all the more freely because the administra-

tion of the local brotherhoods was, just as in many places, entirely placed into the hands of the Indians. Everywhere the native *imaginaire* multiplied, mixed, and dispersed forces and presences; it "idolized" the ancient as well as the new, the dead as well as the living; it worshipped or changed into a simple amulet—a "lucky stone"[77]—that which could be obtained via tradition, transmitted through "custom," or more simply, bought at market. The range of possibilities became more and more open as the colonial era progressed, and as all kinds of hybridization intensified. The two worlds—those of native Christianity and of "idolatry"—were never watertight.[78]

Even Christian anthropomorphism, which a priori seemed able to separate them, usually turned out to be an inoperative criterion: the assimilation of the divinity of St. Joseph's fire gives us one example of this. Looking at a physical resemblance deduced from the observation of images or the hearing of sermons, a few Indians established a link between the old St. Joseph—or sometimes St. Simeon—and the wrinkled character of the fire-god Huehueteotl; then, leaving the sphere of the figurative, they immediately confused the saint and the flame. According to them, "the fire was St. Joseph and when the wood was green or humid, and smoked a lot and wept while burning, they used to say that St. Joseph was angry and that he wanted to eat."[79] Without reaching such a dematerialization, the manufacture of many of the saints was sometimes so rudimentary that they came to resemble "dolls or little stick figures or other ridiculous things."[80]

In the critical eye of the priests, these saintly images sometimes ended up being confused with idols or "things." For the natives, the approximations resulting from reduplication, the ravages of time, or the imagination of the artist encouraged successive rapprochements that were only further multiplied by local beliefs and practices. Mestizos, and more exceptionally, Spaniards, out of curiosity, complicity, or opportunism, might also work up enough courage to ask the idols for what the saints had refused to grant them, just as others in the same straits invoked the European devil. The history of these reverse cultural adaptations, which are only now being discovered, is as engaging and complex as the slow Westernization of native societies.[81] The space surrounding the idol constantly crossed and overlapped that of the saint, despite barriers between them that the Church tried to make insurmountable, and the abyss originally separating their visions of the world.

In fact, rather than opposing the idol to the saint, it would probably be more pertinent, during the colonial period, to oppose that pair (either together, or separately) to the deritualized object emptied of its effectiveness and deprived of its aura; an idol without memory, covered in dust, that children grabbed as a toy.[82] Right from the start the Indians had to learn the virtues of "disenchantment" in order to escape persecution by portraying the idols they owned as ridiculous, worthless objects, as things "held as nothing"; minimizing them by pretending they were simply recycled materials; or passing off ancient *ixiptla* as portraits of their ancestors.[83] If the weight of native traditions, the proliferation of Iberian beliefs, and baroque sacralization had not erected repeated barriers, the games of disenchantment the evangelizers had caused might have ended in superficial secularization as a short-lived tactic or as a real distanciation. For the baroque *imaginaire* of the saint and that of the *ixiptla* had this in common: they played on the abolition of distance; the presence of the force or the familiar assistance of the saint were situated at opposite ends of disenchantment. This is why there were unending fluctuations in secularization and sacralization: it is not astonishing that scissors, rags, and bits of iron could become, inside the pouch of a mulatto "hail hunter," the divine sources of his power over the clouds.[84]

Within the *imaginaire* of the colony's idolaters, the idol's figurative dimension seems to have been an indifferent one. Confronted with the tide of the baroque, the idol, "shapeless," fluid as the flame or hidden within an *otate* (rattan) basket, hid away in its clandestine condition. What remained, surrounding that which was above all else a presence, were ritualistic inventions, a set of gestures, and sounds. Perhaps these compensated for a gaze that, before the Conquest, had settled everywhere—on the temples, the frescoes, the priests and the victims clothed as gods—but that was now blind. What remained were the dances, the guitar music whose chords marked the unfolding of the rites, the manipulation of the "little men," the sprinkling of the blood of sacrificed animals, the screen of copal smoke, the light of the candles: "They lit the candles they had cut into little pieces in a corner and laid out in a circle, and placed one of them in the middle when they danced."[85]

This *imaginaire* displayed a surprising openness to both ancient and new elements, simultaneously espousing yet escaping the simulacra and scenographies the Church tried to trap it in. The idolatrous *imaginaire* could just as easily stick to the baroque *imaginaire,* be inspired by it and

copy it, as leave it behind. The delirious states caused by the ingestion of hallucinogens played a large part in this plasticity: they so easily allowed visions of the gods and saints, or even brought about their appearance, and abolished at will any distance between the image and the original. The baroque Church, though it was generous, tried to restrict the immediacy of the supernatural to the miraculous images, experiences, and traditions it approved. But instant access to the supernatural could be obtained anywhere via drugs, for only a few pennies given to the healer. The astonishing survival of the hallucinogen under Spanish dominion may perhaps be explained by the new role it played: substituting an interior vision—even more desirable because it was unattainable—for a gaze that could no longer recognize anything. It was a discreet, intimate bedazzlement in contrast to the extinguished blaze of pre-Hispanic liturgies.

Going from visions to analogies, from confusion to verification, the idol's *imaginaire* contaminated the *imaginaire* of the saint; the colonial or contemporary Church was never able to completely eliminate interference or contamination, even if it had been able to see clearly what was happening under its very eyes. Was this the indifference of a conqueror convinced of his ultimate victory, or the inability to understand the manner in which the Indians were recuperating and deforming the Christian image? It would be too much to pretend that the great tide of the baroque almost carried off the Church that had unleashed it. It is even possible that this heterodox flowering contributed to allowing the baroque model to put down strong roots. But the eddies and swirls that were apparent everywhere proved that nothing was more fragile than the mastery of the image.

Indigenous Reproduction

It was in this hybrid and shifting weave of practices, beliefs, and objects, of attractions and fears, that the conquerors' saints—that is to say, their images—took root within the Indian community. The crucial role that indigenous creation immediately played explains how this integration could take place at all. With the opening of Peter of Ghent's workshops in the 1520s, Indians threw themselves into the massive production of sculptures, paintings, and feather mosaics. During the 1530s, even before the great monasteries sprang forth, native nobility took the initiative in

having their homes adorned with Christian frescoes. The rich merchant Martín Ocelotl, who was widely talked about in 1536, owned an oratory in one of his residences: it opened onto the patio, with, on the left, "its large stone arch and a tabernacle on which St. Francis was painted on one side, and on the other, St. Jerome, and in the middle, St. Louis, and everything had recently been made."[86] The phenomenon acquired such popularity that during the 1550s the viceroy, the Church—through the voice of the First Mexican Council—and the Spanish painters all demanded a harsh control of the production of images.[87] But paradoxically, the Indians escaped from it for the most part, since the ordinances organizing the art trades excluded them from the corporations.

This marginalization, meant to protect the Spanish artists, had incalculable consequences. The Indians, who from the very start had mastered the victor's images by learning to copy them in the monasteries, then to reproduce them outside of any "corporate" shackles, became relatively autonomous when the regular orders lost their initial hold. It was not until 1686, the peak of the baroque image, that the native production of saints' images, paintings, or sculptures finally was subjected to regulations covering all but still life paintings and decorative motifs. The increasing demand for images at the end of the century and the new requirements for quality created by the tide of the baroque are probably sufficient to explain this reversal.[88] Nonetheless, for over a century and a half, the Indians' creativity had met no official restraint, as if encouragement had outweighed repression in the baroque image's gestation.

This freedom did not keep it from displaying a virtuosity that staggered the Spanish: "They copy and imitate all retables and images, no matter how excellent, particularly the painters from Mexico."[89] During the mid-sixteenth century, the chronicler Bernal Díaz del Castillo immediately placed three native painters among the ranks of Apelle, Michelangelo, and the Spaniard Berruguete: Andrés (or Marcos) de Aquino, Juan de la Cruz, and El Crespillo.[90] This was a remarkable enthusiasm, since it was rare for the historian expressly to name Indians among his contemporaries. One senses that these artists dominated the country's production at that time for lack of any sizable Spanish competition. But their success depended on the pre-Hispanic experience they had acquired, in terms of technical virtuosity and the mastery of color, drawing, and pen work. The painters the Franciscans had formed were the heirs of the former tlacuilo (indigenous painters or writers), or even "retrained"

15. *Virgin with Child.*
From Codex
Monteleone, sixteenth
century. Library of
Congress, Washington,
D.C.

tlacuilo. In other words, they had, from the outset, a solid arts formation and they belonged to the native nobility. They possessed the technical tricks and the social status that enabled them to assimilate and spread, even to impose, the new images. They knew how to modify the scale of their models easily, and how to render, with "special charm," the dramatic tension of religious scenes.[91] It is to them that we owe not only the frescos of the convents, but also those extraordinary combinations of pictographic expression and European image and alphabet that made the codices of the sixteenth century the witnesses of a successful encounter between the West and America.

The strangely fixed and lost gaze of the Virgin of the Codex Monteleone no doubt reflects one of the unfolding moments of a Christian image still caught in a pre-Hispanic gangue (illustration 15).[92] Its rigidity and schematic nature involuntarily restored the hieratism of the icons of the Greek world, whose echo was superbly mastered in the feather Pantocrator of the Tepotzotlán Museum (illustration 16). It is conceivable that this stunning polychrome was due to the encounter of native traditions and medieval miniatures. I have explored elsewhere[93] what the marriage of writing and glyphs, what the play of landscapes and symbology on the codices and Indian maps revealed about the workings of native figurative thought, about its discoveries and its dead ends, and the reasons for its interpretations of Western art. The dialogue between native colorists and the monochrome image that engraving presented them needs to be studied more closely. If the West imposed its lines, its

16. Tepoztlán Pantocrator, feather mosaic, sixteenth century. Viceregal Museum, Mexico City.

"black and white" framework, what freedom did that leave for the palette of the native painter, for the almost imperceptible continuities such as the tint of blue in the Virgin's veil, which was perhaps inspired by the blue that the god Huitzilopochtli, son of the Virgin Coatlicue, wore? One would also have to wonder what the use of such a traditional medium as

the feather could add to the meaning and nature of the Christian image, what this visually gleaming texture might have introduced in terms of aura and "presence." Before the Conquest the *ixiptla* were made of feathers,[94] and divine beings—among whose ranks was Quetzalcoatl, the serpent with the Quetzal feathers—displayed this precious attribute. The native artists used the same technique to copy the Christians' images and retables, with an enthusiasm that astonished Las Casas.[95] The success of the Christian image among the Indians is thus inextricably tied to an initial situation that was exceptional in many respects, since it linked their immediate receptivity and precocious mastery to a notable capability for assimilation, interpretation, and creation.

Juan Gerson's frescoes of the Apocalypse (1562) adorning the Tecamachalco church in the valley of Puebla inherently summarize the talent that was available. On a canvas closely inspired by European biblical engravings, the native *tlacuilo* displayed a polychrome palette almost that of pre-Hispanic codices. The decoration of the Ixmiquilpan church north of the valley of Mexico City had other surprises in store: pre-Hispanic figures of fighting warriors were mixed in with monstrous creatures taken from Greek and Latin mythology.[96] The ancient symbology rejoined mannerist virtuosity in surprising combinations. Elsewhere it was the number of images that was astonishing: a half-century after the Conquest, the parish of San Juan Xiquipilco, at the north end of the valley of Toluca, housed several dozen of them among its church, its chapels, and its hospital. The proliferation of painted or sculpted—*de bulto*—images or feather mosaics, the *mucha imaginería,* the abundance of liturgical decorations seemed to be the rule there and elsewhere.[97] Tragic coincidence: the epidemic of images hitting the native world was contemporaneous with the otherwise deadly waves of sickness decimating it.[98]

Throughout the sixteenth century, while the workshops of San José de Los Naturales produced works for the whole of New Spain, and while both convents and individuals often called upon native painters during the course of the colonial era,[99] the results were not always to the taste of the Church. Alongside a painting from the great workshops of the capital—the Virgin of the Guadalupe would be the most illustrious example[100]—proliferated the village painters and sculptors, who had forgotten the legacy of the ancient *tlacuilo* but nevertheless lacked the European savoir-faire. In 1616 a beneficiary from the region of Teotihuacan hastened to denounce the state of affairs in his parish to the Inquisition: "I

constantly saw sculpted Christs, painted images on panels and on paper of such ugly and deformed manufacture that they resembled dolls, little men, or some ridiculous thing other than what they represented; not long ago [the natives] brought to this church images on panels and a sculpture of the Conception that looked like an old wrinkled Indian woman, and worse."[101] The priests constantly condemned the proliferation of "gross, inept, and scandalous" productions, and confiscated them when they could. These, and the distortions and misunderstandings pointed out earlier, were not so much the result of an inherent inability, but rather expressed a creativity that upset the official canons while demonstrating how completely the natives had grasped the Christian image. The *Primordial Titles* and the *Techyaloyan Codices* that were developed by the scribes of the Indian communities during the latter part of the seventeenth century offered many examples of this (illustrations 17, 18, 19). Their seemingly crude draftsmanship gives us back a vision of objects and paintings that time has generally destroyed.[102]

The Saint's Adoption

The image and the saint were constantly associated with each other. One cannot be explored without taking the other into account. The Indians were able to set an appreciable autonomy aside for themselves in this matter as well, for the choice of saint was not always left up to the evangelizers. Some communities managed to elect as patron saints Christian figures whose attributes reminded them of pre-Hispanic precedents, or celebrated saints whose feast corresponded to a special moment within the native ritual calendar.[103] We know almost nothing—and for good reason—about the Indians' motives. Perhaps the growing worship of saints corresponded to winning back local sanctuaries under Christianized forms, since the outlying regions had experienced the disappearance of cults—those of Huitzilopochtli, for example—in response to pressure by the big cities, which had been hit head-on by defeat, evangelization, and idoloclasty. It cannot be ruled out that the adoption of Christian images hid and expressed "revivals" whose dynamics, for the most part, escape us. A few individuals were also at the origin of prestigious cults and miraculous images. The legendary Juan Diego was emulated by far more historically important people, and the Copacabana Virgin in Peru would not have existed without the devotion of a cacique who decided to

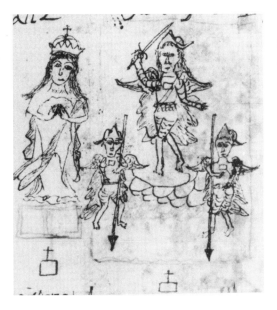

17. Virgin and
St. Michael.

18. St. Francis.

19. St. Peter.

All from Ocoyoacac, *Primordial Titles,*
seventeenth century. Tierras, vol. 2998,
Archivo General de la Nación, Mexico City.

become a sculptor in order to mold her image.[104] The worship of the Virgin de los Remedios owes to yet another cacique. In the late sixteenth century the native elite of the valley of Mexico City probably influenced the diffusion of miraculous images, and most notably the rise of the devotion to the Virgin of Guadalupe. These examples can testify that the Indians were not passive consumers, nor were they kept on the sidelines in the process of diffusing the Christian image. It was they, on the contrary, who so often showed initiative: in choosing the image, its manufacture, the splendor with which it was celebrated, all the while projecting their own concepts of representation onto the Christian effigy.

But this did not keep the priests from being interested, or even pushy about collaborating. If we are to believe the British Dominican Thomas Gage who roamed through Mexico during the 1630s,

the churches are full of [these saints], and they are placed upon standers gilded or painted, to be carried in procession upon men's shoulders, upon their proper day. And from hence cometh no little profit to the priests; for upon such saints' days, the owner of the saint maketh a great feast in the town, and presenteth unto the priest sometimes two or three, sometimes four or five, crowns for his Mass and sermon, besides a turkey and three or four fowls, with as much *cacao* as will serve to make him chocolate for all the whole octave or eight days following. So that in some churches, where there are at least forty of these saints' statues and images, they bring unto the priest at least forty pounds a year. The priest therefore is very watchful over those saints' days, and sendeth warning before hand unto the Indians of the day of their saint, that they may provide themselves for the better celebrating it both at home and in the church."[105]

Throughout the seventeenth century, the *santos* were central to the unfolding of a hybrid *imaginaire* whose inventiveness and malleability contributed to the rise of a new indigenous identity. This sense of self arose from the crossing of an ancient heritage (or what was left of it) and the constraints of the colonial society, and through this, the influences of a Mediterranean Christianity whose Indian campaigns reproduced its conventions and attitudes with surprising faithfulness. Like the baroque *imaginaire*, this native *imaginaire* was built from the coupling of expectations and miraculous sanctions. The *santos* were the answer to expectations that the disappearance of the former priests, the suppression of pre-

Hispanic liturgies, and the persecution of idolatry left largely unsatisfied. These expectations were exacerbated by the epidemics that mowed down the populace until the middle of the seventeenth century: the twenty million Indians of Conquest times had dwindled to barely seven hundred and fifty thousand, one hundred years later. After the second half of the sixteenth century, the introduction of the saints into the community was accompanied by prodigies that guaranteed their effectiveness in the eyes of the natives. The rumor spreading the miraculous appearances of the Guadalupe Virgin and the prodigious nature of her image, if not her *ixiptla,* was symbolic of those times. One could think of many others.[106]

From Domestic Hearth to Confraternity

The expectations, the miracles, the aura that the *imaginaire* radiated were not enough to shore it up solidly. It still needed a structure, a framework that would direct the faithful and their gaze, regulate their practices, and ensure their replication. The home and the confraternity offered these supports. Domestic worship underwent a remarkable expansion at the end of the sixteenth century: as early as 1585, an observer noted, for the third Mexican council, "There is no Indian so poor that he does not have a cubicle where he has placed two or three images."[107] Domestic oratories, or *santocalli,* were filled from that time on with a "multitude of effigies of Our Lord Christ, his Very Holy Mother, and of saints." Among the poorest people these were probably paper images. During the seventeenth and the eighteenth centuries the wills of caciques or more modest Indians clearly indicated the attachment the Indians felt for their images: a bequest was always left for them, even if it was only a tiny parcel of land, a yoke of cattle, or an ax to allow the heirs to "serve" the saint and offer it, according to custom, candles, flowers, and incense.

Bequests were made in pairs: land and an oratory, a field (or a house) and an image, as if the painting, the statue, and the property were only one item.[108] One is tempted to liken this practice to the cult that the ancient Nahua and other ethnicities used to reserve for the "lineage idols" (*tlapialli*). The *santos* of the hearth had conquered those same powers of attraction. They also received offerings, and their owners violently refused to part with them, to give them to a chapel or the village

church, for example, just as formerly none had dared to move the *idolillos* (bundles) or even touch them. The fanatical attachment of the Indians to their *santos*—as can be seen through expressions such as "my saints," "my Lady of the Conception," "my Lady of Guadalupe"—might well have had its roots in the unique tie associating the inhabitants of a house with the "idols" in it. The familial worship of images maintained an analogous solidarity with that imposed by the preservation and handing down of the "venerable bundles" we have mentioned. The continuity of the lineage, which had found its expression in the worship given to the bundles, now was indicated through the chain of obligations (*cargos,* charges) linked to the presence of the *santos*. Ultimately, the Christian image embodied the household memory, for it too brought the precious comfort of time immemorial that nothing could threaten.[109]

The *imaginaire* was also grafted onto another framework and another form of sociability: confraternities and chapels. They took on many forms and adapted to milieus whose origins were extremely diverse. After the late sixteenth century the proliferation of hermitages alarmed the ecclesiastic authorities, who were literally overcome by the natives' infatuation for them. Indeed, the number of fraternities for that time and for the Mexico City alone reached more than three hundred, each with an image or a retable.[110]

The borders separating the confraternity and the *santocalli* were never watertight. An Indian might leave a parcel of land to a saint, charging his descendants with using its revenues to celebrate the image's feast. Four or five natives could unite their efforts in order to honor a saint of their choice each year. They would choose a majordomo among themselves and ask for permission to collect alms in order to meet the costs of the worship. The image was then placed in a chapel, or it stayed in an individual's oratory. The affiliation with the hamlet (*barrio*) or *pueblo* where the image was found determined confraternity of which it was a member. Sometimes an Indian would disappear without an heir, and the image was handed over to a new owner. Thomas Gage explained that in that case, the priest found an excuse for exerting pressure on the population: an unowned saint would be "cast out of church."[111] While the priest might have worried about preserving the share of revenues that the image brought him, the Indians "understood that the judgment of God fell upon the village," and fearing the "saint's anger," hurried to designate a new holder. Even if Gage's observations were biased by his own anti-

papism—the Dominican had converted to Protestantism—they never-
theless revealed the active solidarity that gathered the *pueblo* around
its images. Of course there existed more classical confraternities, set
up in due form under the authority of the bishop; they had important
sums of money at their disposal, as well as written constitutions that set
down the amount of the dues, the calendar of masses, and the brothers'
obligations.[112]

A private image could, given sufficient miraculous activity, become the
center of a local devotion, provoke the creation of a *mayordomía*, raise its
status to that of a regional cult, and finally become the heart of a pil-
grimage. Around 1650, during the revival of the Guadalupe Virgin's wor-
ship, this was how a few Indians renewed the tiny sanctuary of Tecaxique
on the outskirts of Toluca. As they restored it the miracles multiplied,
thanks to the "Virgin's water" the natives administered to the Nahua,
Otomi, and Mazahua pilgrims flocking there. Cabins clustered around
the chapel and housed the families devoted to the upkeep of the sanctu-
ary and the Virgin, an image of Our Lady of the Assumption "painted in
tempera on an ordinary blanket of Sierra cotton."[113] A rare testimony
allows us to imagine how the natives addressed the Virgin through dance
and music. The scene was set in 1684, at the height of the baroque era:

The variety of dances and music with which the natives of distant lands
celebrate this Virgin is the following: there come groups of eight, ten, and
sometimes twelve young girls clothed, in their manner, in rich blouses (*huipi-
les*), in costly blankets that are elegantly arranged, their hair in tufts tied with
variously-colored ribbons; they wear a dance (*mitote*) costume; they carry in
their left hand a very large and thin feather and a little bell or *ayacastle* in their
right hand, and on their forehead they wear a large headband they call *copili* in
their language, decorated with green stones that are the baubles these people
use. The parents bring them, and musicians accompany them with harps and
guitars during the dances they have prepared and studied. Some come in
gypsy costumes, others with tambourines and garlands of green rags that
stand in for the crowns of laurel they use. Finally each troupe or group dances
in different costumes. All bring their hieroglyph that they place in the middle
of where they dance: for example, a palm leaf mounted with a terrestrial globe
that slowly opens as the dance goes on and in which the Most Holy Virgin of
Tecaxique appears, to whom they offer their poor wax candles, incense, copal,
flowers and fruits. . . . Because of this the sanctuary is invaded by various

dances and frequently the groups run into each other, for before one *pueblo*'s troupe has finished its nonces, another group from another place arrives, so that there are continuously native dances and music.[114]

One cannot help but be astonished at these Indian girls in gypsy costumes, at the little baroque machines (the globe that opened to reveal the Virgin of Tecaxique), at that Andalusian scent in places that were far enough from Mexico City. This proves the indisputable success of the baroque model; we have already traced its official manifestations in the capital of the viceroyalty.

The building of a chapel or the celebration of a feast were means by which local prestige could be evaluated in comparison with that of less wealthy *pueblos*. It is understandable how the image could have provoked confrontations, not only among the natives but even with the Spanish authorities: when in 1786 the priest of Cuautitlán, northeast of the capital, tried to withdraw the image of the Immaculate Conception, the Indians gathered together and claimed the image for themselves: " 'The image,' they said, 'did not belong to the Spanish, but belonged to the natives.' "[115] The antiquity of the effigy—the veneration had existed "from time immemorial"—and their blind devotion to their patron Virgin, the countless miracles, the confraternity's bodies buried in its chapel, were all arguments revealing the significance of the *imaginaire* and how it was shaken by the image's removal: it was a weave of physical and supernatural ties, the expression of a memory and a temporality, a bridge between the living and the dead. Sometimes the holder of an image was also tempted to impose his saint and substitute it for the *pueblo*'s *santo*, drawing the opposition and rancor of rival factions. In some cases a saint's support was immediately called upon in order to take revenge on a living person.

It was never the meaning, the origins, or the nature of the image that influenced these battles, no matter who the protagonists were, but rather the social, cultural, affective, and material texture that had grown up around the effigy. Beyond the image, it was the *imaginaire* that was in play. An eighteenth-century observer with extremely little patience for the native confraternities, but perceptive nonetheless, precisely identified this elastic network of practices and initiatives: "[Among the Indians], ordinarily there is no more religion than this external worship of images, as evidenced not only by the annual feast, but also by all the preliminary

preparations and measures taken to gather alms and cultivate the saint's lands. . . . And if they are deprived of this, and if the cult is reduced to the yearly feast, I fear that in little time those small relics of religion found among them will disappear."[116]

This portrayal would be incomplete if the extraordinary success of the religious theater, periodically offering the Indians an occasion to play the part of saints, were not taken into account. As in other areas the Church had finally lost control of a spectacle that it had struggled to initiate. The Indians took advantage of the mendicant orders' waning influence and appropriated the plays, turning them more into liturgy. Not only did they invent their costumes and comment on the mysteries they played, but also, "this nation is excessive in its devotion to the point where they incense and kiss the Indian who plays Christ Our Lord."[117] With the help of a ritual drunkenness (or not) that all the participants shared, the native actor became a sort of *ixiptla* of the Christian god, doing away with the distance the Church was trying to maintain between the sacred and the profane, but that the miraculous image continuously short-circuited.

The *Santo's* Imaginaire

The *santo* was thus not the inert matter that Enlightenment texts might imply, a misleading artifice created by a religious alienation that could easily be ignored in order to concentrate on its context. The *santo* in fact was never considered or described by the Indians as a material object; in this, it did not matter whether it was a statue or a painted canvas, any more than it was meant to represent a being who was located elsewhere. The saint was an entity that was sufficient unto itself, and that was never exhausted in the dialectic of the signifier and the signified.[118] It was a presence that could reveal itself even in the Eucharist: an Indian woman from Mixco (Guatemala) whom Thomas Gage was questioning, when pressed to identify what the Holy Sacrament contained, "began to look about to the saints in the church (which was dedicated to a saint which they call St. Dominic) . . . and, as it seemed, being troubled and doubtful what to say, at last she cast her eyes upon the high altar; . . . she replied S. Dominic who was the patron of that church and town."[119] A half-century earlier, at the translation of the Totolapan Christ in Mexico City, the Indians took the image to be the Christ himself, or the living God.[120]

Neither object nor representation, the saint could more likely be un-

derstood either through its prophylactic and therapeutic interventions, or its ability to contain a divine force; an image through its role as sensor. But the magnet-image was a baroque metaphor loaded with obscure metaphysics used and abused by the thurifer chroniclers.[121] The presence contained within the image and the saint only operated and gave of itself through its corresponding *imaginaire*. It was the *imaginaire* grafted onto the image that polarized the worshippers' attention, drove their desires and hopes, gave shape to their expectations and channeled them, and organized the interpretations and scenarios of their belief system.

The ties that seemed to run through the *imaginaire* were no longer those tying the Indian to his former bundles, for the saint could not be confused with the force contained in a collection of plants, figurines, and jugs. It was a person with whom its holder and the brothers maintained "family" ties, a person who could welcome godfathers or godmothers into the domestic group or community. Some Indians wished to be buried near the saint they venerated the most. This physical proximity— the defunct person's body forever associated with the image—extended the intimacy the living person had kept with the saint during his existence. The adoption of the Christian image not only implied an anthropomorphization of divinity, it also contributed to personalizing relationships and replicating, within the *imaginaire,* interactions of which the Christian family—contained and monogamous—was to be the terrestrial aspect and prototype. The image was endowed with the behaviors of living beings: it could walk, cry, sweat, bleed, eat. At the same time the ties became personalized, they became visual: the *santo* was displayed, exposed on the altar, promenaded under the eyes of all during processions and celebrations, whereas the idols had remained in the shadow of sanctuaries or at the bottom of sacred bundles. The new forces had a face, like that of St. Dominic with which the Mixco Indian woman, under Gage's sarcastic pen, personalized the Holy Sacrament.[122]

The *imaginaire* of the *santo* in its infinite variations became the filter and device through which the Indians of New Spain conceived, visualized, and practiced their Christianity. It was through this *imaginaire* that the Christian institutions and beliefs were ordered, that they took on meaning, that they acquired plausibility and credibility.[123] It contributed to making compatible and complementary the heterogeneous elements—ancient or recent, intact or not—that from then on would configure native existence: their chapels, rituals, and liturgical plays; ban-

quets and collective drinking rituals; their relationship to their homeland, to the house, to sickness, and to death. The *imaginaire* accompanying the worship of images thus played a crucial role in the cultural restructuring that blended native heritage together with the traits the colonizers had introduced; subsequently, it was equally important in reproducing the patrimony this fusion created. The replication of Iberian and Mediterranean models on native grounds was therefore ambiguous since it revealed a formal and existential Westernization, yet also provided an answer to this same process.

The Hot Nights of Coatlán

As in the case of the Spanish and the mestizos, the Indians' *imaginaire* also had an iconoclastic side to it. Little about it is known for the sixteenth and seventeenth centuries. Even the "idolaters" did seem not particularly inclined to destroy the Christian image, probably because the Indians would have had to internalize the worship of images fully enough to cover all of its deviations. The sources for the eighteenth century are more prolific. In 1700 the Indians of the Oaxaca Sierra mixed statues and paintings of saints placed upside down, their heads downward, with traditional sacrifices.[124] Around 1740 a few natives gathered during the humid nights of Coatlán, south of Cuernavaca, to organize blasphemous ceremonies: "At midnight they even go out clothed in ornaments, with a cross, a banner, and the candle-holders; when there was a coffin, they went out with Death and the images of Christ and they whipped the images on the crosses during the whole station; while they were whipping them, they showed them their behinds by pulling their underwear down."[125] The usual elements of sacrilege and iconoclastic scenarios were brought together: the usurping of vestments, physical insults, the use of the whip, as well as the punches, the slaps, or the verbal defiance directed toward an all-powerful god: "Do you not call yourself God, who is all-powerful and all-knowing. Else raise him again and heal him if you can." The iconoclasts—here referred to as the "image-tramplers"—limited themselves to humiliation. It was said that when the dead, whether children or adults, were buried, they dug out the bodies "in order to draw blood, flesh, or bones from the sepultures."[126] If the Indians were hesitant to hit the images, they were disciplined, felled with blows, and left for almost dead. Vampirism, sadism, infanticide, night rapes,

incurable illnesses, sudden mysterious deaths—yet so well explained by sorcery—maintained a climate of terror over the country's villages.

These practices attest to the intensity of the rapport with the Christian image, even if it had become the focal point for a systematic and organized deviance. Were such practices real, or simply fantasized by Indians or mestizos eager to harm their neighbors? Witnesses attested that the accused themselves, "as soon as they drink, boast of everything we have told here, and make it known to other Indian men and women."[127] Alcohol was not absent from the nocturnal reunions, either: "We stole from the late Angélica a jugful of *tepache* [a liquor made of pulque, water, pineapple and cloves], we drank it and we gathered at Juan Ayón's house; at midnight we all went to the cavalry, we started to whip Jesus Christ and with each stroke we gave him, we hit our Adam's apple and mouth as a sign of joy; after this we all went down to the church to do the same thing to the Lord of the Entombment."[128] But a declaration that turns into a vision or a waking dream might make us wonder: "When they got to the whipping, I heard many roosters sing, and the church then lit up with a light stronger than day . . . , I saw that and was terrified."[129] Others affirm that in order to mislead spies, the profaners "disguised themselves and took the shape of donkeys, and the noise of the whips was made by shaking their ears."[130] These transgressions constituted, for a good part of the Indian community, irrefutable evidence; but under the reign of terror the suspects created around themselves such testimony was withheld.

It was common, however, during the eighteenth century for Indians to denounce blasphemies that had been committed by Spaniards, mestizos, or even their priest to the ecclesiastic authorities. The natives proved to be surprisingly sensitive and sensitized to the worship of images, to the *reverencia* the latter were due, and thus to the scandal of a profanation. Their silence in Coatlán was linked to the singularity of native "iconoclasm." Though the acts of the Coatlán blasphemers expressed an unrestrained violence that does not really surprise us, they did stand out by their collective dimension, by their recurrent and quasi-programmed character. These were no longer isolated gestures, fleeting and unpredictable outbursts, but an activity that was explicitly codified by Indians who were deeply steeped in Catholic liturgy. The ritualization of the act manifested itself here in several ways. It reproduced a pre-established scenario: a witness explained that the whipping of the images was a "repeti-

tion" of the Passion.[131] It obeyed a religious calendar: the gatherings happened on Wednesdays and Fridays, almost every day during Lent, and the Tuesday of carnival. The act took place under cover of night. Nor was the place left to chance: it happened either at the calvary or at the church. Finally, the blasphemers left behind their clothes to perform their aggressions, and wore liturgical dress instead.

Let us move to the steppe plains of the North, to San Luís de la Paz in 1797. Again, the stillness of night reigned. Thirty or so Indians shut themselves up in their chapel, drank *peyotl*, lit candles upside down, made little male dolls or figures (*muñecos*) "engraved on a piece of paper"[132] dance, and struck the crosses with wax candles. Then they tied a wet rope to the figure of Holy Death and threatened to whip and burn it if "it did not make a miracle" and grant them what they were asking for. It was said that they buried the "holy crosses" with dogs' heads and human bones so that the Indians they made sick would die.[133] One of their practices, the dance of the *muñecos,* speaks volumes about the manner in which the Indians animated their images, and how pre-Hispanic beliefs concerning the use of ritual paper lingered on:[134] "[These are] *muñecos* stamped on paper, of several colors: [the Indians] take the stamped paper, fold it and throw it onto a plate; when it is on the plate, they tell the *muñecos* to come out and perform their duty, the paper strips itself off and the *muñecos* come out; [the assistants] dance with them, cry with them, they worship them and kiss them as if they were God himself, and gather alms for them."[135] Like cartoons leaving the screen to mingle with reality—as Zemeckis' "Toons" do in *Roger Rabbit*—the *muñecos* of San Luís obeyed the natives' orders and gestures. It is understandable that paper was the seat of a presence, as were the pre-Hispanic codices. But it is more surprising to see nameless creatures spring from it, these *muñecos* of limitless powers. The animated image was thus not only of the realm of vision and dream, statue or painting; it could spring from the space of a sheet of paper, in a path that reversed the Guadalupan prodigy: the Virgin had left her image settle—imprint itself—onto Juan Diego's cape; the *muñecos* of San Luís peeled off of their base, as did St. Rose in Tarímbaro, coming out of her frame.[136]

Struck, buried, the crosses received an entirely different treatment. These sadistic unleashings were reminiscent of the sacrilegious practices for which the Judaizers of the seventeenth century were reproached, and of the Passion plays the natives put on each year in order to stage the

agony of Christ in a more expressionist than baroque style.[137] But the profanation was more than a revival, or rather, a distortion of the Christian myth. It incorporated recipes for witchery that were quite common in San Luís (and elsewhere), where *muñecas* pierced with thorns and needles were used to attract death and sickness onto the sorcerers' victims. Dolls and recipients were all the same to the healer, who screamed at her victim while showing him a figurine that she drew from a rattan chest: "Look! this is how I hold you, I must punish you as I was punished because of you!"[138]

From image to divinity, doll to victim, from inanimate to animate, the oscillation was as constant as the metamorphoses of the Coatlán blasphemers who "make believe they are animals and even balls of fire."[139] This propensity for wearing multiple shapes was the expression of a native thought that postulated an extreme fluidity in beings, things, and appearances. This was how Nahualism, whose principle was close to that of the *ixiptla,* interfered with the perception of the Christian image.[140]

The Subversion of the Baroque Image

During the course of the eighteenth century, images openly became an expression of native resistance that occasionally turned into rebellion. They even became concrete representations of the political, social, and religious refusal of colonial order. The example of the Chiapas Indians' "speaking Virgin" of Cancuc[141] (1712) was one of the more spectacular and well-known ones.[142] But others were equally revealing. In 1761 a millenarian movement began in the foothills of the Popocatepetl volcano. It brought together, in an extremely complex relationship, Indian heritage and Christian elements.[143] Under the direction of an Indian man, Antonio Pérez, the movement attacked the Church, its priests, and its images: "The images the painters were making were false." But the repudiation of Christian representations did not result in an "imageless" religion. On the contrary, Antonio Pérez ordered his followers to follow the true God, that is to say, the images made by the Indians, thus two centuries later reviving the idoloclastic language of the evangelizers. In doing this Antonio Pérez revolutionized the terms of the debate: it was no longer the idols, but instead the native images who were opposed to the Church saints. The native images not only succeeded in fusing ancient idols and Christian representations—the Indians had been doing

this for a long time, in different ways—but also claimed the monopoly and the authenticity of Christian worship for themselves. The fake, the impostor, the devil, was the Spaniard. This fusion of the objects of worship was reflected in the confused descriptions made of them, and the telescoping of concepts and words contained within them: "They brought out the statue of a child that had the heads of a dog and a devil to make it dance; they saw in it the Virgin, whom they adored and had as an idol."[144] Statue, monster, devil, Virgin, idol: an observer might understandably be disconcerted. Antonio Pérez's Virgin was a "miraculous" Virgin who had "appeared," in the best baroque style, but—an important adjustment—she was also "brought back by them from Purgatory."[145] This time any ecclesiastic mediation was rejected.

The attacks against pilgrimages and the Guadalupe Virgin, in the name of new effigies that had been wholly "Indianized," inaugurated an entirely distinct stage of the war of images that fully deserves its name here, since images confronted each other on either side, those of the Church against those of the Indians. The baroque monopoly had never been so radically put into question: "[Antonio Pérez] said that he did not believe in the sanctuaries' images, nor in those inside the churches." But the war hung fire. The movement fell through, having mixed up its speeches, millenarian dreams, and the reality of colonial domination. It was symptomatic that it should have started in 1761, right when the enlightened elite were beginning to distance themselves from a popular form of worship that was overly centered on miracles and images. It foreshadowed other native reactions to the Enlightenment's push for secularization and the fin de siècle enlightened despotism. Antonio Pérez's revolt raised such a passionate appropriation, such a frenzied rush to sacralize objects and persons, that the movement's leaders themselves changed into saints and divinities. The destruction of Church images rapidly tumbled into exaggeration. Not only did it create new images—the Popocatepetl Virgin, the Lord of Purgatory—but it produced a series of incarnations that were all human images. These were inspired by native plays, and were implicitly linked to the *ixiptla* tradition, claiming full divinity against the "devils" of the Spanish Church.

In 1769, in other mountains further from the capital, at the heart of the foggy sierra of Puebla, a few Otomi Indians associated their rejection from the Church and its clergy with a similar requestioning of baroque cults. Like Antonio Pérez and his adepts, they appropriated divinity by

substituting themselves for it. The Indians embodied themselves as a Savior, St. Michael, or St. Peter, while they proclaimed the fall of the "Guadalupe Virgin, she who appeared in Mexico City."[146] A Tlachco woman took her place: "She must have been the Virgin."[147] She wore a blouse, a *quechquémetl* on which the Lord appeared to her each time she stopped dancing. The Lord's appearance on the cloth could be a flash-back to the print the Guadalupe Virgin left on Juan Diego the Indian's cape. Especially as some Indians called her partner by that very name, Juan Diego. Discreet, the woman would simply put her blouse back into a box "without showing it,"[148] just as she would let no one see the shawl she had used to wrap "the arm of the cross on which the Lord fell [from the heavens]."[149] There were some crosses around a gibbet that were purported to have become angels, as they marked the perimeter of a holy space where "one found the Glory they were to know and where the Lord of the Sky was to fall."[150]

It is not easy to untangle this amalgam of ancient idols and Christian references. It seems to center around the awaiting of a God whose frag-ments had already fallen to earth: a "large rock [is] God's heart . . . that fell from the sky;" "another was smaller, the God's finger."[151] While "God's heart," the "cape" (*rebozo*, a long narrow stole or shawl), or the *quechquémetl* were intended to capture and contain divinity, and while the "idolatry papers," the sanctuaries on top of the "Blue Mountain," the sun, moon, and air cults had obvious pre-Hispanic roots, the theme of the fall of the Sky Lord, in contrast, was apparently taken from the Christian myth of the fall of the angels. But the "fall" of god—and the saints who were to accompany him—was, contrary to the biblical punishment, a sort of inverted apotheosis. With two exceptions—the Guadalupe Virgin and St. Matthew—the Christian image in its painted or sculpted shape was absent here. Waiting for God, the Indians focused on cult objects and native incarnations—saints, a Savior, and a Virgin. The additional pres-ence of a visionary image was represented by the vision of Christ on the cross, who gave the native leader his divine mission. The Otomi Indians, in contrast to the Popocatepetl Nahua, did not invent Christian gods. They awaited them. But these gods also upset the usual associations between Christianity and idolatry. Going beyond the parameters of na-tive paganism and baroque Catholicism, these beings were destined to take the place of the Spanish saints, who would burst forth, would "fall"

from the sky, just as the native Virgin had replaced the Mexico City Guadalupe: truth would triumph over falsehood.

The whole was linked to apocalyptic expectations: "The mountains were to be transformed into plains, and all were to die and come back to life four days later, and thus would come back to earth. . . . The waters of the Mexican lagoon and those of San Pablo, also in this jurisdiction, would flood, [but] the flood waters would not reach [their] mountain."[152] Strengthened by this hope, the Indians gathered reserves of wooden weapons that would become knives, machetes, guns, and metal blunderbusses when they were resurrected. Lightning would strike the Spanish, and the mountains would crush them if they tried to attack the rebels' mountain. But the wait was in vain, and the Blue Mountain faithful scattered or were arrested.

One can measure the absorption of the baroque *imaginaire* by these two exceptional, and quasi-contemporaneous, examples. Such movements defined themselves with respect to official forms of worship by the escalation and surpassing of images, instead of by their rejection. Native iconoclasm was only the prelude to a substitution, to a new cult that was more real, more authentic: the awaited or created god was never a simple representation, but was the living god, the new divine presence. This tension, quickly choked off if it grew to spectacular proportions, was never powerful enough to put the supremacy of "established images" into question. But it was sufficient to excite the *imaginaires,* awaken expectations, welcome miracles, and unfailingly reinterpret its presence within the image.

Baroque Imaginaires

The indigenous and mestizo *imaginaires* were multiple, as numerous and diverse as the uses of Christian images and as the ethnicities and other groupings on New Spain's soil. The receptivity of the Nahua Indians close to the valley of Mexico City was not that of the Otomis in the Puebla sierra, even if their beliefs and expectations shared a same anti-Spanish radicalism. The Indians, the mestizos, and the Spanish were not the only ones to place themselves under the protection of images. In the sugar cane mills of the tropical regions, the *trapiches* that became more numerous during the seventeenth century, a whole people of black slaves

survived. The scenarios were similar: a black woman devoted to the Virgin might speak to an image that visited her in her cabin, the image sweated several times in front of the slaves, and finally became the patron saint of the plantation. The slaves celebrated the miraculous "revivals" just as the Indians did, by dances, *saraos* (soirees), and banquets.[153] The image might perhaps offer a central rallying point around which the mestizos and mulattos would later try to create a village, to escape the subjection of the mill's owner or the neighboring haciendas. As for the Indian communities, the image would then serve as the expression of an identity, of solidarity; in this form it was already a political image. But one should also evoke the scene of the northern silver mines where, in subhuman conditions, a miserable and overworked class of laborers was proliferating. These workers all venerated a patron saint whose annual celebration was the chance for a meager procession and for a few poor feasts.[154]

The voyage into baroque images might thus extend itself forever: from the Indians to the blacks, the blacks to the mestizos, and from the mestizos to the *petits Blancs,* the poor whites, from the urban solemnities to the syncretisms of the southern mountains and northern deserts. One might notice that the *imaginaires* overlapped everywhere, like those Jesuits irrupting into the sordid confines of an *obraje* (workshop) to organize the saint's feast, or those Indians creating new Marian cults on their sierras. Ideas crossed each other, expectations mingled and collided around images everywhere, inextricably. Individual and collective *imaginaires* superimposed their grids of images and interpretations onto the oscillating rhythm between mass consumption and a myriad of personal and collective interventions, between extremely sophisticated forms (the triumphal arches) and immediately legible manifestations (the Marian scenarios). There was even a tension breaching that tried madly, through the image, to abolish the distance between man and myth, between society and the divine: to make things sacred. The baroque image might be its instrument of predilection, just as today other images strive to fill in the gap that separates our lives from fiction in all its forms.

Where these multiple and ceaseless initiatives met with the politics of the Church, the baroque *imaginaire* played on the federating power of the image, on its polysemous tolerance of the hybrid and the unspeakable, on the sharing of experiences that it elicited from its faithful, its public. It was an *imaginaire* where communal sensitivities transcending their lin-

guistic, social, and cultural barriers ran under its surface; one briefly inhabited by the most wildly disparate visual experiences, from the Italian Maria Magdalena de Pazzi's ecstasies to the delirious visions of María Felipa. It was an *imaginaire* crisscrossed by parades of prodigious images, imported from Europe or miraculously discovered, copied and reinvented by the Indians, fallen from the sky, shredded and "revived." Most of the groups, even the most marginal among them, participated to one degree or another in this *imaginaire* where baroque society managed to absorb or soften the dissidents, sorcerers, syncretic shamans, enlightened souls, visionaries, millenarists, and inventors of cults who replicated the Guadalupan scenario everywhere with less success and fewer means, but just as much stubbornness. It was because the baroque *imaginaire,* above all, made the world sacred—the descent of the Virgin onto the Tepeyac, Popocatepetl; the God falling onto the "Blue Mountain"—that only "disenchantment" truly menaced reproduction. And disenchantment first assumed the insidious, but still controllable, shape of the Enlightenment and enlightened despotism.

From the Enlightenment to Televisa

Baroque devotion reached its height during the early eighteenth century in Mexico: the collegiate church of Our Lady of Guadalupe was finished in 1709, the Chalma Christ's sanctuary was consecrated in 1729, and the Virgin of Guadalupe gained unlimited influence by becoming the official patron of Mexico City in 1737 and of Tlaxcala in 1739. New devotions sprang up in the provinces: those of the Virgin of Tlalpujahua, a mining center on the road to Michoacán; the Tlayacapan cross (1728); and the *Patrocinio* Virgin of Tepetlatzinco, who brought the son of a native sculptor back to life in 1739. The Franciscan Antonio de la Rosa Figueroa, one of the order's most active figures during the eighteenth century, started this new cult by having four thousand engravings of the Virgin printed, each of course proving to be miraculous. It was true that these devotions did not last equally: after having accomplished thirty-two miracles in three years, the Tepetlatzinco image lost favor with its faithful during the second half of the century.[1]

A different tone emerged during the late 1700s. In 1774 a miraculous image of the Virgin appeared on a grain of corn to an Indian woman from Tlamacazapa, not far from the Taxco silver mines.[2] The enthusiasm and responsiveness of the faithful was countered, this time, by the authorities' distinctly lukewarm response. Baroque effervescence was still bubbling among the rural and urban masses, but the colonial authorities were preparing to lay down other cards. The Spanish Crown was abandoning the baroque galaxy in order to enter the orbit of Enlightened despotism under the aegis of a dynasty of French origins: with the Bourbons, spurred on by Charles III, the Hispanic world was projected, *nolens volens,* toward modernity. This was a time of reforms and violent splits: the Society of Jesus, which figured prominently during the beginnings of the baroque image and which was largely responsible for its diffusion and success, was thrown out of New Spain in 1767.[3]

The Brakes of the Enlightenment

The metropolitan and colonial elite began to worry about the excesses and superstitions they felt were infesting the native world and the common people. With the idea of regaining control of colony possessions, the Bourbon administration deployed a new model of civilization that went beyond institutional and economic reform, and attacked the still dominant religious and aesthetic sensibilities head-on. The organization of this intercontinental model—from Naples to Mexico City—was based on the deep-seated belief that an immeasurable abyss separated the ignorance of the masses from the Enlightened elite. The full-scale recuperation of the baroque era gave way to a sneering rejection and cold repression instituted by bureaucrats who lacked the humanist gaze that had tempered the violence of the priests during the sixteenth century. Under the influence of the Enlightenment, one block after another would stem, if not entirely dry up, the great baroque tide.

The catechism set forth by the fourth Mexican provincial council (1771)—just as most of the assembly's decisions, for that matter—was an example of this new direction: it warned against those who would try "to feign miracles, revelations, relics, even if it is with the goal of increasing devotions."[4] The Church had previously shown itself to be much more indulgent toward those who wanted to "increase devotions." The council, merely the devoted interpreter of the King's desires, asked for the destruction of such images and chapels as were considered useless and superfluous.[5] The worshipping of saints—such as the Indians practiced it—was increasingly considered an "external cult," the manifestation of a religious varnish, a substitute, as it were, for religious fervor. It was no longer believed that "spectacles" and "plays" were necessary for the edification of the natives, and that the eye was more necessary than the ear or the intellect. And thus the *al vivo* "plays" of the Passion of Christ were forbidden.

The instances of superstition, scandals, and disturbing the peace were not the only causes for this. What was also condemned, more implicitly, was the Indians' participation in the representations, the autonomy they enjoyed and knew how to manipulate. What once might have passed as a "means for opportunity" had since then, "after more than two and a half centuries,"[6] become intolerable. "Exterior things," the "exterior ob-

jects of an embodied representation," "the experience of these remembrances" were discredited as were the senses in general, in order to favor reason.[7] The goal was nothing less than modifying the hierarchies of meaning. The Enlightened West readjusted the model with which it meant to subjugate its dependent populations. As several wise observers pointed out, this was an attitude that might give rise, "among the rustics or the idiot people, to some disbelief" or to "a growing coolness."[8]

One would have to travel backward in time to detect the precursory signs of this reversal. They can be seen from the late seventeenth century on. In 1698 and 1704 the archbishops of Mexico City, made wary by the 1692 commotion that had shaken the capital and stirred up the viceroy's palace,[9] began to worry about the excesses that they insisted were distorting religious representations: "It seems that the motivation leading the first venerable friars and apostles to organize these representations in the beginning, to shape these slow and unpolished hearts to the mysteries of our Holy Faith by all paths possible, is obsolete."[10] In 1729 scandals broke out around the images circulating in the region of Mexico City under the pretext of gathering moneys:[11] obscene dances, the cheating of a priest who had tried to pass off a poor copy for the original, in short, a precursory taste of the flood of denunciations that was to inundate the second half of the century. Eight years later, in 1737, in the name of the Holy Office, a Chalco priest solemnly forbid the Temamate Indians to "at any moment take out the painting of Our Lady of Guadalupe that they pretended had restored itself, sweat, and spoken to them."[12]

In 1745 the archbishop of Mexico City decided to put an end to the disorder that the cult of the Virgin de los Angeles had created in a neighborhood of Mexico City by having the wall on which the Virgin was painted covered up with boards. The rumor was that the image had "restored itself" (that is, that it had regained its original colors); in order to calm everybody down, the archbishop ordered to "uncover it so that the people might be set right and might observe that the renewal of this image was not miraculous in the slightest, but that it was a natural phenomenon." This indicated the priest's distrust of spontaneous gatherings that might trouble the public order and favor "dissolution and libertinage,"[13] but also a distancing from miracles that the Church would probably have sanctioned in the previous century instead of choosing the perilous path of disenchantment, opposing the "natural" to the miraculous.

Baroque Religious Practices under High Surveillance

During the second half of the century, native and popular religious practices generally became the target of constant attacks: feasts and chapels were deemed too numerous, processions too costly, and the confraternities excessively prolific. No longer were native practices singled out for denunciation: ridicule also fell on "the superficiality of everything the Indians practice in terms of religion; the pains taken with their oratories and the decoration of holy images makes me think of the care taken by little girls with their dolls, and women with the display of their charms."[14] It was not yet time to denounce fetishism, or for the psychology of the worship of images—at that time downgraded to a mere childish and feminine activity—but it was time for "reforms": reforms in "the matter of images, because there are countless ones that are extremely indecent, ugly and ridiculous; far from arousing devotion, they serve to feed mockery and derision."[15] The clergy's response was to impose cult objects and images that conformed to "decency," that is to say, to the classical canons of good taste and reason. They did this through measures that constrained their display in public: in 1778 the priests of Mexico City condemned one of the major celebrations of the Mexican calendar, the feast of Santiago de Compostela, and the unruliness for which it would be the pretext; by the end of the century other voices clamored for "reform" and the "purification" of the processions during Holy Week.[16]

In 1794, one hundred and forty-six years after the publication of Sánchez's work, there was a sudden turn of events in Madrid: the Spaniard Juan Bautista Muñoz attacked the cult of the Virgin of Guadalupe. Cosmographer of the Indies, charged by Charles III with writing the history of the American holdings, Muñoz closely examined, with his Enlightened criticism, "what they call the Tepeyac tradition," the "so-called apparitions," "fables," "tales," fanaticism, and "easy and indiscreet" devotion. His verdict: the Academia de la Historia "holds the vulgar tradition to be fictitious."[17] In Mexico, however, this news was a waste of time, revealing the fierce resistance the Enlightenment provoked by its strategies of disenchantment. This condemnation might have signaled the end of an era: instead, it only galvanized—even today—the Mexican defenders of the apparitionist theories. The same raising of the shields

happened elsewhere against Servando Teresa de Mier's sermon in 1794: the Franciscan had not denied the apparition, but, in an unbridled exaggeration, pushed the origin of the worship back to pre-Hispanic times, thus discrediting the Spanish evangelizers: "Seventeen hundred years ago, the image of Our Lady of Guadalupe was already much celebrated and worshipped by Indians who were already Christians, on the heights of the Sierra of Tenayuca where St. Thomas erected a temple to her."[18] The Franciscans had come a long way from Bustamante's sermon in 1556 to Mier's, via Vetancurt's *Teatro mexicano*.

It was easier to address peripheral signs. In 1805 the authorities refused the Popotla Indians a building permit for a chapel to shelter an image of the Agony of Christ.[19] In 1810 the Puebla bishop went to war against the Holy Cross of Huaquechula. Painted on a rock, surrounded by a multitude of ex votos, perpetuated through hundreds of stamps, the cross was said to have appeared miraculously. Its feast, on the third of May, attracted crowds from everywhere, from Acapulco to Veracruz. The prelate secretly had the cross and the numerous ex votos decorating the sanctuary, "ex votos of silver, seductive retables on which are painted false miracles," removed.[20]

The divorce between a popular and spontaneous devotion, and a hierarchy worried about "stifling an unfounded and pernicious cult that allows libertines to mock true miracles," was finalized.[21] Piety became only a "credulity and simplicity of the ignorant people lacking criteria who let themselves be taken in because they love novelty." The theme of degeneration replaced the denouncing of hybrids and "mixes" so dear to the idolatry exterminators of the preceding century: "By virtue of the inconsistency of human affairs, [devotions] have degenerated into irreverence and ridicule."[22]

It remains to be known to what extent this Enlightened repression, modeled after Europe's, was the answer to the evolution of the social and cultural structures of New Spain during the eighteenth century. The native communities rejected the new shackles being imposed on them, and often the fear of provoking unrest allowed the former state of affairs to persist. Everything leads us to believe that the politics of the Bourbons surprised a society still deeply immersed in baroque sensibility, and that by resisting bans and condemnations with all its strength, it proved its continuing imperviousness, for the most part, to the slightest attempt at secularization. The enterprising Puebla bishop had good reason to fear

that his intervention might cause a *commoción popular* (popular uprising). Just as Montufar was said to have secretly placed an image of the Guadalupe Virgin in the Tepeyac sanctuary in 1555, the Puebla bishop, just as secretly, took away the object of devotion from his faithful. The baroque era—for some—was to end, paradoxically, just as it had opened: quietly. This discretion stemmed from its awareness of the dangers that any undertaking of disenchantment raises when it is based on overly subtle distinctions and implicit criteria, the disruption of long-tolerated traditions, and the rejection of popular initiatives.

Let us not hastily conclude that the Church was sharply breaking away from the worship of images: exceptional indulgences were still granted in 1794 to the pilgrims going to the sanctuary of the Christ of the Sacromonte, at the foot of the Popocatepetl.[23] None of its measures attacked the principle of the worship of images, nor the authority of the miraculous images. But in wanting to privilege public order and decency motifs, they drained the baroque *imaginaire,* and even more so, threatened its native or popular ramifications. By rewarding the value of internal piety and by sowing discredit on the hold that "external things" had over the natives, the ecclesiastic hierarchy and the colonial elite alike distanced themselves from an indiscriminate and invasive use of the image. It is significant, indeed, that in 1777 and in 1789 the Crown decided that, from then on, the plans for any repairs or decorations applied to a Mexican sanctuary would be submitted first to the Madrid Academy of Fine Arts. It warned people to avoid wooden retables (an easy prey for flames) or gold-leaf work (which was "enormously costly," yet fated to blacken) and to reduce lighting (again, to prevent the risk of fire).[24] In the name of security, profit, and the economy, the gilded wooden retables, carriers of the great baroque image, were objects of the past. Finally, in 1783, the Royal Academy of San Carlos was created in Mexico City, a local replica of that of Madrid.[25] The control of Enlightenment bureaucracy would subsequently be substituted for the oft-eluded constraints of the baroque image, even if academicism was yet far from triumphing.

The decline shown by the great painting of Mexico, hit with an official abandonment of the baroque and the receding of religious themes, contrasted with the flowering of popular productions that lasted throughout the nineteenth century: usually religious, sometimes the work of indigenous artists, they tirelessly reproduced the souls in purgatory, the life of the saints, and the miraculous Virgins, Our Lady of Guadalupe at the

head of them. In the semitropical countryside of Morelos, the building of the sanctuary of Tepalcingo ended only in 1781. The sanctuary sheltered the miraculous image of Jesus the Nazarene, a marvel of "popular," "provincial," "rural" baroque; an art, in fact, that was unclassifiably exuberant, bursting with "Roman," "paleochristian," or even "Breton" recollections—which they were not, of course; a repository for all the archaisms muddling the maps of style, like the gaze of an art historian. The churches around Puebla that had kept their interior decoration— Ecatepec, and most of all, Tonantzintla—opened their polychrome grottoes where the golds competed with the greens and reds. At first dependent on the sumptuous urban baroque of the churches of Puebla, the decoration of the Tonantzintla church stucco continued throughout the nineteenth century, ending only in the twentieth. It exhibited an artistic thought whose chronological movement and intentions were quite difficult to follow, because after that the elite would display only indifference, silence, or scorn. But this renewed attempt was to shape the looks cast upon the new images of the twentieth century.[26]

Images and Independence

The longevity of baroque sensibilities was only one of the many repercussions of the Bourbon's demise, and of the success of the Independence movements. Bluntly imposed from the outside, Enlightenment politics died with the breakup of the Spanish empire at the beginning of the nineteenth century. Charles III had laid down the bases of an experience that was interrupted in Europe by the French occupation of Spain, and in America by the Resistance movements to colonial domination. Troubled times began in which, more than ever, images would have a part to play.

The war of Independence has been presented as a conflict where each protagonist placed itself under the protection of one of the great Marian images: the Guadalupe Virgin for the Revolutionaries, the Virgin de los Remedios for the Royalists: "the two images of the Mother of God took their position as for a fight."[27] The battle would thus, in its own manner, also have ended by a "war of images." No doubt this distorts history, but the interpretation contains some truth. The Spanish were even said to have hated the Tepeyac Virgin so much so that they shot one of her effigies and profaned others.

But it would be too easy to imagine baroque images in the nineteenth century becoming political and nationalist symbols around which parties gathered. Reality seems more blurred. When one of the insurrection leaders, the priest Hidalgo, flew the Guadalupe Virgin's flag at the head of his troops, the gesture was not truly premeditated, and one could find a precedent for his action in the banner accompanying Cortés during the Conquest. Had Hidalgo purposefully aimed to "better seduce the *pueblos*" and cynically exploit popular devotion, as his enemies accused? Did he simply allow the situation "to attract the people to him"? Was he completely unaware of these events and more worried about military strategies than manipulation?[28] The ambiguity of his gesture is equal to the ambiguity of the Independence movement. By way of counterattack the viceroy Venegas had the Virgin de los Remedios come to Mexico City, and solemnly placed the insignia of his power in her hands. Our Lady de los Remedios became the patron of the Royalists and the Spanish.

That the conflict managed to appear to be a duel between the two Virgins should not be surprising in a Mexico that had only just left the baroque age behind, still humming with the innumerable rivalries opposing images, sanctuaries, and confraternities. Mexico's case was not an isolated one: in the 1790s the people of Tuscany and southern Italy rose up against Leopold's reforms with the cry "Viva María."[29] Once again, on either side of the Mediterranean, linking the Tyrrhenian to the Gulf of Mexico, voices echoed each other.

A National Divinity

Nonetheless, starting with the Independence and for several decades thereafter, the Mexican political class seized control of the Tepeyac image; liberals and conservatives showed themselves to be equally desirous of dominating what would henceforth be considered the nation's symbol, and what had kept its absolute hold over the crowds. Up until 1867 the Guadalupe Virgin participated in the great national liturgies: the Virgin became the patron of the Mexican Empire (1821); the deputies worshipped her in the halls of Congress and declared "the twelfth of December the greatest day because of Mary of Guadalupe's marvelous apparition";[30] the Emperor Iturbide created an order of chivalry, the

Order of Guadalupe (1822); the Emperor Maximilian meditated in her sanctuary (1864) and renewed the Order of Guadalupe, which did not survive the crushing of his empire. The image acquired, for the liberals, a political stature that in their eyes superseded its religious identity. There were even Freemasons who were unable to resist the Virgin's charms. A lodge whose membership included the great figures of insurrectionist and republican Mexico, the *India Azteca* lodge, mixed the Guadalupe Virgin's celebrations with its rites, so that she became a new syncretic avatar in the already crowded history of the Tepeyac goddess.[31] The new authorities of the first half of the century even showed some interest in going back on the restrictions imposed by Enlightened Spain on the worship of images: in 1834 the governor of the federal district (the capital) granted great freedom to religious processions.[32]

It was after Maximilian's short reign that the ties between the Guadalupe Virgin and political power loosened. The image paid the price for an irreversible situation: the Mexican state separated from the Catholic church. The laws of the Reform ratifying the break were written into the constitution in 1873. The holdings of the communities and confraternities involved in the worship of images were officially removed, and with them a great part of the material infrastructure permitting its existence collapsed.

Despite the separation, and these measures that for the most part simply developed the Enlightened politics of the remaining Bourbons, the great sanctuaries did not empty out. They even kept the discreet favor of those in power. In 1859 Juarez retained the Guadalupe Virgin's feast among the national holidays, and exempted the riches of her basilica from the nationalization of the holdings of the Church, as he did for the endowment of the chaplain of the sanctuary de los Remedios.[33] Besides these exceptional dispensations one must also take into account the repeated violations of the law suppressing Catholic feasts and processions: the liberal Altamirano read into this a "constant collusion between the political authorities and the priests and sacristans to be allowed to take the wooden saints out of the church at any time in order to get some fresh air processionally or to preside over a bacchanal."[34] Just as it had stubbornly lived down the assault of Enlightenment, the local, popular, and consensual Christianity with its baroque filiation resisted the even more radical measures of liberalism. This allowed the priest Fortino Hipólito Vera, following the example of his illustrious predecessors, the Florencias and

Vetancurts of the seventeenth century, to make a long census of pious images in his *Itinerario parroquial* (1880), in a language that evoked baroque prose: "sacred image of a miracle and a miracle of images."[35] According to Vera, neither the turmoil of Independence and civil wars nor the laws of nationalization succeeded in drying up the devotion to images.

The Totolapan Christ, once given into the care of the Augustine convent of Mexico City in 1583, came back to the *pueblo* after the convent had been closed. The worship of St. Anthony in Tultitlán came through the Independence unscathed. In 1826 the inhabitants of Azcapotzalco asked the new town council, established after the Independence, to be allowed to retain possession of their images, stating that they belonged "to the community of the *pueblo*" and reminding the council that since 1790, during the Enlightenment, "the customs of banquets and drunkenness" had been abolished.[36] At the end of the century the feast of the Virgin de los Angeles attracted several thousand people to a Mexico City neighborhood, and prompted forty or so *pulque* bars, where they served the fermented agave juice, to open. This image's success, however, only dated back to the 1780s.[37] New miracles and cults continued to flourish here and there, like that of Our Lady de las Lágrimas, who had miraculously been saved from a fire in 1839. Elsewhere the Holy Weeks and colonial devotions continued to attract crowds: seventy to eighty thousand people for the Juquila Virgin in Oaxaca state.[38]

The procession of the Christs of Tixtla (a small town in the hot lands of the Guerrero) at the end of the nineteenth century points not only to the profound attachment the natives had to their images, but also to the significance of distant interpretations, in part explained by their isolation: "For them, sculpture is still the same rudimentary and purely ideographic art that existed before the Conquest. This is how they can improvise, from a *calehual* tree trunk or any other hollow tree, a body that seems to be that of a man; they spread it with a coat of *aguacola* [water from the cola nut] and plaster, and then paint it with very bright colors, and literally bathe it in blood."[39] Each family came out with its Christ, carrying it on stretchers or in their arms, and eight hundred to a thousand Christs went by: "It is enough to make an iconoclast faint."[40] The nocturnal spectacle was hallucinatory for a Western gaze:

There, parading by, range statues from the colossal *Altepe*-Christ the Indians hide in the grottoes and that is almost an idol from the old mythology, to the

microscopic Christ the little nine-year-old Indians carry between their thumb and forefinger by the light of candles as slender as cigarettes. All the sizes, all the colors, all the emaciated flanks, all the wounds, all the deformities, all the humps, all the contortions, all the bizarre things that can be sculpted are represented within the procession. When in the torchlight . . . one sees this immense cohort of hanging, hairy, and bloody bodies go by, one imagines being in the grips of some horrible nightmare, or crossing a forest during the Middle Ages, hung with a tribe of naked Gypsies.[41]

The sensitivity of the liberal Altamirano to extremely ancient cults—the *altepecristo* is the descendent of the *altepetéotl*, the pre-Hispanic god protecting the *pueblo* and usually living in a neighboring mountain—finally dissolved into the macabre shadow of Hugolian romanticism.

The great devotions were encouraged by the ecclesiastic hierarchy, and more than ever their feasts drew crowds. The Catholic press was fired with enthusiasm when it described the two hundred thousand spectators gathered to celebrate the Sacromonte Christ in 1852: "The brilliant pens of Chateaubriand or Lamartine could barely have described the religious scene that then took place."[42] This devotion even seems to have reached its height at that time: "Although the worship of the Lord of Sacromonte has always been important, we can assure you that it did not reach half of what it is under the current priest: his ecstasy, his unique thoughts are what foment this."[43] It was true that the worship fared worse in the small villages and the suburbs of the capital "in these times of atheism, of incredulity, and libertinage."[44] The native populations were the primary constituents of the battalions of faithful whose piety was continually praised by the Church: "There is no doubt that because of the purity of their heart, they are the ones who deserve to enter into the tabernacle, they are the ones whom the Lord favors and protects."[45] The reversal was spectacular. Romantic enthusiasm replaced the scorn of Enlightenment; the Church now seemed convinced that the baroque inheritance, with its popular devotions and its images, was the best defense against atheism, especially that of the cities. It was true that the Mexican Church took advantage of the peace of the late nineteenth century to reorganize and regain its footing in the country: paradoxically, it was under the reign of the liberals (1859–1910) that it carried out its "reconquest."[46] The solemn coronation of the Tepeyac image in 1895 probably constituted the official height of its worship; it took place in the presence of the entire ecclesias-

tic hierarchy, but without the attendance of the dictator Porfirio Díaz, card-carrying layman.

The split between the political elite, the Church, and popular devotions only continued to grow. Altamirano, visibly uneasy, judged that the Catholic religion in Mexico was related to idolatry or fetishism—a term popular during the nineteenth century. However, he could not help but note the continuing spread of the worship of the Guadalupe Virgin. In 1870 her feast continued to be "one of the greatest feasts of Mexican Catholicism, surely the top one by its popularity and universality, since the Indians take part in it as often as people of reason."[47] The unanimity the celebration gave rise to remained intact: "all races . . . all classes . . . all castes . . . all political opinions."[48] Altamirano never tired of emphasizing it: "The cult of the Mexican Virgin is the only tie uniting them."[49]

One can therefore feel the underlying unease in this liberal who was quick to denounce superstition, "idolatry," and the hold of the clergy, but also his fascination with the vigor, the continuity, and the authenticity—lo genuino—of the popular demonstrations, as by the political and social power of the symbol: "Before the Virgin all are equal; it is a national idolatry."[50] The association of the old term "idolatry" with the adjective "national" reflects the astonishing trajectory of an image that had become the expression of a national consciousness or, more exactly (and the nuance is significant), a substitute that would stand in for it. Had the cult, by the end of the century, become "an exclusively religious and peaceful cult,"[51] confined to the reassuring and guarded sphere of an assimilated religiousness? Altamirano wanted to believe so.

Following its destiny up to today would mean the considerable task of following the history of Catholicism in Mexico, and, even more breathtaking, that of examining the evolution of popular cultures throughout each of the stages of the revolution, the urbanization, and the industrialization of the country. Until what point, under what forms, did baroque Christianity prove itself capable of surviving and resisting the assaults of liberalism during the nineteenth century, and the assaults of the Mexican revolution, which carried the torch of anticlericalism in its 1917 constitution? The *pueblos,* who moved during the turmoil of revolution, taking their patron saints with them, or the Cristero rebellion that bloodied the 1920s might provide elements of an answer that would reveal the double hold of popular Christianity, and in the case of the Cristero rebellion, the stubborn rejection of the secularism touted by the Mexican state. What is

left today of native cultures vouches for the importance they assigned to the image, from the poor quality color prints of domestic altars to the sculpted masks, from the village festivals to the multitudinous shifts toward the great sanctuaries of Chalma, de los Remedios, or the Guada-lupe. And let us not forget the underworld of the shantytowns, and the uprooted proletariat crowding ever more numerous around these and many other images.[52]

It would seem therefore—but this is only a working hypothesis—that in the absence of a deep de-Christianization and a real industrialization, Mexico, until the second World War, kept the receptivity to the image it had inherited from baroque religiosity and its *imaginaire*. This receptivity would explain both the rise, and in certain cases the limits, of such an experience as muralism.

The New Walls of Images

The Mexican revolution, in search of a renewed imagery, birthed mural-ism. Rivera, Orozco, Siqueiros each in his own way illustrated what remains one of the greatest art experiments of the first half of the twen-tieth century. The baroque image had followed that of the missionaries, and a new didactic image, in turn, ensued. Four centuries after the Fran-ciscan experiment, the "muralists'" image covered the walls of public buildings with gigantic frescoes intended for the people's revolutionary edification, before giving way to a metamorphosis of the baroque image, just as omnipresent and miraculous, spread by thousands of sparkling screens.

"One of the first remarks I made to them was that we should get rid of the era of living room painting and reestablish mural painting and large canvases. . . . The true artist must work for art and religion; and modern religion, the modern fetish, is the socialist State organized for the com-mon good. . . . My aesthetics in painting can be narrowed down to two goals: speed and area, that is to say that they paint quickly, and cover a lot of walls." This was not Peter of Ghent exhorting his disciples, but the Minister of Public Education, Vasconcelos, who gave this speech during the early 1920s to the best Mexican artists.[53]

It might seem paradoxical to discover a distant secular echo of the Franciscan image in Mexican muralism. But the texts themselves draw the rapprochement. Let us listen to one of the masters and theoreticians

of Mexican muralism, Orozco, talk once again in 1947 about the major traits of that school, "a movement of revolutionary and socialist propaganda in which appears, with a curious persistence, Christian iconography and its interminable martyrs, its persecutions, miracles, prophets, father-like saints, evangelists, sovereign pontiffs; the Final Judgment, Hell and Heaven, the meek and the sinners, the heretics, schismatics, the triumph of the Church. . . ."[54]

Beyond iconographic revivals, the repeated borrowings of an "outdated imagery" (Orozco), and sometimes the ghost of the Italian primitives and the Quattrocento (in Diego Rivera's work), one can make out other deep common bonds: the utopic bent, or the plan for spreading an aggressive ideological discourse accessible to the masses; the will to impose a redemptive and militant art; and finally, the rejection of all painting which, like baroque art, would transcend groups and classes while exuding the pomp and circumstance of a misleading unanimism. The *murales* of the 1920s to 50s were an echo of the walls of images expressly addressing the Indians during the sixteenth century. Among thousands of other things, it remains to be seen to what degree these frescoes, with their historical pretensions, repeated in schoolbooks and teaching, managed to animate and lastingly implant a nationalistic imagery in the heart of the Mexican peoples. The heroes of the Independence and the Revolution never received the adulation that continued to be demonstrated toward the great religious images, even if it is undeniable that illustration popularized them everywhere. The new lay liturgies seemed to not have had the decisive impact of the great baroque liturgies, no doubt because they lacked time, and the fascination of the "miraculous image."

Televisa: The Fifth Power

If certain aspects of muralism were reminiscent of the evangelizing ambitions of sixteenth-century fresco painters, the fantastic rise of Mexican commercial television, under the aegis of the Televisa company, certainly conjured up the miraculous and invasive image of baroque times.[55] The expression of an electronic culture without any national ties replaced the furiously Mexican frescoes—influenced, notably in Diego Rivera's painting, by native folklore. Certainly the advent of the televised image was preceded by movies that showed, after 1895, "creatures as Christian as we and as animated by souls as we."[56] The new technique, in any case,

only gave secular value to souls "in order to sow, once again, miracles throughout the psychic universe of its spectators."[57] The images of Mexican cinema, during its golden age in particular, prepared the farmer and town masses for the trauma of the industrialization of the 40s; they carried an *imaginaire* that, in league with the radio, either undermined or actualized traditions by initiating the crowds to the modern world through its mythical figures, such as Pedro Armendáriz, Dolores del Río, María Félix, and many others. From the late 30s on, the flood of cinematographic images wove a new consensus centered on the new values of city, technology, illusions of consumerism, and even at times the assimilation of the most denigrating stereotypes.[58]

With its political and cultural choices, with its strategies, private Mexican television once again revived the onslaught of images by taking, as did commercial film, the opposite view from state muralism. Televisa's experience was exceptional in that it overstepped its borders in order to extend its hold over the Hispanic populations of the United States and the rest of Latin America, before penetrating Spain in a counter-conquest, an unforeseen reversal of a war of images five centuries old. The continental success of Televisa is based on a commercial power, a cultural hegemony, and politics that reach quasi-mythical proportions: the notion of "fifth power" has even been broached.[59] Without overly abusing these qualifiers, one is forced to admit that in the crucial domain of the contemporary image, Mexico has acquired a mastery that equals, or even goes beyond, that of the great baroque era. The machinery that has been put in place breaks a European dependency and extends over an area that largely exceeds the former territory of New Spain. Since 1950, Televisa broadcasts an overconfident image that ensnares the highly contrastive segments of the population within a common and "apolitical" culture, and efficiently participates in subjugating them to the established authorities. The televised image easily recuperates the most disparate ambitions in order to neutralize and visually pipe them through; it is a leveling image, meant to bring about a consensus—"television must bridge the gap between all Mexicans"[60]—built on a universal model of North American inspiration.

The spiriting away of transcendence and religion in favor of consumerism—thus making what was only one of the results of the baroque *imaginaire* an end unto itself—is the abyss that separates Televisa from the colonial machinery. A systematic exploitation of the attraction, the ubiq-

uity, and the magic of the image; making *imaginaires* uniform; and the reuse of popular stories—the rhythm and efficiency of soap operas were already present in the Guadalupe legend—brings them closer.

Perhaps, from this perspective, we can better explain the pomp and circumstance of the Televisa exposition devoted to the Guadalupe Virgin in 1988.[61] Was this a calculated homage, an umpteenth attempt at recuperation, or a transfer of the powers of the image? In the showroom the Virgin's face was inscribed, multiplied on the video screens while the names of generous donors scrolled by. A quiet transition, the Church's discretion was only equaled by Televisa's, set on having its mainly commercial ambitions and logic forgotten. But the fascination of the Guadalupan image, greatly increased by dozens of colonial replicas, remained, working on the silent crowds of mixed class flowing through the dim light. A whiff of expiation could be added to this. Televisa had offered its show to a public opinion troubled by the iconoclastic attempt of a painter who had recently placed the Guadalupe Virgin's head on Marilyn Monroe's body, thus illustrating in a spectacular fashion the telescoping of all images. The Church, the faithful, and certain newspapers offended by the montage had once more, for the occasion, found the impetuosity and the language of the baroque seventeenth century.[62] The vehement condemnation of this iconoclasm confirmed the sacred value of the image, no matter where it should originate, and the principle of a certain order to things. Nonetheless, one could search the electronic screen in vain today for the blasphemous and destructive gesture of the "image-tramplers," the *conculcadores* of long ago. The televised image does not seem, at first, either capable of being recuperated as were the images of saints, nor capable of being destroyed, as were the idols.

From Baroque Image to Electronic Image

In fact, it would be advisable, in Mexico and Latin America, to examine the manner in which—through the failure of the Enlightenment, the mistakes of liberalism, and the slowness of illiteracy—the post-baroque era (1750–1940) prepared minds and bodies to receive a new image associated with new forms of consumerism. This is a journey that in contrast to that of Western Europe—except for southern Italy and some parts of Spain—would be accomplished without the industrial and urban revolution of the nineteenth century. It would bluntly and with little transition

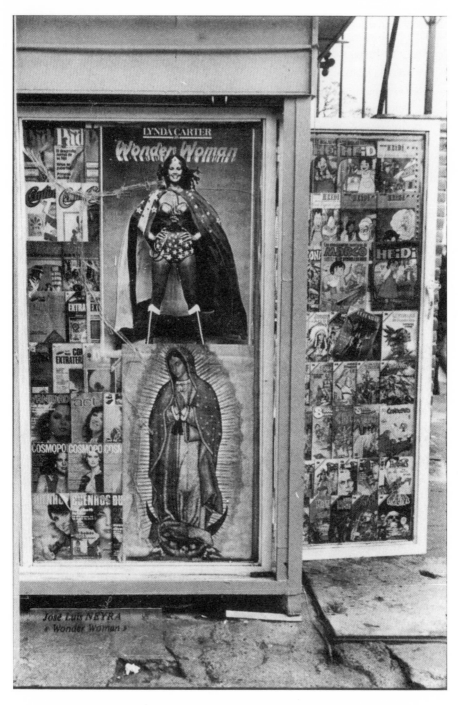

20. José Luis Neyra, *Wonder Woman*. Mexican Cultural Center, Paris.

lead to the world of contemporary consumerism—or to the gates of such a world. Instead of staying with the classical evolutionary scheme that tears populations from "archaism" and backwardness and propels them into "modernity," it would therefore be preferable to insist on the links that run, through their sensitivity to images and "exorbitant" consumption, from the baroque to the industrial and postindustrial *imaginaires*. Modernity—and even more so, postmodernity—diverts tradition, instead of abandoning it.

The contemporary image establishes a presence that saturates daily life and imposes itself as a unique and obsessive reality. Just as the baroque image, whether Renaissance or muralist, it broadcasts a visual and social order; it infuses models of behavior and belief; it anticipates, in the visual field, evolutions that have not even yet given rise to conceptual or discursive explanation. Already, by instilling a standardized and omnipresent image that forever recalled other images—the thousands of copies of the Guadalupe Virgin—the baroque machinery had opened the way for the politics, machinery, and effects of the image today. It did so not only through its homogenizing function and its universalizing obsession, but also by creating a singular rapport to the image, making it the basis of a surreality into which the gaze could sink, that abolished the distance from prototype to reflection, erasing the conditions of its production. In this respect the televised image would once again take charge of a "diffuse religion" that would dissolve into consumerism, secreting the scarcity of its miracles on a day-to-day basis, spreading a paradise of immediate presence, ethereal immanence (illustration 20).

Baroque Consumption, Syncretism, and Postmodernity

In light of the baroque experience, one must reconsider any assessment that would treat the current uses of television and the abundant forms of receptivity to images lightly. One should distrust a review that neglects possible appropriations, or one that minimizes the potential misappropriations, fostered by the breaches electronic image technologies can open today. The term "neo-baroque"[63] could be used to qualify our times, when the channels of communication (video, cable, satellites, computers, video-games, etc.) have multiplied in Mexico as elsewhere, and the spectator has been left with the new freedom to compose his or her own images. This label "neo-baroque" has been chosen because the

individual and collective experiences of the image-consumers of the colonial era shed light on the ideas taking shape today, the margins that are breaking free, but also on the traps that this apparent freedom, this apparent disorder of the *imaginaire* dissimulate. In this respect the mention of baroque Mexico can be precious; and the long detour through the miraculous Virgins, of which today we can only perceive the faded *saint-sulpicerie*,[64] is certainly not wasted. The colonial *imaginaires,* as those of today, practiced decontextualization and reuse, the destructuralization and restructuralization of languages. The blurring of references, the confusion of ethnic and cultural registers, the overlap of life and fiction, the diffusion of drugs, the multiplication of the image's bases also turned the New Spain baroque *imaginaires* into a prefiguration of the neobaroque or postmodern *imaginaires* that we experience today—just as the baroque body, in its ties to the religious image, foreshadowed the electronic body hooked up to its machines, walkmans, vcrs, and computers.

There are still other links between this little-known past, the disconcerting present, and futures like the one the scenario of *Blade Runner* imagined in 1982, futures as fictitious as the miraculous origins of the Guadalupe Virgin, but ones that sometimes replay the past. In Los Angeles in 2019, they chased "replicants," arguing that these android slaves were inhuman, just as five centuries earlier the conquistadors had subjugated and massacred Indians, pretending they had no soul. But the main point is elsewhere. It can be found in *Blade Runner*'s titanic, filthy, sticky, and littered metropolis, in its blended and "contaminated" cultures; it can be taken as one of the distant endings for a story begun in 1492. This world of images and spectacle partakes more than ever of the hybrid, of syncretism and mixtures, of the confusion of races and languages, than it already did in New Spain: yet one more reason to search for elements of reflection in the colonial baroque experience, so exemplary in its capacity for dealing with ethnic and cultural pluralism on the American continent. One more reason to rethink, perhaps, this long trajectory where, inexorably, in all its complexity, its procrastination, and its contradictions, the Westernization of the planet progressed. A Westernization that, by successive sedimentation, used the image to deposit and impose its *imaginaires* on the Americas, images and *imaginaires* that were in turn repeated, hybridized, and adulterated by the dominated peoples.

Research laboratory for modernity and postmodernity; prodigious

chaos of doubles and cultural "replicants"; gigantic "remnant ware-house" where the mutilated images and memories of three continents—Europe, Africa, and America—piled up; where the projects and fictions, more authentic than history, clung: Latin America hides within its past elements that allow us better to grasp the postmodern world that sur-rounds us.

Notes

Abbreviations

AGN Archivo General de la Nación, Mexico City
AINAH Archivo del Instituto Nacional de Antropología e Historia
BN Biblioteca Nacional, Mexico City
exp. *expediente* (bundle, file)
fol. folio
FCE Fondo de Cultura Económica
INAH Instituto Nacional de Antropología e Historia
PUF Presses Universitaires de France
SEP Secretaría de Educación Pública
UNAM Universidad Nacional Autónoma de México
UP University Press
v *verso*

Introduction

1 This movie is freely drawn from a novel by Philip K. Dick, *Do Androids Dream of Electric Sheep?* (London: Grafton Books, 1973 [1968]).

2 Henri Hudrisier, *L'iconothèque: Documentation audiovisuelle et banques d'images* (Paris: La Documentation Française-INA, 1982), 78.

3 Leonide Ouspensky, *Theology of the Icon* (Crestwood, NY: St. Vladimir's Seminary P, 1992); Egon Sendler, *The Icon, Image of the Invisible: Elements of Theology, Aesthetics, and Technique* (Redondo Beach, CA: Oakwood Publications, 1988); Christoph von Schönborn, *God's Human Face: The Christ-Icon* (See Francisco: Ignatius P, 1994). There are two major points to be made: in contrast with oriental orthodoxy and its sophisticated iconic theology, Western Christianity leaves an indefinite margin around the religious image which remains crucial even in the Americas; the confrontation between Christian images and ancient idols masks the links that unite them historically, icons often having taken the place of pagan representations (see André Grabar, *L'iconoclasme byzantin: Le dossier archéologique,* 2d ed. revised and augmented [Paris: Flammarion, 1984], 105).

4 See Grabar, *L'iconoclasme byzantin*.

5 For more on the period and stance of the Reformation, see the works of Robert W. Scribner, *For the Sake of Simple Folk: Popular Propaganda for the German Reformation* (Cambridge: Cambridge UP, 1981), and of John Phillips, *The Reformation of Images: Destruction of Art in England, 1535–1660* (Berkeley: U of California P, 1973).

6 Pierre Francastel (*La figure et le lieu: L'ordre visuel du Quattrocento* [Paris: Gallimard, 1967]) has established the specificity of languages and figurative orders by demonstrating their insurmountable differences from speech and writing.

7 For more on engraving techniques, see William Mills Ivins, *Prints and Visual Communication* (Cambridge: Harvard UP, 1953).

8 From this perspective, Scribner, *For the Sake of Simple Folk,* has shown the usefulness of analyzing the mechanisms of Lutheran visual propaganda based on a study of iconography and image-based rhetoric in Reformation Germany.

9 Remo Guidieri, *Cargaison* (Paris: Seuil, 1987), 42.

10 Serge Gruzinski, *Man-Gods in the Mexican Highlands: Indian Power and Colonial Society, 1520–1800,* trans. Eileen Corrigan (Stanford: Stanford UP, 1989); Gruzinski, *The Conquest of Mexico: The Incorporation of Indian Societies into the Western World, 16th–18th Centuries,* trans. Eileen Corrigan (Cambridge: Polity P, 1993); and Gruzinski, with Carmen Bernand, *De l'idolâtrie: Une archéologie des sciences religieuses* (Paris: Seuil, 1988).

1. Points of Reference

1 See Pierre Chaunu's clarifications about this history in *Conquête et exploitation des Nouveaux Mondes (XVIe siècle),* Nouvelle Clio 26 bis (Paris: PUF, 1969), and Carl Otwin Sauer's classic *The Early Spanish Main* (Berkeley: U of California P, 1966).

2 Bernand and Gruzinski *De l'idolâtrie.*

3 Quote translated by Susan C. Griswold in "Appendices," *Taíno: Pre-Columbian Art and Culture from the Caribbean,* eds. Fatima Bercht, Estrellita Brodsky, John Alan Farmer, and Dicey Taylor (New York: Monacelli P, 1997), 170. Christopher Columbus, *The* Diario *of Christopher Columbus's First Voyage to America, 1492–1493,* abstracted by Fray Bartolomé de las Casas, transcribed and trans., notes and concordance, by Oliver Dunn and James E. Kelley Jr. (Norman: U of Oklahoma P, 1989), 121. On beauty (*hermosura* in Spanish), see Columbus, *Diario,* 99–101. The leitmotif of "wonder" should be added to this. On Columbus, consult Antonello Gerbi, *Nature in the New World: From Christopher Columbus to Gonzalo Fernandez de Oviedo,* trans. Jeremy Moyle (Pittsburgh: U of Pittsburgh P,

1985), 12–13; and Pierre Chaunu, *European Expansion in the Later Middle Ages,* trans. Katharine Bertram (Amsterdam: North-Holland Publishing Company, 1979), 13.

4 Columbus, *Diario,* 73–75. This refers to the Taino Indians, a branch of the Arawak family.

5 Columbus, *Diario,* 67, 189.

6 See note 3 on *hermosura.*

7 Pietro Martire d'Anghiera [Peter Martyr], 1457–1526, *Décadas del Nuevo Mundo,* vol. 1 (Mexico City: Porrúa, 1964), 115. Let us immediately note that the usage of the term "image" (in " . . . images worshipped by the natives") raises some delicate issues. Peter Martyr's Latin text (*P. Martyris Anglerii Mediolamensis opera. Legatio Babilonica. Oceani decas. Poemata. Epigrammata.* [Seville: Jacobus Cromberger, 1511]) uses the word *simulacrum,* which we have translated as "image." This term inclusively designates, in classical Latin, a figurative meaning, an effigy, a material representation of ideas, a shadow, and a ghost.

8 Columbus, *Diario,* 197.

9 Francastel, *Figure et le lieu,* 95, 98.

10 Columbus, *Diario,* 69.

11 Ibid.

12 Fray Ramón Pané, *"Relación acerca de las antigüedades de los Indios": El primer tratado escrito en America,* 2d ed. (Mexico City: Siglo Veintiuno, 1977). This was the first work—ethnographic before the term was ever invented—inspired by the Americas.

13 Spanish sources use the terms *devoción y reverencia,* which place the *cemíes* on the same footing as statues of Catholic saints. For the term *cemí,* see José Juan Arrom's note in Pané, *Relación,* 57.

14 Pané, *Relación,* 34, 45; quote translated in McGinnis, "Zemi Three-Pointer Stones," in Bercht et al., *Taino,* 92.

15 Pané, *Relación,* 43, 45, 76; translation of last phrase in Jeffery B. Walker, "Taino Stone Collars, Elbow Stones, and Three-Pointers," in Bercht et al., *Taino,* 80.

16 According to a letter from Columbus (circa 1496) cited in Pané, *Relación,* 88.

17 Pané, *Relación,* 33.

18 Pané, *Relación,* 37, 46, 89.

19 Pané, *Relación,* 37.

20 Pané, *Relación,* 40, 47.

21 William Pietz, "The Problem of the Fetish, II: The Origin of the Fetish," *Res* 13 (spring 1987): 23–45.

22 Columbus, *Diario,* 147–49.

23 Chaunu, *Conquête,* 129–30.

24 Pané, *Relación*, 53–54.

25 Guidieri, *Cargaison*, 90. Which does not mean that a fetish and a *cemí* are one and the same thing. To a certain extent they express, from within the premodern (Pané belongs to the end of the Middle Ages) or Guidieri's postmodern and Western way of thinking, an attempt at understanding, at capturing that which does not belong to the classical tradition.

26 Founder of the Roman Academy, one of the centers for Italian humanism in the fifteenth century.

27 For Peter Martyr's life, see Anghiera, *Décadas*, vol. 1, 191; and Jean-Hippolyte Mariéjol, *Un lettré italien à la cour d'Espagne (1488–1526): Pierre Martyr d'Anghera, sa vie et ses oeuvres* (Paris: Hachette, 1887).

28 Anghiera, *Décadas*, vol. 1, 191.

29 Anghiera, *Décadas*, vol. 1, 115. Peter Martyr retranscribed his information in humanist Latin and shellacked his island objects with a Roman varnish, perhaps taken from Horatio: his masks were *larva* and his ghosts, *lemures*.

30 Anghiera, *Décadas*, vol. 1, 191.

31 On the gamut of meanings carried by the term *simulacrum*, see note 7 of this chapter. Besides the term *lemures*—for ghosts—appears that of *imago*, translated as image ("*ex bombice nanque intexto stipato interius sedentes imagenes . . .* "), a word which in classical Latin—that the humanists pretended to cultivate—carried all at once the meanings of representation, portrait, replica, but also image of the dead, ghost, specter. One might as well say that the specificity of the zemi disappeared, buried under the accumulation of meanings that the explorers, the Castilian sailors, Peter Martyr's interpretation, and that of his contemporary and modern readers gave it. One could add, to the Islander / Castilian distance, the separation between a Spaniard of the sea, and an Italian humanist speaking the most elegant Latin and moving in the most sophisticated circles of the peninsula.

32 Anghiera, *Décadas*, vol. 1, 252.

33 Anghiera, *Décadas*, vol. 1, 191; quote translated in Griswold, "Appendices," in Bercht et al., *Taino*, 172.

34 Danielle Régnier-Bohler, "Le simulacre ambigu: Miroirs, portraits et statues," "Le champ visuel," *Nouvelle Revue de Psychanalyse* 35 (1987): 102.

35 Anghiera, *Décadas*, vol. 1, 191.

36 Anghiera, *Décadas*, vol. 1, 429.

37 Anghiera, *Décadas*, vol. 2, 638, 643.

38 Anghiera, *Décadas*, vol. 1, 196.

39 Anghiera, *Décadas*, vol. 1, 352.

40 Which does not mean that Peter Martyr ignored Pané's rich information on the zemi, but that he organized it more and more systematically through the years around his "spectral" interpretation.

41 Carlo Ginzburg, *The Night Battles: Witchcraft & Agrarian Cults in the Sixteenth and Seventeenth Centuries,* trans. Anne Tedeschi and John Tedeschi (Baltimore: Johns Hopkins UP, 1983), 59–60.

42 Gabriella Zarri, "Purgatorio 'particolare' e ritorno dei morti tra Riforma e Controriforma: l'area italiana," *Cuaderni Storici* 50 (Aug. 1982): 466.

43 Zarri, "Purgatorio," 494.

44 About the event and its broadcasting, see Jean-Michel Sallmann, *Visions indiennes, visions baroques: Les métissages de l'inconscient* (Paris: PUF, 1992).

45 Régnier-Bohler, "Le simulacre ambigu," 96.

46 Anghiera, *Décadas,* vol. 1, 191.

47 Anghiera, *Décadas,* vol. 1, 196, 191. Peter Martyr considers the content of the "illusory islander beliefs" to be much superior to "Lucian's genuine narrations, so celebrated amongst the people."

48 On the relationship between the Italian humanists and painting, see Michael Baxandall, *Giotto and the Orators: Humanist Observers of Painting in Italy and the Discovery of Pictorial Composition, 1350–1450* (Oxford: Clarendon P, 1971).

49 Jean Delumeau, *La civilisation de la Renaissance* (Paris: Arthaud, 1967), 344.

50 Bartolomé de Las Casas, *History of the Indies,* trans. and ed. Andrée Collard (New York: Harper & Row, 1971), 154.

51 Chaunu, *Conquête,* 129; Frank Moya Pons, *La Española en el siglo XVI, 1493–1520: Trabajo, sociedad y politica en la economia del oro,* 3rd ed. (Santiago: Universidad Católica Madre y Maestra, 1971); Troy S. Floyd, *The Columbus Dynasty in the Caribbean, 1492–1526* (Albuquerque: U of New Mexico P, 1973).

52 Anghiera, *Décadas,* vol. 1, 254.

53 Anghiera, *Décadas,* vol. 2, 645, 638.

54 Anghiera, *Décadas,* vol. 2, 639.

55 Anghiera, *Décadas,* vol. 2, 643.

56 Anghiera, *Décadas,* vol. 2, 644.

57 Anghiera, *Décadas,* vol. 2, 645.

58 In 1501 the Catholic Kings sent Peter Martyr as an ambassador to the Sultan of Egypt. He brought back the description entitled *Legatio Babylonica* in which he told of the country's fauna and flora, and of his visit to the pyramids. He refers to this voyage, which brought him to the banks of the Nile via Venice and Crete, in his *Décadas.*

59 Gonzalo Fernández de Oviedo y Valdés, *Historia general y natural de las Indias,* fol. L (Salamanca: Junta 1547). Born in Madrid in 1478, Oviedo stayed in Italy at the beginning of the sixteenth century and went to the Americas in 1514. Among other things, he fulfilled the functions of *alcalde* (magistrate) of Santo Domingo, and chronicler of the Indies.

60 Oviedo, *Historia general,* fol. XLV.

61 Oviedo, *Historia general*, fol. CXXXII.

62 Oviedo, *Historia general*, fol. XLV.

63 Ibid. In those times "Terra Firma" usually designated the coasts of Venezuela, Columbia, and Panama, instead of the Caribbean Islands.

64 Ibid.

65 Oviedo, *Historia general*, fol. CXXXII.

66 Oviedo, *Historia general*, fol. XLV.

67 Ibid.

68 On Fernández de Oviedo's relationship with Italy, see Gerbi, *Nature in the New World*, 145–200.

69 Anghiera, *Décadas*, vol. 1, 416.

70 Anghiera, *Décadas*, vol. 1, 426.

71 Anghiera, *Décadas*, vol. 1, 427.

72 Anghiera, *Décadas*, vol. 1, 429.

73 Anghiera, *Décadas*, vol. 1, 430.

74 Marcel Bataillon, "Les premiers Mexicains envoyés en Espagne par Cortés," *Journal de la Société des Américanistes* 48 (1959): 139.

75 Joaquín García Icazbalceta, "Itinerario de Grijalva" *Colección de documentos inéditos para la historia de México*, vol. 1 (Mexico City: Porrúa, 1971 [1858]), 282. This text, written by the chaplain of the expedition (Juan Díaz del Castillo) led by Juan de Grijalva, survived in Italian.

76 Hernán Cortés, *Cartas y documentos*, ed. and intro. Mario Hernández Sánchez-Barba, vol. 1 (Mexico City: Porrúa, 1963), 25.

77 Bernal Díaz del Castillo, *Historia verdadera de la conquista de la Nueva España*, 6th ed., vol. 1 (Mexico City: Porrúa, 1968), 47.

78 Díaz del Castillo, *Historia verdadera*, vol. 1, 56.

79 Díaz del Castillo, *Historia verdadera*, vol. 1, 65.

80 García Icazbalceta, "Itinerario de Grijalva," *Colección*, vol. 1, 307, note 75.

81 Cortés, *Cartas*, 25.

82 García Icazbalceta, "Itinerario de Grijalva," *Colección*, vol. 1, 297.

83 Anghiera, *Décadas*, vol. 1, 421.

84 García Icazbalceta, "Itinerario de Grijalva," *Colección*, vol. 1, 299.

85 Cortés, *Cartas*, 28–29.

86 Bataillon, "Les premiers Mexicains," 138–40.

87 Anghiera, *Décadas*, vol. 1, 430, and Benjamin Keen, *The Aztec Image in Western Thought* (New Brunswick: Rutgers UP, 1971), 64–65.

88 For more on the manner in which the process of "aesthetization" blocks the comprehension of the object's origin, see Guidieri, *Cargaison*, 125–26. However, one should only very carefully manipulate the categories of the "aesthetic" when examining the beginning of the sixteenth century, since they are so loaded with everything the eighteenth century, romanticism, and post-romanticism have added to—or taken away from—the gaze of

the humanists. The theme of idolatry is developed in Bernand and Gruzinski, *De l'idolâtrie*, 41–71.

89 Cortés, *Cartas*, 31.

90 Cortés, *Cartas*, 32.

91 Anghiera, *Décadas*, vol. 1, 418.

92 María Sten, *Vida y muerte del teatro nahuatl: El Olimpo sin Prometeo*, SepSetentas 120 (Mexico City: SEP, 1974), 106. Among the Nahua, Tlaloc was the god of waters and rain, while Quetzalcoatl, the "feathered serpent," was the god of wind, whom some Indians believed they recognized in Hernán Cortés.

93 Cortés, *Cartas*, 25.

94 It was the technical skill, the artisan's mastery, that was considered marvelous, much more so than the intrinsic artistic value of the object. Beauty and the technical ability that produced it seemed inseparable.

95 On the influx of exotic objects as so many "semiophores . . . collected, not because of their practical value but because of their significance as representatives of the invisible" and collectors, see Krzysztof Pomian, *Collectors and Curiosities: Paris and Venice, 1500–1800*, trans. Elizabeth Wiles-Portier (Cambridge: Polity P, 1990 [1987]), 36.

2. War

1 Anghiera, *Décadas*, vol. 1, 252.

2 Anghiera, *Décadas*, vol. 1, 290. The conquerors' dogs ripped the victims to shreds.

3 Anghiera, *Décadas*, vol. 1, 379.

4 Anghiera, *Décadas*, vol. 1, 290, 326, 234.

5 Anghiera, *Décadas*, vol. 1, 209.

6 Díaz del Castillo, *Historia verdadera*, vol. 1, 100.

7 Díaz del Castillo, *Historia verdadera*, vol. 1, 59–80; García Icazbalceta, "Itinerario de Grijalva," *Colección*, vol. 1 and throughout.

8 Anghiera, *Décadas*, vol. 1, 100.

9 Díaz del Castillo, *Historia verdadera*, vol. 1, 100.

10 Díaz del Castillo, *Historia verdadera*, vol. 1, 101. Let us remember the principal stages of the conquest led by Cortés and his companions. *March 1518*: the Cozumel episode in Maya country; then the navigation along the coasts of the Gulf of Mexico, marked by the landing at Tabasco and the battle of Cintla (March 25); the site of Vera Cruz—near what would become the port of Veracruz—was reached in April: it was the first encounter with Montezuma's envoys, as the exploration of the country up to Cempoala began; then in August the conquistadors abandoned the tropical coast to penetrate Mexico toward the high, cool, and temperate

plateaus. Having reached the lands of Tlaxcala, the traditional enemy of the Triple Alliance dominated by the Mexicans of Mexico-Tenochtitlán (the Aztecs), the conquistadors allied themselves with the Tlaxcaltecas; *October 1519:* on the road to Mexico City, the Tlaxcaltecas and Spanish crushed the city of Cholula with a massacre that was burned into memory; *November 1519:* they reached Mexico-Tenochtitlán and Montezuma received the conquerors in his city; *June 1520:* the Spanish had to flee the town during the disastrous *Noche Triste* but they returned to siege Tenochtitlán; it fell on 13 August 1521 (there is a convenient summary in Chaunu, *Conquête,* 142–58; and a more classical one in Fernando Benitez, *La ruta de Hernán Cortés,* 2d ed. [Mexico City: FCE, 1956]).

11 Díaz del Castillo, *Historia verdadera,* vol. 1, 160.

12 Joaquín García Icazbalceta, "Relación de Andrés de Tapia sobre la conquista de México," *Colección de documentos inéditos para la historia de México,* vol. 2 (Mexico City: Porrúa, 1971), 585; Toribio de Benavente, called Motolinía, *Memoriales; o, Libro de las cosas de la Nueva España y de los naturales de ella,* ed. E. O'Gorman, 2d ed. (Mexico City: UNAM, 1971), 422, xc. See also Francisco Cervantés de Salazar, *Crónica de la Nueva España* (Mexico City: Porrúa, 1985 [1914]), 344–345.

13 Díaz del Castillo, *Historia verdadera,* vol. 1, 78, 84. On Hernan Cortés' politics, see Anthony Pagden and John H. Elliott's essays in Hernan Cortés, *Letters from Mexico,* trans. and ed. Anthony Pagden, intro. J. H. Elliott (New Haven: Yale UP, 1986). With Cortés, the Spanish expansion became a conquest, or even better, a *conquista.* Chaunu reminds us that it "does not target the land but only the men. . . . It stops when it crosses the borders of the most compactly peopled zones" (*Conquête,* 135).

14 Cortés, *Cartas,* 337: "The principal motif and the principal intention of war consist in separating and tearing the natives away from these idolatries."

15 Francisco López de Gómara, *Historia de las Indias y conquista de México* (Saragossa: Agustín Millán, 1552), fol. XI.

16 Díaz del Castillo, *Historia verdadera,* vol. 1, 84. About Mendieta's vision of Cortés, making him the "Moses" of the New World, see John L. Phelan, *The Millennial Kingdom of the Franciscans in the New World* (Berkeley: U of California P, 1970 [1956]), 39–78.

17 Díaz del Castillo, *Historia verdadera,* vol. 1, 133.

18 Díaz del Castillo, vol. 1, 100, 246, 249, 133.

19 In the England of Edward VI, a victim of the Reformation and growing Anglicanism, Gardiner maintained that "the destruction of images, containeth an enterprise to subvert religion, and the state of the world with it, and especially the nobility" (Phillips, *The Reformation of Images: Destruction of Art in England 1535–1660* [Berkeley: U of California P, 1973], 90).

20 To which it must be added that, theoretically, neither conquest nor conversion implied a systematic challenge to the local legitimacies, provided they recognized the suzerainty of the Spanish Crown. Cortés' attitude toward the native clergy corroborates this (see this chapter, "The Ambiguities of Substitution").

21 García Icazbalceta, "Itinerario de Grijalva," *Colección*, vol. 1, 307.

22 Michael Baxandall, *Painting and Experience in Fifteenth-Century Italy: A Primer in the Social History of Pictorial Style*, 2d ed. (Oxford: Oxford UP, 1988 [1972]), 42.

23 George McClelland Foster, *Culture and Conquest: America's Spanish Heritage*, Viking Fund Publications in Anthropology 27 (New York: Wenner-Gren Foundation for Anthropological Research, 1960), 161–62; Luis Weckmann, *The Medieval Heritage of Mexico*, trans. Frances M. López-Morillas (New York: Fordham UP, 1992), 278–80; William A. Christian Jr., *Local Religion in Sixteenth-Century Spain* (Princeton: Princeton UP, 1981), 75–81.

24 López de Gómara, fol. II; Baltasar Dorantes de Carranza, *Sumaria relación de las cosas de la Nueva España: Con noticia individual de los descendientes legitimos de los conquistadores y primeros pobladores españoles*, 2d ed. (Mexico City: Jesús Medina, 1970 [1902]), 88.

25 García Icazbalceta, "Relación de Andrés de Tapia," *Colección*, vol. 2, 586.

26 Weckmann, *Medieval Heritage*, 111–13.

27 Notably so in Mexico, during the bloody episode of the *Noche Triste*, then during the battle of Otumba (Weckmann, *Medieval Heritage*, 162–63).

28 Diáz del Castillo, *Historia verdadera*, vol. 1, 100, 133, 163.

29 García Icazbalceta, "Relación de Andrés de Tapia," *Colección*, vol. 2, 586.

30 García Icazbalceta, "Relación de Andrés de Tapia," *Colección*, vol. 2, 586. Andrés de Tapia's remark confirms that the Spanish had already largely dipped from their reserves and that the gesture of placing the image of a saint could count as much as or even more than the identity of the chosen saint. The Templo Mayor was the great temple of Huitzilopochtli, the god who had guided the march of the Mexica through the northern steppes; recent digs have shown the richness and importance of this sanctuary in the cultural center of Mexico-Tenochtitlán. See Daniel Lévine, *Le Grand Temple de Mexico: Du mythe à la réalité—l'histoire des Aztèques entre 1325 et 1521* (Paris: Artcom', 1997).

31 Tlaxcala was the only city-state of the altiplano to have resisted the expansion of the Triple Alliance directed by the Mexica of Mexico-Tenochtitlán.

32 For the *Conquistadora*, see Bernardino Lopez de Mendoza, *Información jurídica* . . . (Puebla de Los Angeles: Pedro de la Rosa, 1804).

33 Díaz del Castillo, *Historia verdadera*, vol. 2, 224, 247.

34 See also the prudence of Fray Bartolomé de Olmedo, who discouraged

Cortés from prematurely demanding Montezuma's authorization to open a church on the Templo Mayor (Díaz del Castillo, vol. 2, 281).

35 Díaz del Castillo, *Historia verdadera*, vol. 1, 119; García Icazbalceta, "Relación de Andrés de Tapia," *Colección*, vol. 2, 573.

36 Like Christopher Columbus, Ignatius of Loyola, or Teresa of Avila, the conquistadors were fond of romances of chivalry. The most famous episodes occupied the imaginations of the conquerors, allowed them to express their reactions when faced with the wonders of the New World, and gave their actions a fantastic and prestigious dimension. The copies of these romances became so numerous in colonial America that the authorities took notice, and forbade their importation (Weckmann, *The Medieval Heritage of Mexico*, trans. Frances M. López-Morillas [New York: Fordham UP], 135–44; and Irving Albert Leonard, *Books of the Brave: Being an Account of Books and of Men in the Spanish Conquest and Settlement of the Sixteenth-Century New World* [Berkeley: U of California P, 1949]).

37 Díaz del Castillo, *Historia verdadera*, vol. 1, 100.

38 Díaz del Castillo, *Historia verdadera*, vol. 1, 160.

39 García Icazbalceta, "Relación de Andrés de Tapia," *Colección*, vol. 2, 557.

40 "The autos-da-fé of the divine and ancestral effigies . . . did not so much serve to credit the thesis of the inexistence and falseness of pagan gods, but rather, set up a representation for the death of these divinities" (Alain Babadzan, "Les idoles des iconoclastes: La position actuelle des *ti'i* aux îles de la Société," *Res* 4 [autumn 1982]: 71).

41 According to Tapia, this is the case in Tlaxcala (García Icazbalceta, "Relación de Andrés de Tapia," *Colección*, vol. 2, 572–73).

42 Díaz del Castillo, *Historia verdadera*, vol. 1, 133.

43 Díaz del Castillo, *Historia verdadera*, vol. 1, 135.

44 Díaz del Castillo, *Historia verdadera*, vol. 1, 282.

45 García Icazbalceta, "Relación de Andrés de Tapia," *Colección*, vol. 2, 585.

46 Díaz del Castillo, *Historia verdadera*, vol. 1, 286. It is understood that the terms "sacrilege," "blaspheme," and "profanation" are European approximations, handy but without any true equivalent in the native world. The chronicler's text produced the Nahua term designating in Montezuma's thought the sacrilege or the profanation committed by Cortés: "A great *tatacul*, which means sin" (vol. 1, 283). *Tatacul* or *tlatlacolli* (fault, infraction), Christianized into "sin" by the evangelizers, should probably be put in relation to *tlaçolli* or *tlaçulli* (filth, excrement), in other words, with a problematics of staining and purity distinct from that of the Christian ethic.

47 Díaz del Castillo, *Historia verdadera*, vol. 1, 329.

48 Cortés, *Letters*, 106.

49 Cortés, *Cartas*, 75.

50 Díaz del Castillo, *Historia verdadera*, vol. 1, 101, 122.

51 The Dominican Fra Michele da Carcano's sermon in 1492 furnished an illustration of this. See Baxandall, *Painting*, 41.

52 Díaz del Castillo, *Historia verdadera*, vol. 1, 163. The Indians also learned how to make candles with "local" wax, the liturgy serving here as a vehicle for a transfer of technology: "for up until then, they did not know how to exploit wax." The respect for the established order as witnessed by the conquerors—and in this case, the skills of the pagan clergy—has been analyzed by Richard C. Trexler in "Aztec Priests for Christian Altars: The Theory and Practice of Reverence in New Spain," *Scienze, credenze occulte, livelli di cultura: Convegno internazionale di studi (Firenze, 26–30 giugno 1980)*, Istituto nazionale di studi sul Rinascimento (Florence: Leo S. Olschki, 1982), 175–96.

53 García Icazbalceta, "Relación de Andrés de Tapia," *Colección*, vol. 2, 586.

54 Anghiera, *Décadas*, vol. 1, 252.

55 García Icazbalceta, "Relación de Andrés de Tapia," *Colección*, vol. 2, 557.

56 Díaz del Castillo, *Historia verdadera*, vol. 1, 184.

57 García Icazbalceta, "Relación de Andrés de Tapia," *Colección*, vol. 2, 586.

58 Díaz del Castillo, *Historia verdadera*, vol. 1, 133.

59 Ibid.

60 Motolinía, *Memoriales*, 35.

61 Díaz del Castillo, *Historia verdadera*, vol. 1, 133.

62 Díaz del Castillo, *Historia verdadera*, vol. 1, 131.

63 Motolinía, *Memoriales*, 37.

64 Díaz del Castillo, *Historia verdadera*, vol. 1, 130; Bernardino de Sahagún, *Historia general de las cosas de Nueva España*, ed. Angel María Garibay K., vol. 4 (Mexico City: Porrúa, 1977), 87–89. The Nahua thought they had identified Cortés as the god Quetzalcoatl, come back from the East to accept the position whose symbols were being offered to him. The reader should bear in mind that this interpretation had become the standard one by mid-sixteenth century.

65 On this theme see Remo Guidieri, *L'abondance des pauvres: Six aperçus sur l'anthropologie* (Paris: Seuil, 1984) throughout; and Gruzinski, *Conquest*.

66 Bartolomé de Las Casas, *Apologética historia sumaria*, ed. E. O'Gorman, 3rd ed., vol. 1 (Mexico City: UNAM, 1967), 687.

67 López de Gómara, *Historia*, fol. 20v.

68 Bernand and Gruzinski, *De l'idolâtrie*, 41–87; Las Casas, *Apologética*, vol. 1, 580, is referring to a work by Albrico, *De deorum imaginibus*.

69 Bernand and Gruzinski, *De l'idolâtrie*, 12–14.

70 García Icazbalceta, "Relación de Andrés de Tapia," *Colección*, vol. 2, 555; Cortés, *Cartas*, 251.

71 *Le conquistador anonyme,* ed. Jean Rose (Mexico City: Institut Français d'Amérique Latine, 1970), 17.

72 Las Casas, *Apologética,* vol. 1, 687.

73 It took the advent of the chroniclers Sahagún, Mendieta, and Durán to be able to read detailed descriptions and interpretations of the native gods.

74 Las Casas, *Apologética,* vol. 1, 386.

75 García Icazbalceta, "Relación de Andrés de Tapia," *Colección,* vol. 2, 557.

76 Díaz del Castillo, *Historia verdadera,* vol. 1, 47.

77 Rose, *Le conquistador,* 16; Cortés, *Letters,* 107.

78 Cortés, *Letters,* 107.

79 Cortés, *Letters,* 106–07; Díaz del Castillo, vol. 1, 285, 312.

80 Rose, *Le conquistador,* 16.

81 Cortés, *Letters,* 107.

82 Cortés, *Letters,* 107.

83 Cortés, *Cartas,* 74.

84 It is not certain that the author of this text (handed down to us in Italian) was a direct witness to the conquest.

85 Motolinía, *Memoriales,* 152; Las Casas, *Apologética,* vol. 1, 639.

86 Rose, *Le conquistador,* 16.

87 Rose, *Le conquistador,* 17.

88 Díaz del Castillo, *Historia verdadera,* vol. 1, 65; on the other hand Tapia (García Icazbalceta, "Relación de Andrés de Tapia," *Colección,* vol. 2, 584)—like *Le conquistador anonyme* of which we only possess an Italian version—evokes "the images of idols."

89 Díaz del Castillo, *Historia verdadera,* vol. 1, 119.

90 Díaz del Castillo, *Historia verdadera,* vol. 1, 223.

91 On the "relation of identity" between the model-archetype and the Byzantine icon, see I. Florenski, *Le porte regali* (Milan: n.p., 1977), cited in Remo Guidieri, "Statue and Mask," *Res* 5 (spring 1983): 16. Allowing that the icon was the "door through which the Divine penetrates" the sensible world brings us closer to the native domain of *ixiptla,* but one must remind the reader that the Word of God was the primary foundation for the Incarnation, the image, and the icon.

92 Díaz del Castillo, *Historia verdadera,* vol. 1, 329, 381, 282.

93 Rose, *Le conquistador,* 15; Díaz del Castillo, vol. 1, 282.

94 Juan de Torquemada, *Monarquía indiana,* ed. Miguel Leon-Portilla, 3rd ed., vol. 3 (Mexico City: UNAM, 1976), 108–09.

95 García Icazbalceta, "Relación de Andrés de Tapia," *Colección,* vol. 2, 560; Díaz del Castillo, vol. 1, 132–33.

96 Díaz del Castillo, *Historia verdadera,* vol. 1, 100.

97 García Icazbalceta, "Relación de Andrés de Tapia," *Colección,* vol. 2, 586. Narvaez was commanding a fleet sent from Cuba to subjugate Cortés and his partisans.

98 Cortés, *Letters,* 100.

99 García Icazbalceta, "Carta del licenciado Alonso Zuazo, Nov. 1521," *Colección,* vol. 1, 360.

100 On the limits of the idolatrous grid, see Bernand and Gruzinski, *De l'idolâtrie,* 89–121.

101 One can reread, for example, the reflections on modernism and the primitive in Jill Lloyd's "Emil Nolde's Still Lifes, 1911–1912," *Res* 9 (spring 1985): 51–52.

102 Díaz del Castillo, *Historia verdadera,* vol. 1, 347.

103 Díaz del Castillo, *Historia verdadera,* vol. 1, 330.

104 Díaz del Castillo, *Historia verdadera,* vol. 1, 248.

105 Díaz del Castillo, *Historia verdadera,* vol. 1, 264.

106 Díaz del Castillo, *Historia verdadera,* vol. 1, 291–92.

107 In the sense, of course, that the Nahuas gave to the concept of representation. See below, n. 113.

108 Gerónimo de Mendieta, *Historia eclesiástica indiana,* vol. 1 (Mexico City: Salvador Chávez Hayhoe, 1945), 102; Torquemada, *Monarquía,* vol. 3, 126.

109 Gruzinski, *Conquest* 10–13; Hubert Damisch, *Théorie du nuage: Pour une histoire de la peinture* (Paris: Seuil, 1972), 160, 277–311.

110 Damisch, *Théorie,* 308–10.

111 Damisch, *Théorie,* 305; for an overview, see *Anthropologie de l'écriture,* ed. Robert Lafont, Centre de création industrielle (Paris: Centre Georges Pompidou, 1984); as concerns the Egyptian example, which furnishes yet another case, see Whitney Davis, "Canonical Representation in Egyptian Art" *Res* 4 (autumn 1982): 21–46.

112 Gestural language and song were also part of this transmutation of the individual; it is thus that the captive representing Quetzalcoatl at Cholula "sang and danced . . . to be recognized as being the semblance of his god" (José de Acosta, *Historia natural y moral de las Indias,* ed. E. O'Gorman [Mexico City: FCE, 1979], 276). On the difference between the appearance of the idol and the man-god corresponding to him, see Juan Bautista Pomar, *Relación de Tezcoco: Siglo XVI,* ed. J. García Icazbalceta (Mexico City: Biblioteca Enciclopédica del Estado de México, 1975), 10.

113 Alfredo López Austin, *Hombre-Dios: Religión y política en el mundo náhuatl* (Mexico City: UNAM, 1973), 118–21. See also Arild Hvidtfeldt, *Teotl and Ixiptlatli: Some Central Conceptions in Ancient Mexican Religion. With a General Introduction on Cult and Myth* (Copenhagen: Munksgaard, 1958). It is possible that López Austin's analysis still remains too influenced by the

signifier / signified dichotomy. The conception of time, and that of divine forces, were indissociable in Nahua thought. The sudden appearance of these forces and their nature were essentially determined by the interaction between divine time and human time that occurred through the complex cycles describing the ritual calendars. The important thing is to accept the idea that native "godhood" was not transcendental. See Christian Duverger, *L'esprit du jeu chez les Aztèques* (Paris: Mouton, 1978), 264.

114 The *ixiptla* could also be seen as the product of a secret code, constituting a finite and exhaustive repertory of elements and combinations, in opposition to the Western image which opened onto a real or fictional elsewhere. In the same conceptual line one will notice that the Nahua mask tended to be confused with the face it was meant to represent, attesting once again to the telescoping, from our point of view of course, of the signifier and the signified; see Duverger, *L'esprit*, 234–43.

115 Rose, *Le conquistador*, 14; Torquemada, *Monarquía*, vol. 2, 113–15.

116 *Proceso inquisitorial del cacique de Tetzcoco* (Mexico City: Eusebio Gómez de la Puente, 1910), 22–23.

117 Mendieta, *Historia*, vol. 2, 160.

118 *Procesos de Indios idólatras y hechiceros*, Publicaciones del Archivo General de la Nación (Mexico City: Guerrero Hnos, 1912), 179, 182, 183. About Xantico, see Torquemada, *Monarchía*, vol. 1, 245–46.

119 *Procesos de Indios*, 178, 181.

120 *Procesos de Indios*, 181.

121 *Procesos de Indios*, 115–16.

122 *Procesos de Indios*, 124.

123 *Proceso inquisitorial*, 27, 25.

124 *Proceso inquisitorial*, 31; *Procesos de Indios* 3.

125 *Procesos de Indios*, 3.

126 *Proceso inquisitorial*, 8.

127 *Procesos de Indios*, 122, 124; Charles Gibson, *The Aztecs Under Spanish Rule: A History of the Indians of the Valley of Mexico, 1519–1810* (Stanford: Stanford UP, 1964), 169.

128 *Procesos de Indios*, 140.

129 Motolinía, *Memoriales*, 86.

130 *Procesos de Indios*, 186.

131 *Proceso inquisitorial*, 85.

132 *Procesos de Indios*, 143.

133 *Procesos de Indios*, 11, 100, 102.

134 Motolinía, *Memoriales*, 41.

135 *Procesos de Indios*, 2.

136 *Procesos de Indios*, 7.

137 *Procesos de Indios*, 116, 119.

138 *Proceso inquisitorial*, 11–12, 125.

139 *Procesos de Indios*, 11.

140 Motolinía, *Memoriales*, 87.

141 *Procesos de Indios*, 19, 142, 143, 161; *Proceso inquisitorial*, 19.

142 "The seat, the copal and the knives found in his house were in memory of these idols." *Proceso inquisitorial*, 86.

143 Torquemada, *Monarquía*, vol. 3, 122.

144 *Procesos de Indios*, 188–93.

145 *Procesos de Indios*, 72, 190.

146 Motolinía, *Memoriales*, 87.

147 *Procesos de Indios*, 60.

148 *Proceso inquisitorial*, 18, 16, 17.

149 *Procesos de Indios*, 60.

150 Mendieta, *Historia*, vol. 2, 78–79. It is possible that the chewing of obsidian shards could be likened to a penitential practice of autosacrifice. The behavior, nonetheless, surprised the Indians by its unusual character, for "it was rare that these (priests) leave the temples clothed in such a manner" (Mendieta, vol. 2, 79).

151 Gruzinski, *Man-Gods*, 31–62, and the first version in French, *Les Hommes-Dieux*, 14–23.

152 *Procesos de Indios*, 58, 54, 55.

153 *Procesos de Indios*, 64.

154 *Procesos de Indios*, 60.

155 *Procesos de Indios*, 58.

156 Mendieta, *Historia*, vol. 2, 78.

157 *Procesos de indios*, 69.

158 *Proceso inquisitorial*, 10, 27.

159 Motolinía, *Memoriales*, 87.

3. The Walls of Images

1 Motolinía, *Memoriales*, 34.

2 See Motolinía, *Memoriales*, and Mendieta, *Historia;* for an overview see Robert Ricard, *The "Spiritual Conquest" of Mexico: An Essay on the Apostolate and the Evangelizing Methods of the Mendicant Orders in New Spain, 1523–1572,* trans. Lesley Byrd Simpson (Berkeley: U of California P, 1966); and Georges Baudot, *Utopia and History in Mexico: The First Chroniclers of Mexican Civilisation (1520–1569),* trans. Bernard R. Ortiz de Montellano and Thelma Ortiz de Montellano (Niwot: UP of Colorado, 1995 [1977]).

3 Emile G. Léonard, *A History of Protestantism: I. The Reformation,* ed. H. H. Rowley, trans. Joyce M. H. Reid (London: Nelson, 1965 [1961]), 315–20.

4 Phillips, *Reformation of Images,* 64.

5 E. Léonard, *History of Protestantism*, 321.

6 Genaro García, *Documentos inéditos o muy raros para la historia de México*, 2d ed. (Mexico City: Porrúa, 1974), 428–429.

7 Phillips, *Reformation of Images*, 89.

8 Norman Cohn, *The Pursuit of the Millennium: Revolutionary Millenarians and Mystical Anarchists of the Middle Ages*, rev. and expanded ed. (New York: Oxford UP, 1972), 262; Phyllis Mack Crew, *Calvinist Preaching and Iconoclasm in the Netherlands, 1544–1569* (Cambridge, Cambridge UP, 1978 [1973]).

9 Keith Thomas, *Religion and the Decline of Magic: Studies in Popular Beliefs in Sixteenth- and Seventeenth Century England* (New York: Charles Scribner's Sons, 1971), 280.

10 Motolinía, *Memoriales*, 299. The *Wisdom of Salomon* was probably written in Alexandria in a Hellenic milieu constantly confronted with paganism, in a context similar to that of Mexico during the first half of the sixteenth century.

11 Motolinía, *Memoriales*, 69.

12 Motolinía, *Memoriales*, 90.

13 "20. Confesión de Fray Maturino" in Francisco Fernández del Castillo, *Libros y libreros en el siglo XVI* (Mexico City: FCE, 1982 [1914]), 21; on Erasmus and the cult of images, see Marcel Bataillon, *Erasme et l'Espagne: Recherches sur l'histoire spirituelle du XVIe siècle* (Paris: Droz, 1937) and Phillips, *Reformation of Images*, 35–40. Meanwhile, Thomas More was banishing images from *Utopia*.

14 Motolinía, *Memoriales*, 37.

15 Edmundo O'Gorman, *Destierro de sombras: Luz en el origen de la imagen y culto de Nuestra Señora de Guadalupe del Tepeyac* (Mexico City: UNAM, 1986), 77.

16 O'Gorman, *Destierro*, 78.

17 Fernández del Castillo, "Proceso seguido por la Justicia Eclesiástica contra Fray Maturino Gilberti," in *Libros y libreros*, 33.

18 Fernández del Castillo, "Proceso seguido por la Justicia Eclesiástica contra Fray Maturino Gilberti," 21.

19 Baxandall, *Painting and Experience*, 41.

20 Esteban J. Palomera, *Fray Diego Valadés O.F.M., evangelizador humanista de la Nueva España: Su obra* (Mexico City: Jus, 1962), 141.

21 J. Benedict Warren, *The Conquest of Michoacan: The Spanish Domination of the Tarascan Kingdom in Western Mexico, 1521–1530* (Norman: U of Oklahoma P, 1985), 90–101.

22 Juan Bautista Mendez, *Crónica de la provincia de Santiago de México del orden de los Predicadores*, Colección Gómez de Orozco, number 24 (Mex-

ico City: Archivo del Instituto Nacional de Antropología e Historia, 1685), unpublished.

23 Fernández del Castillo, "Proceso seguido por la Justicia Eclesiástica contra Fray Maturino Gilberti," 35.

24 Fernández del Castillo, "Proceso seguido por la Justicia Eclesiástica contra Fray Maturino Gilberti," 21.

25 Fernández del Castillo, "Proceso seguido por la Justicia Eclesiástica contra Fray Maturino Gilberti," 11. The images could cause other suspicions, this time on a psychological level, which were added to the first. Having tried to "dismantle" the illusions of the senses, the Dominican Las Casas underlined the dangers of a badly controlled *imaginaire*: "the demons paint and represent in our imagination and fantasy the images or figures or types they wish, whether we are asleep or awake, by night or by day" (Las Casas, *Apologética,* vol. 2, 498).

26 Torquemada, *Monarquía,* vol. 3, 104.

27 Damisch, *Théorie du nuage,* 300.

28 Damisch, *Théorie du nuage,* 308.

29 Damisch, *Théorie du nuage,* 161.

30 Torquemada, *Monarquía,* vol. 3, 106.

31 Torquemada, *Monarquía,* vol. 3, 108; the chronicler faithfully reflected the line of the Council of Trent, which had forbidden that "one believe there is some divinity or some virtue [in images] for which we must give them this worship" (see Martial Chanut, *Le Saint Concile de Trente, oecuménique et général célébré sous Paul III, Jules III, et Pie IV, souverains pontifs,* 3rd ed. [Paris: Sébastien Mabre-Cramoizy, 1686], 362).

32 Manuel Toussaint, *Pintura colonial en México,* 2d ed. (Mexico City: UNAM, 1982), 14. After 1519 the Casa de Contratación of Seville acquired works to be sent to America, and Flemish painters worked in the port of Guadalquivir for the Western Indies.

33 Damisch, *Théorie du nuage,* 118–19.

34 James P. R. Lyell, *Early Book Illustration in Spain* (New York: Hacker Art Books, 1976 [1926]), 3, 31.

35 Fabienne Emilie Hellendoorn, *Influencia del manierismo-nórdico en la arquitectura virreinal religiosa de México* (Mexico City: UNAM, 1980), 165.

36 Las Casas, *Apologética,* vol. 1, 322.

37 Las Casas, *Apologética,* vol. 1, 340.

38 Anthony Robin Pagden, *The Fall of Natural Man: The American Indian and the Origins of Comparative Ethnology* (New York: Cambridge UP, 1982), 60.

39 Torquemada, *Monarquía,* vol. 5, 21.

40 Torquemada, *Monarquía,* vol. 5, 51.

41 Toussaint, *Pintura,* 21.

42 Motolinía, *Memoriales*, 123.

43 Baudot, *Utopia and History in Mexico*, 254–55. On the Evangelization, see Ricard, and Gruzinski, *Conquest*, 184–91 and throughout.

44 Torquemada, *Monarquía*, vol. 6, 184–88.

45 Torquemada, *Monarquía*, vol. 6, 187–88.

46 Pedro de Gante, "Introduction of Ernest de la Torre Villar to Fray Pedro de Gante," *Doctrina Cristiana en lengua mexicana*, facsimile reproduction of the 1553 edition (Mexico City: Centro de Estudios Históricos Fray Bernardino de Sahagún, 1981), 80.

47 José Guadalupe Victoria, *Pintura y sociedad en Nueva España: Siglo XVI* (Mexico City: UNAM, 1986), 108.

48 Mendieta, *Historia*, vol. 3, 62.

49 Ibid.

50 Ibid.

51 William Mills Ivins, *Prints and Visual Communication* (Cambridge: Harvard UP, 1953).

52 Lyell, *Early Book Illustration*, 3. On the use of colors at the end of the Middle Ages, see Michel Pastoureau, "Du bleu au noir: Ethique et pratique de la couleur à fin du Moyen Age" *Médiévales* 14 (1988): 9–21.

53 Gante, "Introduction," fol. 109, 100, 139v.

54 Miguel Mathés, *Santa Cruz de Tlatelolco: La primera biblioteca académica de las Américas* (Mexico City: Secretaria de Relaciones Exteriores, 1982), 93–96 [*The America's First Academic Library: Santa Cruz de Tlatelolco* (Sacramento: California State Library Foundation, 1985)].

55 Mathés, *Santa Cruz de Tlatelolco*, 30; Hellendoorn, *Influencia*, 191.

56 Torquemada, *Monarquía*, vol. 6, 184. On the teaching of alphabetic writing and its cultural and social consequences, see Gruzinski, *Conquest*, 6–69.

57 See the unsurpassed—and in French, unpublished—work by George Kubler, *Mexican Architecture of the Sixteenth Century*, 2 vols. (New Haven: Yale UP, 1948).

58 Valadés, in Palomera, *Fray Diego Valadés*, 139.

59 Toussaint, *Pintura*, 40.

60 Torquemada, *Monarquía*, vol. 6, 268.

61 Fernández del Castillo, "Proceso seguido contra Antón, sacristán," in *Libros y libreros*, 38–45.

62 In the paintings of the Casa del Deán in Puebla (see Francisco de la Maza, "Las pinturas de la Casa del Deán," *Artes de Mexico* 2 [1954]: 17–24).

63 Maza, "Las pinturas."

64 Torquemada, *Monarquía*, vol. 3, 104.

65 "San Francisco," Huejotzingo Convent in the state of Puebla.

66 Daniel Arasse, *L'homme en perspective: Les primitifs d'Italie*, 2d ed. (Geneva: Famot, 1986), 269, 207.

67 Baxandall, *Painting*, 60–70.

68 Arasse, *L'homme*, 259.

69 Damisch, *Théorie du nuage*, 156.

70 Gante, "Introduction," fol. 14v.

71 Epazoyucan is an Augustine convent in the state of Hidalgo; see Toussaint, *Pintura*, 39.

72 Toussaint, *Pintura*, 40.

73 Gante, "Introduction," fol. 129v; Toussaint, *Pintura*, 26.

74 Toussaint, *Pintura*, 46; Gante, "Introduction," fol. 37.

75 Toussaint, *Pintura*, 43, 61.

76 Gante, "Introduction," fol. 14v.

77 Toussaint, *Pintura*, 40.

78 Toussaint, *Pintura*, 43.

79 Toussaint, *Pintura*, 43. This Virgin is surrounded by St. Thomas and Duns Scott. This is an Immaculate, painted toward the middle of the sixteenth century.

80 Toussaint, *Pintura*, 26. The reuse of Christian symbolism is patently obvious in the process of the creation of "neoglyphs" of Western inspiration enriching the native pictographic repertoire after the Conquest; see Gruzinski, *Conquest*, 33–34.

81 Gante, "Introduction," fol. 37, 17.

82 It is obvious that in the space given by the perspective, one can visualize narrative and logical relationships as well as a grasp of past time—that we call history—that are proper to the European world and its lettered milieus, and thus completely new to the native spectators.

83 Motolinía, *Memoriales*, 119; Othón Arróniz, *Teatro de evangelización en Nueva España* (Mexico City: UNAM, 1979), 48–50; and Fernando Horcasitas, *El teatro náhuatl: Epocas novohispana y moderna* (Mexico City: UNAM, 1974), 107–08 and throughout.

84 Horcasitas, *El teatro náhuatl*, 77.

85 Horcasitas, *El teatro náhuatl*, 78–79.

86 Mendieta, cited in Arróniz, *Teatro de evangelización*, 55.

87 Horcasitas, *El teatro náhuatl*, 33–46.

88 Horcasitas, *El teatro náhuatl*, 102–03. The use of the terms "sacrifice" or "god" raises the same obstacle; see Bernand and Gruzinski *De l'idolâtrie* throughout.

89 Diego Durán, *Historia de las Indias de Nueva España e Islas de la Tierra Firme*, vol. 1 (Mexico City: Porrúa, 1967), 86–88.

90 Sten, *Vida y muerte*, 22.

91 Sahagún, *Historia general*, vol. 4, 309–10.

92 Durán, *Historia*, vol. 1, 66.

93 Ibid.

94 Acosta, *Historia natural*, 277–78.

95 Durán, *Historia*, vol. 1, 193.

96 On Mayan theater, see René Acuña, *Introducción al estudio del Rabinal Achi* (Mexico City: UNAM, 1975).

97 Arróniz, *Teatro de evangelización*, 47.

98 Horcasitas, *El teatro náhuatl*, 163.

99 Horcasitas, *El teatro náhuatl*, 114.

100 Alfredo López Austin, *The Human Body and Ideology: Concepts of the Ancient Nahuas*, trans. Thelma Ortiz de Montellano and Bernard R. Ortiz de Montellano, vol. 1 (Salt Lake City: U of Utah P, 1988), 56.

101 Horcasitas, *El teatro náhuatl*, 499–509; about the memories of the *Last Judgment* of Tlatelolco (1533) by a native chronicler from the beginning of the seventeenth century, see Domingo Francisco de San Antón Muñón Chimalpahin Cuauhtlehuanitzin, *Relaciones originales de Chalco-Amequemecan*, ed. and trans. Silvia Rendón (Mexico City: FCE, 1965), 253, in the "Seventh Account."

102 Motolinía, *Memoriales*, 105.

103 Motolinía, *Memoriales*, 114.

104 Motolinía, *Memoriales*, 106.

105 Motolinía, *Memoriales*, 111.

106 Arróniz, *Teatro de evangelización*, 43–44.

107 Motolinía, *Memoriales*, 100.

108 Motolinía, *Memoriales*, 106–07, 114, 480; Arróniz, *Teatro de evangelización*, 43.

109 Las Casas, *Apologética*, vol. 1, 334.

110 Durán, *Historia*, vol. 1, 86.

111 Horcasitas, *El teatro náhuatl*, 113, 111–12.

112 Arróniz, *Teatro de evangelización*, 18.

113 García Icazbalceta, "Relación de Andrés de Tapia," *Colección*, vol. 2, 555.

114 Arróniz, *Teatro de evangelización*, 68.

115 Arróniz, *Teatro de evangelización*, 69–70.

116 Las Casas, *Apologética*, vol. 1, 334.

117 Horcasitas, *El teatro náhuatl*, 84.

118 Arróniz, *Teatro de evangelizacion*, 26.

119 Arróniz, *Teatro de evangelización*, 22.

120 "*Ixiptlati*: to play a person in a farce," in Alonso de Molina, *Vocabulario en lengua castellana y mexicana* (Mexico City: Antonio de Espinosa, 1571).

121 Arróniz, *Teatro de evangelizacion*, 20; also see note 101 above.

122 Horcasitas, *El teatro náhuatl*, 165, 87.

123 Arasse, *L'homme en perspective*, 228.

4. The Admirable Effects of the Baroque Image

1 Peter Gerhard, *A Guide to the Historical Geography of New Spain*, rev. ed. (Norman: U of Oklahoma P, 1993), 181–82.

2 Marcel Bataillon, *Erasmo y España: Estudios sobre la historia espiritual del siglo XVI* (Mexico City: FCE, 1982), 828.

3 O'Gorman, *Destierro*, 128.

4 Antonio Garrido Aranda, *Organización de la Iglesia en el reino de Granada y su proyección en Indias, Siglo XVI* (Seville: Escuela de Estudios Hispano-Americanos de Sevilla, 1979), 186–87. The term "Moresque" can be applied to the Spanish Moors who converted to Christianity and accepted Christian domination.

5 Garrido Aranda, *Organización*, 254.

6 Garrido Aranda, *Organización*, 102; Antonio Domínguez Ortiz and Bernard Vincent, *Historia de los Moriscos: Vida y tragedia de una minoría*, 1st ed. (Madrid: Alianza Editorial, 1984).

7 Fernández del Castillo, *Libros*, 12.

8 In O'Gorman's *Destierro de sombras;* nonetheless, we do not believe all his hypotheses.

9 O'Gorman, *Destierro*, 168. Montufar had had the hermitage restored, and had placed it under the care of a secular priest.

10 O'Gorman, *Destierro*, 70.

11 Phillips, *Reformation of Images*, 117.

12 O'Gorman, *Destierro*, 70.

13 O'Gorman, *Destierro*, 28.

14 Chimalpahin Cuauhtlehuanitzin, *Relaciones originales de Chalco-Amequemecan*, ed. and trans. Silvia Rendón (Mexico City: FCE, 1965), 288.

15 O'Gorman, *Destierro*, 71.

16 O'Gorman, *Destierro*, 139.

17 O'Gorman, *Destierro*, 139.

18 O'Gorman, *Destierro*, 86.

19 Sahagún, *Historia*, vol. 3, 352.

20 Toussaint, *Pintura*, 34.

21 O'Gorman, *Destierro*, 132.

22 Francisco Antonio Lorenzana, *Concilios provinciales primero y segundo* (Mexico City: Antonio de Hogal, 1769), 91–92.

23 Damisch, *Théorie du nuage*, 71.

24 Toussaint, *Pintura*, 220.

25 Toussaint, *Pintura,* 37.

26 For the activities of the Holy Office, see the indispensable study by So-lange Alberro, *Inquisition et société au Mexique: 1571–1700* (Mexico City: Centre d'Etudes Mexicaines et Centraméricaines, 1988).

27 AGN, *Inquisición* (Puebla: 1629), vol. 363, exp. 21.

28 Toussaint, *Pintura,* 100–01.

29 O'Gorman, *Destierro,* 99.

30 Antonio Lorenzana, *Concilios,* 67.

31 O'Gorman, *Destierro,* 119–20.

32 Ernesto de la Torre Villar and Ramiro Navarro de Anda, "Información de 1556," *Testimonios históricos guadalupanos: Compilación, prólogo, notas biblio-graficas y indices* (Mexico City: FCE, 1982), 52.

33 Torre Villar and Navarro de Anda, "Información de 1556," 53.

34 O'Gorman, *Destierro,* 141, 105; on Zumárraga, see Bataillon, *Erasmo y España,* 826.

35 Martín de León, *Camino del Cielo en lengua mexicana con todos los requisitos necessarios para conseguir este fin, co[n] todo lo que un Xtiano deve creer, saber, y obrar, desde el punto que uso de razon, hasta que muere* (Mexico City: Diego Lopez, 1611), fol. 96v.

36 *Regla Christiana breve* cited in Joaquín García Icazbalceta, *Don Fray Juan de Zumárraga: Primer obispo y arzobispo de Mexico,* vol. 2 (Mexico City: Por-rúa, 1947), 67.

37 O'Gorman, *Destierro,* 78, 87.

38 AGN, *Inquisición* (Mexico City: May 1583), vol. 133, exp. 23.

39 Gruzinski, *Conquest,* 195–96; and our contribution to Jean-Michel Sall-mann, *Visions indiennes, visions baroques: Les métissages de l'inconscient* (Paris: PUF, 1992).

40 Rogelio Ruíz Gomar, *El pintor Luis Juárez: Su vida y obra* (Mexico City: UNAM, 1987), 161.

41 See, for example, the *Apparition of the Child Jesus to St. Anthony of Padua* by Luis Juárez (Ruíz Gomar, *Luis Juárez,* 199).

42 The simulation in the domain of images of synthesis, realized with the help of the computer, is "the art of exploring a field of possibilities on the basis of formal laws given *a priori.* . . . With simulation . . . it is less about representing the world, than recreating it" (in Philippe Quéau, *Eloge de la simulation: De la vie des langages à la synthèse des images* [Paris: Champ Vallon, Institut National de l'Audiovisuel, 1986], 118). Though the confrontation with new techniques of the image allows for a better un-derstanding of ancient mechanisms and a clearer unveiling of processes and specifics, one can nonetheless not confuse cultures and times.

43 Serge Gruzinski and Jean-Michel Sallmann, "Une source d'ethnohistoire: Les vies de 'Vénérables' dans l'Italie méridionale et le Mexique ba-

roques," *Mélanges de l'Ecole française de Rome: Moyen Age-Temps Modernes* 88 (1976): 789–822.

44 Quéau, *Eloge,* 119.

45 Antonio Lorenzana, *Concilios,* 144.

46 AGN, *Inquisición,* vol. 81, exp. 38, fols. 246–47.

47 Fernández del Castillo, "Proceso," 35.

48 Fernández del Castillo, "Proceso," 21.

49 Fernández del Castillo, "Proceso," 26.

50 Toussaint, *Pintura,* 10, 51.

51 Toussaint, *Pintura,* 223.

52 Ruíz Gomar, *Luis Juárez,* 28; Manuel Toussaint, *Claudio de Arciniega arquitecto de la Nueva España* (Mexico City: UNAM, 1981).

53 Ruíz Gomar, *Luis Juárez,* 22–23.

54 Toussaint, *Pintura,* 57; Hellendoorn, *Influencia,* 170.

55 Francisco de la Maza, *El pintor Martín de Vos en México* (Mexico City: UNAM, 1971), 45.

56 Maza, *Martín de Vos,* 44.

57 José Guadalupe Victoria, *Pintura y sociedad en Nueva España: Siglo XVI* (Mexico City: UNAM, 1986), 123.

58 Hellendoorn, *Influencia,* 18.

59 Ruíz Gomar, *Luis Juárez,* 60–61.

60 Ruíz Gomar, *Luis Juárez,* 40; Abelardo Carrillo y Gariel, *Técnica de la pintura de Nueva España,* 2d ed. (Mexico City: UNAM, 1983), 132–33; Ruíz Gomar, 50.

61 Jeannine Baticle, "L'art baroque en Espagne," in Jeannine Baticle and Alain Roy, *L'art baroque en Espagne et en Europe septentrionale* (Geneva: Famot, 1981), 20. The rejection of popular reality from painting has its equivalent in Mexican literature of the seventeenth century, which ignores Spanish, mestizo, or native picaresque and peasant circles (Ruíz Gomar, *Luis Juárez,* 50).

62 Ruíz Gomar, *Luis Juárez,* 63.

63 Toussaint, *Pintura,* 104.

64 Toussaint, *Pintura,* 10–108, 137.

65 See note 61.

66 Damisch, *Théorie du nuage,* 80–83.

67 Cesare Ripa, *Iconologia,* ed. Piero Buscaroli (Milan: Editori Associati, 1992), 38.

68 Torquemada, *Monarquía,* vol. 3, 112.

69 Torquemada was familiar with the *Emblems* of Alciati. The contribution of the "Mexican antiquities"—that is to say, the manner in which the Europeans "saw" the native representations—to aesthetic reflections is still largely unexplored.

70 Along these lines, see the remarks of Remo Guidieri in "Commentaire," *Res* 1 (spring 1981): 40–43.

71 Octavio Paz, *Sor Juana Inés de la Cruz ou les pièges de la foi,* trans. Roger Munier (Paris: Gallimard, 1987).

72 Guillermo Tovar de Teresa, *Bibliografia novohispana de arte, Primera parte: Impresos mexicanos relativos al arte de los siglos XVI y XVII* (Mexico City: FCE, 1988), 59.

73 Tovar de Teresa, *Primera parte,* 60.

74 Tovar de Teresa, *Primera parte,* 61.

75 Tovar de Teresa, *Primera parte,* 98.

76 Tovar de Teresa, *Primera parte,* 58–68 (*Historia de [. . .] la Santa Imagen de Nuestra Señora de los Remedios* [Mexico City: Bachiller Juan Blanco de Alcaçar, 1621]).

77 O'Gorman, *Destierro,* 147.

78 O'Gorman, *Destierro,* 27.

79 O'Gorman, *Destierro,* 59, note 28.

80 Francisco de la Maza, *El guadalupanismo mexicano* (Mexico City: FCE, 1981), 34.

81 Chimalpahin Cuauhtlehuanitzin, *Relaciones,* 277; AGN, *Bienes Nacionales* (Mexico, n.d.) vol. 810, exp. 91.

82 Ruíz Gomar, *Luis Juárez,* 41.

83 Maza, *Guadalupanismo,* 36, and above, note 76.

84 Antonio de Robles, *Diario de sucesos notables: 1665–1703,* ed. Antonio Castro Leal, vol. 1 (Mexico City: Porrúa, 1946), 145.

85 Miguel Sánchez, "Imagen de la Virgen María, Madre de Dios de Guadalupe," in Torre Villar and Navarro de Anda, *Testimonios,* 190.

86 Gruzinski, *Conquest,* 98–145.

87 Torre Villar and Navarro de Anda, *Testimonios,* 1350.

88 Torre Villar and Navarro de Anda, *Testimonios,* 288.

89 Torre Villar and Navarro de Anda, *Testimonios,* 282–83; Maza, *Guadalupanismo mexicano,* 73–81.

90 Torre Villar and Navarro de Anda, *Testimonios,* 1346.

91 Torre Villar and Navarro de Anda, *Testimonios,* 1362, 1369; Maza, *Guadalupanismo mexicano,* 41–43.

92 O'Gorman, *Destierro,* 61, note 32.

93 Torre Villar and Navarro de Anda, *Testimonios,* 289; trans. in Gruzinski, *Conquest,* 192.

94 AGN, *Indiferente general,* Arzobispado de México, "Cuaderno de la visita que hizo don Juan de Aguirre en la hermita de Nuestra Señora de Guadalupe" (1653).

95 AGN, *Bienes Nacionales,* vol. 373 (1630); Torre Villar and Navarro de Anda, *Testimonios,* 310.

96 Torre Villar and Navarro de Anda, *Testimonios*, 359–99.

97 On the mechanisms of fetishism, see J.-B. Pontalis, "Présentation," *Objets du fétichisme. Nouvelle Revue de Psychanalyse* 2 (fall 1970): 11.

98 Guidieri, *Cargaison* (Paris: Sueil, 1987), 59.

99 Maza, *Guadalupanismo mexicano*, 83.

100 José Mariano Beristáin de Souza, *Biblioteca Hispano Americana Septentrional*, 3rd ed., vol. 4 (Mexico City: Fuente Cultural, 1947), 355.

101 Beristáin de Souza, *Biblioteca*, 308.

102 Torre Villar and Navarro de Anda, *Testimonios*, 263.

103 Torre Villar and Navarro de Anda, *Testimonios*, 216, 263.

104 Jean-Michel Sallmann, "Il santo patrono cittadino nel'600 nel regno di Napoli e in Sicilia," *Per la storia sociale e religiosa del Mezzogiorno d'Italia,* eds. Giuseppe Galasso and Carla Russo, vol. 2 (Naples: Guida, 1982), 187–211.

105 Torre Villar and Navarro de Anda, *Testimonios*, 1345; AGN, *Bienes Nacionales,* vol. 1162, exp. 5 (Inquest known as "Informaciones guadalupanas de 1666").

106 Torre Villar and Navarro de Anda, *Testimonios*, 153, 260, 266. For the origins of Mexican patriotism, see David A. Brading, *Los orígenes del nacionalismo mexicano* (Mexico City: Secretaria de Educación Audiovisual y Divulgación, 1973); and Jacques Lafaye, *Quetzalcoatl and Guadalupe: The Formation of Mexican National Consciousness, 1531–1813,* foreword Octavio Paz, trans. Benjamin Keen (Chicago: U of Chicago P, 1976 [1974]).

107 The miraculous Christ of Ixmiquilpan was invoked against the Marranos. See Alfonso Alberto de Velasco, *Historia de la renovación de la soberana imagen de Christo Nuestro Señor crucificado* (Mexico City: Calle de la Palma num. 4, 1845).

108 Alberro, *Inquisition*, 294.

109 Jonathan Irvine Israel, *Race, Class and Politics in Colonial Mexico, 1610–1670* (London, Oxford UP, 1975), 247.

110 Torre Villar and Navarro de Anda, *Testimonios*, 273.

111 Torre Villar and Navarro de Anda, *Testimonios*, 257.

112 Torre Villar and Navarro de Anda, *Testimonios*, 257, 153.

113 Torre Villar and Navarro de Anda, *Testimonios*, 288.

114 Maza, *Guadalupanismo mexicano*, 83.

115 Torre Villar and Navarro de Anda, *Testimonios*, 157, 160.

116 Maza, *Guadalupanismo mexicano*, 39.

117 Toussaint, *Pintura*, 96. The iconography of the Immaculate Conception was set by the Cavalier of Arpin in about 1600–1610; see Baticle, "L'art baroque en Espagne," 67.

118 Maza, *Guadalupanismo mexicano*, 57; Torre Villar and Navarro de Anda, *Testimonios*, 164.

119 And an invitation to distinguish—more clearly than we usually do—between the temporality of historians, reconstituted according to a strictly linear scheme and a mathematical chronology, and the times lived within the *imaginaire*, for whom the past is never static.

120 Torre Villar and Navarro de Anda, *Testimonios*, 158.

121 Torre Villar and Navarro de Anda, *Testimonios*, 164.

122 Torre Villar and Navarro de Anda, *Testimonios*, 260, 275.

123 Torre Villar and Navarro de Anda, *Testimonios*, 272–73.

124 Torre Villar and Navarro de Anda, *Testimonios*, 201.

125 Maza, *Guadalupanismo mexicano*, 39.

126 Maza, *Guadalupanismo mexicano*, 124.

127 Torre Villar and Navarro de Anda, *Testimonios*, 159.

128 Torre Villar and Navarro de Anda, *Testimonios*, 249.

129 Torre Villar and Navarro de Anda, *Testimonios*, 189–90.

130 Torre Villar and Navarro de Anda, *Testimonios*, 190.

131 Torre Villar and Navarro de Anda, *Testimonios*, 328, 331.

132 See Francisco de Florencia, *Narración de la maravillosa aparición que hizo el Arcangel San Miguel a Diego Lazaro de San Francisco* (Seville: Tomás López de Haro, 1692), 141.

133 Maza, *Guadalupanismo mexicano*, 166.

134 Cayetano de Cabrera y Quintero, *Escudo de armas de México* (Mexico City: Viuda de don J. B. de Hogal, 1746), 311.

135 Ibid.

136 Torre Villar and Navarro de Anda, *Testimonios*, 178.

137 Torre Villar and Navarro de Anda, *Testimonios*, 263.

138 Torre Villar and Navarro de Anda, *Testimonios*, 331.

139 Torre Villar and Navarro de Anda, *Testimonios*, 281.

140 Torre Villar and Navarro de Anda, *Testimonios*, 259.

141 Torre Villar and Navarro de Anda, *Testimonios*, 264.

142 Gruzinski, *Man-Gods*, 127–34.

143 Cabrera y Quintero, *Escudo*, 8–9; Maza, *Guadalupanismo mexicano*, 154. The information was drawn from the work of a French Recollet, a missionary in Louisiana, Louis de Hennepin.

144 Bernand and Gruzinski, *De l'idolâtrie*, 146–71.

145 Miguel Flores Solis, *Nuestra Señora de los Remedios* (Mexico City: Jus, 1972), 63.

146 Agustin de Vetancurt, *Teatro mexicano: Quarta Parte*, vol. 4 (Mexico City: Doña María de Benavides, 1697), 133.

147 Vetancurt, *Teatro mexicano*, 132.

148 Ignacio Manuel Altamirano, *Obras completas, V, Textos costumbristas*, ed. Catalina Sierra Casasus et al., vol. 5 (Mexico City: SEP, 1986), 7.

149 Chimalpahin Cuauhtlehuanitzin, *Relaciones*, 287.

150 Antonio de la Calancha and Bernardo de Torres, *Crónicas augustinias del Peru,* ed. Manuel Merino. [Original title: *Crónica moralizada del orden de San Agustín*] (Madrid: Consejo Superior de Investigaciones Científicas, 1972), 223.

151 Joaquín Sardo, *Relación histórica y moral de la portentosa imagen de Nuestro Señor Jesucristo crucificado aparecido en una de las cuevas de San Miguel de Chalma,* facsimile of the 1810 edition (Mexico City: Biblioteca Enciclopédica del Estado de México, 1979).

152 Ruíz Gomar, *Luis Juárez,* 59.

153 Tovar de Teresa, *Primera Parte,* 55.

154 Tovar de Teresa, *Primera parte,* 321.

155 Tovar de Teresa, *Primera parte,* 69.

156 Vetancurt, *Teatro mexicano,* 132.

157 Tovar de Teresa, *Primera parte,* 313. The hermitage had been restored and refurbished in 1595 (*Primera parte,* 58).

158 Tovar de Teresa, *Primera parte,* 98.

159 See Florencia, *Narración;* and D. Pedro Salmerón, *Relación de la aparición [del] soveran Arcángel San Miguel en un lugar del obispado de la Puebla de los Angeles* (AGN, *Historia,* vol. 1, exp. 7).

160 Florencia, *Narración,* 97.

161 Florencia, *Narración,* 119.

162 Florencia, *Narración,* 162. In 1633, in the region of Oaxaca, a priest had a miraculous image of the Blessed Virgin transferred to Juquila; see José Manuel Ruíz y Cervantes, *Memorias de la portentosa imagen de Nuestra Señora de Xuquila* (Mexico City: F. de Zunigas y Ontiveros, 1786), 28; and James B. Greenberg, *Santiago's Sword: Chatino Peasant Religion and Economics* (Berkeley: U of California P, 1981), 44.

163 Vetancurt, *Teatro mexicano,* 131.

164 Manuel Loaisaga, *Historia de la milagrosíssima imagen de Nuestra Señora de Ocotlán* (Mexico City: Viuda de Joseph de Hogal, 1750), 73. In 1647, near the coast of the Gulf of Mexico, the Child Jesus of Acayucan sweated; the miracle united Spanish and Indians with the same fervor.

165 Tovar de Teresa, *Primera parte,* 157.

166 AGN, *Misiones,* vol. 26, exp. 7; Tovar de Teresa, *Primera parte,* 164.

167 Tovar de Teresa, *Primera parte,* 194.

168 Vetancurt, *Teatro mexicano,* 134.

169 Tovar de Teresa, *Primera parte,* 326.

170 Sardo, *Relación,* xxi.

171 Giovanni Francesco Gemelli Careri, *Viaje a la Nueva España* (Mexico City: UNAM, 1976), 116, 114.

172 Florencia, *Narración,* 155.

173 Tovar de Teresa, *Primera parte,* 325–26.

174 Florencia, *Narración*, 81.

175 *La estrella del Norte de México*, cited in Torre Villar and Navarro de Anda, *Testimonios*, 394.

176 Tovar de Teresa, *Primera parte*, 309.

177 Tovar de Teresa, *Primera parte*, 312.

178 Tovar de Teresa, *Primera parte*, 346.

179 Vetancurt, *Teatro mexicano*, 135. This proliferation has its counterpart in Mediterranean Europe: during the seventeenth century Catalonia numbered, counting all origins, two hundred miraculous images of the Blessed Virgin; see *L'imagerie catalane: Lectures et rituels,* ed. Dominique Blanc, exhibition catalogue (Carcassonne: Garae, 1988), 69.

180 Vetancurt, *Teatro mexicano*, 127.

181 Francisco de la Maza, *El pintor Cristobal de Villalpando* (Mexico City: INAH, 1964), 66, 102, 103.

182 Florencia, *Narración*, 13.

183 And from which arises a "celestial odor" (Florencia, *Narración*, 133).

184 Loaisaga, *Historia*, 27; Sánchez in Torre Villar and Navarro de Anda, *Testimonios*, 179.

185 Jesús Estrada, *Música y músicos de la época virreinal*, 2d ed., Diana 95 (Mexico City: SepSetentas, 1980), 88–121.

186 Gregorio Martín de Guijo, *Diario, 1648–1664*, vol. 2 (Mexico City: Porrúa, 1953), 51; José Guadalupe Victoria, "Forma y expresión en un retablo novohispano del siglo XVII," *Estudios acerca del arte novohispano: Homenaje a Elisa Vargas Lugo* (Mexico City: UNAM, 1983), 181.

187 Elisa Vargas Lugo, "Las fiestas de beatificacion de Rosa de Lima," *El arte efímero en el mundo hispánico* (Mexico City: UNAM, 1983), 96.

188 Robert W. Malcolmson, *Popular Recreations in English Society, 1700–1850* (Cambridge: Cambridge UP, 1979), 7.

189 Torre Villar and Navarro de Anda, *Testimonios*, 179. The threshold marked by images in the space in which they are inscribed remains to be explored, as it has been done for Mediterranean Europe; one should emphasize that colonial baroque imagery repeated a medieval process centuries later; see Christian, *Local Religion in Sixteenth-Century Spain* (Princeton: Princeton UP, 1981), 91.

190 Vetancurt, *Teátro mexicano*, 129–30.

191 Florencia, *Narración*, 64, 81.

192 Florencia, *Narración*, 82. Let us add the Sacramonte of Amecameca where there was an image of the goddess Chalchiuhtlicue (Chimalpahin Cuauhtlehuanitzin, *Relaciones*, 287).

193 Florencia, *Narración*, 6.

194 Florencia, *Narración*, 135.

195 Tovar de Teresa, *Primera parte*, 326.

196 Maza, *Guadalupanismo mexicano,* 159.

197 Maza, *Guadalupanismo mexicano,* 160, 162.

198 Torquemada, *Manarquía,* vol. 3, 67, 61.

199 Guidieri, *Cargaison,* 61.

200 Gruzinski, *Conquest,* 109–10.

201 Sardo, *Relación histórica,* 77–82.

202 Francisco Antonio Lorenzana in Genaro García, *Documentos inéditos o muy raros para la historia de México* (Mexico City: Porrúa, 1746), 529. The Creole Cayetano Cabrera y Quintero (1746) wrote endlessly on the theme of the shield-image (*escudo de armas*), infallible weapon against the epidemics.

203 Florencia, *Narración,* 17.

204 Loaisaga, *Historia,* 70–71.

205 Gruzinski, *Conquest,* 270.

206 Gemelli Careri, *Viaje,* 73, 114.

207 Loaisaga, *Historia,* 48.

208 Loaisaga, *Historia,* 63.

209 This was the case for Las Casas (*Apologética*) or Motolinía (*Memoriales*). The Indians even consumed their own images, since they ate the paste idols they made, and for a few, the human *ixiptla* whom they had sacrificed.

210 Gruzinski, *Conquest,* 248.

211 Tovar de Teresa, *Primera parte,* 28–35.

212 Tovar de Teresa, *Primera parte,* 53.

213 Tovar de Teresa, *Primera parte,* 163–64.

214 Tovar de Teresa, *Primera parte,* 169.

215 Tovar de Teresa, *Primera parte,* 188, 196.

216 Guillermo Tovar de Teresa, *Bibliografía novohispana de arte, Secunda parte: Impresos mexicanos relativos al arte del siglo XVIII* (Mexico City: FCE, 1988), 55, 178, 222, 231, 334.

217 Tovar de Teresa, *Primera parte,* 249.

218 Ibid.

219 Tovar de Teresa, *Primera parte,* 262. The Church of los Remedios frescoes lined the recapitulation of the history of the miraculous image with sibyls and antique gods, see Victoria, "Forma y expresión," 120.

220 Tovar de Teresa, *Primera parte,* 373, 268.

221 Tovar de Teresa, *Primera parte,* 355.

222 Bernand and Gruzinski, *De l'idolâtrie,* 89–121.

223 Gemelli Careri, *Viaje,* 114.

224 Tovar de Teresa, *Primera parte,* 179.

225 Tovar de Teresa, *Primera parte,* 261.

226 Tovar de Teresa, *Primera parte,* 356.

227 David Moore Bergeron, *English Civic Pageantry, 1558–1642* (Columbia: U of South Carolina P, 1971), 7.

228 Phillips, *Reformation of Images*, 119.

229 Peter Greenaway, *Fear of Drowning by Numbers—Règles du jeu*, trans. Barbara Dent, Danièle Rivière, and Bruno Alcala (Paris: Dis Voir, 1996), 14. Screenplay based on the 1988 movie.

230 Greenaway, *Fear of Drowning*, 12.

231 AGN, *Inquisición*, vol. 1552, fol. 292.

232 Fernández del Castillo, *Libros y libreros*, 463; Carrillo y Gariel, *Técnica*, 116–17.

233 Fernández del Castillo, *Libros y libreros*, 158, 147, 151.

234 Fernández del Castillo, *Libros y libreros*, 178, 196.

235 Fernández del Castillo, *Libros y libreros*, 170.

236 Fernández del Castillo, *Libros y libreros*, 149.

237 AGN, *Inquisición*, vol. 82, exp. 7.

238 AGN, *Inquisición*, vol. 76, exp. 41.

239 Ruiz Gomar, *Luis Juárez*, 156.

240 AGN, *Inquisición*, vol. 165, exp. 8.

241 AGN, *Inquisición*, vol. 165, exp. 8. One of the witnesses was a native from Dancuyque in Lower Germany (our Dunkirk?).

242 AGN, *Riva Palacio*, vol. 11 (1581).

243 AGN, *Inquisición*, vol. 165, "Contra Alvaro Zambrano" (1598).

244 AGN, *Inquisición*, vol. 283, fol. 522.

245 AGN, *Inquisición* vol. 360, 2d parte, fol. 284.

246 Alberro, *Inquisition*, 301–07.

247 AGN, *Criminal*, vol. 284, exp. 6, fol. 220–70. It was even said that a little wooden dog that had belonged to Palafox had barked (fol. 396v).

248 AGN, *Inquisición: Edictos*, vol. 3, exp. 230, 258.

249 AGN, *Inquisición*, vol. 628, exp. 5.

250 AGN, *Inquisición*, vol. 1346, exp. 3.

251 AGN, *Inquisición: Edictos*, vol. 3, exp. 229.

252 AGN, *Inquisición*, vol. 545, exp. 3.

253 AGN, *Inquisición*, vol. 471, exp. 105.

254 AGN, *Inquisición: Edictos*, vol. 2 (1767).

255 AGN, *Inquisición*, vol. 684, exp. 8.

256 AGN, *Inquisición: Edictos*, vol. 2 (1768).

257 AGN, *Inquisición*, vol. 684, exp. 34.

258 AGN, *Inquisición*, vol. 1108, fol. 49. This extreme position, in fact, reveals a mutation of the Church's gaze that will be explored in the first few pages of the conclusion.

259 AGN, "Reglas del Expurgatorio," *Inquisición*, vol. 733, fol. 238–39.

260 Ibid.

261 Gonzalo Aguirre Beltrán, *La población negra de México: Estudio etno-historico* (Mexico City: FCE, 1972), 210, 222. These numbers, it goes without saying, mainly provide an order of magnitude.

262 Loaisaga, *Historia,* 129, 141, and throughout.

5. Image Consumers

1 Paraphrasing Torquemada, *Monarquía,* vol. 3, 50.

2 AGN, *Inquisición,* vol. 452, 2d parte, fol. 234–35.

3 Chapter 4, note 256.

4 AGN, *Inquisición* (Colima), vol. 1145, fol. 98–105.

5 AGN, *Inquisición,* vol. 796, exp. 9, fol. 202–06.

6 AGN, *Inquisición,* vol. 830, fol. 167–72.

7 AGN, *Misiones,* vol. 25, exp. 15.

8 AGN, *Inquisición* (Celaya), vol. 1049, fol. 286.

9 AGN, *Indiferente General,* "Los naturales de San Sebastián de Querétaro contra don Agustín Río de la Loza" (Dec. 1777), fol. 199v.

10 Carlos Navarrete, *San Pascualito Rey y el culto a la muerte en Chiapas* (Mexico City: UNAM, 1982).

11 AGN, *Inquisición,* vol. 1202, fol. 50–56.

12 AGN, *Inquisición,* vol. 1133, fol. 134.

13 AGN, *Inquisición,* vol. 416, fol. 252.

14 AGN, *Inquisición,* vol. 1552, fol. 160.

15 AGN, *Inquisición,* vol. 836, fol. 518–28.

16 AGN, *Inquisición,* vol. 937, fol. 234v.

17 For the relationship between *imaginaire,* bodies and forms of communication, see the suggestions of Alberto Abruzzese, *Il corpo elettronico: Dinamiche delle comunicazioni de massa in Italia* (Scandicci, Florence: Nuova Italia, 1988).

18 AGN, *Inquisición,* vol. 1130, fol. 315.

19 AGN, *Inquisición,* vol. 1108, fol. 137; vol. 147, exp. 6.

20 AGN, *Inquisición,* vol. 244, fol. 76.

21 *Supersticiones de los indios de la Nueva España* (Mexico City: Biblioteca de Aportación Histórica, 1946), 31; AGN, *Inquisición,* vol. 727, fol. 391–405.

22 AGN, *Inquisición,* vol. 781, exp. 39.

23 AGN, *Inquisición,* vol. 727, fol. 347–51.

24 AGN, *Inquisición,* vol. 165, exp. 4.

25 AGN, *Inquisición,* vol. 794, exp. 3.

26 AGN, *Inquisición,* vol. 1049, fol. 276–77; vol. 967, exp. 8, 30.

27 Serge Gruzinski, "Las cenizas del deseo: Homosexuales novohispanos a

mediados del siglo XVII," *De la Santidad a la perversión: O de porqué no se cumplía la ley de Dios en la sociedad novohispana*, ed. Sergio Ortega Noriega (Mexico City: Grijalbo, 1986), 274.

28 AGN, *Inquisición*, vol. 798, exp. 12.

29 Serge Gruzinski, "La mère dévorante: Alcoolisme, sexualité et déculturation chez les Mexica (1500–1550)," *Cahiers des Amériques latines* 20 (1979): 5–36.

30 AGN, *Inquisición*, vol. 803, exp. 61, fol. 558.

31 AGN, *Inquisición*, vol. 1155, fol. 333–491; vol. 1140, fol. 258.

32 AGN, *Inquisición*, vol. 727, fol. 391–405.

33 García, *Documentos inéditos*, 526.

34 Alberro, *Inquisition*, 292.

35 AGN, *Inquisición*, vol. 794, exp. 3, fol. 72–85.

36 AGN, *Inquisición*, vol. 947, exp. 3.

37 AGN, *Inquisición*, vol. 1140, fol. 252.

38 *Peyotl*, or peyote, is a small cactus (*Lophophora*) rich in alkaloids.

39 AGN, *Inquisición*, vol. 668, exp. 5, 6.

40 Casa de Morelos, *Documentos de la Inquisición* (Guanajuato, 1769), vol. 43.

41 Gruzinski, *Conquest*, 220–21.

42 Piero Camporesi, *Bread of Dreams: Food and Fantasy in Early Modern Europe* (Chicago: U of Chicago P, 1996).

43 Gruzinski, *Conquest*, 201–21.

44 "Proceso contra María Felipa de Alcaraz, bruja española de Oaxaca, Oaxaca (extracto)," third series, vol. 2: (4) 6 *Boletín del Archivo General de la Nación* (Mexico City: n. ed., 1978): 33.

45 "Proceso contra María Felipa," 38.

46 "Proceso contra María Felipa," 34.

47 Ibid.

48 Ibid.

49 "Proceso contra María Felipa," 39.

50 Other cases appear in *De la Santidad* (see note 27).

51 Serge Gruzinski, "Individualization and Acculturation: Confession among the Nahuas of Mexico from the Sixteenth to the Eighteenth Century," *Sexuality and Marriage in Colonial Latin America*, ed. Asunción Lavrin (Lincoln: U of Nebraska P, 1989), 89–108.

52 Marquis de Sade, *Juliette: or, Vice Amply Rewarded* (New York: Lance, 1969).

53 Torre Villar and Navarro de Anda, *Testimonios*, 263.

54 On the idolatry exterminators, see Bernand and Gruzinski, *De l'idolâtrie*, 146–71.

55 León, *Camino del Cielo*, 96.

56 AGN, *Misiones*, vol. 25, exp. 15, fol. 152.

57 Bernand and Gruzinski, *De l'idolâtrie*, 41–86.

58 Emily Umberger, "Antiques, Revivals and References to the Past in Aztec Art," *Res* 13 (spring 1987): 107–22.

59 A relief of the Coyolxauhqui was unearthed during recent digs within the walls of the Templo Mayor in Mexico City.

60 AINAH, *Colección Antigua*, 2d parte, vol. 209, fol. 436.

61 García Icazbalceta, "Relación de Andrés de Tapia," *Colección*, vol. 2, 586.

62 AINAH, *Colección Antigua*, 2d parte, vol. 209, fol. 438.

63 Rosa, Información *jurídica*, viii.

64 Gemelli Careri, *Viaje*, 78.

65 Cited in José A. Llaguno, *La personalidad jurídica del indio y el III Concilio Provincial Mexicano (1585)* (Mexico City: Porrúa, 1963), 201.

66 Thomas Gage, *A New Survey of the West Indies, 1648: The English-American*, ed. and intro. A. P. Newton (New York: Robert M. McBride, 1929), 254.

67 López Austin, *The Human Body*, vol. 1, 429.

68 Antonio de Guadalupe Ramírez, *Breve compendio de todo lo que debe saber y entender el cristiano* (Mexico City: Madrilena de las Herederos del Lic. J. De Jauregui, 1785).

69 Juan Guillermo Durán, *El Catecismo del III Concilio Provincial de Lima y sus complementos pastorales (1584–1585)* (Buenos Aires: El Derecho, 1982), 454.

70 Gruzinski, *Conquest*, 153–54.

71 AGN, *Misiones*, vol. 25, exp. 15, fol. 157.

72 "Denonciación contre Santiago Antonio." Hacienda de Totoapa, Acatlán, July 1774. Bancroft Library (Berkeley), *MM 406*, folder 16.

73 "Proceso de Julian Maria contre María Durán." San Miguel Acatlán, Aug. 14 1769. Bancroft Library (Berkeley), *MM 406*, folder 17, fol. 9.

74 AGN, *Bienes Nacionales*, vol. 663, exp. 19, fol. 33v.

75 AGN, *Bienes Nacionales*, vol. 1030, exp. 3.

76 AGN, *Bienes Nacionales*, vol. 905, exp. 3.

77 AGN, *Inquisición*, vol. 356, fol. 180.

78 Gruzinski, *Conquest*, 175–80.

79 AGN, *Misiones*, vol. 25, exp. 15, fol. 157.

80 AGN, *Inquisición*, vol. 312, fol. 97.

81 See Solange Alberro's work on the acculturation of the Spanish in *Les Espagnols dans le Mexique colonial: Histoire d'une acculturation* (Paris: A. Cohn, 1992).

82 AGN, *Inquisición*, vol. 312, exp. 55, fol. 282.

83 AGN, *Inquisición*, vol. 281, fol. 625.

84 AGN, *Inquisición*, vol. 1055, fol. 303.

85 Casa de Morelos, *Documentos de la Inquisición*, leg. 44 (1770).

86 *Procesos de Indios*, 37.

87 See chapter 4, the section titled "Toward a New Politics of the Image."

88 María del Consuelo Maquívar y Maquívar, "Notas sobre la escultura

novohispana del siglo XVI," *Estudios acerca del arte novohispano: Homenaje a Elisa Vargas Lugo* (Mexico City: UNAM, 1983), 87; Fernández, *Libros y libreras,* 190 (The 1703 ordinances are to be taken in a similar vein).

89 Motolinía, *Memoriales,* 240.

90 Díaz del Castillo, *Historia verdadero,* vol. 2, 362; Carrillo y Gariel, *Técnica de la pintura,* 63–67.

91 Las Casas, *Apologética,* vol. 1, 323.

92 *Codex Monteleone,* around 1531–1532. Library of Congress, Washington, D.C.

93 Gruzinski, *Conquest,* 6–70.

94 Torquemada, *Monarquía,* vol. 3, 409.

95 Las Casas, *Apologética,* vol. 1, 323–24.

96 Rosa Camelo Arredondo, Jorge Gurría Lacroix, and Constantino Reyes Valerio, *Juan Gerson: Tlacuilo de Tecamachalco* (Mexico City: INAH, 1964).

97 Federico Gómez de Orozco, *El mobiliario y la decoración en la Nueva España en el siglo XVI* (Mexico City: UNAM, 1983), 103.

98 Gerhard, *Guide,* 22–25.

99 Torquemada, *Monarquía,* vol. 4, 254–55.

100 Supposedly painted by the Indian Marcos.

101 AGN, *Inquisición,* vol. 312, exp. 24, fol. 97.

102 Gruzinski, *Conquest,* 98–145.

103 Durán, *El Catecismo,* vol. 1, 236.

104 Calancha and Torres, *Cronicas,* 183–204.

105 Gage, *New Survey,* 254.

106 For example, the tale of the appearance of the Virgin of Milpa Alta in the southeast of the valley of Mexico City; see AGN, *Tierras,* vol. 3032, exp. 3, fol. 207–16.

107 Llaguno, *Personalidad,* 200.

108 Guillermo S. Fernández de Recas, *Cacicazgos y nobiliario indigena de la Nueva España* (Mexico: Instituto Bibliografico Mexicano, 1961), 86.

109 Gruzinski, *Conquest,* 245–46.

110 Llaguno, *Personalidad,* 205.

111 Gage, *New Survey,* 255–56.

112 Serge Gruzinski, "Indian Confraternities, Brotherhoods and *Mayordomías* in Central New Spain: A List of Questions for the Historian and the Anthropologist," in Arij Ouweneel and Simon Miller, eds., *The Indian Community of Colonial Mexico,* Latin American Studies 58 (Amsterdam: CEDLA, 1990), 205–23.

113 Juan de Mendoza, *Relación del santuario de Tecaxique [. . .]: Noticia de los milagros [. . .]* (Mexico City: Juan de Ribera, 1684).

114 Mendoza, *Relación.*

115 Antonio Joaquín Rivadeneira y Barrientos, *Disertaciones que le asistente real*

 Don Antonio Joaquín de Rivadeneira escribió sobre los puntos que se le con-sultaron por el Cuarto Concilio Mexicano en 1774 (Madrid: n. p., 1881), 66.

116 AGN, *Bienes Nacionales,* vol. 230, exp. 5.

117 AGN, *Bienes Nacionales,* vol. 990, exp. 10.

118 Henri Favre, *Cambio y continuidad entre los Mayas de México: Contribución al estudio de la situación colonialista en America Latina* (Mexico City: Siglo Veintiuno, 1973), 309.

119 Gage, *New Survey,* 258.

120 AGN, *Inquisición,* vol. 133, exp. 23, fol. 209.

121 A few titles reflect this assimilation: see Francisco Xavier de Santa Ger-trudis, *La Cruz de piedra: Imán de la devoción* (Mexico City: J. FOL. de Ortega y Bonilla, 1722), which deals with the miraculous crucifix of Querétaro. By insisting on the prevalence of the *imaginaire* we reverse the point of view that we maintained in Gruzinski, *The Conquest of Mexico,* which made images the driving force and the point of departure for the cultural production of reality.

122 For the diffusion of the Christian family model, see Carmen Bernand and Serge Gruzinski, "Les enfants de l'Apocalypse: La famille en Méso-Amérique et dans les Andes," *Histoire de la Famille: 2, Le choc des moder-nités,* vol. 2 (Paris: Armand Colin, 1987), 157–210.

123 Gruzinski, *Conquest,* 249–50.

124 Archivo General de Indias (Sevilla), *México,* vol. 882 and throughout.

125 "Causa contra indios y castas de la región de Coatlán [. . .] (1738–1745)," *Boletín de Archivo General de la Nación,* 3rd series, vol. 2: 4 (6) (1978): 21.

126 "Causa contra indios," 21–22.

127 "Causa contra indios," 22.

128 Ibid.

129 Ibid.

130 "Causa contra indios," 21.

131 "Causa contra indios," 26.

132 Casa de Morelos, *Documentos de la Inquisición,* leg. 41, "Superstición con-tra varios indios," 1797.

133 Casa de Morelos, *Documentos de la Inquisición.*

134 Hans Lenz, *El papel indígena mexicano* (Mexico City: Secretaria de Educa-ción Publica, 1973).

135 Casa de Morelos, *Documentos de la Inquisición.*

136 See earlier in this chapter, "Images and Visions," 170–72.

137 Gruzinski, *Conquest,* 109–10.

138 *Boletín del Archivo General de la Nación* (Mexico, 1978), 24.

139 *Boletín del Archivo General de la Nación* (Mexico, 1978), 21.

140 Gruzinski, *Conquest,* 146–83.

141 The "speaking Virgin" of Cancuc was discovered in 1712 by a Chiapas

woman. An oracular cult, in the Mayan tradition, arose around the image. The feast for the miraculous image, August 10, was the beginning of a bloody revolt against the Spanish. Speaking images still play an important role in the Chiapas communities and owning one leads to an elevated rank within the *pueblo.*

142 Favre, *Cambio,* 301, 307–08; AGN, *Inquisición,* vol. 801, fol. 108–14 (a diverting of the cult by the Dutch to make the Indians rise up against the Spanish Crown).

143 Gruzinski, *Conquest,* 73–123.

144 AGN, *Inquisición,* vol. 1000, exp. 21, fol. 292v.

145 Located inside of Popocatepetl, this purgatory was an adaptation of the third Holy Place of Christianity and the subterranean worlds of pre-Hispanic times.

146 AGN, *Criminal,* vol. 308, fol. 1–92.

147 Ibid.

148 Ibid.

149 Ibid.

150 Ibid.

151 Ibid.

152 Ibid.

153 Miguel Venegas, *Relación del tumulto [. . .] contra el ingenio de Xalmolonga* (Mexico City: Biblioteca Nacional, 1721), ms 1006.

154 "Annuae 1602," *Fondo Astrain,* vol. 33 (Mexico City: Archives of the Society of Jesus, 1602), fol. 22.

Conclusion

1 Fortino Hipólito Vera, *Itinerario parroquial del arzobispado de México [. . .]* (Amecameca: Imprenta del Colegio Católico, 1880), 108, 123.

2 AGN, *Bienes Nacionales,* vol. 1086, exp. 10.

3 Emiliano Fernandez de Pinedo, *Centralismo, ilustración y agonía del Antiguo Régimen (1715–1833),* ed. Alberto Gil Novales and Albert Derozier, History of Spain, vol. 7 (Barcelona: Labor, 1980), 357–75.

4 *Catecismo para el uso del IV Concilio Provincial Mexicano* (Mexico City: n. ed., 1772).

5 Biblioteca Nacional, ms. 4178 (Madrid), fol. 341–341v.

6 AGN, *Inquisición,* vol. 1037, fol. 288.

7 AGN, "Los naturales de la Congregación de Silao [. . .]," *Historia,* 1797–1798, vol. 437.

8 AGN, "Los naturales."

9 Douglas Cope, *The Limits of Racial Domination: Plebeian Society in Colonial Mexico City, 1660–1720* (Madison: U of Wisconsin P, 1994), 125–60.

10 AGN, *Bienes Nacionales,* vol. 990, exp. 10.

11 AGN, *Bienes Nacionales,* vol. 1212, exp. 26.

12 Fortino Hipólito Vera, *Colección de documentos eclesiasticos de Mexico* [. . .], vol. 2 (Amecameca: Colegio Católico, 1887), 144.

13 Ignacio Manuel Altamirano, *Obras completas,* vol. 5: *Textos costumbristas,* ed. Catalina Sierra Casasus et al. (Mexico City: SEP, 1986), 75.

14 Archivo del Cabildo de la Catedral de Puebla, "Papel sobre el verdadero y único modo de beneficiar a los Indios [. . .]," vol. 10, fol. 75.

15 AGN, *Bienes Nacionales,* vol. 1182, exp. 28.

16 Archivo del Cabildo de la Catedral de Puebla, "Informe de la Real Sala del Crimen [. . .]," vol. 9 (1784).

17 Torre Villar and Navarro de Anda, *Testimonios,* 696, 698.

18 José Servando Teresa de Mier Noriega y Guerra, *Obras completas. I. El heterodoxo guadalupano,* ed. Edmundo O'Gorman (Mexico City: UNAM, 1981), 238.

19 AGN, *Criminal,* vol. 179, exp. 10.

20 Ibid.

21 Vera, *Colección,* vol. 2, 30–33.

22 AGN, *Criminal,* vol. 84, exp. 5, fol. 141v.

23 Fortino Hipólito Vera, *Santuario del Sacromonte* (Amecameca: Colegio Católico, 1881), 19.

24 Juan Nepomuceno Rodríguez de San Miguel, *Pandectas hispanomexicanas,* vol. 1 (Mexico City: UNAM, 1980), 82–83.

25 Toussaint, *Pintura,* 201.

26 Constantino Reyes Valerio, *Tepalcingo* (Mexico City: INAH, 1960); Pedro Rojas, *Tonantzintla,* 1st ed. (Mexico City: UNAM, 1956).

27 Altamirano, *Obras completas,* 228.

28 Altamirano, *Obras completas,* 222–23.

29 Gabriele Turi, *Viva María: Le reazioni alle reforme leopoldine (1790–1799)* (Florence: Olschki, 1969).

30 O'Gorman, *Destierro,* 130, 133.

31 Altamirano, *Obras completas,* 235.

32 Rodríguez de San Miguel, *Pandectas,* vol. 1, 773.

33 Altamirano, *Obras completas,* 236.

34 Altamirano, *Obras completas,* 57.

35 Vera, *Itinerario parroquial del arzobispado de México* [. . .] (Amecameca: Colegio Católico, 1880), 69.

36 Vera, *Itinerario,* 78, 79.

37 Altamirano, *Obras completas,* 77.

38 Brigitte Boehm de Lameiras, *Indios de México y viajeros extranjeros* (Mexico City: SEP, 1973), 129.

39 Altamirano, *Obras completas,* 51.

40 Altamirano, *Obras completas*, 51.

41 Altamirano, *Obras completas*, 52.

42 Vera, *Santuario*, 21, 23.

43 Ibid.

44 Ibid.

45 Ibid.

46 Jean A. Meyer, *The Cristero Rebellion: The Mexican People Between Church and State, 1926–1929*, trans. Richard Southern (Cambridge: Cambridge UP, 1976), 8.

47 Altamirano, *Obras completas*, 115.

48 Altamirano, *Obras completas*, 118.

49 Altamirano, *Obras completas*, 122.

50 Altamirano, *Obras completas*, 116.

51 Altamirano, *Obras completas*, 240.

52 Meyer, *Cristero Rebellion*, throughout; it is impossible to inventory accurately the ethnographic output on this subject. On masks, see Donald Bush Cordry, *Mexican Masks* (Austin: U of Texas P, 1980), 103–05, who describes the role of the *santeros* who still make the masks and the church's statues.

53 Raquel Tibol, *José Clemente Orozco, Una vida para el arte: Breve historia documental* (Mexico City: SEP, 1984), 68–69.

54 Tibol, *Orozco*, 188.

55 *Televisa, el quinto poder*, eds. Fernando Mejia Barquera and Raúl Trejo Delarbre (Mexico City: Claves Latinoamericanas, 1985); *Las redes de Televisa*, ed. Raúl Trejo Delarbre (Mexico City: Claves Latinoamericanas, 1988).

56 Carlos Monsiváis, "Del difícil matrimonio entre cultura y medios masivos," *Primer simposio sobre historia contemporánea de México: Inventario sobre el pasado reciente (1940–1984)* (Mexico City: INAH, 1986), 119.

57 Monsivais, "Del difícil matrimonio," 119–31.

58 In 1946, during the Festival de Cannes, Europe discovered Mexican film and applauded *María Candelaria*, directed by Emilio "The Indian" Fernández, mestizo and revolutionary. This fresco-film—with a pair of cursed lovers, and a study of Indian society—also told the story of an image: a painting, symbol of modern Mexico, that scandalized the village farmers. Instead of destroying the painter's work, they stoned María, the young Indian woman who had served as his model, to death. The spectator never saw, on screen, the unforgivable allegory, "the face itself of Mexico." It is true that it was a nude. The scenario was taken from a news story. See Roger Boussinot, *L'encyclopédie du cinéma*, vol. 2 (Paris: Bordas, 1980), 847–48.

59 The first three are the executive, legislative and judicial powers; the fourth power is the press.

60 Cited in Yolande Le Gallo, *Nuevas máscaras, comedia antigua: Las representaciones de las mujeres en la televisión mexicana* (Mexico City: Premia, 1988), 23.

61 *Imágenes guadalupanas: Cuatro siglos (noviembre 1987–marzo 1988)* (Mexico City: Centro Cultural de Arte Contemporáneo, 1987).

62 One of the headlines in a Spanish-language magazine was "The Image Has Been Offended."

63 Abruzzese, *Il corpo elettronico: Dinamiche delle comunicazioni de massa in Italia* (Florence: Nuova Italia, 1988), throughout; Omar Calabrese, *L'età neobarocca* (Bari: Laterza, 1987).

64 A kind of pious image mass-produced during the nineteenth century in the Saint-Sulpice area of Paris.

Bibliography

Abruzzese, Alberto. *Il corpo elettronico: Dinamiche delle comunicazioni de massa in Italia.* Scandicci, Florence: Nuova Italia, 1988.

Acosta, José de. *Historia natural y moral de las Indias.* Ed. Edmundo O'Gorman. Mexico City: FCE, 1979.

Acuña, René. *Introducción al estudio del Rabinal Achi.* Mexico City: UNAM, 1975.

Aguirre Beltrán, Gonzalo. *La población negra de México: Estudio etnohistorico.* Mexico City: FCE, 1972.

Alberro, Solange. *Inquisition et société au Mexique: 1571–1700.* Mexico City: Centre d'Etudes Mexicaines et Centraméricaines, 1988.

——. *Les Espagnols dans le Mexique colonial: Histoire d'une acculturation.* Paris: A. Cohn, 1992.

Altamirano, Ignacio Manuel. *Obras completas. Vol. 5: Textos costumbristas.* Ed. Catalina Sierra Casasus et al. 22 vols. Mexico City: SEP, 1986.

Anghiera, Pietro Martire d' [Peter Martyr]. *Décadas del Nuevo Mundo.* Ed. Edmundo O'Gorman. 2 vols. Mexico City: Porrúa, 1964.

——. *P. Martyris Anglerii Mediolamensis opera. Legatio Babilonica. Oceani decas. Poemata. Epigrammata.* Seville: Jacobus Cromberger, 1511.

"Annuae 1602." *Fondo Astrain.* Vol. 33. Mexico City: Archives of the Company of Jesus, 1602.

Anthropologie de l'écriture. Ed. Robert Lafont. Centre de création industrielle. Paris: Centre Georges Pompidou, 1984.

Antonio Lorenzana, Francisco. *Concilios provinciales primero y segundo.* Mexico City: Antonio de Hogal, 1769.

Arasse, Daniel. *L'homme en perspective: Les primitifs d'Italie.* 2d ed. Geneva: Famot, 1986.

Arróniz, Othón. *Teatro de evangelización en Nueva España.* Mexico City: UNAM, 1979.

Babadzan, Alain. "Les idoles des iconoclastes: La position actuelle des *ti'i* aux îles de la Société." *Res* 4 (autumn 1982): 63–84.

Bataillon, Marcel. "Les premiers Mexicains envoyés en Espagne par Cortés." *Journal de la Société des Américanistes* new series 48 (1959): 135–40.

——. *Erasmo y España: Estudios sobre la historia espiritual del siglo XVI.* Mexico City: FCE, 1982.

Baticle, Jeannine. "L'art baroque en Espagne." *L'art baroque en Espagne et en Europe septentrionale.* By Jeannine Baticle and Alain Roy. Geneva: Famot, 1981.

Baudot, Georges. *Utopia and History in Mexico: The First Chroniclers of Mexican Civilization (1520–1569).* Trans. Bernard R. Ortiz de Montellano and Thelma Ortiz de Montellano. Boulder: UP of Colorado, 1995 [1977].

Baxandall, Michael. *Giotto and the Orators: Humanist Observers of Painting in Italy and the Discovery of Pictorial Composition, 1350–1450.* Oxford: Clarendon P, 1971.

——. *Painting and Experience in Fifteenth-Century Italy: A Primer in the Social History of Pictorial Style.* 2d ed. Oxford: Oxford UP, 1988 [1972].

Benitez, Fernando. *La ruta de Hernán Cortés.* 2d ed. Mexico: FCE, 1956.

Bercht, Fatima, Estrellita Brodsky, John Alan Farmer, and Dicey Taylor, eds. *Taíno: Pre-Columbian Art and Culture from the Caribbean.* New York: Monacelli P, 1997.

Bergeron, David Moore. *English Civic Pageantry, 1558–1642.* Columbia: U of South Carolina P, 1971.

Beristáin de Souza, José Mariano. *Biblioteca Hispano Americana Septentrional.* 3rd ed 4 vols. Mexico City: Fuente Cultural, 1947.

Bernand, Carmen, and Serge Gruzinski. *De l'idolâtrie: Une archéologie des sciences religieuses.* Paris: Seuil, 1988.

——. "Les enfants de l'Apocalypse: La famille en Méso-Amérique et dans les Andes." *Histoire de la Famille: 2, Le choc des modernités.* Vol. 2. Paris: Armand Colin, 1987: 157–210.

Blade Runner. Dir. Ridley Scott. Warner Brothers, 1982.

Boussinot, Roger. *L'encyclopédie du cinéma.* 2 vols. Paris: Bordas, 1980.

Brading, David A. *Los Origenes del nacionalismo mexicano.* Trans. Soledad Loaeza Grave. SepSententas 82. Mexico City: SEP, 1973.

Cabrera y Quintero, Cayetano de. *Escudo de armas de México.* Mexico City: Viuda de don J. B. de Hogal, 1746.

Calabrese, Omar. *L'età neobarocca.* Bari: Laterza, 1987.

Calancha, Antonio de la, and Bernardo de Torres. *Cronicas augustinias del Peru.* Ed. Manuel Merino. Original title: *Crónica moralizada del orden de San Agustin.* Madrid: Consejo Superior de Investigaciones Científicas, 1972.

Camelo Arredondo, Rosa, Jorge Gurría Lacroix and Constantino Reyes Valerio. *Juan Gerson: Tlacuilo de Tecamachalco.* Mexico City: INAH, 1964.

Camporesi, Piero. *Il pane selvaggio.* Bologna: Il Mulino, 1980.

Carrillo y Gariel, Abelardo. *Técnica de la pintura de Nueva España.* 2d ed. Mexico City: UNAM, 1983.

Casa de Morelos. "Superstición contra varios indios." *Documentos de la Inquisición.* n. pl: n. ed., 1797.

Las Casas, Bartolomé de. *Apologética historia sumaria.* Ed. E. O'Gorman. 3rd ed. 2 vols. Mexico City: UNAM, 1967.

——. *Historia de las Indias.* 3 vols. Caracas: Biblioteca Ayacucho, 1986.

——. *History of the Indies.* Ed. and trans. Andrée Collard. New York: Harper & Row, 1971.

Cervantés de Salazar, Francisco. *Crónica de la Nueva España.* Mexico City: Porrúa, 1985.

Chanut, Martial. *Le Saint Concile de Trente, oecuménique et général célébré sous Paul III, Jules III, et Pie IV, souverains pontifs.* 3rd ed. Paris: Sébastien Mabre-Cramoizy, 1686.

Chaunu, Pierre. *Conquête et exploitation des Nouveaux Mondes (XVIe siècle).* Nouvelle Clio 26 bis. Paris: PUF, 1969.

——. *European Expansion in the Later Middle Ages.* Trans. Katharine Bertram. Amsterdam: North-Holland Publishing Company, 1979 [1969].

Chimalpahin Cuauhtlehuanitzin, Domingo Francisco de San Antón Muñón. *Relaciones originales de Chalco-Amequemecan.* Ed. and trans. Silvia Rendón. Mexico City: FCE, 1965.

Christian, William A. Jr. *Local Religion in Sixteenth-Century Spain.* Princeton: Princeton UP, 1981.

Cohn, Norman. *The Pursuit of the Millennium.* New York: Oxford UP, 1974.

Columbus, Christopher. *The Diario of Christopher Columbus's First Voyage to America, 1492–1493.* Abstracted by Fray Bartolomé de las Casas. Transcribed and trans., notes and concordance Oliver Dunn and James E. Kelley Jr. Norman: U of Oklahoma P, 1989.

Cope, Douglas. *The Limits of Racial Domination: Plebeian Society in Colonial Mexico City, 1660–1720.* Madison: U of Wisconsin P, 1994.

Cordry, Donald Bush. *Mexican Masks.* Austin: U of Texas P, 1980.

Cortés, Hernán. *Cartas y documentos.* Ed. and intro. Mario Hernández Sánchez-Barba. Mexico City: Porrúa, 1963.

——. *Letters from Mexico.* Trans. and ed. Anthony Pagden. Intro. J. H. Elliott. New Haven: Yale UP, 1986.

Crew, Phyllis Mack. *Calvinist Preaching and Iconoclasm in the Netherlands, 1544–1569.* Cambridge, Cambridge UP, 1978 [1973].

Damisch, Hubert. *Théorie du nuage: Pour une histoire de la peinture.* Paris: Seuil, 1972.

Davis, Whitney. "Canonical Representation in Egyptian Art" *Res* 4 (autumn 1982): 21–46.

Delumeau, Jean. *La civilisation de la Renaissance.* Paris: Arthaud, 1967.

Díaz del Castillo, Bernal. *Historia verdadera de la conquista de la Nueva España.* 6th ed. 2 vols. Mexico City: Porrúa, 1968.

Dick, Philip K. *Do Androids Dream of Electric Sheep?* London: Grafton Books, 1973 [1968].

Domínguez Ortiz, Antonio, and Bernard Vincent. *Historia de los Moriscos: Vida y tragedia de una minoría.* 1st ed. Madrid: Alianza Editorial, 1984.

Dorantes de Carranza, Baltasar. *Sumaria relación de las cosas de la Nueva España: Con noticia individual de los decendientes legitimos de los conquistadores y primeros pobladores españoles.* 2d ed. Mexico City: Jesús Medina, 1970 [1902].

Durán, Juan Guillermo. *El Catecismo del III Concilio Provincial de Lima y sus complementos pastorales (1584–1585).* Buenos Aires: El Derecho, 1982.

Duverger, Christian. *L'esprit du jeu chez les Aztèques.* Paris: Mouton, 1978.

Estrada, Jesús. *Música y músicos de la época virreinal.* 2d ed. Diana 95. Mexico City: SepSetentas, 1980.

Favre, Henri. *Cambio y continuidad entre los Mayas de México: Contribución al estudio de la situación colonialista en America Latina.* Mexico City: Siglo Veintiuno, 1973.

Fernández del Castillo, Francisco. "20. Confesión de Fray Maturino." Fernández del Castillo, "Proceso seguido," *Libros* 19–21.

———, ed. *Libros y libreros en el siglo XVI: Selección de documentos y paleografía.* 2d ed. Mexico City: FCE, 1982 [1914].

———. "Proceso seguido por la Justicia Eclesiástica contra Fray Maturino Gilberti por la publicación de unos Diálogos de doctrina cristiana en lengua tarasca (1559 a 1576)." Fernández del Castillo, *Libros* 4–37.

———. "Proceso seguido contra Antón, sacristán, por haberse robado ciertos libros prohibidos, que se habían recogido y estaban depositados en la iglesia de Zacatecos." Fernández del Castillo, *Libros* 38–45.

Fernandez de Pinedo, Emiliano. *Centralismo, ilustración y agonía del Antiguo Régimen (1715–1833).* Ed. Alberto Gil Novales and Albert Derozier. History of Spain. 7 vols. Barcelona: Labor, 1980.

Fernández de Recas, Guillermo S. *Cacicazgos y nobiliario indigena de la Nueva España.* Mexico City: Instituto Bibliografico Mexicano, 1961.

Florencia, Francisco de. *Narración de la maravillosa aparición que hizo el Arcangel San Miguel a Diego Lazaro de San Francisco.* Sevilla: Tomás López de Haro, 1692.

Flores Solis, Miguel. *Nuestra Señora de los Remedios.* Mexico City: Jus, 1972.

Floyd, Troy S. *The Columbus Dynasty in the Caribbean, 1492–1526.* Albuquerque: U of New Mexico P, 1973.

Foster, George McClelland. *Culture and Conquest: America's Spanish Heritage.* Viking Fund Publications in Anthropology, 27. New York: Wenner-Gren Foundation for Anthropological Research, 1960.

Francastel, Pierre. *La figure et le lieu: L'ordre visuel du Quattrocento.* Paris: Gallimard, 1967.

Gage, Thomas. *A New Survey of the West Indies, 1648: The English-American.* Ed. and intro. A. P. Newton. New York: Robert M. McBride, 1929.

Gante, Pedro de. "Introduction of Ernest de la Torre Villar to Fray Pedro de Gante." *Doctrina Cristiana en lengua mexicana.* Facsimile reproduction of the 1553 edition. Mexico City: Centro de Estudios Históricos Fray Bernardino de Sahagún, 1981.

García Icazbalceta, Joaquín. *Colección de documentos inéditos para la historia de México.* 2 vols. Mexico: Porrúa, 1971 [1858].

——. *Don Fray Juan de Zumárraga: Primer obispo y arzobispo de Mexico.* 4 vols. Mexico City: Porrúa, 1947.

García, Genaro. *Documentos inéditos o muy raros para la historia de México.* Mexico City: Porrúa, 1746.

——. *Documentos inéditos o muy raros para la historia de México.* 2d ed. Mexico City: Porrúa, 1974.

Garrido Aranda, Antonio. *Organización de la Iglesia en el reino de Granada y su proyección en Indias, Siglo XVI.* Seville: Escuela de Estudios Hispano-Americanos de Sevilla, 1979.

Gemelli Careri, Giovanni Francesco. *Viaje a la Nueva España.* Mexico City: UNAM, 1976.

Gerbi, Antonello. *Nature in the New World: From Christopher Columbus to Gonzalo Fernandez de Oviedo.* Trans. Jeremy Moyle. Pittsburgh: U of Pittsburgh P, 1985 [1975].

Gerhard, Peter. *A Guide to the Historical Geography of New Spain.* Rev. ed. Norman: U of Oklahoma P, 1993.

Gibson, Charles. *The Aztecs under Spanish Rule: A History of the Indians of the Valley of Mexico, 1519–1810.* Stanford: Stanford UP, 1964.

Ginzburg, Carlo. *The Night Battles: Witchcraft & Agrarian Cults in the Sixteenth and Seventeenth Centuries.* Trans. Anne Tedeschi and John Tedeschi. Baltimore: Johns Hopkins UP, 1983.

Gómez de Orozco, Federico. *El mobiliario y la decoración en la Nueva España en el siglo XVI.* Mexico City: UNAM, 1983.

Grabar, André. *L'iconoclasme byzantin: Le dossier archéologique.* 2d ed. revised and augmented. Paris: Flammarion, 1984.

Greenaway, Peter. *Fear of Drowning by Numbers—Règles du jeu.* Trans. Barbara Dent, Danièle Rivière, and Bruno Alcala. Paris: Dis Voir, 1996.

Greenberg, James B. *Santiago's Sword: Chatino Peasant Religion and Economics.* Berkeley: U of California P, 1981.

Griswold, Susan C. "Appendices." Bercht, 170–80.

Gruzinski, Serge. "Las cenizas del deseo: Homosexuales novohispanos a mediados del siglo XVII." *De la Santidad a la perversión: O de porqué no se cumplia la ley de Dios en la sociedad novohispana.* Ed. Sergio Ortega Noriega. Mexico City: Grijalbo, 1986.

——. *The Conquest of Mexico: The Incorporation of Indian Societies into the Western World, 16th–18th Centuries.* Cambridge: Polity P, 1993. [Originally published as *La colonisation de l'imaginaire: Sociétés indigènes et occidentalisation dans le Mexique espagnol, XVIe–XVIIIe siècle.* Paris: Gallimard, 1988.]

——. *Man-Gods in the Mexican Highlands: Indian Power and Colonial Society, 1520–1800.* Stanford: Stanford UP, 1989. [Originally published as *Les Hommes-Dieux du Mexique: Pouvoir indien et domination coloniale, XVIe–XVIIIe siècles.* Paris: Editions des archives contemporaines, 1985.]

——. "Indian Confraternities, Brotherhoods and *Mayordomías* in Central New Spain: A List of Questions for the Historian and the Anthropologist." Arij Ouweneel and Simon Miller, eds. *The Indian Community of Colonial Mexico.* Latin American Studies 58. Amsterdam: CEDLA, 1990: 205–223.

——. "Individualization and Acculturation: Confession among the Nahuas of Mexico from the Sixteenth to the Eighteenth Century." *Sexuality and Marriage in Colonial Latin America.* Ed. Asunción Lavrin. Lincoln: U of Nebraska P, 1989: 89–108.

——. "La mère dévorante: Alcoolisme, sexualité et déculturation chez les Mexica (1500–1550)" *Cahiers des Amériques latines* 20 (1979): 5–36.

——. *Painting the Conquest: The Mexican Indians and the European Renaissance.* Trans. Deke Dusinberre. Paris: Flammarion, 1992.

——. *La Pensée metisse.* Paris: Fayard, 1999.

Gruzinski, Serge, and Jean-Michel Sallmann. "Une source d'ethnohistoire: Les vies des 'Vénerables' dans l'Italie méridionale et le Mexique baroques." *Mélanges de l'Ecole française de Rome: Moyen Age–Temps Modernes* 88 (1976): 789–822.

Guidieri, Remo. *L'abondance des pauvres: Six aperçus sur l'anthropologie.* Paris: Seuil, 1984.

——. *Cargaison.* Paris: Seuil, 1987.

——. "Commentaire." *Res* 1 (spring 1981): 40–43.

——. "Statue and Mask." Trans. Sharon A. Willis. *Res* 5 (spring 1983): 15–27.

Guijo, Gregorio Martín de. *Diario, 1648–1664.* 2 vols. Mexico City: Porrúa, 1953.

Hellendoorn, Fabienne Emilie. *Influencia del manierismo-nórdico en la arquitectura virreinal religiosa de México.* Mexico City: UNAM, 1980.

Horcasitas, Fernando. *El teatro náhuatl: Epocas novohispana y moderna.* Mexico City: UNAM, 1974.

Hudrisier, Henri. *L'iconothèque: Documentation audiovisuelle et banques d'images.* Paris: La Documentation Française-INA, 1982.

Hvidtfeldt, Arild. *Teotl and Ixiptlatli: Some Central Conceptions in Ancient Mexican Religion. With a General Introduction on Cult and Myth.* Copenhagen: Munksgaard, 1958.

Imágenes guadalupanas: Cuatro siglos (noviembre 1987–marzo 1988). Mexico City: Centro Cultural de Arte Contemporáneo, 1987.

L'imagerie catalane: Lectures et rituels. Ed. Dominique Blanc. Exhibition Catalogue. Carcassonne: Garae, 1988.

Israel, Jonathan Irvine. *Race, Class and Politics in Colonial Mexico, 1610–1670*. London, Oxford UP, 1975.

Ivins, William Mills. *Prints and Visual Communication*. Cambridge: Harvard UP, 1953.

Keen, Benjamin. *The Aztec Image in Western Thought*. New Brunswick: Rutgers UP, 1971.

Kubler, George. *Mexican Architecture of the Sixteenth Century*. 2 vols. New Haven: Yale UP, 1948.

Lafaye, Jacques. *Quetzalcoatl and Guadalupe: The Formation of Mexican National Consciousness, 1531–1813*. Foreword Octavio Paz. Trans. Benjamin Keen. Chicago: U of Chicago P, 1976 [1974].

Lameiras, Brigitte Boehm de. *Indios de México y viajeros extranjeros*. SepSetentas 74. Mexico City: SEP, 1973.

Le Gallo, Yolande. *Nuevas máscaras, comedia antigua: Las representaciones de las mujeres en la televisión mexicana*. Mexico City: Premia, 1988.

Lenz, Hans. *El papel indígena mexicano*. Mexico City: SEP, 1973 [1961].

León, Martín de. *Camino del Cielo en lengua mexicana con todos los requisitos necessarios para conseguir este fin, co[n] todo lo que un Xtiano deve creer, saber, y obrar, desde el punto que uso de razon, hasta que muere*. Mexico City: Diego Lopez, 1611.

Léonard, Emile G. *A History of Protestantism: I. The Reformation*. Ed. H. H. Rowley. Trans. Joyce M. H. Reid. London: Nelson, 1965 [1961].

Leonard, Irving Albert. *Los libros del conquistador*. Mexico: FCE, 1953.

Lévine, Daniel. *Le Grand Temple de Mexico: Du mythe à la réalité—l'histoire des Aztèques entre 1325 et 1521*. Paris: Artcom', 1997.

Llaguno, José A. *La personalidad jurídica del indio y el III Concilio Provincial Mexicano (1585)*. Mexico City: Porrúa, 1963.

Lloyd, Jill. "Emil Nolde's Still Lifes, 1911–1912." *Res 9* (spring 1985): 37–52.

Loaisaga, Manuel. *Historia de la milagrosíssima imagen de Nuestra Señora de Ocotlán*. Mexico City: Viuda de Joseph de Hogal, 1750.

López Austin, Alfredo. *The Human Body and Ideology: Concepts of the Ancient Nahuas*. Trans. Thelma Ortiz de Montellano and Bernard R. Ortiz de Montellano. 2 vols. Salt Lake City: U of Utah P, 1988 [1980].

———. *Hombre-Dios: Religión y política en el mundo náhuatl*. Mexico City: UNAM, 1973.

López de Gómara, Francisco. *Historia de las Indias y conquista de México*. Saragossa: Agustín Millán, 1552.

López de Mendoza, Bernardino. *Información jurídica recibida en el año de mil*

quinientos ochenta y dos [. . .]. Puebla de Los Angeles: Pedro de la Rosa, 1804.

Lyell, James Patrick Ronaldson. *Early Book Illustration in Spain.* New York: Hacker Art Books, 1976 [1926].

Malcolmson, Robert W. *Popular Recreations in English Society, 1700–1850.* Cambridge: Cambridge UP, 1979 [1973].

Mariéjol, Jean-Hippolyte. *Un lettré italien à la cour d'Espagne (1488–1526): Pierre Martyr d'Anghera, sa vie et ses oeuvres.* Paris: Hachette, 1887.

Mathés, Miguel. *Santa Cruz de Tlatelolco: La primera biblioteca académica de las Américas.* Mexico City: Secretaria de Relaciones Exteriores, 1982.

Maza, Francisco de la. *El guadalupanismo mexicano.* Mexico City: FCE, 1981.

——. *El pintor Cristobal de Villalpando.* Mexico City: INAH, 1964.

——. *El pintor Martín de Vos en México.* Mexico City: UNAM, 1971.

——. "Las pinturas de la Casa del Deán." *Artes de Mexico* 2 (1954): 17–24.

McGinnis, Shirley. "Zemi Three-Pointer Stones." Bercht et. al., 92–105.

Mendez, Juan Bautista. "Crónica de la provincia de Santiago de México del orden de los Predicadores." Colección Gómez de Orozco, number 24. Mexico City: Archivo del Instituto Nacional de Antropología e Historia, 1685. Unpublished.

Mendieta, Gerónimo de. *Historia eclesiástica indiana.* 4 vols. Mexico City: Salvador Chávez Hayhoe, 1945.

Mendoza, Juan de. *Relación del santuario de Tecaxique* [. . .]: *Noticia de los milagros* [. . .]. Mexico City: Juan de Ribera, 1684.

Meyer, Jean A. *The Cristero Rebellion: The Mexican People Between Church and State, 1926–1929.* Trans. Richard Southern. Cambridge: Cambridge UP, 1976.

Mier Noriega y Guerra, José Servando Teresa de. *Obras completas. I. El heterodoxo guadalupano.* Ed. Edmundo O'Gorman. 4 vols. Mexico City: UNAM, 1981.

Molina, Alonso de. *Vocabulario en lengua castellana y mexicana.* Mexico City: Antonio de Espinosa, 1571.

Monsiváis, Carlos. "Del difícil matrimonio entre cultura y medios masivos." *Primer simposio sobre historia contemporánea de México: Inventario sobre el pasado reciente (1940–1984).* Mexico City: INAH, 1986.

Morison, S. E. *Christopher Columbus.* London: Mariner, 1956.

Motolinía, Toribio de. *Memoriales; o, Libro de las cosas de la Nueva España y de los naturales de ella.* Ed. E. O'Gorman, 2d ed. Mexico City: UNAM, 1971.

Navarrete, Carlos. *San Pascualito Rey y el culto a la muerte en Chiapas.* Mexico City: UNAM, 1982.

O'Gorman, Edmundo. *Destierro de sombras: Luz en el origen de la imagen y culto de Nuestra Señora de Guadalupe del Tepeyac.* Mexico City: UNAM, 1986.

Ouspensky, Leonide. *Theology of the Icon.* 2 vols. Crestwood, NY: St. Vladimir's Seminary P, 1992.

Oviedo y Valdés, Gonzalo Fernández de. *Historia general y natural de las Indias.* Salamanca: Junta, 1547.

Pagden, Anthony Robin. *The Fall of Natural Man: The American Indian and the Origins of Comparative Ethnology.* New York: Cambridge UP, 1982.

Palomera, Esteban J. *Fray Diego Valadés O.F.M., evangelizador humanista de la Nueva España.* 2 vols. Mexico City: Jus, 1962.

Pané, Fray Ramón. *"Relación acerca de las antigüedades de los Indios": El primer tratado escrito en America.* 2d ed. Mexico City: Siglo Veintiuno, 1977.

Pastoureau, Michel. "Du bleu au noir: Ethique et pratique de la couleur à la fin du Moyen Age." *Médiévales* 14 (1988): 9–21.

Paz, Octavio. *Sor Juana Inés de la Cruz ou les pièges de la foi.* Trans. Roger Munier. Paris: Gallimard, 1987.

Phelan, John Leddy. *The Millennial Kingdom of the Franciscans in the New World.* 2d ed., rev. Berkeley: U of California P, 1970 [1956].

Phillips, John. *The Reformation of Images: Destruction of Art in England, 1535–1660.* Berkeley: U of California P, 1973.

Pietz, William. "The Problem of the Fetish, II: The Origin of the Fetish." *Res* 13 (spring 1987): 23–46.

Pomar, Juan Bautista. *Relación de Tezcoco: Siglo XVI.* Ed. J. García Icazbalceta. Mexico City: Biblioteca Enciclopédica del Estado de México, 1975.

Pomian, Krzysztof. *Collectors and Curiosities: Paris and Venice, 1500–1800.* Trans. Elizabeth Wiles-Portier. Cambridge: Polity P, 1990 [1987].

Pons, Frank Moya. *La Española en el siglo XVI, 1493–1520: Trabajo, sociedad y politica en la economia del oro.* 3rd ed. Santiago: Universidad Católica Madre y Maestra, 1971.

Pontalis, J.-B. "Présentation." *Objets du fétichisme. Nouvelle Revue de Psychanalyse* 2 (fall 1970): 5–15.

"Proceso contra María Felipa de Alcaraz, bruja española de Oaxaca, Oaxaca (extracto)," Third series, vol. 2: (4) 6 *Boletín del Archivo General de la Nación* (Mexico, 1978): 33.

Proceso inquisitorial del cacique de Tetzcoco. Mexico City: Eusebio Gómez de la Puente, 1910.

Procesos de Indios idólatras y hechiceros. Publicaciones del Archivo General de la Nación. Mexico City: Guerrero Hermanos, 1912.

Quéau, Philippe. *Eloge de la simulation: De la vie des langages à la synthèse des images.* Paris: Champ Vallon, Institut National de l'Audiovisuel, 1986.

Ramírez, Antonio de Guadalupe. *Breve compendio de todo lo que debe saber y entender el cristiano.* Mexico City: Madrilena de las Herederos del Lic. J. De Jauregui, 1785.

Las redes de Televisa. Ed. Raúl Trejo Delarbre. Mexico City: Claves Latino-
americanas, 1988.

Régnier-Bohler, Danielle. "Le simulacre ambigu: Miroirs, portraits et
statues." "Le champ visuel." *Nouvelle Revue de Psychanalyse* 35 (1987): 91–
107.

Reyes Valerio, Constantino. *Tepalcingo*. Mexico City: INAH, 1960.

Ricard, Robert. *The "Spiritual Conquest" of Mexico: An Essay on the Apostolate
and the Evangelizing Methods of the Mendicant Orders in New Spain, 1523–1572*.
Trans. Lesley Byrd Simpson. Berkeley: U of California P, 1966 [1933].

Ripa, Cesare. *Iconologia*. Ed. Piero Buscaroli. Milano: Editori Associati, 1992.

Rivadeneira y Barrientos, Antonio Joaquín. *Disertaciones que le asistente real
Don Antonio Joaquín de Rivadeneira escribió sobre los puntos que se le con-
sultaron por el Cuarto Concilio mexicano en 1774*. Madrid: n. pub., 1881.

Robles, Antonio de. *Diario de sucesos notables (1665–1703)*. Ed. Antonio Castro
Leal. 3 vols. Mexico City: Porrúa, 1946.

Rodríguez de San Miguel, Juan Nepomuceno. *Pandectas hispanomexicanas*. 3
vols. Mexico City: UNAM, 1980.

Rojas, Pedro. *Tonantzintla*. 1st ed. Mexico: UNAM, 1956.

Rosa, Pedro de la. *Información jurídica* Puebla de Los Angeles: Oficina
de D. P. de la Rosa, 1804.

Rose, Jean, ed. *Le conquistador anonyme*. Mexico City: Institut Français
d'Amérique Latine, 1970.

Ruíz Gomar, Rogelio. *El pintor Luis Juárez: Su vida y obra*. Mexico City:
UNAM, 1987.

Ruíz y Cervantes, José Manuel. *Memorias de la portentosa imagen de Nuestra
Señora de Xuquila*. Mexico City: F. de Zunigas y Ontiveros, 1791.

Sade, Marquis de. *Juliette: or, Vice Amply Rewarded*. New York: Lance, 1969.

Sahagún, Bernardino de. *Historia general de las cosas de Nueva España*. Ed. An-
gel María Garibay Kintana. 3rd ed. 4 vols. Mexico City: Porrúa, 1977.

Sallmann, Jean-Michel. "Il santo patrono cittadino nel'600 nel regno di
Napoli e in Sicilia." *Per la storia sociale e religiosa del Messogiorno d'Italia*.
Eds. Giuseppe Galasso and Carla Russo. 2 vols. Naples: Guida, 1982: 187–
211.

———. *Visions indiennes, visions baroques: Les métissages de l'inconscient*. Paris:
PUF, 1992.

Sardo, Joaquín. *Relación histórica y moral de la portentosa imagen de Nuestro
Señor Jesucristo crucificado aparecido en una de las cuevas de San Miguel de
Chalma*. Facsimile of the 1810 edition. Mexico City: Biblioteca Enciclo-
pédica del Estado de México, 1979.

Sauer, Carl Otwin. *The Early Spanish Main*. Berkeley: U of California P, 1966.

Schönborn, Christoph von. *God's Human Face: The Christ-Icon*. San Francisco:
Ignatius P, 1994.

Scribner, Robert W. *For the Sake of Simple Folk: Popular Propaganda for the German Reformation.* Cambridge: Cambridge UP, 1981.

Sendler, Egon. *The Icon, Image of the Invisible: Elements of Theology, Aesthetics, and Technique.* Redondo Beach, CA: Oakwood Publications, 1988.

Sten, María. *Vida y muerte del teatro nahuatl: El Olimpo sin Prometeo.* Sep-Setentas 120. Mexico City: SEP, 1974.

Supersticiones de los indios de la Nueva España. Mexico City: Biblioteca de Aportación histórica, 1946.

Televisa, el quinto poder. Eds. Fernando Mejia Barquera and Raúl Trejo Delarbre. Mexico City: Claves Latinoamericanas, 1985.

Thomas, Keith. *Religion and the Decline of Magic: Studies in Popular Beliefs in Sixteenth- and Seventeenth-Century England.* New York, Charles Scribner's Sons, 1971.

Tibol, Raquel. *José Clemente Orozco, Una vida para el arte: Breve historia documental.* Mexico City: SEP, 1984.

Torquemada, Juan de. *Monarquía indiana.* Ed. Miguel Leon-Portilla. 3rd ed. 7 vols. Mexico City: UNAM, 1976.

Torre Villar, Ernesto de la, and Ramiro Navarro de Anda. *Testimonios históricos guadalupanos: Compilación, prólogo, notas bibliograficas y indices.* Mexico City: FCE, 1982.

Toussaint, Manuel. *Claudio de Arciniega: Arquitecto de la Nueva España.* Mexico City: UNAM, 1981.

——. *Pintura colonial en México.* 2d ed. Mexico: UNAM, 1982 [1962].

Tovar de Teresa, Guillermo. *Bibliografía novohispana de arte, Primera parte: Impresos mexicanos relativos al arte de los siglos XVI y XVII.* Mexico City: FCE, 1988.

——. *Bibliografía novohispana de arte, Secunda parte: Impresos mexicanos relativos al arte del siglo XVIII.* Mexico City: FCE, 1988.

Trexler, Richard C. "Aztec Priests for Christian Altars: The Theory and Practice of Reverence in New Spain." *Scienze, credenze occulte, livelli di cultura: Convegno internazionale di studi (Firenze, 26–30 giugno 1980).* Istituto nazionale di studi sul Rinascimento. Florence: Olschki, 1982: 175–96.

Turi, Gabriele. *Viva María: Le reazioni alle reforme leopoldine (1790–1799).* Florence: Olschki, 1969.

Umberger, Emily. "Antiques, Revivals and References to the Past in Aztec Art." *Res* 13 (spring 1987): 107–22.

Vargas Lugo, Elisa. "Las fiestas de beatificación de Rosa de Lima." *El arte efímero en el mundo hispánico.* Mexico City: UNAM, 1983.

Velasco, Alfonso Alberto de. *Historia de la renovación de la soberana imagen de Christo Nuestro Señor crucificado.* Mexico City: calle de la Palma num. 4, 1845.

Venegas, Miguel. *Relación del tumulto [. . .] contra el ingenio de Xalmolonga.* Mexico City: Biblioteca Nacional, 1721: Ms 1006.

Vera, Fortino Hipólito. *Colección de documentos eclesiásticos de México [. . .].* 3 vols. Amecameca: Colegio Católico, 1887.

———. *Itinerario parroquial del arzobispado de México [. . .].* Amecameca: Colegio Católico, 1880.

———. *Santuario del Sacromonte.* Amecameca: Colegio Católico, 1881.

Vetancurt, Agustin de. *Teatro mexicano: Quarta Parte.* 4 vols. Mexico City: Doña María de Benavides, 1697.

Victoria, José Guadalupe. "Forma y expresión en un retablo novohispano del siglo XVII," *Estudios aerca del arte novohispano: Homenaje a Elisa Vargas Lugo.* Mexico City: UNAM, 1983.

———. *Pintura y sociedad en Nueva España: Siglo XVI.* Mexico City: UNAM, 1986.

Walker, Jeffery B. "Taino Stone Collars, Elbow Stones, and Three-Pointers." Bercht et al., 80–91.

Warren, J. Benedict. *The Conquest of Michoacan: The Spanish Domination of the Tarascan Kingdom in Western Mexico, 1521–1530.* Norman: U of Oklahoma, 1985.

Weckmann, Luis. *The Medieval Heritage of Mexico.* Trans. Frances M. López-Morillas. New York: Fordham UP, 1992 [1983].

Zarri, Gabriella. "Purgatorio 'particolare' e ritorno dei morti tra Riforma e Controriforma: l'area italiana." *Cuaderni Storici* 50 (Aug. 1982).

Index

Serge Gruzinski is director of graduate studies at
the Ecole des Hautes Etudes en Sciences Sociales,
Paris, and director of the Centre de Recherches
sur les Mondes Américains.

Library of Congress Cataloging-in-Publication Data
Gruzinski, Serge.
[Guerre des images. English]
Images at war : Mexico from Columbus to Blade Runner (1492–2019) /
Serge Gruzinski;
translated by Heather MacLean.
p. cm. — (Latin America Otherwise)
Includes bibliographical references and index.
ISBN 0-8223-2653-1 (cloth : alk. paper)—ISBN 0-8223-2643-4 (pbk. : alk. paper)
1. Mexico—Civilization—Spanish influences. 2. Acculturation—Mexico.
3. Idols and images—Mexico. 4. Art and history—Mexico.
I. MacLean, Heather. II. Title.
F1210 .G7813 2001
972—dc21 00-049074